Eugenic Design

Eugenic Design

Streamlining America in the 1930s

Christina Cogdell

PENN

University of Pennsylvania Press
Philadelphia

Publication of this volume was assisted by a grant from the Graham Foundation for Advanced Studies in the Fine Arts.

10 9 8 7 6 5 4 3 2 1

Published by
University of Pennsylvania Press
Philadelphia, Pennsylvania 19104-4011

Library of Congress Cataloging-in-Publication Data

Cogdell, Christina.
 Eugenic design: streamlining America in the 1930s / Christina Cogdell.
 p. cm.
 ISBN 0-8122-3824-9 (cloth : alk. paper)
 Includes bibliographical references and index.
 1. Eugenics—Social aspects—United States—History—20th century. 2. Design—Social aspects—United States—History—20th century. 3. Aerodynamics—Social aspects—United States—History—20th century. 4. Design, Industrial—Social aspects—United States—History—20th century. 5. Genetics—Social aspects—United States—History—20th century. 6. Racism—United States History—20th century. 7. United States—Civilization—1918–1945. 8. United States—Race relations. 9. United States—Social conditions—1933–1945.
HQ755.5.U5 C64 2004
363.9'2'097309043—dc22 2004049499

For Todd, Jeff Meikle, my parents,
and in memory of my grandmother,
Willie Josephine Cogdell

and in praise of the beauty and exuberance of streamline design,
this interpretation notwithstanding.

Contents

Preface

Norman Bel Geddes possessed a strong sense of his own impor-
tance to history. This much is clear from his prodigious archive, housed at
the University of Texas, some four hundred linear feet, containing his per-
sonal papers, copious documentation of his theater and industrial design
projects, the films he made, and his personal library, among many other
things. I first encountered his archive, and his personality, while trying to
determine whether he consciously created a sexual narrative in the architec-
tural layout of the General Motors Futurama at the New York World's Fair
in 1939–1940. What I found led me to many other archives, and then to the
premise of this book—an argument for the interconnectedness of stream-
line design with eugenic ideology.

In hindsight, it seems almost coincidental that the sexual theme of the
Futurama that so intrigued me was related to evolutionary thought, for at
the time I knew almost nothing about eugenics, *the* arena where evolution
and human sexuality coalesced in the interwar period. I had, however,
throughout my years of graduate study, been exploring the longstanding
legacy of evolutionary ideology and its various discourses of race, class,
gender, and disability. I had also been interested in the ideological and
figurative relationships between bodies and machines that so many mod-
ernists voiced in their art and in their cultural criticism. The complex dec-
ade of the 1930s—with all its difficulties, optimism, agitation, and creative
expression—has always fascinated me, and simply by personal bent, I've
always enjoyed considering the influence of ideology on material culture.

So, perhaps it was not coincidence after all but rather a convergence
of these various paths of exploration that carried me far beyond the Futu-
rama into this study. All of these interests combined to open my eyes to a
new way of perceiving a familiar subject—the streamline style of the dec-
ade—and undoubtedly they account for why I remain interested in both
design and eugenics upon the completion of this book. The history of the
influence of eugenics in the United States—on modern artists and writers,
architects, designers and advertisers, on scientists and politicians, and, most

profoundly, on the thousands of people affected by policies enacted in the name of eugenics—is only beginning to be written, and I expect that publication will continue until eugenics is widely acknowledged and taught us having stood as a central pillar of modernism, and reparations are begun. After all, so many core debates of the period circled around its tenets— birth control, prohibition, free-love, anti-immigration, miscegenation, segregation, feminism and maternity, perceptions of race, class, sexuality and disability, the rights of the individual in relation to the state, nationalism and the devastating effects of the first world war, alleviation of the economic collapse, and even the protection and improvement of the future of humanity. That the major design style of the Thirties also bears its mark, therefore, in some ways is not surprising, given the pervasiveness of eugenics as a defining ideology of modernity.

A growing literature has illuminated these individual areas of influence. Cultural historian Robert Rydell first disclosed the presence of eugenics in exhibits at the world's fairs of the 1930s, seen by thousands, while medical historian Martin Pernick has examined the influence of eugenics in medicine, motion pictures, and debates over euthanasia after 1915. At the same time, other scholars have demonstrated its prevalence in high school textbooks and debates over educational curricula between the 1910s and the 1940s, as well as the power of eugenics to shape female sexuality and gender roles through the baby boom era. Two books have documented the connections between American eugenics programs and those of the German National Socialists. Nonetheless, investigations of how eugenics infused American modernist creativity, as opposed to society and politics, have been rarer.[1] What this book offers, then, is not only a revisionist interpretation of the major popular design style of the period, but an in-depth analysis of three of the formative principles beneath eugenic ideology—the pursuits of efficiency, hygiene, and the ideal type—that place its aims as coincident with deeply rooted ideals in American culture. Furthermore, it provides strong evidence for the widespread popularization of eugenic ideology among the middle class during the 1930s, in contrast to most studies that have focused on the 1920s and earlier.

The historical strand traced by this narrative connecting streamlining and eugenics is only one of the many possible trajectories arising from research in the archives of streamline designers and eugenicists. Other historians accessing much of the same material have told different and equally valid stories. Hence the numerous books on American eugenics just mentioned, and the histories of streamline design that examine the style as an

outgrowth of research into physical efficiency, a result of new materials and production processes, a buoying counter to the effects of the Depression, and a corporate strategy to create a consumer culture.[2] Streamlining and eugenics were all of these things. I chose to pursue this particular narrative because it offers new insight into both streamlining and eugenics, and as a result, into the cultural history of the 1930s.

From this choice, however, readers might get the impression that eugenics appealed only to middle- and upper-class whites in a capitalist economy, since that is the population predominantly addressed in this study and with which many eugenicists, and the six designers on whom I focus, identified. Such is not the case. Eugenics appealed to capitalists and socialists, political conservatives and radicals, fascists and anarchists, feminists and social conservatives. Supporters included members of a wide variety of ethnic groups all over the world, including not only self-proclaimed "Nordics" in Europe, the United States, and Canada, but also Jews, African Americans, Mexicans, Brazilians, Russians, Indians, the Japanese, and many others.[3] The narrative this book offers, therefore, is only partial, and in discussing the popularity of eugenics, I am discussing a specific populace which in many instances was actually much broader.

The term "popular" has been used to mask the distinctions between producers and receivers, to hide rather than to name agency. This study is primarily about producers, eugenicists and designers who, through their work, proclaimed a particular modern vision to a receptive, middle-class, predominantly white audience. The voices that speak are theirs, in quotations from speeches and letters or through the aesthetics of the visual forms they created. Yet often, because of the medium in which they were published (newspapers, scientific and architectural journals, magazines such as the *Atlantic Monthly, Ladies Home Journal, Vogue,* and *Forum*) or the contexts in which they spoke or for which they created (public lectures at high schools and churches, meetings of executives, radio broadcasts, world's fair exhibits, and the design of mass produced goods), a broad audience for their ideas was certainly present. To document historically how well their messages were actually internalized by these audiences would be an impossible task. In a very real sense, however, the reception of eugenic ideology is demonstrated by the beliefs of streamline designers themselves, for none of them was a eugenic activist per se. Though not immersed in the formal eugenics movement, each to a greater or lesser extent still managed to absorb its rhetoric and its principles because they were so much a part of contemporary social, political, and scientific debates, so much a part of the

social circles in which they moved, and so much a part of what it meant to make something "modern" and "civilized" in an evolutionary sense. Their speeches and writings thus reveal their acceptance of eugenic ideas and their application of them to the realm of design.

The association of streamline designers with eugenics in no way indicts them as complicit with fascism or as supporting totalitarian politics; all of them supported democracy and worked within the capitalist system. If press coverage can serve as a general indicator, politics and science could occupy separate mental compartments, for during the mid-1930s many American and British journalists criticized Germany for its political totalitarianism while remaining remarkably silent on its racist social policies. Similarly, because of the vagueness of key eugenic terminology (the "fit," the "unfit," the "feebleminded," etc.) and the countless ways that eugenics could be argued by people with divergent political and social viewpoints to support completely opposite ends (e.g., the debate over birth control), to accept eugenic principles did not mean that one could be pigeonholed as belonging to a particular political or social persuasion.

Likewise, to accept eugenic principles did not automatically define one as racist, although the likelihood of this in the U.S. was far greater than one's being fascist; the desire to improve the genetic future of humanity did not *have* to entail a racist perspective. In theory, and especially during the 1930s, mainline eugenic rhetoric shifted from naming entire "races" or classes as dysgenic to focusing on the individual. This shift, however, was only nominal in that many eugenicists still proclaimed that more individuals from certain races and the lower classes were dysgenic than those from other races and the middle and upper classes. In practice, eugenic policies were in fact applied more heavily to lower-class whites and to nonwhites, and most eugenicists were racist in that they believed in an evolutionary racial hierarchy with their own race occupying the position at the top. From the latter fundamentally racist standpoint, then, most eugenics supporters were quite well-intentioned; eugenics, after all, was also known as race-betterment, and improvement is generally esteemed as a laudable goal.

If their extant papers serve as an accurate indicator (and this is frequently *not* the case, owing to what was saved or discarded), the designers in this study—including Norman Bel Geddes, Egmont Arens, Walter Dorwin Teague, Raymond Loewy, Henry Dreyfuss, and Donald Deskey—possessed differing levels of interest in eugenics and espoused differing degrees of racism. None of them appears to have been anti-Semitic or a white supremacist in the rabid fashion that term implies. Arens was quite

outspoken about his opinion of the evolutionary backwardness of people of African, Indian, and Asian descent, while others, including Geddes, Teague, Loewy, and Deskey, were far more reticent but still considered certain groups to be more "primitive" than "civilized" whites. In terms of obvious interest in eugenics, the abundance of material in Geddes's archive places him in the lead by far, followed by Arens, then Teague, Loewy, and Deskey (all about even), with Dreyfuss trailing at the end. Of them all on both these issues, Dreyfuss seems to have been the most ecumenical, most inclusive, and least judgmental, perhaps because of his Jewish background and his training at the Ethical Culture school. The intention of this study, however, is not to rate or rank the beliefs of these designers, who were very much men of their time and social milieu, but rather to show the extent to which eugenic ideology infiltrated middle-class culture of the 1930s, was adopted with differing levels of belief, and became embodied within the aesthetics of streamline design.

In retrospect, eugenics is rightly called a pseudoscience because of the powerful ways in which the faulty and unproven assumptions driving much of the research and propaganda were asserted as truth and quickly turned into damning social and political policies. Especially during the 1930s within the scientific community, it was a science in flux, making the transition in name and methodology from eugenics to genetics. In fact, however, many of the goals of eugenic research survived the transition to genetics, adjusting only as needed to match current scientific understanding. This fact is shown in part by the many trained scientists and social scientists, in both the U.S. and Germany, who held eugenic beliefs and worked in connection with eugenic researchers at Cold Spring Harbor in New York during the 1920s and 1930s, who managed to maintain professional affiliations into the decades beyond. Public perception of this transition from eugenics to genetics proceeded slowly, as evidenced by the increase in number of states passing and enforcing sterilization statutes, by the persistence of eugenics in high school textbooks and college courses, and by the types of exhibits shown in museums and at world's fairs throughout the 1930s. It is therefore not surprising that designers, writers, and artists, among others, continued to express and debate eugenic ideals in their work during this period.

Although the Second World War and its demand for resources interrupted the production of streamlined goods at the height of their popularity, and the "final solution" of the Holocaust revealed the catastrophic ends to which eugenic ideology and policy could lead, many of the values undergirding both streamlining and eugenics continued in the postwar world.

The results of the technocratic logic of eugenics and the explosions of the atomic bomb undoubtedly dissolved many critical Americans' faith in "progress" as defined by advances in science and technology. Yet, this dissolution was countered by government and corporate messages upholding American scientific genius and technology as the powers that had won the war and allowed democracy to triumph over totalitarianism. Advertisements, in some cases featuring well-known streamline designers, claimed that benefits brought through technology during wartime, like material goods themselves, would be converted into enhancing postwar domestic comforts and happiness and to making the American lifestyle into the epitome of social evolution. Many middle-class Americans bought into this denial of the negative consequences of technology through consuming mass-produced goods on an unprecedented scale during the 1950s, and all the while prewar social injustices against minorities continued. This lack of real postwar change—in corporate power (which strengthened), in social and race prejudice and inequality, and in the belief that science, technology, and free enterprise bring evolutionary progress—showed that the results of the war had failed to challenge many of the underlying values which had led to eugenics in the first place.[4]

Today, eugenics is back, as a result of ongoing developments in the field of genetics that have led to biotechnology, genetic engineering, cloning, and proposals that soon the human "germline" will be able to be "enhanced." This study concludes by critiquing the new eugenics and its promoters' claims that it is different from the pseudoscience of the old eugenics by placing its promoters' goals and claims in the context of historical comparison, not only against the old eugenics but also against the backdrop of wartime marketing strategies and the transformation of streamline design. What may appear to be different in the new eugenics today because of contextual changes in politics, in technology, and in cultural patterns of consumption, when placed next to the old eugenics—with its values of controlling evolution, its technocratic logic, its pursuits of efficiency, hygiene and the ideal type—seems uncomfortably familiar. This resonance, with the old eugenics and with corporate strategies of control, urges us to carefully consider and question the presumed benefits of the ways the values and strategies of design have infused American culture, even to its most intimate level of the commodification of our selves.

In writing this book, I am most grateful to Jeff Meikle for his continuous support, meticulous criticism, and friendship. Had he not been open to sharing what I've always thought of as *his* topic—the history of American

streamline design—I'm certain that I would not have pursued this project. This book would not have been possible, nor half as much fun, without him. I am also grateful to Linda Henderson, who has been so supportive over the years. Her indefatigable energy, openness, and scholarship are an example for many people. Kathleen Pyne has also been a superb mentor and generous friend and colleague, and I very much appreciate all of her encouragement.

Over the years, I received financial assistance from numerous organizations. The Department of Art and Art History at the University of Texas at Austin generously offered me a David R. Bruton, Jr., Endowed Graduate Fellowship in 1994, as well as numerous travel grants for conference presentations of my work. I appreciate the support of the Graduate School through a University Continuing Fellowship in 1998 and another David R. Bruton, Jr., Fellowship in 1999. With this funding, I was able to complete the bulk of my research in the New York archives of numerous industrial designers during the Fall of 1998. For their assistance then, as well as on later research trips, I am grateful to numerous librarians, including Claire Gunning and Elizabeth Broman at the Cooper-Hewitt National Design Museum, Mary Huth at the Rush Rhees Library at the University of Rochester, Caroline Davis at the Special Collections Research Center at the Syracuse University Library, Rick Watson and the staff at the Harry Ransom Humanities Research Center at the University of Texas at Austin, Jennifer Nieves and Jim Edmonson at the Dittrick Medical History Library at Case Western Reserve University, and the staff at the libraries of the American Museum of Natural History and the Museum of Modern Art in New York.

During the summer of 1999, I received an Andrew Mellon Resident Research Fellowship from the American Philosophical Society to examine their archives documenting the eugenics movement in the United States. This study would have been noticeably incomplete without the research that their generous assistance enabled me to accomplish during those two months in residence in Philadelphia and on a later visit. I am thankful to Marty Levitt, curator Robert Cox and librarian Scott de Haven, who all generously offered their time, knowledge, and humor to make my time there both productive and enjoyable. Without the help of a Henry Luce Dissertation Fellowship in American Art from the American Council of Learned Societies, I would never have been able to write the bulk of this manuscript during the academic year, 1999–2000. I am very grateful for their support.

Over the years, I have presented parts of this project at numerous

conferences and symposia, including the annual conventions of the American Studies Association, College Art Association, Society for Literature and Science, and the Society for Architectural Historians, as well as at Hypotheses 3 at the Princeton School of Architectural History and Theory and at the Buell Dissertation Colloquium at Columbia University's Center for the Study of American Architecture. At each of these events, I received valuable criticism and encouragement and met wonderful colleagues working in related areas, including, among many others, Robert Rydell, Rosemarie Garland Thompson, Joan Ockman, Victor Margolin, Jonathan Massey, Tim Rohan, Anne Collins-Goodyear, Sue Currell, Carma Gorman, Cathy Gudis, Elspeth Brown, Oliver Botar, Isabel Wünsche, and Jeanette Redensek. I am also grateful for travel grants from the American Studies Association, the Society for Literature and Science, and the College Art Association. During this time, *American Quarterly* published "The Futurama Recontextualized: Norman Bel Geddes's Eugenic 'World of Tomorrow.'" I am very thankful for the comments and assistance I received from Lucy Maddox and the reviewers during this process and for the excitement of seeing my first article in print. Subsequently, a portion from the second chapter of this book, "Products or Bodies? Streamline Design and Eugenics as Applied Biology," was published in the Winter, 2003, issue of *Design Issues.* My thanks go out to Victor Margolin and the editorial staff for their support and suggestions. Recognition is due to both the Johns Hopkins University Press and MIT Press, who publish each journal respectively, as parts of those articles are repeated in this manuscript.

 I also wish to acknowledge and thank Barbara Buhler Lynes and the Georgia O'Keeffe Museum Research Center for awarding me an opportunity to guest curate an exhibition on the topic of this book. I was in residence at the Research Center during the first eight months of 2003 completing the preparatory planning and further research, and through working on the exhibition and having discussions with the other scholars there—Carolyn Butler Palmer, Audrey Goodman, Bett Schumacher, Ann Prentice Wagner, Mary Woods, and Heather Hole—I benefited greatly. I also very much appreciate librarian Eumie Imm-Stroukoff's assistance and cheerfulness. Colleagues at California State University Fullerton who have offered great support and friendship are Terri Snyder, Angeles Sancho-Velasquez, Joe Gonzalez, Jim Hofmann, Thomas Klammer, Joanna Roche, and Linda Kim; thanks to all of you, as well as to Kate Catterall, Chris Taylor, Lois Weinthal, Miodrag Mitrasinovic, Peter Dick, Katie Robinson-Edwards, Sally Whitman, Julie Levin, Joel Dinerstein, Frank Goodyear, Siva Vaidhya-

nathan, David de la Peña, and Cynthia Henthorn, as well as to Dieter Kunst, Paul Rose and Claire Cronin at the U.S. Holocaust Memorial Museum for their generosity, and to many others who have aided me along the way. At the University of Pennsylvania Press, Bob Lockhart receives all my thanks for enthusiastically believing in this project, carefully editing the manuscript, and securing suggestions for revision from very helpful readers.

I must finally thank my family for their love, encouragement, example, and financial support. The countless dinner discussions with all of them over the years taught me to love using my mind, and their continual acceptance encouraged me to express my own opinions. My father inspired me to become a professor, and he first taught me how to write and edit. I treasure our conversations, both academic and personal. My heartfelt thanks also to Lisa Davis and Natalie Spain, to Carolyn de la Peña for being the superb academic example and friend that she is, and to Todd Gogulski, whose multiple talents, patience, and love, as well as his collection of large streamlined objects, have inspired me and given me so much joy over the last four years, making them seem like many more.

Chapter 1
Introduction: Controlling Evolution

In the chronology at the back of his autobiography, under the year 1927, Norman Bel Geddes boldly claimed credit for establishing the "profession of the industrial designer," noting mistakenly that he also created that year one of the first stylistically "advanced" streamlined automobiles for the Graham-Paige Motor Corporation and designed the "first streamlined ocean liner." Last for that year, he listed his production of "the 16-mm. motion pictures *Amphibia*, *Reptilia*, and *Insectia*, using high magnification." Although these films may seem like an addendum to a chronology and a career focused on his theatrical and industrial designs, under the year 1933, he cordoned the fact that he "Designed and constructed a private aquarium, housing 2,000 live amphibia and reptilia, for motion-picture study" on either side by "Design for a streamlined ocean-going tanker" and "Exhibition of designs, Italian National Exposition, Milan, Italy." [1]

Geddes failed to mention that this "private aquarium" was his own, and that by 1934 its tanks were so large that he had completely given over a room in his 79th Street apartment in New York City to house its 20 × 4 × 3 dimensions. He built the terrarium to be of a "sufficiently spacious nature" to "allow the inhabitants to live normally" and "be photographed in normal surroundings." The 2,000 creatures were of numerous species—chameleons, skinks, lizards, snakes, toads, frogs, salamanders, newts, black ants, snails, turtles, crayfish, and plants—that he ordered from biological supply warehouses around the nation. They lived in tanks of two different climates, each controlled by its own heating and ventilating systems, flanked by tropical fish aquariums and resting on "a half dozen other tanks" that he used "for breeding purposes." [2]

His scientific notebooks, arranged by species, contain notes categorized by "Popular Name, Order, Family, Genus, Species, Range, Habitat, Distinguishing Characteristics, Breeding, Food @ month old, Food @ six months, Food adult," and he carefully noted the breeding habits and physi-

cal characteristics of males and females.[3] He marked and saved one leaflet entitled "Drosophila Flies and Their Use in Demonstrating Mendel's Law of Heredity," which promised to teach the "Mendelian ratios and other principles such as linkage, dominance, variations and sex inheritance." Expert zoologists congratulated Geddes for his expertise in breeding and rearing young of different species. For instance, Geddes spent part of the summer of 1935 on Long Island gathering salt-water eels from the ocean, taking them home to his aquariums, breeding them and rearing the young in freshwater, and returning them to the ocean to live. G. Kingsley Noble at the American Museum of Natural History knew of "no other local naturalist" who had tried this experiment and succeeded in disproving "what authorities say about eel breeding."[4] Geddes's success and dedication to his breeding experiments—as shown by his films, his investment of time, space and money, and his correspondence—belie his statement in one letter that "All of this is merely by way of hobby with me."[5]

Since childhood, Geddes had been deeply interested in studying nature and understanding the processes of evolution. He remembered his mother frequenting the Field Museum of Natural History in Chicago when he was a boy, and after they moved to Newcomerstown, Ohio, when he was around fifteen years old, he spent much of his free time in the woods around the Tuscarawas River watching and collecting animals, bringing home many as pets. He studied their habitats, and recounted specifically his observations of the animals' struggle for survival against rival species and their failure in death.[6] This interest in "hard competition" continued throughout his life; he admitted fascination with sports and with war, "that deadliest 'sport' of all." During the 1910s and 1920s, he designed a number of very elaborate simulation games (football, baseball, miniature golf, horse racing, and war) so that he and his friends could vicariously experience their challenges, and engage in betting, from the confines of his apartments.[7] During the summer of 1913, at the age of nineteen, he spent three months living on the Blackfoot reservation in Montana, creating almost five hundred ethnographic drawings and paintings for the Field Museum. While there, he pondered the cycle of racial development and decay in light of racial competition, noting that the Blackfoot had "degenerated" at the hands of the whites and wondering whether the same fate lay in store for his kind at some point in the future.[8]

A few years after moving to New York City in 1918, Geddes resumed collecting animals, as he had left his childhood collection far behind during his brief attempts at higher education. His breeding experiments of the

1920s, which continued through the mid-1930s, and his films documenting them, however, suggest his interests matured from merely observing evolution to attempting to control its mechanisms through conscious selection and breeding. This change may have been a natural outgrowth of his awareness of the goals of eugenics, an international scientific and sociopolitical movement very much in the spotlight in the U.S. during the 1920s, when it was used as justification for the federal Immigration Restriction Act of 1924 and the Supreme Court's upholding in 1927 of state sterilization statutes in *Buck v. Bell*, among other issues. The word eugenics, coined by Charles Darwin's cousin Francis Galton in 1883, means to be "well-born," and the scientific portion of the movement aimed at understanding the principles of genetics in order to improve human heredity. Its professional organization in the U.S. first began as an extension of the American Breeders Association in 1906. The sociopolitical portion of eugenics, however, applied its unproven scientific principles to quickly fashion the movement into a two-pronged effort to "positively" increase the birthrate of the "fit" while "negatively" diminishing that of the "unfit." The controversy caused by these policies made eugenics a highly publicized and widely debated issue as early as the 1910s.

During this period, Geddes's library grew to include numerous books on animal breeding, as well as texts by eugenicists applying these principles to man and his racial development. Two of these, Ellsworth Huntington's *The Evolution of the Earth and Its Inhabitants* (1918) and Leon Whitney's *The Basis of Breeding* (1928), both heavily annotated by Geddes, were written by men who served as president of the American Eugenics Society. Geddes's "hobby," therefore, was in full sway when he turned in 1927 from making films of highly magnified animals mating in tanks in his apartment toward establishing the profession of industrial design. His designs for the Graham-Paige Motor Corporation would not be commissioned until 1929, however, the year he also likely turned to ocean liner design and to the formalization of the streamline style.[9]

Geddes's interest in evolution and its extension into eugenics was shared by other designers. Although most of the early literature on streamlining focuses on air and fluid dynamics, there is good reason to believe that evolutionary concerns were never far from the surface. Around 1933, when the style became widely popular, streamlining assumed a more eugenic cast, owing in part to interpretations offered by Egmont Arens, the chief popularizer of the style behind Geddes, as well as to statements made by Geddes himself in 1934. This shift was so marked that in rhetoric and

meaning, streamlining effectively became a popular expression of eugenic ideology.

On first hearing, this assertion is likely perplexing. I am frequently asked with some incredulity, what is the connection between eugenics and streamline industrial design? The simplest answer is this: streamline designers approached products the same way that eugenicists approached bodies. Both considered themselves to be agents of reform, tackling problems of mass (re)production, eliminating "defectiveness" and "parasite drag" that were thought to be slowing forward evolutionary progress. Both were obsessed with increasing efficiency and hygiene and the realization of the "ideal type" as the means to achieve an imminent "civilized" utopia. In short, streamline design served as a material embodiment of eugenic ideology. This assertion, of which I was quite certain based upon the otherwise improbable numerous theoretical overlaps between the two and the fact that the style's main theorizer, Geddes, was very interested in eugenics, contradicted the conclusions of many historians of eugenics, not to mention design, at the time I began this project. Only a few stated, in a sentence or two, that eugenics might have been more than a moribund movement beyond the end of the 1920s.[10] I therefore determined to scour the archives of designers and eugenicists, seventeen of them, to see what evidence existed to back my hypothesis. I was also curious to find out whether, in the papers that remain, eugenicists or designers ever *specifically* made mention of each other.

They almost never did. Some eugenicists compared people to products and strategized how to infiltrate the arts and literature with their beliefs. Although Geddes was experimenting with breeding and reading books about eugenics, most of the other designers' archives contain only hints (if strong ones) that they too were familiar with its principles. Arens, for example, kept a clipping of an article from a 1929 issue of *Popular Science Monthly* about a eugenicist's prediction of future man's attributes. Walter Dorwin Teague wrote in his book *Design This Day* (1940) about the imminent possibilities of "creating that race of fair, god-like men who have been dreamed about and talked about for ages." Only at the very end of my research did I actually find a designer, Raymond Loewy, using the word "eugenics," and he wasn't referring specifically to industrial design.[11]

This anomaly—to write a historical book based upon an idea that cannot be *literally* documented in the archives—presented a challenge. As a cultural historian, I am aware that broad cultural patterns are not easily identifiable in often fragmentary archives. On the other hand, by training

and bent, I crave documentation. My argument, therefore, is based upon the building up of layers of evidence drawn from extensive research in the primary and secondary literature on eugenics, early industrial design, modern architecture, anthropology, psychology, and developments in American social, political, and cultural history during the first four decades of the twentieth century. I became convinced that in the decades surrounding the turn of the twentieth century, evolutionary thought in its numerous guises served as a common ideological foundation upon which modernists in almost every field constructed their work, arguments, and perceptions of the world and themselves, either consciously or unconsciously.

In the first few decades of the twentieth century and continuing into the 1930s, eugenics became widely popular by adding onto this solid ideological base the allure of *control*: control over evolutionary progress, control over social problems plaguing middle- and upper-class whites, and even control over the future. By showing some of the almost limitless ways that evolutionary and eugenic thought infiltrated American culture during this period—in the academic arena of the natural and social sciences, in theories of modern architecture, in popular culture and advertisements, in political legislation and social policies, in concerns about personal health, and in the rhetoric of speeches by industrial designers—I hope to convince you that the proposed relation between streamlining and eugenics is not farfetched, but rather stands as yet one more highly logical manifestation of an ongoing trend.

By casting my net wide and offering significant documentation for the popularity of eugenics during the 1920s and 1930s, and by showing the stamp of eugenic ideology upon the material culture of the decade, I hope not only to establish that eugenic thought was integral to developments in the arts, culture, politics, and society of the U.S. during the decade prior to World War II (during which responsibility for the practice of eugenics is typically attributed to Germany), but also to offer the most holistic ideological explanation to date for the rise of the streamline style and its three major pursuits of efficiency, hygiene, and the "ideal type."[12] In doing so, I hope to shed light on certain difficulties historians of design have had in explaining the style.

For example, why the shift from the angularity of Art Deco to the organic curves of streamlining? Was streamlining democratic or corporately elitist in intent, and progressive, conservative, totalitarian, or some combination thereof in its vision? How to reconcile designers' persistent adherence to the notion of the "ideal type" despite their regular practice of

altering designs for planned obsolescence? Moreover, by establishing the precedent set by modern architects—including Louis Sullivan, Le Corbusier, and Adolf Loos—of basing architectural and design theories upon evolutionary ideas, I propose the "popular" style of streamlining and its relation to eugenics as a logical extension of "high" modernist architectural theories. This correlation calls into question the evolutionary rationale behind the rejection of streamlining by International Style favoritists in the 1930s and 1940s, whereby the popular style was considered as a bastardized offshoot of the one "true" lineage of architectural and design history.[13]

To begin, though, I want to distinguish the traits of streamlining from Art Deco styling, for the two are often grouped together in general books on modern design in the interwar period, and my argument connecting eugenics to modern design applies specifically to streamlining. The term Art Deco came into use in the 1960s as a practical way to describe the popular modern style that arose in architecture and the decorative arts after the 1925 Exposition Internationale des Arts Décoratifs et Industriels Modernes in Paris. Referred to at the time as "zigzag moderne," the angular, faceted, vertical style graced the facades of theaters, apartments, and office buildings, as well as housewares, jewelry, and sculpture. Decorative details in keeping with this jagged aesthetic at times derived from the multidimensional Cubist patterning which was still popular in Paris in the mid-1920s, such as in the Ruba Rhombic dinnerware designed by Reuben Haley in 1928 (Figure 1.1). Cubism and other styles of modern art had themselves been strongly influenced by the geometric art of "primitive" European colonial subjects in Africa and elsewhere that had been brought to Europe and displayed in anthropology and ethnology museums.

Other details of the style referenced such natural phenomena as lightning, electricity, and waves, symbols of the social and financial exuberance of the decade. For this reason, Art Deco styling was a logical choice for architects creating buildings associated with power itself. In 1932, architects Bley and Lyman shaped the Niagara Mohawk Power Corporation Building in Syracuse, New York (Figure 1.2), utilizing the symmetrical step-back pattern exhibited by contemporary skyscrapers as well as by ancient Mesoamerican pyramids. They covered its brick surfaces with vertical stainless steel accents juxtaposed against an abundance of clear and black glass, and installed exterior lighting in vertical triangular shafts running up the facade that had the effect of making the building at night appear as if it were a giant jukebox. A metallic Mohawk warrior, sculpturally integrated into the front facade, towers over the main entrance of the building.

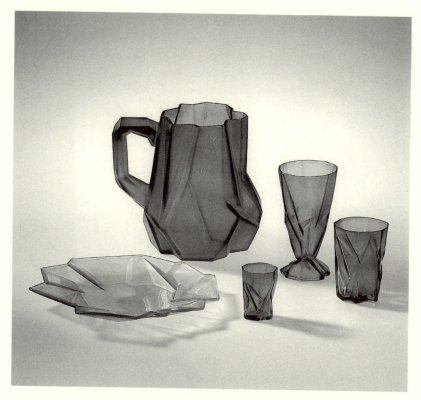

Figure 1.1. Reuben Haley, *Ruba Rhombic Dinnerware*, 1928. Courtesy of the Metropolitan Museum of Art.

 The Niagara Mohawk Building in many ways exemplifies Art Deco architecture in the U.S. (missing only the requisite colored terra-cotta tile), which frequently drew upon Mayan and Native American aesthetics as a way to infuse modern design with vitality, force, power and energy. These appropriations bespoke the political power of the "civilized," who presumed they had surpassed "primitive" peoples not only in military strength but also in evolution itself.[14] Yet if, as contemporary belief supposed, the mind of modern man had evolved to such great lengths, as shown through developments in science and technology, his body had unfortunately lingered behind. The civilized thus envied those they considered primitive for their physical strength, power, and fertility. The Mohawk warrior thus stands as an apt symbol of American nativism and the "spirit of light," as

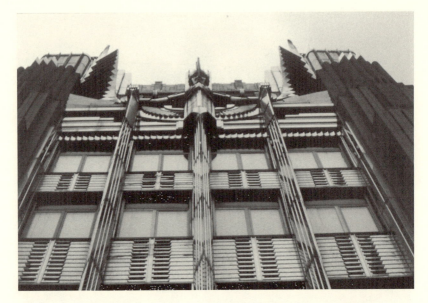

Figure 1.2. Bley and Lyman, Niagara Mohawk Power Corporation Building, Syracuse, New York, 1932. Author's photo.

well as the modern harnessing of energy produced by the corporation. As both primitive and modern, then, Art Deco angularity metaphorically captured civilized man's development of technology, his colonialist powers, and his desire for his own long-lost primitive vitality.

Arising in the late 1920s at the same time as Art Deco and flourishing as well during the following decade, streamline designs by contrast are rounded, tapered, horizontal in their emphasis, and often marked with three parallel "speed" or "flow" lines. These qualities are apparent in Lurelle Guild's Electrolux vacuum cleaner design (Figure 1.3), with its sloping front, swept-back handle, and chrome-plated steel marquee that lines the center and emphasizes its overall horizontality. Similarly, they informed Robert Derrah's Coca-Cola Bottling Plant and Office in Los Angeles (Figure 1.4), with its rounded windows and corner, accented by the stepped-back "flow" lines that rakishly swoop around it, surmounted overall by a low-lying, asymmetrical, teardrop-shaped tower. Streamlining's technological antecedents lay in modern transportation design—ships, zeppelins, and airplanes—forms that are clearly reflected in the ocean-lineresque Coca-Cola building and in the diner architecture of the period.

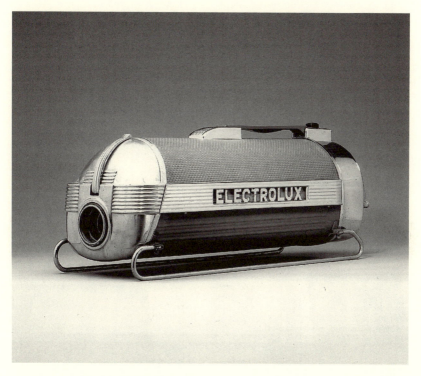

Figure 1.3. Lurelle Guild, Electrolux, Model 30 Vacuum Cleaner, 1937. Courtesy of the Metropolitan Museum of Art.

Streamlining's origins and innuendos were not only mechanical, however, but also quite organic, derived from the physical forms of animals such as dolphins, fish and birds, which, after all, swam and flew before man ever invented ships and planes. Russel Wright's *American Modern Dinnerware* from 1937 (Figure 1.5) captures this side of the style's origins. The squat bodies of his pitcher and teapot sit firmly on the ground while their mouths turn upward as if in a howl, and his buoyant gravy boat swims along the table like a fish taken to land. Streamlining therefore also embodied the "primitive," although in a purer biological and less colonialist sense than the primitivism of Art Deco, a biological orientation that I will argue coincides closely with eugenic thought. Despite the foregoing distinctions—aesthetic and metaphorical—that seemingly characterize the two styles as visual counters to each other that both expressed ideas about the primitive and the modern, in many instances, especially in architecture, the two pop-

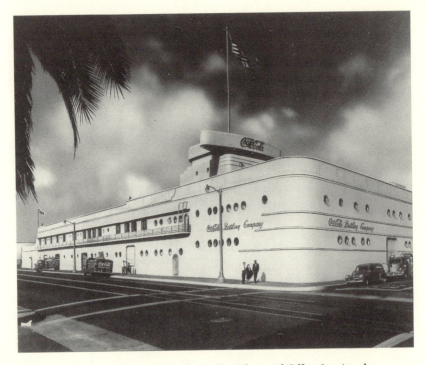

Figure 1.4. Robert Derrah, Coca-Cola Bottling Plant and Office, Los Angeles, California, 1936. Courtesy of the Coca-Cola Bottling Plant of Los Angeles.

ular styles were interwoven into a conglomerate modern style containing both horizontal and vertical, angular and rounded elements.

Although streamlining appeared in many of the same venues as Art Deco (architecture, housewares, jewelry, and sculpture), it differed from Deco in that it was the first wide-scale, mass-produced industrial design style in the U.S.; hence Geddes's claim in 1927 that he established the profession (though other designers were also setting up firms that year). Many Deco objects were handmade and handpainted, adding to their value today. The Decorative Arts Exposition in Paris clearly demonstrated the aesthetic value and economic potential of consciously incorporating artistic style into the decorative arts. However, it wasn't until large department stores and corporations in the U.S. began commissioning their window-display specialists and advertisers (including Geddes, Raymond Loewy, and Donald Deskey) to redesign their product lines that industrial design as a profession

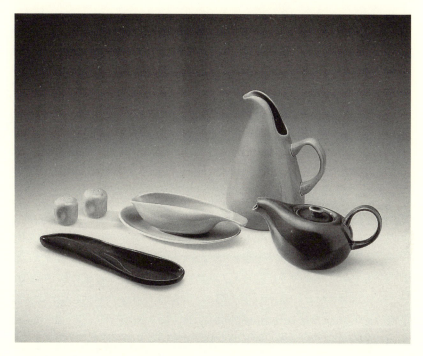

Figure 1.5. Russel Wright, *American Modern Dinnerware*, 1937. Courtesy of the Metropolitan Museum of Art, John C. Waddell Collection.

was born. The rapid sales of designed items quickly established the designer as an indispensable economic and aesthetic asset to diverse types of corporations. In addition to Geddes, Loewy, and Deskey, Walter Dorwin Teague, Egmont Arens, Henry Dreyfuss, Russel Wright, Gilbert Rohde, and Lurelle Guild were some of the key streamline designers who did their best to "elevate" the tastes of the middle class through the proliferation of modern designed goods.

Although much of the motivation for industrial design certainly was profit-driven, the rhetoric of product "degeneracy" that many designers and retailers used to describe the need for redesign reveals an underlying evolutionary mindset and reformist attitude inherited from Progressivism. During the late nineteenth and early twentieth centuries in the U.S., much academic research in the newly created social sciences centered on trying to understand questions of human origin and development, be it racial, cultural, or mental, based upon an amalgam of accepted evolutionary con-

cepts. These included Darwin's ideas of natural selection and survival of the fittest, Herbert Spencer's social and racial hierarchies based upon the progressive development of society, and Jean-Baptiste Lamarck's theory of the inheritance of acquired characteristics.[15] The latter, whose theory both Darwin and Spencer accepted, offered the best explanation for *how* species evolved, that is to say, the mechanism whereby evolutionary change occurred, and it functioned as a vague, early hypothesis that was later replaced by more specific knowledge of genetics. Lamarck posited that traits— physical, mental, or temperamental—that an organism acquired by repeated use or environmental exposure throughout its adult existence were inherited and passed on to its offspring. A few other popular, influential evolutionary theories that derived from Lamarckism were German biologist Ernst Haeckel's theory of recapitulation, the idea of arrested development and degeneration, and Italian criminal anthropologist Cesare Lombroso's assertion that criminals were atavistic, equivalent to racial "primitives," throwbacks to an earlier era.

All these ideas were highly influential, both in Europe and the U.S., and were used by theorists of modern architecture—Loos, Sullivan, and Le Corbusier, men whose writings influenced the designers in this study—to argue certain notions that became fundamental principles of modern architecture and design. They also served as the scientific means and justifying rationale for much Progressive social activism. Therefore, it is important have a basic understanding of their hypotheses and their implications. Loos's application of them in his controversial lecture "Ornament and Crime" (1908, published 1930) not only offers a contemporary layman's solid understanding of Lamarckian theory and its theoretical extensions, but demonstrates his application of these ideas toward creating a stripped-down aesthetic of modern architecture and design.

Haeckel's recapitulation theory built upon Lamarck's idea of the inheritance of acquired characteristics to describe the relation between individual development and that of the species. He posited that only characteristics acquired through long experience would become additions to the next generation's development, and that more temporally distant inherited characteristics would appear earlier in an individual's development than recently adapted ones. In scientific parlance, this is summarized by the phrase "ontogeny recapitulates phylogeny."[16] Loos described the implications beautifully in the opening lines of his lecture. "In the womb, the human embryo goes through all phases of development the animal kingdom has passed through. And when a human being is born, his sense impressions are like a new-born dog's," he began, as if he were stating a

scientific fact. "In childhood he goes through all changes corresponding to the stages in the development of humanity. At two he sees with the eyes of a Papuan, at four with those of a Germanic tribesman, at six of Socrates, at eight of Voltaire."[17] To Loos, as well as to many other modernists, the "human embryo" was that of a "civilized" white male who, like himself, was supposedly the most advanced type. By definition, only the most advanced could pass through "all phases of development the animal kingdom has passed through."[18]

As Loos clarified, at birth the embryo was considered to be at a stage equivalent to a dog. Many in the U.S. shared a similar belief; when architect Claude Bragdon's grandson David was born in 1932, for example, he postponed visiting him because he had decided "to wait until he emerges from the animal to the human state, which should be in a few months."[19] Yet, according to the theory, after a short while, a child matured to the stage of "primitive" man: "At two, he sees with the eyes of a Papuan." His physical and perceptual development then progressed through the stages of Western civilization, until he attained full rationality at maturity, around the age of eighteen. In an essay on "Ornament and Education" (1924), Loos described the child's educational process: "To educate someone is to help them leave their primeval condition. Every child has to repeat the development that took mankind thousands of years. Every child is a genius. . . . But the genius of a Papuan, that is of a six-year-old child, is of no use to humanity."[20] The people whom Loos considered to be of use to humanity were modern men like himself whose superior genius and racial background positioned them at the apex of evolutionary advancement.

Although modern man was considered by some to have passed through the developmental stages of plant, animal, primitive man, European peasant, and even the feminine before attaining maturity, early psychological theories of mental evolution asserted that he still retained within himself vestiges of his journey. Loos brought on the vilification of his Viennese contemporaries, who worked in a highly decorative style, when he argued that the taste for ornamentation was one such vestige.[21] The countless references in books by modern architects to the "primitive" and "effeminate" character of decorative Victorian architecture revealed that the atavistic trait was tied in their minds not only to the primitive but to the feminine as well. Loos stated this explicitly. In analyzing the evolution of women's and men's fashion, he described the floor-length and decorated qualities of contemporary women's dress as equivalent to men's dress of preceding centuries. Because modern men currently dressed plainly, this

demonstrated "how much women have lagged behind the advances made in recent centuries," or alternately, how far men had progressed beyond the feminine stage. "Fortunately, the great development of culture in this century has left ornamentation far behind. . . . The lower the cultural level, the greater the degree of ornamentation."[22] Elsewhere he tersely deduced: "In the final analysis, women's ornament goes back to the savage."[23]

This idea of the "primitive" nature of ornamentation had been popularized by Lombroso in his famous study *Criminal Man* (1887), which compared the tattoos and scarification of primitive tribes with those of criminals.[24] The resemblance between the two was easily explained by Lombroso, who had determined that "the born criminal was also an atavistic being. Physiologically, he was a 'throwback,' a reversion to past races of mankind, who was born out of time and would have been normal had he been born at some earlier point in time."[25] Because criminals and primitives were evolutionarily equivalent, both seemingly possessed moral standards that were less developed than that of modern man. For this reason, a Papuan who "slaughters and devours" his enemies could not be judged a criminal in relation to his own culture's standards, for this was supposedly "normal" behavior. Yet, for modern man to exhibit the supposedly primitive traits of unrestrained sensuality, eroticism, and decoration, he would have to have been "either a criminal or a degenerate." Because Loos believed that "as [culture] progresses, [it] frees one object after another from ornamentation," in order for the products of modern man to truly express his evolutionary state, "ornament is something that must be overcome."[26]

Although Loos's essays sounded a clear call for the conscious rejection of ornament by modern architects and designers, he believed that its demise was imminent regardless of their conscious efforts, based upon evolutionary precedent. Just as conquered primitive races were dying out supposedly through a biological process of selection, so ornament was simultaneously facing extinction. When asked in 1924 if ornamentation should be eliminated from the art school curriculum, he declared that "Ornament will disappear of its own accord, and schools should not interfere in this natural process, which humanity has been going through ever since it came into existence."[27] Le Corbusier, influenced by Loos, more colorfully described this process of extinction: "Without a revolution, barricades, or gun-fire, but as a result of simple evolution accelerated by the rapid tempo of our time, we can see decorative art in its decline, and observe that the almost hysterical rush in recent years towards quasi-orgiastic decoration is no more than the final spasm of an already forseeable death."[28]

One final example from Loos's writings illustrates how completely he accepted this idea of the inheritance of acquired characteristics and his application of it to fashion design. Loos believed that the human foot had undergone a transformation during the nineteenth century owing to "[c]hanged social conditions," which prompted ever more speedy walking. Because "we push off the ground more strongly with our big toe," Loos believed that "our big toes are becoming bigger and stronger," while the little toe was atrophying through disuse, causing an overall narrowing of the foot. Loos thought that people "of more advanced civilizations" walked "more quickly than those who are behind the times, the Americans more quickly than the Italians, for example," likely owing to their more complex business environments that demanded quick response. Such environments and the habits they seemingly produced caused physical peculiarities that were hereditarily transmitted, progressive, and confined to national and racial boundaries. He equated the "normal pace of a fit and active person" in his day to "one that in the previous century was used by running footmen preceding the carriages."[29]

Based upon the theory of arrested development, Loos considered it possible that some people's development, while passing through the stages of their evolutionary predecessors, had halted at the levels of maximum advance of different evolutionary eras; therefore, people exhibiting these different evolutionary (and temporal) stages were currently living contemporaneously. Placing himself at the apex in the present, he explained, "I am living, say, in 1912, my neighbor around 1900, and that man over there in 1880. . . . [H]ere in Austria we still have tribes from the fourth century."[30] Because of their different evolutionary levels, it followed that not all people would have the same shape foot as the modern man of Loos's day; many might have feet like those of the running footmen from the previous century. Ever thinking of the artisan, however, Loos asks, "What can the shoemaker do about it? Which shape of foot should he make his standard? For he, too, must endeavor to produce *modern* shoes. . . . What he does is what all craftsmen do. He bases his styles on the shape of foot of the socially dominant class," not for economic but for evolutionary reasons, for they alone were "modern," the highest standard that could be attained.[31] According to this line of reasoning, if people who were "behind the times" regularly wore modern shoes, from this habit eventually the shape of their feet and their aesthetic tastes would conform to the level of the "most advanced." Contrarily, if modern men wore shoes created to fit peasants or

those "living in the fourth century," their feet and aesthetic tastes would degenerate to those of an earlier era.

The scientific possibilities of controlling heredity through environmental manipulation inspired reform-minded architects and designers, as well as criminal anthropologists, psychologists, social workers, politicians, and eugenicists during the Progressive era. If environmentally influenced habits—including physical, mental, and moral practices—that were repeated throughout a lifetime became hereditary and were in fact the major source of evolutionary change, then the effects of environmentally induced reforms were profound and almost permanent (until undone by other habits). The promise of dramatic, far-reaching results proved to be highly motivating to those in positions to effect change. Similarly, if recapitulation was in fact the normal developmental process of a maturing body, mind, and spirit, and if through arrested development various groups currently embodied earlier phases of human evolution, then researchers trying to understand the origins of humanity or child psychology, say, as well as social and psychological aberrations such as criminality, feeblemindedness, idiocy, and neuroses, possessed all the data they needed at their fingertips by studying different living groups. Evolutionary thought thus offered a powerful ideological framework upon which hung the development of comparative social studies, psychological theories, the Progressive social reform and eugenics movements, as well as theories of modern art, architecture and design.

In considering the influence of evolutionary thought among early twentieth-century intellectuals and reformers, it is important to keep in mind how influential Lamarckian theory was in the U.S. even though it had in fact been rejected by a considerable portion of the European scientific community. This rejection was largely due to German biologist August Weismann's scientific discoveries in the late 1880s of the distinction of reproductive "germ" cells (in egg and sperm) from somatic cells (which make up the rest of the body), as well as to the rediscovery in 1900 of the theories of Gregor Mendel. Weismann and Mendel respectively offered conclusive evidence that changes in bodily somatic cells caused by environmental influences did not in fact affect the "germ" cells, which transmitted their qualities based upon patterns of dominance and recession within the genes themselves. In the U.S. in the 1890s, however, a large contingent of scientists who called themselves neo-Lamarckians disputed that Weismann's theory disproved Lamarck's, for in their estimation Weismann offered no mechanism by which evolutionary development would have proceeded "beyond

the protozoan."[32] They faulted Weismann for not accounting for *how* organisms came by certain traits in the first place or explained, in the words of the title of Harvard neo-Lamarckian E. D. Cope's book, the *Origin of the Fittest*. Only through use or disuse of certain organs or behaviors over an extended period of time (such as the period of an organism's adulthood), the neo-Lamarckians claimed, could such changes take place.

Thus, well into the first decade of the twentieth century, neo-Lamarckianism and its theoretical extensions (recapitulation and arrested development) persisted in U.S. social theory, undergirding theories of mental development, race formation, racial and gender differences, and comparative social study methods.[33] For example, owing to extended residency in different geographic regions during which certain adaptive behavior patterns had remained constant, different national groups (which in part for this reason came to be thought of by many as separate "races") were thought to have acquired different traits and thus possessed unique hereditary makeups. From this understanding arose the idea of America as a "melting pot" and Frederick Jackson Turner's theory of the "crucible of the frontier."[34] Alternately, an application of recapitulation theory that held that when inherited traits were mental or moral, they would be transmitted to subsequent generations as instincts, explains feminist writer Rheta Childe Dorr's explanation of the differences between the sexes in her essay "The Role of the American Woman" (1910).[35] She wrote that "Back of the differences between the masculine and the feminine ideal lie centuries of different habits, different duties, different ambitions. . . . [D]ifferent habits of action necessarily result, after long centuries, in different habits of thought." For the woman in particular, "A thousand generations of service, unpaid, loving, intimate, must have left the strongest kind of a mental habit in its wake."[36]

Similarly, because the social reform aspects of the Progressive movement in the U.S. were closely allied to these theoretical suppositions, owing to the training and positions of many of the reformers, Lamarckian influences on social theory carried over into reform practices throughout much of the movement. One of the chief arenas in which this influence surfaced was in the emphasis placed on education and environmental reform as a means of race betterment, referred to by Progressives as "euthenics." As early as 1877, Robert Dugdale had popularized this notion in his book *The Jukes, a Study in Crime, Pauperism, Disease and Heredity*, writing that "Where the environment changes in youth the characteristics of heredity may measurably be altered. Hence the importance of education." He felt

these changes could be so powerful as to even permit the control of crime and pauperism, "if the necessary training can be made to reach over two or three generations."[37] Such thinking motivated sociologist Lester Frank Ward in his lifelong attempts to improve the race though environmental change. Historian George Stocking, Jr., also suggests that it informed Booker T. Washington's theory of gradualism, as well as various "Americanization" efforts, including Woodrow Wilson's attitude toward the education and democratization of Filipinos.[38] This idea of the inheritance of acquired characteristics could be used either as an impetus towards reform or as a rationale for asserting inherent differences that could take decades or even centuries to erase. Henry Cabot Lodge argued to restrict immigration because newcomers did not possess the "ideas, traditions, sentiments, [and] modes of thought" that were "an unconscious inheritance" of "the slow growth and accumulation of centuries of toil and conflict."[39]

As the rediscovery of Mendel's laws and Weismann's theory became more widely known in the U.S. between the 1890s and 1910s, reformers were forced to alter their beliefs in environment as the main route to reform, and to turn instead to sexual selection, if they wanted to remain current with accepted scientific beliefs. This change was not an easy adjustment for some. Economist Simon Patten in 1912 sympathized with the social worker whose efforts toward social improvement suffered from the "downfall of Lamarckianism."[40] Upon realization of the impact of Weismann's discovery, in the early 1890s biologist Joseph Le Conte of Berkeley lamented that reformers' "schemes of *education*, intellectual and moral," which were "glorified by the hope that the race is also thereby gradually elevated," were all for naught. Although he was revolted by the alternative, he logically deduced that if "selection of the fittest" were "the only method available," then "to have race-improvement at all, the dreadful law of *destruction of the weak and helpless* must with Spartan firmness be carried out voluntarily and deliberately."[41] Le Conte's alternative, in keeping with social Darwinist ideas that were prevalent in the U.S. between the 1870s and 1890s, dwelled on the negative side of the selection process, tending ultimately toward euthanasia. His statement, however, acknowledged the beginning shift away from the laissez-faire social Darwinist position of not interfering with the processes of "natural selection" toward an acceptance of human intervention in evolution, otherwise referred to as "rational selection," a position that dominated after the turn of the twentieth century through the rising popularity of eugenics.

If, as Weisman and Mendel had demonstrated, germ cells were unaf-

fected by environmental effects on somatic cells, and character traits were transmitted as dominant or recessive units on chromosomes that segregated and combined during reproduction with a highly predictable outcome, then the production of human character traits could likely be controlled through breeding. In large part owing to these realizations, in 1901 while teaching at the University of Chicago, Harvard-trained biologist Charles Davenport published one of the first papers in the U.S. on Mendelism and began pursuing its possibilities. In 1903, he worked with U.S. assistant secretary of agriculture, W. H. Hays, to found the American Breeders Association (ABA) with the goal of uniting the work of academic biologists with the experience of established animal breeders. The ABA established over forty committees dealing with various aspects of heredity, and the Eugenics Committee, created in 1906 to "investigate and report on heredity in the human race, and emphasize the value of superior blood and the menace to society of inferior blood," proved to be highly influential.[42] Founded by Davenport, the Committee included such respected members as Henry Fairfield Osborn, president of the American Museum of Natural History, well-known plant breeder Luther Burbank, inventor Alexander Graham Bell, Professor Vernon L. Kellogg of Stanford University (later permanent secretary of the National Research Council and a trustee of the Rockefeller Foundation), and Stanford University president David Starr Jordan (who was also national vice-president of the Boy Scouts).[43]

In 1904, Davenport left the academic arena to become the director of the newly founded Station for Experimental Evolution (SEE), for which he had proposed and received funding from the Carnegie Institute of Washington (CIW) to establish a research station for the study of heredity and evolution.[44] At the SEE, Davenport implemented methods of biometric analysis (a statistical method for studying heredity patterns, begun in Britain by Karl Pearson) and Mendelian research for the study of heredity and the processes of evolution in plants and non-human animals. He hoped to gain knowledge of general principles of heredity as well as insight into specific benefits for agriculture and animal husbandry. From his work at the SEE and with the Eugenics Committee of the ABA, Davenport realized the necessity of establishing a research station focused on the understanding of human heredity in the United States.

In 1910, he approached the recent widow of Edward H. Harriman, owner of the Union Pacific, Southern Pacific, and Illinois Central Railroads, for a bequest to found the Eugenics Record Office (ERO). Mary Harriman gave generously to Davenport, for in keeping with progressive ideals she

believed in "efficient" philanthropy that facilitated the increased efficiency of members of society. She had also learned the values of thoroughbred breeding through her late husband's and her father's hobby of breeding racehorses. She purchased a beautiful estate with multiple buildings on a cove at Cold Spring Harbor, New York, funded the construction of a fireproof cement vault intended to hold the pedigree records of the American populace, and paid the operating expenses of the ERO for the first five years.[45] In 1917, she transferred the ERO and its operating expenses to the CIW with an additional bequest of $300,000, making the ERO one of the most well-funded departments of the CIW until its closure in 1939 (owing to the controversy of eugenics in light of German practices). Overall, Mrs. Harriman gave over $440,000 to the ERO, and her funding for the programs at Cold Spring Harbor (along with the generous support of John D. Rockefeller, Jr., Andrew Carnegie, and Kodak's George Eastman) secured its reputation as the headquarters of what was already a growing international eugenics movement, as scientists in other countries lacked the necessary funding to implement broadscale research programs and public policy campaigns.[46]

Although Davenport remained the director of the ERO until his retirement in 1934, in 1910 he hired an agriculture instructor from Missouri, Harry H. Laughlin, as superintendent to accomplish its many goals. Laughlin proved a tireless crusader, a vociferous political propagandist both nationally and internationally, and an able researcher. Despite his severe, humorless personality, out of sheer tenacity he proved adept at public relations and organizational management. With Davenport's assistance and the help of numerous volunteers (many of whom were Vassar graduates) who were trained at the ERO during the 1910s and 1920s to canvass the nation collecting data on hundreds of hereditary traits, he began to fill the fireproof vault with pedigree charts of hundreds of Americans. Some were voluntarily submitted by college students eager to contribute to the cause of eugenics and have their superior skills noted, just in case a prospective marriage partner wanted the ERO's advice on the suitability of their pairing. Others came from groups targeted by the ERO for close scrutiny: interbreeding communities such as the Amish, supposed backwoods prohibition-violators like the infamous Jukes and Kallikak families, New York City criminals, and families like the Goodyears with particularly inventive strains, to name only a few. These pedigree charts, in addition to serving as sources for marriage advice or police tracking and ultimately as a bank for monitoring the nation's evolutionary progress, were analyzed by research-

ers for evidence regarding the heredity patterns of specific human traits and the consequences of specific matings.[47]

Ongoing questions about the relative influence and relation between heredity and environment—in part motivated by remnants of neo-Lamarckian thought—were heavily debated by scientists and social scientists, whether eugenics supporters or not. Some studies, such as those of identical twins raised in separate environments, proved particularly useful in helping researchers determine which traits were genetic and which were learned behaviors. Many supported the opinion that numerous traits that today are attributed to personal choice or environmental and social influences, such as criminality or one's occupation, were hereditarily determined.[48] Showing the extremes to which the general shift from environment to heredity spurred by Mendelian principles was taken, even a trait such as the capability of "being Americanized" could be considered to be hereditary. The conservative Davenport reasoned, "No doubt Emma Goldman," who publicly supported eugenics, "and hundreds of her race were placed in an environment favorable to Americanization but lacked the hereditary constitutional capacity of taking advantage of such Americanizing influences."[49] Although the latter example is particularly extreme, it concisely marks eugenicists' lack of faith in the environment as an agent of change and their shift inward to the gene as the site both of blame and reform. As Davenport claimed in 1923, "every thinking person can see that merely improving conditions yields no permanent improvement of the race."[50] Many progressive reformers who were dedicated to race betterment and the prevention of "degeneracy," therefore, supported eugenic policies to improve the nation's heredity while continuing their efforts to alleviate degrading environmental conditions.

Although the noun "degenerate" is used today in a general derogatory sense, around the turn of the twentieth century its meaning was tied to the evolutionary ideas of recapitulation and arrested development. If an individual's development was hampered for some reason (like Loos's countrymen who were supposedly "living in the fourth century," or Lombroso's criminals) and became "arrested" in its development, the individual was classified as a "degenerate" for failing to reach his or her full potential. Underriding the acceptance of this theory in the U.S. was the Spencerian assumption that evolution was progressive, ever-improving toward an attainable ideal. This notion runs counter to the less hierarchical, more neutral Darwinian understanding today of the workings of natural selection. Yet if, according to Spencer, "forward" progress was the modus operandi

of evolution, then "degeneration" reversed this process. By definition, degenerate individuals were less suited to the "civilized" world, and accordingly were classified as "unfit," in part because feeblemindedness and asocial behavior were perceived as producing a genetic and economic "drag" on a nation's development and a hindrance in the international struggle for survival. The application at large of these ideas to the entire populations of nations resulted in the idea of national degeneracy when the birthrate of the civilized fell below that of the "lower" races.

In part because of the linkage between physical, mental, and moral traits that persisted from Lamarckian thought, whereby living in bad environments supposedly both was caused by and also produced lower intelligence, poor character, and undesirable heredity, the term "degeneracy" was remarkably fluid and could be used to define an entire complex of linked traits. Many Mendelian eugenicists believed that if it were present at the most foundational level, "superiority" or "defectiveness" would then permeate one's entire being. For example, although Charles Davenport could not determine the specific genetic roots of dwarfism or cretinism in his research on feebleminded children at Letchworth Village, a state institution for the care of the feebleminded in Thiels, New York, he carefully studied the relation between physical and mental development in both types throughout the 1920s and 1930s. He concluded that "mental development will ordinarily keep pace with the physical development," that is, physical dwarfs would also be intellectual dwarfs.[51]

Although prominent displays and media coverage in the late 1930s of highly intelligent dwarfs contradicted Davenport's determination, the principle he asserted—that physical, mental, and moral aspects of human development occurred in a like manner, proportion, and quality— ran as a theme throughout eugenics literature.[52] Eugenics films such as *Are You Fit to Marry?* and *The Science of Life*, created in 1922 by the U.S. Public Health Service for high school students, depicted the correspondence of exterior physical beauty and robustness with inner genetic health.[53] In 1921, at a meeting of the Galton Society (a group of highly respected scientists who convened at the American Museum of Natural History during the 1910s and 1920s to discuss human heredity from an interdisciplinary perspective), members discussed the relation between "facial beauty and eminence" by examining a series of photographs of important people.[54] Eugenics popularizer Albert E. Wiggam corroborated this notion, stating that "if men and women should select mates solely for beauty, it would increase all the other good qualities of the race."[55] After the election of Miss

Universe in Galveston, Texas, in 1929, the press quoted Wiggam proclaiming, "Beauty is nature's flaming banner of her own evolution. . . . It is often said that 'beauty is only skin deep.' It is as deep as protoplasm, as inherent as intellect, as vital as character. . . . [I]t is woven into the protoplasmic fabric of the race with all that is admirable and excellent."[56] Wiggam and others thus interpreted exterior appearance as a sign of one's inner condition. Beauty signified genetic rightness and superiority, while ugliness evidenced "defectiveness" and inferiority.

This type of reasoning—whereby one's outward appearance was considered to be a visible expression of one's inner genetic character—is similar to an assumption made by early twentieth-century art historians and architects who considered the aesthetic, stylistic appearance of a work of art or architecture to be an outward, visible, indexical expression of its creator's racial character. Louis Sullivan compared an artist to a tree bearing fruit, stating that "like begets like," implying that one's art is like one's offspring; lest this be taken as metaphor, he added, "and this is a *law*, not a phrase."[57] His friend Claude Bragdon described his approach to architecture, stating that Sullivan started by "tracing architecture to its root in the human mind: this physical thing is the manifestation of a psychological state. As a man thinks, so he is; he acts according to his thought, and if that act takes the form of a building it is an emanation of his inmost life, and reveals it."[58] Sullivan believed that a people's racial essence sprang in part from a common heritage and mentality, and that their art expressed this; he described the Parthenon as "the Greek nature, mind, heart, soul . . . a direct product sign and image of Greek civilization" that "expressed for them and for us the true essence of that civilization." He therefore instructed his students to ask the question "not in what *style*, but in what *civilization* is this building."[59] Le Corbusier similarly described style as "a unity of principle animating all the work of an epoch, the result of a state of mind which has its own special character."[60] Furthermore, he associated stylistic variations with racial differentiation. In his book *The Decorative Art of Today* (1925), a caption beneath photos of three sailboats from different cultures explained, "Three races have created their own types. The lyrical feeling of each race is expressed with all its force."[61]

In the early nineteenth century, British art historian John Flaxman had used the term "style" to indicate the artist's stylus, or pencil, metaphorically capturing the longstanding association that linked an artist's mind to his hand, so that style expressed an artist's particular genius. By making this connection explicit, Flaxman extended contemporary notions of style by

correlating it to developmental stages of social and intellectual history. "By the term style we designate the several stages of progression, improvement or decline of the art," he wrote, reasoning that "by the same term, and at the same time, we more indirectly relate to the progress of the human mind, and states of society."[62] When this notion was later coupled with Lamarckism, whereby certain "races," by virtue of sharing a common national environment over many years, acquired certain typical characteristics, including mental ones, artistic style came to be seen as an expression of "the national and racial consciousness," as Bragdon termed it.[63]

The successive historical development of style therefore mirrored the successive historical evolution of the mental faculties, and of racial development at large. Bragdon stated as much: "Architecture mirrors the life of the individual and the race, which is the life of the individual written large in time and space."[64] Sullivan, too, reasoned that "How this need and this power [to build] have varied from time to time and place to place, climatically, ethnologically, following the shifting racial and personal moods of mind, body and soul, the history of building will show to you."[65] From exactly this same standpoint, Loos argued that ornamentation on modern design was degenerate. "Ornament and Crime" shows how seriously he believed that the exterior, aesthetic appearance of a product revealed its creator's evolutionary status, and the unornamented quality of most European and American modern architecture from the 1920s on shows how seriously this idea was taken.

Of the foregoing prophets of modern architecture, Sullivan went farthest in applying evolutionary thought to his theories of modern architecture. Famous as the prophet of "democratic" architecture, he rejected the elitist opinion expressed by Loos and many others that the upper-class aristocracy was more evolved. Born of a "mongrel origin"—by which he meant a mix of Irish, French, and Swiss German—whose "stock was sound" but decidedly middle-class and European, Sullivan defiantly rejected what he considered to be an ongoing favoritism for aristocratic "feudal" systems, labeling such types of economic systems as "degenerate."[66] He characterized the aristocracy as a "decaying," "insane" "parasite" that sucked its energy from the "life-blood of the people."[67] In turn, he proposed democracy as the evolutionary successor to the dying feudal social structure.

In his unpublished lecture "Natural Thinking," from 1905, however, Sullivan revealed that his concept of democracy (and by extension, its application to architecture) was race and class specific in its origins. To define the origin of democracy, he traced the ascent of racial and stylistic develop-

ment. He moved from the "ups and downs of pre-historic civilizations" through the "dawning of conscious history," in which he included the ancient civilizations of the Chaldeans, Babylonians, Assyrians, Egyptians, and Hebrews, to all of whom he attributed "profound impressions of nature" and grand "imaginative power." He posited that "Side by side with these came and spread the racial vigor and mental fecundity of the Aryan." Another lineage flowed from the "feminine thought . . . of the Hindoo" through the Persians to the Greeks, whence began "a new era." From this lineage arose "the clear, brilliant dawn of the objective mind, the vigorous assertion of reason, the development of mechanical exactitude and precision." He attributed to the Greeks a "racial hunger" for knowledge and the beauty of nature. "Coherent and compact of body and brain, the Greek physical soundness, coupled with extraordinary physical receptivity, permitted Nature to enter the Greek mind, and force it up to the clear heights of intellectual splendor. Their priceless heritage is ours."[68] After continuing the trajectory through the Romans and Hebrews and the rise of the Church and feudalism, he arrived in the modern era of science, technology and "Democracy."

Although historically both France and the U.S. promoted democracy almost simultaneously, Sullivan focused on its rise in the U.S. because his ultimate project in "Natural Thinking" and in his life's work was to define a uniquely American architectural style based upon the current evolutionary state of American civilization.[69] Most relevant to this study, resembling John Fiske's writings on American expansionism and the Teutonic origins of democracy, he ascribed democracy in the U.S. to its Aryan roots: "the original individualistic spirit of the Teuton barbarian . . . had reemerged . . . and men had begun thinking somewhat of freedom," he wrote. "Meanwhile constitutional government had assumed form. A new migration of the Aryan races, setting across the Atlantic, had reached the shores of a vast, sleeping continent seemingly destined by Nature to receive and develop organic Democracy on a new and grand scale. Slowly and tenaciously they began to spread over its immense and fertile area."[70]

Like studies by his contemporaries documenting the undeveloped rational faculties of "primitives" and children, Sullivan viewed the evolutionary process as the development of intellect and morality as determined by "the balance of heredity and environment at that time," which he saw in recent centuries played out as the rise of democracy over feudalism. As historian David S. Andrew has found, Sullivan continually emphasized the role of geniuses (of which he considered himself) in creating history and

directing the course of "civilization."[71] Thus, when viewed in light of his personal evolutionary views and those of the authors he respected (Darwin, Spencer, Hippolyte Taine, John Draper, and Max Nordau), Sullivan's idea of democracy can hardly be considered egalitarian.

Sullivan defined "organic Democracy" as a moral quality stemming from proper natural behavior, which he considered to be a middle-class phenomenon. Perhaps making an assumption common to his time that class was related to character and both were largely genetically determined, he actually defined the middle class not in economic terms but as the class that included "all upright men of whatever station in life," those who were honest and just and "whose sense of right approaches and tends evermore closely to approach a normal valuation of justice."[72] Such qualities derived from and further propagated "natural thinking," which preserved health and allowed "the free circulation in our bodies, minds, hearts, and souls of the pure and undefiled stream of Infinite creative power that shapes in us reason, optimism and love."[73]

If the free flow of "natural thinking" were blocked, however, unnatural thinking would result, producing "criminals" who were "a social ulcer, a sore on the body politic, economic and social" and were "symptomatic of the poisons the body-social has itself secreted." Sullivan utilized the metaphor of bodily constipation, which he referred to as "auto-intoxication," to describe what he perceived as the malcontents of the social body. The poisons secreted into the bloodstream of a constipated person, so contemporary thought held, were powerful enough to dampen the efficient workings of the brain and cause mental degeneration. Therefore, in order for progress to continue, the body had to be cleansed and regulated. Applying this metaphor on a national level, Sullivan proposed that the social body, led by the virtuous middle class, "cleanse its own constitution, by natural thinking, that it may have no further sore upon its body, but a clean wholesome physique." The resultant "readjustment of social balances" would be "a movement strictly natural, strictly logical, and is the automatic rebellion of the body social against an auto-intoxication which has reached the limit of its endurance and has produced a deep seated reaction of the primordial social life in its struggle for existence."[74]

Sullivan initially wrote "Natural Thinking" for delivery in an address to the Chicago Architectural Club in early 1905. His elaborated his organic social vision and notion of democracy as preface and explanation for the true focus of his talk: the development of an American architecture that wholly expressed the nature of the American people. If, in the historical

development of the U.S., "Nature [i.e., evolution] has caused [Democracy] to arise in the spirit of Social Man," and if "that Democracy is here, now, under our own very eyes, seeking to develop its forms, and . . . is ceaselessly pouring in her streams of vital energy to that end," then it was imperative that "such Democracy must need evolve a function, Democratic Art, and that such function must seek and find its Organic Expression in Form." Sullivan explained that "The spirit of nature evolved a function Man, which it has manifested in the form Man. . . . [E]very form, in each case, is the living expression of its function, is true to its identity."[75] As form followed function in Nature, so American architectural forms should follow from America's function as the purveyor of Democracy. American architecture therefore had to express "natural thinking"; architectural order had to be based upon the same biological principles as social order. In this way, Sullivan believed, style would honestly express the racial state of civilization of its creators. What logically followed became the primary dictum of modern architecture: *form follows function.*

Forerunners of this idea had surfaced at various times over the previous two hundred years. In the eighteenth and nineteenth centuries philosophers and critics of the arts, including Johann Winckelmann and Gottfried Semper, had turned to the comparative methods of biology and botany as a model for understanding the development of style in the arts. After close observation of the progressive development of natural forms, these writers began to evaluate the arts as analogous to nature, for both natural species and artistic styles were born, matured, and decayed and could be classified based upon comparative analysis.[76] Horatio Greenough, however, in his essay "Form and Function" from the mid-nineteenth century, was one of the first modern writers to specifically develop an artistic theory of "the great principles of construction" from his observations of nature. Greenough found that in nature animal structures unvaryingly adapted to the requirements of their environments.[77] He deduced, "If there be any principle of structure more plainly inculcated in the works of the Creator than all others, it is the principle of unflinching adaptation of forms to functions."[78] Because buildings had functions, he promoted designing "from the heart as the nucleus, and work[ing] outward" instead of "forcing the functions of every sort of building into one general form, adopting an outward shape for the sake of the eye or of association, without reference to the inner distribution."[79] Thus, Sullivan was expressing a familiar idea but giving it new importance, for American architecture as well as for himself; in his *Autobiography of an Idea*, which was his own autobiography, as the title

states he equated his own development with that of the theorem. Both Sullivan and Greenough were committed to Lamarck's theory of evolution, for the idea of the inheritance of acquired characteristics can be explained, in other words, as the idea that the *form* of later generations *followed from the functions or habits* of the previous generations.

In keeping with this thinking, Greenough (and Herbert Spencer as well) had proposed that the natural solution for any design problem came from beginning at the heart of the problem and working outward to its proper form. Sullivan's reasoning concurred: "Every problem contains and suggests its own solution. . . . [T]his logically must be so; for a vital problem is but a vital function seeking to select its form."[80] Although this idea formed the kernel of his essay on "Natural Thinking" and his autobiography, he first published it in 1896 in his essay, "The Tall Office Building Artistically Considered." One oft-quoted passage reads in part: "All things in nature have a shape, that is to say, a form, an outward semblance, that tells us what they are. . . . Unfailingly in nature these shapes express the inner life, the native quality, of the animal, tree, bird, fish, that they present to us." He continues, "Whether it be the sweeping eagle in his flight or the open apple-blossom, the toiling work-horse, the blithe swan, the branching oak, . . . form ever follows function, and this is the law."[81] Sullivan considered the tall office building to be like a tree, with an interior "circulatory system" and other "physiological" parts. He further believed that the "solution to the problem of the tall office building must follow accepted evolutionary principles, 'namely, by proceeding step by step from general to special aspects, from coarser to finer considerations.'"[82]

The writings and works of Sullivan, Loos, and Le Corbusier, in addition to those of Erich Mendelsohn and Walter Gropius, served as key influences on streamline designers. Since 1910 in his advertising and design careers, Walter Dorwin Teague had integrated Platonic ideals and classical geometry into his art, and in 1926, when he traveled to Europe to study the work of Le Corbusier, Gropius, and Robert Mallet-Stevens, he returned professing great admiration for their work. Geddes, too, admired their work and owned a copy of Le Corbusier's *Towards a New Architecture* (1927); he was close friends as well with Bragdon, who vociferously praised Sullivan's ideas in books that Geddes owned. Geddes also knew of efforts at the Bauhaus to design objects for mass production, and as a result of his friendship with Erich Mendelsohn, which began in 1924, he became familiar with the curvature of German Expressionist architecture. During the late 1920s, when he was in the process of codifying his theory of streamlining and

creating some of the first designs in the style, many of which were published in his book *Horizons* in 1932, his work and writings upheld four of the major principles of architecture and design—functionalism, designing from the inside out, nonornamentation, and modern styling as an expression of evolutionary sophistication—which, as the previous discussion has shown, derived from applications of contemporary evolutionary theories.

In his autobiography *Miracle in the Evening*, begun in 1957, Geddes recounts various tales that demonstrate his understanding of functionalism, both in nature and in the arts. When he was about eighteen years old, a sculpture instructor at the Cleveland Institute of Art, Herman Matzen, impressed upon him the importance of visualizing "muscles as working, functional elements beneath the surface which produced external form." This principle, "that the surface effects of visual form were the result of inner elements," struck him as profound, and he understood that it "had far-reaching consequences in areas of design outside those which Matzen's teachings were intended to encompass." He continued his anatomical studies between 1912 and 1913, when he dropped out of classes at the Art Institute of Chicago in favor of studying at a local morgue. That he associated this principle with Sullivan's teaching, however, is apparent from the irony of a story he tells about his struggle to get Frank Lloyd Wright, Sullivan's prodigy, to properly design a theater for Aline Barnsdall, on which the young upstart Geddes was also working, in keeping with the tenets of functionalism. According to Geddes, Wright was so invested in the exterior appearance and classical layout of the theater that he wouldn't consider such functional issues as lighting during the planning phase. " 'Norman, we have to plan our building before we install its equipment,' he told Geddes, who replied, 'But what happens in a theater and what makes it happen should be the basis for the plan.' 'You don't have to tell me these things' " was Wright's end to the conversation, although Geddes thought he had had the last word, as the theater was never successfully designed or built owing to Wright's stubbornness.[83]

That Geddes also absorbed Sullivan's and Bragdon's associations of architectural style with racial development is apparent from a section in *Horizons* where he too applied recapitulation theory to architecture. "There is said to be a law of nature that higher forms must, before maturity, pass through all the stages of evolution of their predecessors. This seems to hold true for the modern art of building." Continuing with what was perhaps a quip at the stylistic cacophony of nineteenth-century American architecture, Geddes reaffirmed Sullivan's search to define a suitably modern style.

"Mankind has had to re-experience the architectural development of the Egyptians, the Greeks, through the Gothic, the Renaissance and the Baroque, before it could express its own time in its own terms."[84] In his own architectural designs from the late 1920s, such as the drawings and plans he made for the Toledo Scale Factory in 1929 (never built), Geddes worked in a modern, functionalist vocabulary. He combined the use of industrial materials such as structural steel and plate glass with an overall horizontal design of classical proportions and a flat roof, traits that three years later became known as the International Style. Yet, he tempered the strict geometric purism by softening the edges of the building; he rounded its glass corners, carrying unbroken the momentum and flow of the front facade into that of the side, a technique that became a defining quality of streamlined architecture of the 1930s.

What was Geddes's impetus for streamlining architectural and industrial designs? Mendelsohn is usually credited with inspiring him toward a curved aesthetic in the mid-1920s, as well as with encouraging him to enter the field of industrial design. In the case of his early vehicular designs (and in contrast with that for the Toledo Scale Factory), functionalist considerations of the physics of air and fluid dynamics in order to increase efficiency clearly played a role as well.[85] Without discounting these influences, I think it is also possible that Geddes's concurrent interest in evolution and eugenics, as demonstrated in part by his breeding experiments and as applied to his understanding of stylistic evolution in the arts, played a role in his thinking, whether consciously or unconsciously. The common usage today of the phrase "to streamline" something means for those in power to pare away everything deemed unimportant, and in the case of corporate management, this often means laying off employees whose salaries drain corporate profits. This process, of judging the social and economic worth or "fitness" of particular individuals and acting upon that judgment to increase efficiency, which seems commonplace today, has close parallels in the ideals and practices of the eugenics movement. While Geddes may not have thought of the term in this way, the precedents for social and economic streamlining had been set by eugenicists throughout the 1910s and 1920s, in their public declarations of the need to purify the nation's blood "stream" lines, to increase its flow (meaning the birthrate of the "fit"), and to eliminate the genetic and economic "drag" posed by social "parasites" in order to increase "national efficiency."

Precedent for racial interpretations of product design (beyond those established by Loos, Sullivan and Le Corbusier) had also been set by advertisements capitalizing on the popularity of eugenics and the prevalent rac-

Figure 1.6. "The New Viking," *Saturday Evening Post* (13 April 1929): 38–39.

ism of the 1920s. General Motors followed suit in 1929 when it ran an advertisement in the *Saturday Evening Post* for the Oldsmobile Viking (Figure 1.6), a model whose name, like the advertisement itself, claimed associations with Teutonic racial heritage.[86] The text, written on yellowed parchment as if it recounted the history of the "new Viking" on the opposite page, described how the "brave" and "hardy" Vikings, dominant at war, colonized much of Europe and part of America five hundred years before Columbus sailed forth from Spain. "From birth, Viking youths were deliberately exposed to the rigors of the severe North-land climate. They were subjected to hardships to test their fitness for leadership. Those who showed signs of weakness were left to . . ." and the text trails off under the folded corner of the parchment, leaving readers to fill in what General Motors was unwilling to state. The hint on the next line of "Sparta . . . ," however, reveals that the corporation wanted readers to think that euthanasia was acceptable, for it supposedly had made the Vikings, and before them the Spartans, dominant. By killing the weak, "Only the strongest survived to contribute to the strength and superiority of the race." The text praised their many accomplishments in the arts and sciences, stating that "We owe much of our present civilization to this fearless, energetic and intel-"ligent

race, just as the British owed their success at sea-faring and colonization to "traits of character inherited," Lamarckian-style, "from their Viking ancestors."

The drawing beneath the text, in which the Viking automobile's medallion appears as if it were the shield of the warrior behind it (thereby metaphorically suggesting protection for those of Teutonic heritage who might purchase it), visually links this historical fiction to the automobile. The "V" on the logo mirrors the shape of the Viking's face and winged helmet, suggesting that the "new Viking" is the offspring and legacy of their inherited intelligence and creativity in the "arts and sciences," an inheritance General Motors is proud to claim. The description beneath the automobile describes how company engineers applied the evolutionary principles of natural selection and survival of the fittest, just described on the preceding page as producing racial superiority, in the rigid testing process used to select the engine for the car. "By constant testing and re-testing, checking and re-checking, they eliminated engine after engine, until one stood out above all others." Continuing the characterization of the product as if it, too, were the eugenic offspring of the inheritance of the Vikings, the advertisement concluded by inviting readers to "inspect this illustrious new member of the General Motors family."

Many of the ideas presented in this advertisement appear in the writings and speeches of streamline designers during the 1930s: the lingering persistence of neo-Lamarckianism; the correlation of products with bodies, as if they too evolve; the application of biological evolutionary laws to product design; the consideration of modern styling as evidence of racial superiority; and, in a few instances, direct references to eugenics. In many ways, these concerns were a natural fit for the fledgling profession of industrial design. After all, prominent theories of modern architecture had also derived from the application of evolutionary ideas to design, and buildings were viewed as expressions of their creator's "racial consciousness," as Bragdon had phrased it. As a new field, industrial design offered an untouched and highly profitable arena in which to practice reform. Considered as representative of the nation's evolutionary achievement, the poor appearance, functioning, and display of many manufactured American goods proved unacceptable. Industrial design therefore gained strength as a means to insure the mass-production of quality designs, and designers themselves became the agents controlling product evolution. For many reasons, their preferred aesthetic was the bringing of all parts into line under the dominance of the streamline curve.

Chapter 2
Products or Bodies?
Streamline Design and Eugenics as
Applied Biology

In 1932, with the publication of his best-seller *Horizons*, Norman Bel Geddes established the theoretical precedent for streamlining. Designs for streamlined motor cars, buses, ocean liners, trains, and airplanes that he had been working on for at least the previous three years took prime position, filling four of the first five chapters. Geddes's vision was much broader than just transportation design, however, for he forecast the new horizon that would "inspire the next phase in the evolution of the age." He believed the upcoming era would be characterized by design applied to four major areas—social structure, machines, objects of everyday use, and the arts. Geddes said little about the last or the first, although in a brief discussion about urban planning, he made the prediction that "to-morrow" only the "most capable" with the "best brains" would make the planning decisions, as he dismissed the idea that these could be made by "popular vote."[1]

Geddes's real concern was to promote the upgrading of machines and products of everyday life through the practice of industrial design, for he thought all contemporary critics would agree that the inferior results of "a swift industrial evolution" had produced not only dirt, noise, glitter and speed, but also mediocre products, "spurious substitutes of a mongrel-imitation type" rather than "genuine creations."[2] To remedy this, Geddes—the "amateur naturalist" and filmmaker who kept breeding tanks in his apartment—turned to biology, calling throughout his book for a persistent adherence to "organicism," by which he meant functionalism. "Organic surface qualities are the direct expression of the functional requirements" of a problem, he wrote, and, in order to have "sincerity and vitality" throughout, the former must follow from the latter. "An unorganic surface treatment," like surface styling of the "mongrel-imitation" type, was "mere

ornamental dress," a superficial cover hiding inner impurity and lacking vitality.[3]

Geddes relied on a genetic metaphor as the standard by which to mark industrial design's evolutionary progress toward "inherent" quality. "We admire the swordfish, seagull, greyhound, Arab stallion and Durham bull because they seem made to do their particular work," he wrote; in the case of the latter three purebred forms, this had been accomplished through the pointed efforts of animal breeders like himself. "When the motor car, bus, truck and tractor have evolved into the essential forms determined by what these machines have to do, they will not need surface ornamentation to make them beautiful. Their beauty will be inherent and that will be all the beauty they need."[4] Geddes may have been paraphrasing a similar statement published by automotive designer H. Ledyard Towle the previous year. "If we go to nature for the basis of everything, we are rather safe," Towle theorized. "The Arabian stallion and the greyhound are built for speed; they function perfectly and they are beautiful because they are so obviously suited for that specific function."[5] In architecture, the Parthenon exemplified design of this sort, Geddes thought, revealing Le Corbusier's influence, for it possessed "no detail of a superfluous nature. This is the result of perfect design."[6]

Geddes's interest in streamlining derived from this fundamentally biological orientation. By taking "organic" principles as a given, like a natural law, when he then applied these principles to the main problems of transportation design, the functional requirements of vehicular motion through air or a fluid seemingly elicited a streamlined form. Within the broader context of this organicism, his specific definition and discussions of streamlining are almost purely physical: "An object is *streamlined* when its exterior surface is so designed that upon passing through a fluid such as water or air the object creates the least disturbance in the fluid in the form of eddies or partial vacua tending to produce resistance" (Figure 2.1). Elsewhere, he stated that "an object is streamlined in order to *eliminate* disturbances in the media through which they [sic] pass," and that in order to accomplish this, "all surfaces and projections which create eddies or cause retarding suction should be eliminated." When he first defined streamlining, his two natural examples were physical ones: a falling drop of water ("approximately" the shape "of an egg") and a tapered ice-flow, which is illustrated in the book. Yet, he followed this discussion a few pages later by returning to his overarching theme of organic design, when he offered the animals cited above as models for the proper direction of design's evolution.[7] As

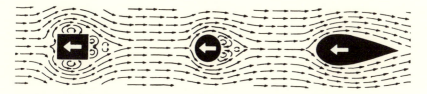

Figure 2.1. Norman Bel Geddes, "Diagram Illustrating the Principle of Stream-lining," *Horizons* (Boston: Little, Brown, 1932), 45. Courtesy of the Estate of Edith Lutyens Bel Geddes.

will be shown, within a year or two after the publication of *Horizons*, the underlying evolutionary rationale of streamlining as a style was elaborated much more fully by other designers, and two years later, Geddes, too, shifted his terminology for the concerns of the style in a decidedly eugenic direction.

Apart from the clear explication of streamlining, many of the ideas promoting industrial design that Geddes expressed in *Horizons* were not new, to New Yorkers at least. Between 1927 and 1930, numerous advertising and theatrical designers—including Geddes, Walter Dorwin Teague, Henry Dreyfuss, Raymond Loewy, Donald Deskey, Russel Wright, and Gilbert Rohde—had transitioned into industrial design, starting their own firms and receiving commissions from major corporations. The Metropolitan Museum of Art and Macy's department store regularly held exhibitions on the "industrial arts," displaying designed goods in highly fashionable, spot-lit windows, copying those created by Geddes for Franklin Simon, that drew crowds of style-conscious onlookers. Studios and galleries, such as the American Designers Gallery, offered recent work for sale, and publications including Viennese furniture designer Paul T. Frankl's *New Dimensions* (1928) and *Form and Re-form* (1930) further popularized developments in the decorative arts, sounding a call for "re-form" to American readers. The same year that *Horizons* appeared, Radio City Music Hall opened to rave reviews and immediately became an icon of modern design. Clearly, design was already fashionable, a trend spurred on by the arrival in New York in the 1910s and 1920s of European émigrés, like Frankl himself, many of whom had been personally involved in recent developments on the conti-nent in modern architecture and design and who worked in a functionalist manner.[8]

Geddes's reputation alone, however, would have been enough to spark sales of his book in the city. During the 1920s, he had established himself as a highly creative theatrical designer who had a strong tendency to infinitely enlarge either his role in a production or the allotted budget. In 1923, when he was hired to create the sets and costumes for Max Reinhardt's production of *The Miracle*, he converted the auditorium of the Century Theater into a Gothic cathedral, replete with eleven forty-foot-high stained glass windows, carved stone walls and floors, twenty fifty-foot-tall stone columns weighing one ton each, pews for an audience of thirty-one hundred, and a fifteen-thousand-square-foot, groin-vaulted, wire-mesh ceiling suspended from the roof by steel cable, all costing half a million dollars to produce.[9] As the play was set in a medieval cathedral in which a Madonna statue comes to life, in one sense Geddes's design was highly functionalist in keeping with his overall design philosophy, created in this case to maximize the psychological, emotional, and transformative intentions of the play. Yet, as at least one critic decades later liked to quip, his modus operandi in the theater and in industrial design commissions was anything but streamlined, for Geddes had an amazing "faculty for starting with a small, concrete project and ending up with a gigantic, theoretical one," producing designs that often went unrealized because of their scale and sheer audacity.[10]

Geddes's penchant for invention—including the creation of thousand-watt spot-lights and their offstage placement on balcony balustrades or the ceiling—secured him his first real job in the theater world in 1916. Aline Barnsdall saw a performance of his play *Thunderbird* on a model stage, with model characters and his innovative spot-lighting technique, and thereupon hired him to become the stage designer for her Little Theater project in Los Angeles. Looking back, Geddes described Barnsdall as a highly remarkable woman who gave generously from her personal wealth to progressive causes she supported, including those promoted by Emma Goldman, Margaret Sanger, and Margaret Anderson, who founded *The Little Review* in 1914.

Significantly, acceptance and promotion of eugenic ideals motivated all these women, and, according to Geddes, played a role in their earning Barnsdall's support. As early as 1906, Sanger had supported sterilization legislation for the "feebleminded," and throughout the 1910s and 1920s she promoted birth control as both a feminist and a eugenic cause, for she saw it as the chief means to lessen the immigrant birthrate. Sanger's crusade was financially aided by Barnsdall and bolstered as well by Goldman, who

in the mid- to late 1910s publicly lectured on anarchy while simultaneously publishing in her monthly, *Mother Earth,* support for birth control. Goldman thought its use would lessen the numbers of "paupers, syphilitics, epileptics, dipsomaniacs [alcoholics], cripples, criminals and degenerates," a group eugenicists referred to as the "socially inadequate persons" whom they thought comprised the lowest one-tenth of the "civilized" populace (Figure 2.2).[11] Around the same time, Barnsdall learned of Anderson's belief that "the race would be improved by familiarity with good poetry," as Geddes phrased it, so she funded the creation of *The Little Review.*[12]

Barnsdall agreed with the association of race betterment with the arts, perhaps naming the theater project in which Geddes participated the Little Theater in honor of this founding ideal of *The Little Review.* "A racial narrowness in art is what is needed in America for the next fifty years," Geddes recalled her telling him in 1923. She had preceded this statement with, "I am only too willing to pass up Shakespeare for the stimulation that pure American expression gives me. I know you don't believe in this entirely. Why should you? But I'm sure we have points in common. As subject matter I am not interested in *The Divine Comedy*, although your designs for it are the most interesting I have seen for the theatre."[13] She invited him and his wife Bel to travel to England as her guests in order to further discuss ways to keep the Los Angeles theater project alive, as Frank Lloyd Wright had faltered on the theater designs and her original producer, Richard Ordynski, and Barnsdall had had a falling out. She offered Geddes the chance to become both designer and producer of what he felt was a "magnificent theater project," which in part was based upon the goal of creating racially pure American theater.

Barnsdall's admission, "I know you don't believe in this entirely," and Geddes's description of it, is vague. Did Geddes not accept Barnsdall's racial ideals, or her proscription on producing non-American masterworks? It seems likely it was the latter, as in the same conversation Barnsdall had praised Geddes's designs for Dante's *The Divine Comedy* but dismissed the foreign subject matter, refusing to pay for the production of what he always felt was his design masterpiece. After all, Geddes *was* interested in evolution and in breeding; a few years after his move to New York in 1918, he had begun to rebuild his animal collection. Yet, strong archival evidence for an interest in eugenics at this time is slim.

Since childhood, Geddes had been aware of the goals of animal breeding. His father bred thoroughbred horses, presiding over the elite Pittsburgh Horse Show group until he lost all his money in the stock market

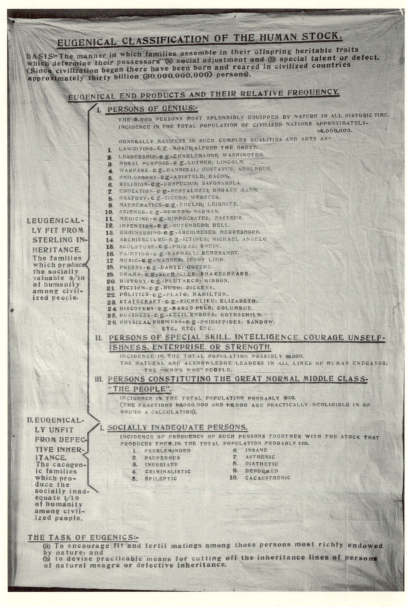

Figure 2.2. "Eugenical Classification of the Human Stock," poster on display at the Second International Congress of Eugenics, 1921, held at the American Museum of Natural History Library. Courtesy of the American Museum of Natural History Library.

crash of the mid-1890s. In fact, the hour that Geddes was born in 1893, his father was "receiving blue ribbons at the Chicago World's Fair, the happy result of having bred and raised several of the finest horses in the country." A telegram that his grandfather sent to his father in Chicago announcing his birth stated that Norman weighed "eight and a half pounds on the hoof," implying humorously that he, too, was a promising young thoroughbred.[14] Geddes's younger brother Dudley, however, was born partially blind and lame, with one leg shorter than the other, a fact that perhaps sparked Geddes's later desire to understand the principles of heredity.[15]

Over the years, Geddes developed an outspoken interest in sex to the point of surprising and offending company clients with his views; so remembered Garth Huxtable, husband of architectural critic Ada Louise Huxtable and one of Geddes's employees. In this he was similar to many liberal eugenics supporters, such as Sanger and Goldman, who felt that in order for people to make personal decisions in accordance with eugenic principles, sex had to move from the realm of the private to the public.[16] Geddes hinted at his developing interest in sex in his autobiography, describing a childhood encounter with a hermaphrodite Sunday School teacher and his visit to a sex museum in 1910 in Buffalo, New York, at age seventeen. Two store-front windows displaying a medieval chastity belt with accompanying illustrations and photos of "human bodies afflicted by various forms and degrees of venereal disease" drew him inside for three hours. There he not only learned "how to avoid this type of infection" but studied scientific models of the sexual organs, their proper functions, and "various abnormal forms of intercourse, freaks, eunuchs, hermaphrodites, and assorted monstrosities."[17] If Geddes became at all interested in eugenics from these experiences, he did not say so in 1957; however, as a result of the influence of his mother, whom he described as "liberal to a fault" in reaction against her own conservative upbringing, Geddes's views were always socially and politically liberal.

In 1924, Geddes was aware of the idea broadcast by eugenicists that the nation's average mental age was supposedly that of a thirteen-year-old, a determination reached by psychological analysts of data taken on hundreds of thousands of World War I army draftees. One primary goal of eugenicists was to increase the national level of intelligence, which they believed to be hereditary, and support for their movement grew through the popularization of this methodologically flawed psychological study. Geddes thought the pronounced average was "fourteen," and it seems he took the idea lightly, stating in his autobiography regarding his experiences

in Los Angeles that instead of the audience, "it was the motion-picture industry itself which had the mental level of an adolescent. Brains were not requisite to success."[18] He himself believed, however, that brains were required for those who would design the future world, as stated in *Horizons*, and he fancied himself a genius who had evolved a higher consciousness and the ability to perceive the fourth dimension, per the influence of his friendship with Claude Bragdon in the early 1920s.

That Geddes thought this perceptual ability was an outgrowth of biological evolution is evident from incomplete notes he kept for a Design Course that he taught during the mid-1920s in New York: "Animal life beginning in its earliest stage has ever explored the unknown," he wrote. Not sure of which examples to use, he continued: "From the _____, we have the _____, and then the _____ followed by the _____ and finally the development of the brain which distinguishes man from beast. . . . A very definite phenomenon is entering into the consciousness of the human. It is a wholly natural development tho not accepted as such." Geddes believed this natural, biological development was "the constant effort on the part of many minds to reach into the understanding of higher space. *Animal* Life began on a one dimensional basis. It has reached the third. It is becoming conscious about the fourth." He thought that artists, in particular, were evolving this faculty.[19]

Shortly after teaching this design course and meeting Frances Resor Waite—who was his student, then his employee in 1928, and then his second wife in 1933—Geddes entered the field of industrial design, receiving his first commissions and clients from Waite's uncle, Stanley Resor, president of the J. Walter Thompson advertising agency. Resor's wife and Waite's aunt, Mrs. Stanley Resor, was active in the eugenics movement during the 1930s, and in recognition of her efforts, she was nominated to the board of directors of the American Eugenics Society (AES) in 1936.[20] At some point in the late-1920s or early-1930s, Geddes, too, became more interested in eugenics, for he acquired Leon Whitney's *The Basis of Breeding*, published by the AES, a book that extended scientific principles he was already familiar with to human fitness and fertility. He likely referred to the legal sterilization of criminals and voiced his own support for such policies when he predicted in January, 1931, in the *Ladies Home Journal*, that "Medical and surgical treatment will reduce crime to a fraction of its present-day proportion."[21] Like intelligence, criminality was presumed by many to be hereditary. The following year, in which *Horizons* was published, he gave Frances a women's health and fitness book that doubled as a eugenic tract,

as its overall purpose was increasing the white birthrate; he and Frances, however, never had children as they, like the liberal Sanger, believed in birth control.[22]

During this time, Geddes's breeding experiments with the animals in his terrarium escalated. In 1931, he placed a large order for amphibians and reptiles from the Southern Biological Supply Company in New Orleans, and acquired the leaflet outlining Mendelian experiments. His collection grew to its largest size, spatially and numerically, by 1934, to the extent that in 1935, after conducting his eel experiments, he decided that he had to sell it, so he wrote to a few school administrators, one of whom purchased it. "The whole outfit has served its purpose with me, and as I am moving from my present apartment in a month, I have decided to dispose of it," he explained. "Any instructor on subjects of nature or biology would be delighted to have such equipment. It is a continual source of amusement and interest, as well as a liberal education in the habits of breeding, eating, sleeping, playing and fighting of totally different species of life."[23]

Correspondence from 1938 reveals that Geddes's daughter Barbara, who was then fifteen years old, was exploring the eugenic implications of her own romantic interests. When she fell in love with her cousin Buel, they discussed the prospects of "the possibility of normal offsprings" with Buel's father, a medical doctor in Toledo, Ohio, who told them that "although they were cousins it was perfectly all right for them to marry." Eugenicists fell on both sides of this issue of cousin marriage, for geniuses and "defectives" alike seemingly resulted from the pairing of closely-related genes. Unlike Buel's father, Geddes was greatly disturbed by this, and wrote to his ex-brother-in-law to verify the story, who responded by saying the children's concerns were strictly "from a biological angle" and that their "approach and attitude was unusually mature for children of their age."[24] This private controversy took place while Geddes was in the midst of creating the highly public General Motors Futurama exhibit for the New York World's Fair, a mammoth undertaking whose message and architectural layout pointed toward a streamlined, eugenic "world of tomorrow."[25]

By 1939, Geddes was not the only industrial designer promoting both eugenics and streamline design. Early that year, *Vogue* magazine invited nine other well-known industrial designers—including Teague, Deskey, Loewy, Dreyfuss, Egmont Arens, and George Sakier—to design a dress for the "Woman of the Future" as part of its special edition promoting the fair and its theme, "The World of Tomorrow." While focusing primarily on her clothing and accessories, many commented as well on future woman's

physique, predicting that her body and mind would be perfected through the implementation of eugenics.[26] For example, Deskey proclaimed, "Medical Science will have made her body Perfect. She'll never know obesity, emaciation, colds in the head, superfluous hair, or a bad complexion—thanks to a controlled diet, controlled basal metabolism. Her height will be increased, her eyelashes lengthened—with some X-hormone." Because of her beautiful body, she would no longer need to wear underwear, he thought, and having passed through a stage of nudism, she would clothe herself in toga-like, semi-transparent draperies (Figure 2.3).[27] Teague's design showed that he also believed that most women would have "beautiful bodies, and the present trend toward nudity [would] continue at an accelerated pace."[28] Sakier stated that "The woman of the future will be tall and slim and lovely; *she will be bred to it*—for the delectation of the community and her own happiness. . . . Her view-point will be clear and direct. She will be free from complexes and inhibitions."[29] Balking the fashion trend, Loewy's dress design (Figure 2.4) focused less on transparency and more on efficiency. The light-weight wool suit had sleeves that zipped on and off for a quick transition between the office and the nightclub. However, this pragmatic costume was also due in part to Loewy's vision of women's bodies. Although films about the future succeeded in showing men and women in "various scanty and often attractive-looking attire" owing to the actors' youth and good looks, Loewy felt that "this type of clothing doesn't seem adapted to contemporary individuals." He did not rule out the possibility, however, that in the future, "eugenic selection may bring generations so aesthetically correct that such clothes will be in order."[30]

Such predictions about eugenics were reiterated throughout the entire issue. One piece written by Allene Talmey was accompanied by an illustration (Figure 2.5) depicting chemically-controlled reproduction of scientists and policemen (note the varied ratio of brain to body size), as if taken from the opening scene of Aldous Huxley's *Brave New World*, published the same year as *Horizons*. In Huxley's best-seller, human embryos are transported on an assembly-line conveyor, receiving injections that determine their future occupations. Talmey declared that in the next century or so, reproduction would be "separated from marriage. Somewhere along about 2050 A.D. the first ectogenetic child, fertilized and grown in a glass tube in a laboratory, and then born outside the mother's body, will be just entering school." She believed that "Genetics, by then, will be an old story. By the right combination, which almost anybody can reason out mathematically then, the world will have the kind of people the world wants." Throwing a

Figure 2.3. "Radically New Dress System for Future Women Prophesies Donald Deskey," *Vogue* (1 Feb. 1939): 73. Anton Bruehl/*Vogue* © Condé Nast Publications Inc.

barb at the public artists of the decade, she continued, "If some one wants them, it will not be difficult to produce some 'fifty-thousand irresponsible, if gifted, mural painters.' "[31] Earlier in the issue, a description of "To-Morrow's Daughter" proclaimed, "To-morrow's American Woman may be the result of formulae—the tilt of her eyes, the curve of her chin, the shade of her hair ordered like crackers from the grocer. She may be gentle, sympathetic, understanding—because of a determinable combination of genes."

Figure 2.4. "Raymond Loewy, Designer of Locomotives and Lipsticks, Creates a Future Travel Dress," *Vogue* (1 Feb. 1939): 76. © Condé Nast Publications Inc.

Furthermore, "her face will be beautiful, but that beauty will not be merely an 'assembly-line' product. . . . [H]er body will be a perfectly-working machine, unencumbered with pain. . . . [H]er mind will work clearly, unfogged; with cold logic and warm sympathy. . . . To-morrow's American Woman may, indeed, be close to perfection."[32]

As these descriptions reveal, ideas promoted by the eugenics movement during the 1920s retained their appeal throughout the 1930s. Although anthropological publications such as Ruth Benedict's *Patterns of Culture*

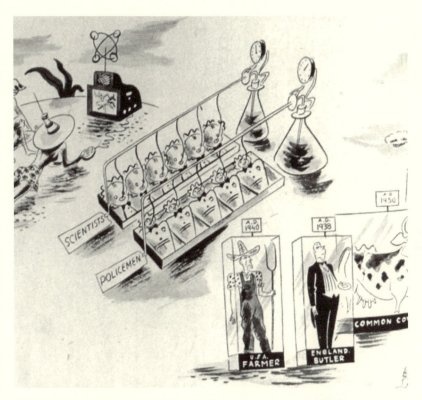

Figure 2.5. Illustration accompanying Allene Talmey, "A World We'll Never See," *Vogue* (1 Feb. 1939): 90. Constantin Aladjálov/*Vogue* © Condé Nast Publications Inc.

(1934) were asserting that many human traits previously considered to be genetic were in fact cultural, such perspectives failed to reach readers of the 1939 issue of *Vogue*, who understood from its contents that one's occupation, intelligence, beauty, and personality stemmed from one's genetic makeup.[33] Based upon the assumption that the inheritance of such traits followed Mendel's laws, eugenicists had been striving since the 1910s, through their own research and through education of the public, to produce the easily stated but ever-elusive "kind of people the world wants." Because they believed that advances in medicine and sanitation were displacing the once-purifying role of natural selection in the process of human evolution, thereby permitting the continuation of the "unfit," eugenicists proposed replacing natural selection with "rational selection." By carefully

controlling human reproduction in favor of selected traits, eugenicists hoped to gain control of evolution itself. Charles Davenport and Frederick Osborn, two leading eugenicists based in New York, clearly articulated this sentiment in 1930 while laying out their goals for eugenic research in the U.S. for the following five years. "When we understand the processes directing contemporary evolution we will be in a position to work actively toward the acceleration of these processes and especially to direct them in what seems to us the best way."[34]

To this end, throughout the previous decades eugenicists had implemented a two-pronged approach to maximize the efficiency of their programs for the genetic improvement of the race. On the one hand, "positive eugenics" targeted the "fit" and worked to increase the quality and number of their offspring through propaganda that explained the Mendelian formulae and simplistically applied them to human character traits (Figures 2.6 and 2.7). On the other hand, "negative eugenics" worked to limit the reproductive capacities of the "unfit" and their supposedly deleterious influence on the national bloodstream. Such programs took form politically in state and federal legislation widely enacted in the 1920s and 1930s aimed at anti-immigration, the distribution of birth control to "less desirable" populations, and the "voluntary" sterilization of criminals and the feebleminded.[35]

The implementation of "positive" and "negative" eugenics depended upon the participation of an enlightened public, both in their support for eugenic legislation and in personal choices, the latter of which *Vogue* authors took for granted. In part, this support arose from public acceptance of the humanitarian goals promoted by eugenics enthusiasts. As Sakier phrased it, good breeding was intended "for the delectation of the community" and an individual's "own happiness." Despite the important role played by the public, however, the media often portrayed the eugenicist himself, through his scientific research, as the mastermind producing the "Superman of Tomorrow" or, as compellingly, "various human types at will" (Figure 2.8).[36]

Beyond the continued popularity of eugenics in the 1930s and designers' references to its possibilities in *Vogue*, what were the connections between eugenics and streamline design? Loewy's "Evolution Chart of Female Dress and Figure" (Figure 2.9) offers an appropriate place to begin, for it expresses his conception in 1934 of the evolution of both the typical female costume *and* the female figure, from 1630 and 1890 respectively, into the indefinite future. In its inclusion of the female body, the chart differs dra-

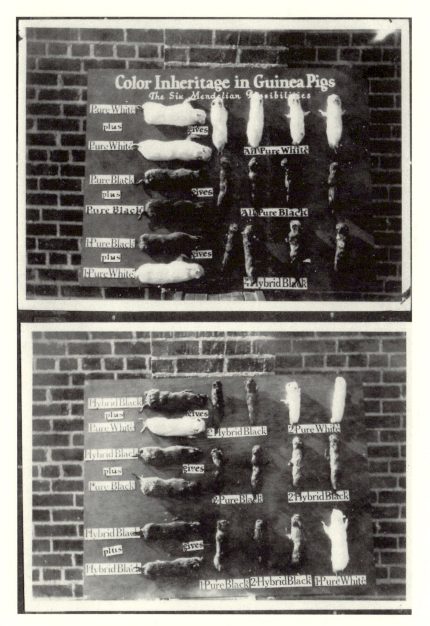

Figure 2.6. American Eugenics Society display, "Board Showing Color Inheritance in Guinea Pigs," 1926, used at various exhibits. Photo in the scrapbook of the American Eugenics Society, AES Papers. Courtesy of the American Philosophical Society.

MARRIAGES,— FIT AND UNFIT

1. PURE + PURE:—
 CHILDREN NORMAL
2. ABNORMAL + ABNORMAL:—
 CHILDREN ABNORMAL
3. PURE + ABNORMAL:—
 CHILDREN NORMAL BUT TAINTED:
 SOME GRANDCHILDREN ABNORMAL.
4. TAINTED + ABNORMAL:—
 CHILDREN ½ NORMAL BUT TAINTED
 ½ ABNORMAL
5. TAINTED + PURE:—
 CHILDREN: ½ PURE NORMAL
 ½ NORMAL BUT TAINTED
6. TAINTED + TAINTED
 CHILDREN: OF EVERY FOUR, 1 ABNORMAL
 1 PURE NORMAL, AND 2 TAINTED.

PURE - NORMAL, AND TRANSMITTING ONLY NORMAL.
TAINTED - NORMAL, BUT CAN TRANSMIT ABNORMALITY.
ABNORMAL - SHOWING THE ABNORMALITY.

HOW LONG ARE WE AMERICANS TO BE SO CAREFUL FOR THE PEDIGREE OF OUR PIGS AND CHICKENS AND CATTLE,— AND THEN LEAVE THE ANCESTRY OF OUR CHILDREN TO CHANCE, OR TO "BLIND" SENTIMENT?

UNFIT HUMAN TRAITS SUCH AS FEEBLEMINDEDNESS EPILEPSY, CRIMINALITY, INSANITY, ALCOHOLISM, PAUPERISM AND MANY OTHERS, RUN IN FAMILIES AND ARE INHERITED IN EXACTLY THE SAME WAY AS COLOR IN GUINEA-PIGS. IF ALL **MARRIAGES** WERE **EUGENIC** WE COULD **BREED OUT** MOST OF THIS UNFITNESS IN *THREE GENERATIONS.*

THE TRIANGLE OF LIFE

YOU CAN IMPROVE YOUR EDUCATION, AND EVEN CHANGE YOUR ENVIRONMENT; BUT WHAT YOU REALLY **ARE** WAS ALL SETTLED WHEN YOUR PARENTS WERE BORN. SELECTED PARENTS WILL HAVE BETTER CHILDREN THIS IS THE GREAT AIM OF EUGENICS

Figure 2.7. American Eugenics Society display, "Marriages—Fit and Unfit," Kansas Free Fair, Topeka, 1929. Photo in the scrapbook of the American Eugenics Society, AES Papers. Courtesy of the American Philosophical Society.

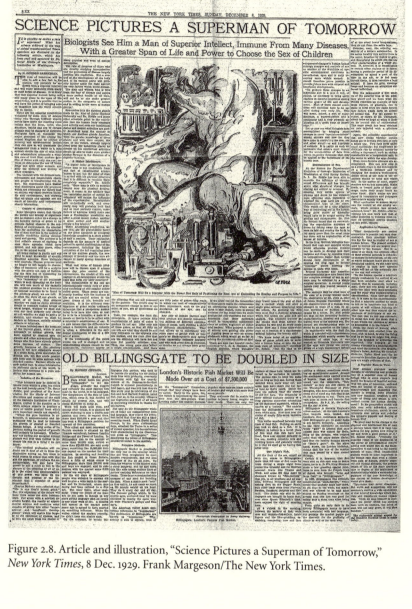

Figure 2.8. Article and illustration, "Science Pictures a Superman of Tomorrow," *New York Times*, 8 Dec. 1929. Frank Margeson/The New York Times.

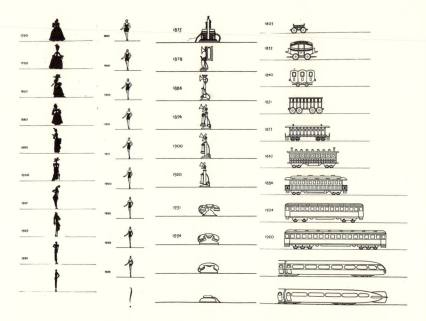

Figure 2.9. Raymond Loewy, "Evolution Chart of Female Dress and the Female Figure," "Evolution Chart of the Desk Telephone," "Evolution Chart of the Railcar," 1934. Originals likely destroyed; photos in a private collection.

matically from others he made, such as the "Evolution Chart of the Desk Telephone" or those of any number of designed products such as railcars, automobiles, ships, and houses. As was certainly intended by Loewy, such charts strongly but silently pointed to the industrial designer himself as the chief agent of product evolution. In this way, then, industrial designers and eugenicists (aspiring designers, after all, of humans and society) considered themselves primary agents of evolutionary progress. Assuming a role heretofore reserved to plant and animal breeders, both groups of designers rationally selected between desirable and undesirable traits to reform "primitive," "criminal," and "degenerate" products and bodies into functional, "fit" forms suitable for mass (re)production.

Geddes had hinted at this in *Horizons* through his use of genetic metaphors, when he upheld purebred animals as models for industrial design, whose products should be "organic" "genuine creations" rather than "mongrel-imitation" types. His rhetoric became more obviously eugenic in 1934, however, in an article focused specifically on "Streamlining" that he

published in the *Atlantic Monthly*. In describing the rationale for streamlining, Geddes replaced the physical terms "eddies" and "partial vacua"—the bête noire of streamline designers, and that which had to be "eliminated"— with the term *"parasite drag."* The more "parasite drag" was eliminated in a vehicle's design, the closer it came to "practical perfection."[37] Geddes's use of the terms "drag" and "parasite" repeated verbatim terminology widely popularized by eugenicists throughout the previous decade. For example, in 1926 in a sermon entered in a contest sponsored by the AES for the best sermon delivered on eugenics, one Jewish rabbi declared that the "weaklings, born of bad breeding,—the insane, defectives, degenerates,— form 3% of our population, and of course, are a source of weakness to our nation; a drag and a drain to us, physically, morally, and economically." He urged his congregation to set their faces firmly against "grossness and heathenisms of all kinds, that drag down the soul of a nation, and its body too; that lower its life stream to the vanishing point."[38] Similarly, in the August 1932, issue of *The Forum*, Henry Fairfield Osborn, president of the American Museum of Natural History, described the "unfittest" (of whom he thought there were twenty-eight million in the U.S. alone) as "dragnets . . . on the progress of the ship of state."

In line with Geddes, from 1934 on, Teague also used the terminology and concerns of eugenics to describe the historical origins of his profession. He spoke of the "sadly defective results" of the Industrial Revolution, which had produced designs "crawling with ornament," as if diseased. This "blight of sheer hideousness," worse than the plagues of Egypt, was "engulfing the world" in a "flood of ugliness," which he tellingly thought served as a poor "reflection on our intelligence."[39] Whereas early mass-produced goods were often covered with "meretricious" ornament, in streamlined designs, as Dreyfuss stated, the qualities of rightness, honesty, utility and beauty—qualities Teague incorporated under the term "fitness"—were integrated into the very structure of the product.[40] Sounding exactly like eugenics popularizer Albert Wiggam, Teague explained that "This approach is based on the theory that beauty is much more than skin deep. A handsome and appealing product is a well-built, well-organized, rightly-proportioned and soundly-functioning product. Beauty must be built in, not applied."[41]

Teague elaborated on product "fitness" in 1934 in a speech to automotive engineers entitled "The Basic Principles of Body Design." "The first law of all design is Fitness," he declared, "And by this is meant Fitness to Function, to Materials, to Construction. This principle of fitness may be

otherwise stated as perfect adaptation of means to end." The proper design of any object, whether an auto body or a human one, like a person's genetic structure, was "inherent in the object itself, and must be evolved inevitably out of the function which the object is adapted to perform, the materials out of which it is made, and the methods by which it is made." Just as beauty and social utility in eugenic thought were intertwined, so Teague found them connected in industrial design as well. "We can reassure ourselves with the knowledge that as we develop a perfectly functioning *organism*," he said, referring to products as if they were bodies, "both our proportions and our line will inevitably be correct."[42]

Elsewhere, paraphrasing the ideals of streamlining, Teague included additional traits in the complex of qualities entailed in good form. "Economy and efficiency must be nicely balanced, so that the simplest means are found for performing a function in the best possible way, and if this perfect balance is achieved, the result will also be beautiful. Beauty is thus visible evidence that a problem has been rightly solved."[43] He was not alone in this belief, as other designers and architects felt similarly. Towle, in the same article Geddes may have seen before referring to the functional perfection of purebred animals in *Horizons*, stated, "A peculiar fact about beauty is that, when you have made a thing that functions well, behold, you have produced something that is beautiful, without having tried to do so"; Arens clipped and saved the article.[44] A Chrysler press release further defined the relationship between beauty and utility and found the acme of both in streamline forms: "As airplane manufacturers came nearer and nearer to true streamlining, they discovered they were coming nearer and nearer to true beauty of appearance."[45]

Because beautiful design resulted from functionality, a designer could not improve the design of a product by "camouflaging" it with ornament, "much as a cosmetician applie[d] rouge," or by merely altering the exterior shell, which, ironically, streamline designers were criticized for doing. Deskey stated that if only surface "styling" were accomplished, a product would be "akin to the woman having applied to her skin and hair the lustrous glow that nature forgot. . . . The appearance was easier to change than the reality, attention was focused on the surface."[46] Such makeovers through applied decoration, in addition to being dangerously feminine, were considered dishonest, for they masked over "birthmarks" and "deficiencies" "with several layers of decoration, curleycues, roses, etc!" proclaiming inner health where, in fact, there was none.[47]

Instead, designers believed that product reform had to begin on the

inside of a product, with its inner workings and perhaps even with the processes that produced it. From there, it proceeded outwards to a smooth, streamlined cover that aptly symbolized the overall wholeness and integrity of the product's design. "Can a first-rate product be made in a third-rate factory?" Geddes asked rhetorically in *Horizons*, implying not only that as in nature, like could only produce like, but also that quality at the foundational level would produce quality throughout the rest of the process.[48] Based upon this same principle, Dreyfuss reasoned that "If a tractor appears well put together outwardly it is logical to assume the internal mechanism is equally sturdy."[49] In Teague's estimation, design of this sort would produce a product's "one ultimate form," a form that was *latent in the thing itself, as the color of our eyes and the shape of our fingers are latent in the uniting cells with which our lives begin.*[50] Like a eugenic body, good product design with its complex of traits originated from a healthy interior; such products were suitably "civilized" and therefore deserved mass-production.

Products that had not undergone the design process, however, like "defective" individuals, were said to be "sick." "Just as the man who is ill, though he may understand the workings of the human body, calls in a physician for diagnosis and prescription," Teague wrote, "so the manufacturer consults a specialist about his product—the industrial designer, or artist-engineer."[51] Raymond Loewy, too, frequently described the role of the industrial designer as being that of a doctor curing product disease. He considered the tactic of simply lowering a product's price to be tantamount to giving "a shot of strong anaesthetic that will create nothing but temporary relief and leave the patient limp and moribund."[52] Continuing the metaphor, he characterized the designer's office as a "clinic." Not only were products examined and diagnosed there, but the studio was as clean and sanitary as a doctor's office, with "light colored washable walls, linoleum floor, scientific lighting and the clean, straight-forward lines of modern furnishings."[53] Ideally, though, Dreyfuss wanted his profession to be used not as the cure for sick products but rather as "preventive medicine."[54] Eugenicists also used this exact phrase to define their work, and it was equally appropriate to both. Like eugenicists, who hoped to sterilize "defectives" prior to reproduction and educate the "well-born" on proper mate selection prior to marriage and childbearing, designers hoped to reform their patients prior to mass production. By doing so, both designers and eugenicists hoped to prevent present and future waste and inefficiency in the (re)production process while simultaneously ensuring permanent race and product betterment for future generations.

What happened between 1932 and 1934 to cause Geddes's brief hints at eugenic ideology in his best-seller *Horizons* to become almost outright declarations of eugenic thought by designers working in the streamline style? Geddes opened his *Atlantic Monthly* article with what may be an explanation. "Last year, . . . advertising copy writers seized upon [streamlining] as a handy synonym for the word 'new,' using it indiscriminately and often inexactly to describe automobiles and women's dresses, railroad trains and men's shoes."[55] But what, then, would explain this explosion of interpretations of streamlining in the popular realm, not as something specific to vehicular motion and air and fluid dynamics, but simply as a synonym for "modern"? The fact that many streamlined products were made of innovative materials such as plastic and looked sleek and futuristic, as well as the fact that streamlining was simply the newest style, surely contributed to this perception. Yet, an additional rationale is revealed in a speech written by Arens in 1933 (but edited and delivered two or three times between 1933 and 1934), which may reveal a causal thought sequence experienced by designers, copy writers, and their audiences alike.

Reflecting the organic mindset expressed by Geddes in *Horizons*, but focused on the evolution of typography rather than industrial design, Arens first titled his speech "Creative Evolution of the Printed Word." Sometime later, he substituted "Streamlining" for "Creative Evolution," crossing out the latter so that the title became "Streamlining the Printed Word," to which he then added "or Tempo in Typography." The interchangeability of these three phrases in the title reflected the speech's content, which traced the workings of "natural selection" in typography that ruled out "all that is too slow, or too cumbersome, and which favors every change in type design that makes for increased tempo." Whether in typography or in "the development of the species of animals on this earth," the "creative evolution"-ary process of survival of the fittest that weeded out the "slow" and "cumbersome" *was*, in other words, the process of streamlining, as his titles and text showed. Both resulted in an increased tempo that, according to Arens, demanded in the arts, more streamlining, and in society, an increased level of intelligence, to survive.[56] In the U.S. in 1933, the only movement claiming to weed out the slow and cumbersome, while at the same time increasing the nation's intelligence through controlling the processes of "creative evolution" in order to produce those who were perceived as evolutionarily "modern," was eugenics, with streamlining at its side.

The conceptual and rhetorical similarities between eugenicists' consideration of bodies and their improvement, and designers' approach to prod-

uct reform, go beyond the foregoing examples. These overlaps, strengthened by the examples that follow, bolster the theory that designers, advertisers and the public, on some level, recognized in streamlining what were already familiar "modern" ideas and practices from their awareness of eugenics, to the extent that after *Horizons* became a best-seller, the style immediately caught on because it embodied the same ideals. Even the term "streamlining" itself resembles a highly prominent metaphor—that of the pure "stream"—that surged through eugenics discourse during the 1910s and 1920s, as shown by the almost ninety sermons submitted to the AES in their sermon contests of 1926 and 1928. In these sermons, the "stream" variously symbolized an individual's unpolluted blood stream and inheritance, the continuous stream in hereditary lineage that linked families and races, and even the "life-stream" prompting all creative acts, both sexual and mental.

In writing their sermons, which had to be delivered before a congregation in order to be eligible for the contest, many pastors plagiarized such popular sources of knowledge about eugenics as Wiggam's *Fruit of the Family Tree* (1925) and even the promotional tracts of the AES itself, resulting in a remarkable consensus of idea, metaphor, and rhetoric. Preachers voiced concern that the "pure," "clean" lifegiving streams "of the best family strains" were being diminished through infertility or "dammed" by birth control: "How little has that fine class of twenty-five [from a typical Yale graduating class] added of its blood to the stream of cultured blood which America needs so sadly!"[57] Worse yet, individuals from these pure streams were hindering "greatness in the offspring" by "intermingling" with the dissimilar streams of "the hordes from southern and south-eastern Europe," whose "wide streams of dangerous blood flowing through our imperiled nation" were polluting and "poisoning our blood-stream."[58]

Of all the sermons submitted, the winning sermon of 1926 most thoroughly developed the stream theme, taking as its text Revelation 22: 1: "And he showed me a river of water of life, bright as crystal, proceeding out of the throne of God." The Rev. K. C. MacArthur, of Sterling, Massachusetts, used history's trajectory as metaphor. Just as the earth had degenerated from a pure state of nature to the current industrial blight caused by factories' dumping refuse into once pure rivers, so the stream of humanity had become successively polluted. "Look at the *whirl-pools* of drift and refuse, its *eddies* of loathsome flotsam and jetsam," he began. "Note its slimy scum and noisome odors. What has happened to this stream?" He directed his congregation to consider the historical course of human life: "Find the

impure streams of social disease, bred of vice and sin, flowing into this river of human life. See the putrefaction of criminal strains of life added to it. Note the currents and eddies of diseased mind or enfeebled intellect." These currents, he explained, joined together into a tide that flowed from past to present. "It receives our own lives into its current and surges onward through all Time, onward to the ocean of Eternity. It is ourselves. We are this Stream of Life . . . this vital force, establishing the fact of its timeless continuity, and naming it to us as the Human Germ Plasm."[59]

The pastors' emphases on the pure stream and the ideas that it entailed had been beautifully captured the year before in a photograph of the family of Oscar B. Rollins, who won a Fitter Family Contest sponsored by the AES in 1925 at the Texas State Fair (Figure 2.10). Such contests, designed to educate the American public about the ideals of eugenics and their own hereditary makeup while garnering information about the nation's heritage for eugenics research, treated "human stock" as other parts of the fair treated livestock. Trained volunteers queried participants about their family history of health, hygiene, and occupation, took anthropometric measurements of participants' bodies, administered intelligence tests, and assigned an overall grade of A, B, C, or D. Everyone scoring all As received a medal stating, "Yea, I have a goodly heritage"; ranking contestants received silver trophy cups as well, and some, including the Rollinses, were even immortalized in photographs placed in the scrapbook of the AES.[60] Posed in a tapering line, stripped down to their form-fitting suits, and standing in a clean flowing stream, this beautiful, fit, intelligent, healthy, well-demeanored, Grade A family prepared to dive into the stream. Their arms mirrored the taper of their descending heights, being brought together to a point at their fingertips to cut the water in truly streamlined fashion.[61]

The year after the Rollins photo was taken, Leon Whitney, then secretary of the AES, asked "a noted sculptor to prepare a rough model depicting a man and wife passing on the *stream of life* to their child, emphasizing the biblical quotation shown on the medal." The mock-up for this medal (Figure 2.11), which was intended to become the medal handed out to Fitter Family contest winners, depicted a standing, classically-attired Nordic couple pouring their conjoined streams, symbolized by a pitcher they both held, into a bowl in their infant son's hands. Henry F. Osborn criticized the design, stating that "the object born [sic] by the female figure is by no means obvious," and so it was altered, the "stream of life" becoming a torch of victory in the medal that was later produced, with the couple kneeling on the ground.[62]

Figure 2.10. O. B. Rollins Family, Champions in the Large Family Class, Fitter Family Contest, Texas State Fair, 1925. Photo in the scrapbook of the American Eugenics Society, AES Papers. Courtesy of the American Philosophical Society.

The Rollinses received seven medals in 1925 and seven more in 1927, when they also won the contest held in Waco, Texas, having traveled both times from their home in San Antonio at the behest of their father, who was then working as a county agricultural agent judging livestock at county fairs. Gloria Rollins Hoot, the youngest in the picture at six years old, remembers the medals, describing them as about 2 ½ inches across with a "'godly (or was it goodly?) heritage' on one side with two pieces of crossed wheat sheaths (I think) on the other." When asked about the family's streamlined pose in the photo, Hoot stated that she suspected the pose was arranged by her father. "He was the one with the athletic background and poetic inclinations. I remember when I was a child he was always trying to

Figure 2.11. Unknown sculptor, preliminary mock-up for the Fitter Families Medal featuring the "Stream of Life." Photo in the Henry Fairfield Osborn Papers, American Museum of Natural History Library, as well as in the scrapbook of the American Eugenics Society, AES Papers. Courtesy of the American Museum of Natural History Library.

get me to memorize poetry. . . . And both my parents must have been competitive, with a strong will to succeed."[63] The photo thus epitomizes the family's athleticism and competitive spirit, and perhaps also the eugenic idea of passing on the "stream of life" as poetically interpreted by her father.

The use of the "stream" as a metaphor for evolution was pervasive,

for the same year that the Rollins family posed for this photo, Teague used the metaphor to describe the evolution of typography in a speech to the Art Directors Club in New York City. Introduced to his audience as a student of the history of ornament "since it originated with the very beginnings of the well-known human race," Teague proceeded to "trace its history from the Dark Ages to our everyday problems." He described the progression of artistic and typographic styles as "the stream of design" which "flow[s] . . . for hundreds and hundreds of years without a break." This "unbroken stream" gradually progressed from one style to the next: "the changes were so slight from one period to another that it was a perfectly natural and normal growth like the growth of a plant or tree." While he discussed the development of type from the Italian Renaissance to French Garamond in 1540, to the Caslon type of England of 1720 and the Italian Bodoni type of 1800, he mused that "it would be interesting to study the evolution of styles and see how each style grew imperceptibly out of its predecessors, and with slight modifications of details continued over a period of years, [and] resulted in a wholly new effect." He thought that by studying the progression of previous styles, modern designers were "trying to connect with the old stream of design."[64]

Arens's application of the language of evolution to typography in his 1933 speech thus contrasted with Teague's earlier evolutionary gradualism, and his emphasis on how the processes of natural selection weed out the slow and cumbersome imbued his interpretation with a eugenic tinge. Arens's notion of what was "civilized" in both society and typography was founded upon a racial basis, as shown by an example he gave comparing type faces with human ones. Arens compared cumbersome fonts with the face of a modern man who wore a beard. Designer Joseph Sinel apparently went "primitive" in Arens's estimation every summer when he grew a beard and traveled to New Mexico, whereas in the winter, his clean-shaven, streamlined face bespoke his "civilized" New York occupation. Overlooking the fact that shaving actually took time, thereby slowing a modern man down, Arens interpreted the less ape-like, visual aspect of a smooth face and clean jawline as symbolically fast and streamlined: "There's quite a moral in that which even Joe won't admit." Furthermore, echoing theories debated by eugenicists about the racial intermixture of the "primitive" with the "civilized," both Arens and Henry Dreyfuss pondered whether "bastard offspring" and "mongrelism" in design restored "vitality" to modern design through "hybrid vigor" or desecrated its principles of "purity."[65]

In 1934, Arens continued to correlate the ideas of the style with identi-

cal ones promoted by eugenicists in a series of lectures entitled "See America Streamlined" and "Streamlining in Nature," which he delivered many times over the next two years around the nation at high schools, colleges, junior leagues, and executive meetings of industrialists.[66] He accompanied his talks with lantern slides that gorgeously displayed streamlined adaptations in natural forms, including trees, flowers, fish, birds, horses, and dogs. For the latter two, he used thoroughbred forms ("Pure Bred Arabian Horses," Irish setters, and greyhounds), noting as Geddes and eugenicists did that trainers and breeders could select and shape animals to produce beautiful, functional forms. In his talk, he contrasted a white greyhound (Figure 2.12) with an Irish setter. "Champion greyhound. Here is the same thing without the benefit of the trainer. It comes almost naturally to a greyhound. It is in his blood. Men have selected for breeding dogs who showed good form. . . . Greyhounds were being bred for lines like these long before the engineers discovered the slip stream."[67] Arens emphasized the role of purebred genes as a basis for the streamline form over the physical requirements of fluid dynamics (the "slip stream"), a primacy reiterated by the visual message of the opening slide of his lecture. An abstraction of two curves representing "Stream Lines" more closely resembled the torso of the greyhound than the typical teardrop representation of a vehicle in the "slip stream" (Figure 2.1). Given the visual similarities with the greyhound and his comments about breeding, the textual separation of the words "Stream" and "Lines" even left room for an association of streamlining as being connected to blood*stream line*age.[68]

Promotional texts and advertisements for goods related to streamline design could have easily been interpreted as resonating with eugenic concerns as well. Stacked horizontal lines, so prevalent in the style, symbolized "speed and power," whereas, according to Teague, vertical lines symbolized the dysgenically familiar "retarding forces" and "drag," both of which he minimized in many of his designs. In his automobile design for the Marmon Sixteen, for example, he tilted the front windshield as far back as was practicable and faired the rear end forward in such a manner as to produce a "minimum amount of suction"; he also either eliminated or covered "all irrelevant details."[69] Blue Sunoco even claimed these ideals for its gasoline, as its advertisement stated, "streamlined speed and economy—because its refining process eliminates those undesirable parts of petroleum which retard swift acceleration, high speed and knockless power."[70]

Although reducing drag through streamlining ostensibly increased vehicular speed, such speed in models from the early 1930s was often more

Figure 2.12. Egmont Arens, lantern slides of "Stream Lines" and a greyhound that accompanied his lectures on "Streamlining in Nature." Box 57, Egmont Arens Papers. Courtesy of the Syracuse University Library, Special Collections Research Center.

rhetorical than actual, according to some studies, a fact that emphasizes the strong pull of streamlining rhetoric and ideals. Alexander Klemin, writing for *Scientific Monthly* in 1934, dismissed the idea that tilting "the windshield a little more rakishly" and giving "the radiator a push and the rear end a pull" made "a 1933 streamlined car out of a 1932 model. . . . Nothing remains but to admit that in 1933 the applied science of automobile streamlining was still in its infancy."[71] If the energy-saving benefits of streamlining were as negligible as these studies suggested, the public still possessed a strong attachment to the style. Streamlining, after all, in part symbolized the quick tempo of modern times resulting from evolutionary processes that were eliminating all retarding hindrances.

After 1934, numerous articles and speeches found in designers' archives point to biological theories of evolution, rather than physical theories of fluid dynamics, as the primary inspiration for streamlining. A 1935 article in *Scientific American* (Figure 2.13) that Arens saved, for example, explored the parallels between birds and planes, fish and ships; its title, "Streamlining in Nature," so resonated with him that he began to use it for his own lectures. After covering some of the lessons on streamlining that man could learn from nature, the article concluded: "That is what makes good streamlining. . . . By the sure process of evolution very effective results have been accomplished."[72] The year before, Klemin had declared, "It is not an accident in nature that fishes which move fast in pursuit, or in avoidance of pursuit, are all of the shape which we have learned recently to call streamline. Nor can evolution have been blind in giving bodies of similar outline to the fastest flying insects and birds."[73] A *New York World-Telegram* article about ship streamlining disclosed that "Proper curvature is the secret of streamlining and, therefore, of speed. Evolution disclosed it long ago. The fleet birds are blunt-breasted. The swift fish are blunt-nosed. Now that shipbuilders are aware of it, ships—beneath the water—will be blunt-bowed."[74]

Indeed, both General Motors (GM) and Chrysler invoked evolution in their promotional brochures. One GM pamphlet on "Aerodynamics and Streamlining" stated that "Successful manufacturing rests upon a knowledge of natural laws," both biological and physical.[75] Charles Kettering, Director of Research at GM, explained in another brochure that the principles of streamlining were "as old as the hills—or older. A shark, for instance, is streamlined to slide through the water as a modern airplane slides through the air. Some species of whales have a surprising resemblance to dirigibles."[76] In the brochure, Kettering described "The Proving Ground"

Theory of ↓

STREAMLINING IN NATURE

**How Man May Learn From Nature . . . The Stream-
lined Salmon . . . Long Over-Seas Flights of Birds
. . . Small Details of Vast Importance**

By RAY HOLLAND, Jr.

IT is common knowledge that fish and birds are streamlined. For that matter, all earthly creatures that move rapidly are, by necessity, well shaped for speed. Insects and land mammals are not exceptions. The interesting thing, however, is not this generality of attention to air and water resistance, but the meticulous sort of work, and the delicate care, which are exhibited by natural streamlining. Close observation of how the avoidable portion of fluid resistance is kept small in nature gives the naval architect or the aircraft designer something to think about. If he believes that his particular design is the ultimate, he should stop to consider the forms found in nature.

But isn't our modern airplane exceptionally well streamlined? To be sure,

The speed-form of an Atlantic salmon, compared with that of a modern streamlined transport plane

Illustrations by the author

We can not deny it. Its even surface, its smooth curves from nose to tail, its blending transformation from wing to fuselage, its freedom from holes and projections, its full robust form; all of these things make for speed. It is an object of beauty, an artistic triumph as well as an engineering success. It represents the apex of streamlining achievement by man. Where is its parallel in nature?

The first random choice of a natural parallel of the super-speed airplane in the matter of streamlining is the Atlantic salmon (*Salmo salar*). At a glance it appears that the form of the salmon could serve as the fuselage for

the transport plane. We notice a slight difference. The airplane fuselage has an elongated section amidships. This is for the cabin, an economic necessity in a passenger plane. Also, there is a discontinuity of form at the nose of the plane to provide for the flat windows through which the pilot sees. Either of these trivial appearing modifications would be highly bothersome to a salmon,

if not decidedly injurious to a good living.

Let us look closer. How about the surface? The metal covering of the airplane fuselage, upon close scrutiny, reveals thousands of rivet heads. More often than otherwise they are not indented into the surface and flattened smooth, but stand out full and round in the breeze. The trailing and side edges of dural sheets, put on so as to lap over each other, stand exposed adjacent to the lines of rivets. Probably you think: "Utterly trivial." But what does the salmon say? He is covered with very small scales. These scales also have their edges. But the edges are not exposed. The entire fish is covered with a slime which is exceedingly slippery. The water flowing past him comes in contact with nothing but the essence of smoothness.

The salmon is not a perfect stream-

line form, by any means. He has a nose which seems too pointed. This, among other purposes, is for digging a trench in the pebble covered stream bed during spawning, to receive the eggs and milt of the parent fish. Also he seems too long in proportion to his depth and beam. The answer to this undoubtedly is that he must use his body for propulsion. It is not merely a shape evolved to have a minimum of resistance in the water. It is provided with the necessary fins for propulsion, maneuverability, and stability.

The airplane has fins projecting from its body; the tail surfaces and perhaps we should include the wings. On a few of the newer machines the filleting of these surfaces into the body is of the

same general form as that seen on the salmon. This blending of surfaces is one of the fine points of good streamlining. On the salmon an observer is not able to say where the body becomes the fin and vice versa, the change is so subtle. This degree of filleting has rarely been accomplished in airplanes. It is a phase of design which engineers are appreciating more all the time.

AMONG the fishes, the salmon is probably not the best streamlined. There are several salt water varieties which could vie for that honor. Their very existence in the open sea depends upon their speed, in avoiding being eaten, and in catching their food. In general, the bodies of these fast swimmers have a cross-section which is quite full, approaching the circular. Their bodies taper almost to a point instead of to an edge. Their narrow forked tails represent a very efficient utilization of surface. The whole arrangement points to a different propulsive mechanism, a different tail action. Instead of a side-to-side sweeping motion, about the long axis of the fish. Such a type of propulsion removes the necessity for the large side area required by the other type, and leaves the body free to take a more high-

where cars were subjected to "grueling" tests to insure their "stamina" and measure their comparative performance against their American and European competition. Since at least 1929, GM had used the processes of natural selection and survival of the fittest to refine their automotive designs, as shown by their advertisement for "The New Viking" (Figure 1.6).

One press release from 1934 for the Chrysler Airflow similarly declared: "Engineers Go Back to Nature for Airflow De Soto Design: Streamlined Cars Take Shape from Birds, Fish and Greyhounds. . . . The engineers started their nature study five years ago when they began their battle to overcome the 'drag' of wind resistance. They discovered that form follows function almost invariably in nature." The shape of fish inspired the broad front and tapering rear of the car while that of greyhounds suggested placing the engine forward on the front axle for more efficient movement.[77] The adaptation of the frontal structure of greyhounds for automobile design had been suggested by Towle as well in his 1931 article in the *Society for Automotive Engineering Journal*.[78] Yet another De Soto press release from 1934 charted man's perennial struggle to overcome "drag," beginning with the "cave man's" discovery that "his drag was easier for his pony to pull when the drag ended in a leafy branch that spread the weight." Subsequent to this realization, the "primitive savage" found he could paddle upriver faster seated astride a streamlined "trimmed log" than he could navigating a raft. "The automobile business can hardly be compared to the cave man and his dragging limb, or to the savage and his log that later developed into a canoe . . . but when we face the facts and read the reports of our engineers, we sometimes think that perhaps we are not so progressive." However, according to the newsflash, the De Soto met the modern challenge by being the first "truly streamlined" car.[79]

Exhibits and publications placed streamlined products at the apex of evolution. The cover of a Burlington Zephyr brochure illustrated the development of transportation from the covered wagon stage, through pre-designed steam locomotives, to the superior Zephyr.[80] This evolutionary theme was further developed in an event staged by the Nebraska Historical Society and the University of Nebraska of the "Zephyr in Service," which set the train in Lincoln next to "an ox-drawn covered wagon of one hundred years ago and two pioneer stage coaches." At Omaha, "the train was greeted by a band of Omaha Indians, descendants of the braves who welcomed Lewis and Clark in 1804."[81] Similarly, a 1936 exhibit at the Broad Street Station in Philadelphia (Figure 2.14) lined up four locomotives—old-style steam, old-style electric, streamlined electric, and "a new streamlined

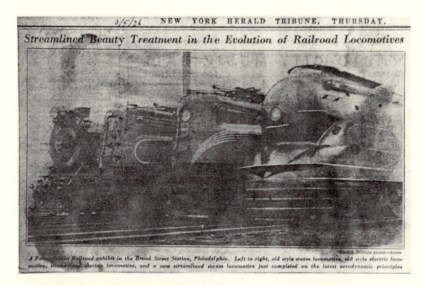

Figure 2.14. "Streamlined Beauty Treatment in the Evolution of Railroad Locomotives," *New York Herald Tribune*, 5 Mar. 1936. In file "Railroad," on Microfilm Roll 16.20, WDT Papers. Courtesy of the Syracuse University Library, Special Collections Research Center.

steam"—to show its evolutionary progress, as the title noted.[82] The newest was Loewy's S-1 locomotive, designed in 1936 for the Pennsylvania Railroad. Reiterating the earlier message of his "Evolution Chart of the Railcar," three years later, at the back of his book *Locomotive* (1937), Loewy included a section entitled "Evolution" (a title that covered an entire page in bold font), which featured comparison photos showing the evolution of the locomotive cab and headlight, both of which culminated in his streamlined designs. In the accompanying text, he discounted trains with the newest engine type, the diesel-electric, as unproven, "snappy looking" youngsters (as if they were the nouveau riche) that could "hardly be classified as 'locomotives,'" favoring instead the steam locomotive which *"retains decidedly 'racial' characteristics."*[83] The same theme of progress from the "primitive" to the "modern" informed the Newark Museum's exhibition in 1930 on "Rugs and Floor Coverings," which featured Donald Deskey's rug and furniture designs, so suited to "our mechanical era," in contrast to "Stone Age" woven mats and a leopard skin.[84]

Although evolution offered the primary ideological framework and

organic models for streamline designs, designers also implemented other biological principles in their designs by utilizing organic growth patterns popularized by D'Arcy Thompson's *On Growth and Form* (1917) and Jay Hambidge's writings on dynamic symmetry. Both Thompson and Hambidge explored the mathematical order of nature, showing that certain numerical relationships recurred almost unfailingly throughout animate and inanimate biological structures. This structural consistency was so universal that, especially to the mystically inclined, it appeared to derive from a fundamental biological principle of design, or a universal life force. From the spiraling seeds of a sunflower to the arrangement of leaves around a stem and the developmental progression of a nautilus's chambers, this mathematical order engendered both natural beauty and sound functioning.

Although in Thompson's study a few different mathematical series frequently surfaced through analysis of measurements of organic forms (and he showed that the series were interrelated as well), the series most frequently cited and utilized by designers was the logarithmic spiral, evident in the nautilus pattern. Although Hambidge also measured various natural forms (including shells and the pelvic structure of a Caucasian human skeleton) to show their perfect conformation to natural mathematical law, he focused his study upon classical art and architecture, for he wanted to ascertain the proportional system utilized by Greek artisans.[85] In the early 1920s, Hambidge began to publish his findings that the same mathematical principles undergirding natural forms infused the work of the Greeks, imparting to their ceramics and temples a biological vitality that had long been noticed by art and architectural historians. He proposed that "dynamic symmetry," as a natural and artistic law, offered "the means of ordering and correlating our design ideas" to the extent that, if it became the basis of modern design instead of the "pilfering" of earlier styles, that it would produce "design expressive of ourselves and our own time . . . a healthy and natural expression of the aspirations of our own age."[86]

Hambidge quickly gained notoriety among U.S. artists, architects, and designers in the 1920s for having "rediscovered" the secret formula of artistic vitality that had supposedly been lost for millennia. Theo Fruchtman, an industrial designer in the late 1940s, reminisced to Teague how "when Hambidge's book came out it set the art world agog. Nobody who had any pretensions about design was considered anybody unless he could speak Hambidge."[87] Hambidge's art historical sleuthing of the ruins of Greek temples and his reconstruction of their original measurements were significant accomplishments. Yet even more amazing was his discovery that

the vitality and beauty of these structures seemingly stemmed from their embodying the same proportional system as nature itself. By utilizing Hambidge's proportional system, streamline designers compounded the biological foundations and implications of their work.

Geddes, Teague, Dreyfuss, Arens, and Harold Van Doren all implemented the principles of dynamic symmetry to some extent within their work and writings. In his book *Design This Day: The Technique of Order in the Machine Age* (1940), Teague devoted a chapter entitled "Rhythm of Proportion" to explaining dynamic symmetry in layman's terms.[88] As historian Jeffrey Meikle notes, given Teague's long-term interest in the artistic unity of classical culture, he adapted many of his designs to the proportions of dynamic symmetry and adopted its holistic approach to his theory of design (holistic in that these proportions offered a way to unify the arts with each other and to harmonize them with the natural order).[89] He discouraged designers from initially using the proportional system of dynamic symmetry as a design formula at the beginning of a project. Rather, he felt it should be used both as a training tool by which a designer could internalize an intuitional sense of good design and a gauge by which to judge the rightness of a design upon its near completion.[90] Dreyfuss had also adopted this intuitional approach; one of his colleagues on a design project recalled his sketching out the proportions, which his colleague subsequently measured and discovered that they conformed to "da Vinci's golden rectangle."[91] Teague felt strongly, however, "that the basic laws of design are unchangeable, invariable" because "they derive their validity from the structure of the universe."[92]

Arens's opinion on the fundamental laws of design was more flexible than Teague's. "There are no immutable rules that can be laid down for the guidance of those who would be designers to the great American public," he reasoned, because styles changed over time.[93] He had been familiar with dynamic symmetry since 1923, when he designed a brochure promoting the application of its principles to the art of dance. His client, Louise Revere Morris, taught classes on "The Art of Fundamental Rhythmic Movement," which incorporated three "fundamental characteristics of rhythm observed in nature: Centralization, . . . Orderly sequence, . . . [and] Perfect balance."[94] He described in his brochure how these characteristics permeated nature and were "obviously manifestations of an obedience to laws governing the movement of all things." Furthermore, his image on the back cover was arranged according to a logarithmic spiral. Van Doren, in his widely used manual *Industrial Design* (1940), spent many pages explain-

ing the design applications of the proportions of the Golden Section and other forms based upon the principles of dynamic symmetry. Though he too advocated using the eye as gauge, he felt that proper proportions followed "a certain inexorable visual logic" because they were "derived from universally apprehended phenomena" which had "become the stock in trade of all subsequent designers."[95]

Designers' interests in biological principles was thus multilayered, ranging from the incorporation of proportional schemes prominent in natural forms, to mimicking evolutionary models, to forwarding eugenic concerns for directed evolution. Just as a deep concern over controlling evolutionary progress compelled many people to accept eugenics, so in many instances designers' applications of evolutionary principles to the realm of product design crossed the line between evolution and eugenics. On one side of this line, according to *evolutionary* thought, natural selection and independent modification directed evolutionary progress; on the other side, according to *eugenic* thought, rational selection and controlled modification determined the paths of the future through the elimination of the weak.

One particularly good example (in addition to those already mentioned) illustrates how designers' applications of evolutionary thought crossed over the line from evolution proper into the more historically improper realm of eugenics. It involves comparing a German rail poster from 1935 with two remarkably similar images published in the U.S.: an advertisement for *Collier's* magazine that same year, and a brochure distributed by the U.S. Department of Agriculture during the previous decade (Figures 2.15–2.17). Following from the trend of lining up past and present locomotives in a row, facing the same direction, symbolically depicting the forward linear thrust of their evolutionary development, graphic designers in the mid-1930s at times heightened the force and appeal of this progressive forward direction through comparison to a counterdirectional motion. For example, the poster for the "100 Jahre Deutsche Eisenbahnen Ausstellung, Nürnberg 1935," (Figure 2.15), contrasts a fiery elevated streamliner speeding toward the right with an earth-hugging, coal-powered, horse-and-buggyish train heading toward the left. Despite the blue smoke belching from the stack of this locomotive from the 1830s, this highly inefficient nineteenth-century train appears immobile, as stationary as the onlookers conversing with its passengers. Meikle interprets the inclusion of this train as a transitional device that, through its allusions to the past, tempered the radicality of the streamliner of the future, making both more palatable to a

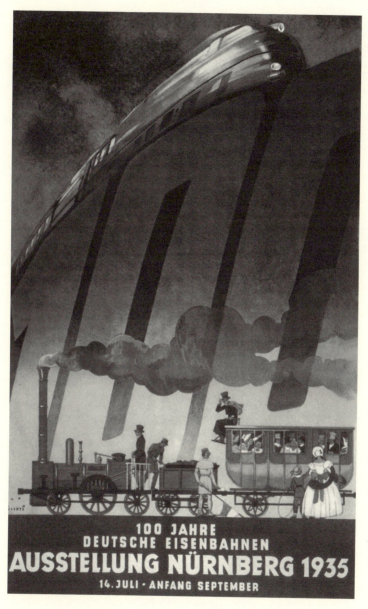

Figure 2.15 "100 Jahre Deutsche Eisenbahnen Ausstellung, Nürnberg 1935"
(Centennial Exhibition of the German State Railroad, Nürnberg, 1935), commercial
color lithograph poster designed by Jupp Wiertz, printed by Christian Weiersmüler,
Nürnberg, Germany. Courtesy of the Wolfsonian-Florida International University,
Miami Beach, Florida, Mitchell Wolfson, Jr., Collection.

Figure 2.16 *Collier's* advertisement, 1935. Copy in folder "Streamlining, 1935–1936," Box 59, Egmont Arens Papers. Courtesy of the Syracuse University Library, Special Collections Research Center.

culturally and socially conservative public. The streamliner thus became a "better version of [an] experience similar to those of the past."⁹⁶

The other two images from the U.S., however, suggest an additional meaning for this counter-directional imagery. The advertisement soliciting advertisers' business for *Collier's* magazine replicated almost exactly the image in the contemporaneous German poster (Figure 2.16). Across the top half of the two-page ad, a streamliner speeds to the right, its shining headlight illuminating the darkness. The train is followed by a swoosh of slanted text that proclaims, "Stream-Lined Editing Long Before Stream-Lined Trains Set New Standards." In the bottom left quarter of the pages, moving toward the left, are a mid- to late nineteenth-century coal-powered locomotive and railcar, which seem to move so slowly they do not even threaten to displace the blocky print stationed in front of them, which reads, "A Slow Ride for Your Money."⁹⁷

As the copy makes clear, the streamliner represented both the quick sales of *Collier's* magazine and the fast-moving merchandise of manufacturers who advertised in its pages. Its swooping progressive curve foretold "an

Figure 2.17. Flyer for the "Better Sires, Better Stock" Campaign, U.S. Department of Agriculture, c. 1921. Courtesy of the American Philosophical Society.

immediate upward response in your sales curve!" in addition to symboliz-
ing through its forward-looking direction "the *alert and progressive*" pur-
chasers who read the magazine. *Collier's* promised that its readers and
advertisers would be enthralled by "Timely, incisive articles—never
dragged out in length."[98] The slow train, on the other hand, signified a
slower-moving medium, one unlike *Collier's*, burdened by extraneous arti-
cles that targeted the "*slow-minded*, self-satisfied type of reader who buys,
if at all, when he gets around to it." By targeting the "active," wealthy,
mentally superior individuals and "side-tracking" the "slow-minded" ones,
Collier's claimed that it had "segregated the very heart of the most respon-
sive market in the United States."

Through its imagery and terminology, this advertisement evoked vari-
ous eugenic metaphors: the side-tracked train, derailed from the line of
progress, following an evolutionary dead-end; the institutional segregation
of the poor, unproductive, developmentally arrested feebleminded who
were a "drag" on national efficiency; the association of progress and
streamlining with the physically, fiscally, and mentally active. The dual-
directional flow thus broadly symbolized evolutionary progress in opposi-
tion to evolutionary degeneracy. When viewed from this perspective, the
German poster for the Nürnberg exhibition elicited a warning similar to
but more subtle than that emphasized by Austrian architect Adolf Loos in
his famous essay "Ornament and Crime." "The speed of cultural develop-
ment is hampered by the stragglers," Loos warned. "It is a misfortune for a
state if the culture of its inhabitants stretches over too great a time span."[99]
Streamlining, of both man and machine, promised to pare away all protu-
berances that hindered cultural and evolutionary progress by bringing both
into line.

This interpretation is strengthened through additional comparison
with the promotional pamphlet published by the U.S. Department of Agri-
culture that was widely distributed through county agents and agricultural
colleges (Figure 2.17). Although it is unlikely that any well-known designer
saw this flyer, it shows the preexistence of this type of imagery and thinking
among groups working to control evolution through breeding. As a push
to "Join the 'Better Sires, Better Stock' Campaign," the top half of the image
portrays a group of healthy, well-fed purebred animals marching upward
to the right on a road toward a well-kept, modern farm. Their scrawny,
sickly counterparts in the bottom half of the picture tramp downward to
the left on the "Scrub Route" toward a disheveled, collapsing hovel.
"Which Way Is Your Live Stock Going?" the flyer asks, and if the road to

progress was still unclear, the text exhorted farmers to "Let YOUR Animals March With The Purebreds." This recommendation, although officially directed at farmers and ranchers, was offered for human improvement as well. Harry Laughlin, director of the Eugenics Research Office at Cold Spring Harbor, New York, made this clear through his exhibit of "the elimination of mongrel chromosomes by the pure sire method" at the Third International Congress of Eugenics, held at the American Museum of Natural History in 1932.[100] Although the text of the *Collier's* advertisement implied as much, in comparison with the message of this agricultural brochure, the streamliner thus symbolized the quick intelligence, good form, and high productivity that resulted from a solid genetic foundation.

Streamline designers and mainline eugenicists also shared a consciously cultivated, if somewhat deceiving, appeal to the masses. In his notes for a lecture given in 1933, Henry Dreyfuss positioned the industrial designer on the ground floor working among and for the masses: "The artist in his ivory tower lives above the multitude. Industrial designer is artist, it is true, but has taken elevator to ground floor. . . . Remember masses follow classes."[101] Due to the interconnection of industrial design with mass produced goods and in contrast to the uniqueness of most handcrafted works of art, Dreyfuss's chosen occupation had been devalued by artists and critics as a "lower," "applied" art during the years around the turn of the twentieth century.[102] He and other industrial designers, however, resisted these criticisms by reasserting their preeminent role as "artists," if ones who worked with industry, and as such, they originated from a position of respect in the "ivory tower . . . above the multitude." From this lofty position they then worked to elevate the tastes and living standards of the masses, bringing them up to the level of the higher classes. Ironically, in their own backgrounds, almost all the early industrial designers spent their childhood years as part of the middle or lower-middle classes, and only attained "class" status as a result of their profits from industrial design.

Like Dreyfuss's lowering himself to offer unostentatious designs for the masses, Wiggam put eugenic thought into layman's terms in his bestseller, *The Fruit of the Family Tree.* Yet, even though he aimed to educate and ultimately improve the American middle class, he unabashedly believed that leadership was reserved for the brilliant few, who alone could ensure continued evolutionary progress. "The common man has nothing to do with progress . . . except to hold it back. All he can do is to follow the leader, to help him, to trust him," he declared in 1930, in a speech entitled "Genius—the Hope of the World."[103] His eugenic program thus offered

much improvement for all, but the most for the few; his speech, delivered to the County Teachers Institute of South Bend, Indiana, strongly advocated differential education programs to separate superior students from middling ones.

This affinity between Dreyfuss's and Wiggam's approaches and audiences is not without reason, nor is it a singular occurrence in the comparison between streamline design and eugenics. Both designers and mainline eugenicists ideologically positioned themselves at the evolutionary apex of society, not in the lot of the "common man" but at the forefront of advance. They all wanted to further progress by bringing their respective areas of reform into harmony with natural biological laws. Both designers and eugenicists believed this was possible only through leadership by an elite, and to a certain extent they thought of democracy as the ability to raise the level of the common man to an upper-class ideal. Furthermore, both primarily were concerned with the elite—bringing them modern products suitable to their level of "civilization" and making their lives easier, and, in the case of eugenics, increasing their wealth, intelligence, beauty, fertility, and progeny. However, each also pursued the secondary goal of raising the level of the masses, bringing overall national improvement in quality of life and an increase in national taste and efficiency, as well as financial profit to industrialists and designers.

Although some historians have characterized the streamline style in general as democratic owing to its broad popular appeal, such an appellation seems largely misplaced, as popularity is not equivalent to equality and as designers promoted leadership by the elite.[104] Most of the designers, excepting Dreyfuss, made statements similar to Geddes's about the need for *real* decisions, those producing the future, to be made by those with the "best brains" rather than by "popular vote." Democracy possesses a variety of meanings; some use it to refer to the equal rights, opportunity, and treatment of all people, whereas others, like Sullivan, conceived of it similarly to how he perceived himself, particularly Aryan, American, and middle-class, less a political system than a highly evolved moral quality stemming from proper natural behavior.[105] In J. B. Hollis Tegarden's entry to the AES's sermon contest, he argued for the democratic ideals of eugenics: "It is often urged against eugenics that it is aristocratic, and not democratic, because it speaks of superior people. But in the deeper meaning of democracy Eugenics is one of the most democratic movements of modern times." He thought that the "democratic yardstick for the measurement of progress" would be the extension to "every child born into the world the

kind of superior brains and character enjoyed by the few at present. Eugenics proposes to let no one be born unless he can be well born, and that is the extension of democracy to nature."[106] Former AES president Frederick Osborn felt that a working democracy was contingent upon a high-quality demos. In his speech in 1941 about "Democracy's Basic Defense," he reasoned that "Only an able people can maintain a democracy. . . . Without social conditions in which the abler stocks from every class and section of the country have good-sized families as a natural, largely unconscious process, democracy will inevitably fail over a period of time for lack of leadership."[107]

In conceding that "every class" contained "abler stocks," Osborn's comment reflected a shift in eugenic thinking that had occurred since the 1920s in the U.S., namely, the transition away from an absolutist assumption equating eugenic "fitness" with racial and class background. Mainline eugenics supporters in the mid-1920s frequently considered certain races and classes to be inherently more dysgenic than others, in line with turn-of-the-century evolutionary views. This type of thinking undergirded the Immigration Restriction Act of 1924, which targeted specific populations. The leveling effects of the Depression helped break down this type of broad-based application, especially on the issue of class, for the fortunes of many wealthy eugenics supporters decreased substantially and they found themselves among groups they had formerly denigrated. In the 1930s, therefore, research began to focus more on individual selection than on selection defined by group, as exemplified by the race-crossing studies of the 1920s. As Osborn stated in 1937, scientists and social scientists agreed that "whether or not there are differences between such groups with respect to the average capacities of the individuals which compose the group, such differences in average capacity are relatively small." On the other hand, "the differences between individuals in the same group are known to be very large."

This revised viewpoint did not preclude continued racism and classism on the part of eugenics supporters. Although Osborn stated that "every class" contained "abler stocks," he still held that certain groups were generally superior. In a study of differences between American population groups sorted by ethnicity, region (rural versus urban), and occupation in 1933, Osborn found that occupation offered the most reliable key to understanding differential fertility and the "relationship between cultural-intellectual development, and *innate* or *genetic* potentiality for intelligence."[108] He had found a direct correlation between the Intelligence Quotient of children and the level of occupation of their fathers, with children of professionals

ranking the highest and those of unskilled laborers the lowest.[109] He thought such differences were not environmentally determined but were "innate or genetic." He unabashedly stated that "on the average those parents who provide the best home training for their children are also those with the best genetic stock."[110]

From its beginnings in both England and the U.S., the eugenics movement had been organized by a scientific, academic, and social elite who sought to protect their status in the face of large social changes. Because they thought that they occupied the top rung of the evolutionary ladder, the mainline movement was led by the "civilized" with the goal of keeping their superior position. Eugenic speeches were largely invited by and delivered to middle- to upper-class white organizations. As a movement promoting rational control not only of society but also of personal emotional and sexual behavior, eugenicists felt it was only logical to target the population they believed possessed the capacity to exercise this type of control. Not only did middle- to upper-class whites occupy positions of social and political power, they also were the only ones who supposedly were capable of high levels of self-control and inhibition. They alone supposedly possessed the wherewithal to rationally choose suitable marriage partners based upon heredity concerns instead of by basely falling in love; witness Barbara Bel Geddes's youthful attempts at this. Unfortunately, they also apparently had developed the rational ability to interrupt the height of passion for birth control, a blow to eugenicists' attempts to raise this group's birthrate that was compounded by their already reduced fertility, owing to their all-consuming daily mental expenditures.

This belief informed eugenicists' justifications for extending birth control to the poor and immigrant classes and for demanding sterilization of the feebleminded. These groups, thought to be either less evolved or developmentally arrested, were supposedly less intelligent, and accordingly more fertile. This combination in eugenicists' opinions posed a severe problem, because without their possessing the necessary intelligence and self-control and with their passionate emotional and sexual drives, the birthrate of these "degenerate" groups was skyrocketing, according to eugenicists' accounts.[111] This reasoning favored sterilization over birth control, for not only was sterilization permanent and generally failproof, but unlike birth control it required no conscious consistent choice to be effective.

These evolutionarily minded movements first aimed to improve "modern" man and only secondarily targeted those who were supposedly more "behind the times." The latter groups were often reached through the

humanitarian efforts of less biased whites or well-educated minority leaders. In the 1920s and 1930s, however, some eugenics enthusiasts, such as Wiggam and the organizers of the Fitter Family Contests, tried to extend their evangelistic message to white Americans solidly in the lower brackets of the middle class. Wiggam, however, hated this "distasteful" work, although he proved his own high level of self-control by making what he perceived to be a martyrlike sacrifice by broadcasting the message to a group he considered to be the "tares" of society. He revealed his deeper thinking in a letter to Charles Davenport in 1922 when he asked Davenport to contribute a scientific endorsement to a series of articles on eugenics that Wiggam was publishing in the *Pictorial Review*, which had an audience of over two million. He praised Davenport's scientific work and writings that focused, as British biologist Julian Huxley's did, on an exclusive audience. An article that "reaches a few thousands," he wrote, "influences the world more vastly than a style that will reach millions in the long run," because he considered the elite to ultimately be more influential. On the other hand, Wiggam considered his own popular writing, which targeted a very broad audience, to be "extremely distasteful to me and 'defective' in style," and at times he felt his efforts to "try to push the frontier a little further" by reaching out to "a stupid and unappreciative public" were "mere dawdling" in view of all the important problems yet to be studied.[112]

Industrial designers, too, targeted first an elite audience and then a broader, more middle-class group, aiming to improve modernity by providing citizens with "civilized" goods suited to their station in life. This initial audience was a natural choice, economically and socially, for many designers worked for the corporate elite (in New York and elsewhere), socialized with them, or did both. For many years, Teague worked closely with Henry Ford as well as with Kodak's George Eastman; Deskey designed interiors for the Rockefellers (residential, as well as Radio City Music Hall) and for Helena Rubinstein. Dreyfuss married into the upper echelon of New York society; his wife, Doris Marks, was the daughter of Marcus Marks, borough president of Manhattan, who was "very good friends" and a golfing partner of Andrew Carnegie.[113] Geddes, through sheer force of personality and the generosity of Otto Kahn, earned fame first within the theater arts and literary circles in New York, and then became infamous among industrialists for his visionary, bold, and costly designs, such as his seven-million-dollar exhibit for General Motors at the New York World's Fair. Though Geddes imagined himself to be fashionable, Loewy always was, wearing one of his three-dozen suits, living in one of his six homes (a

New York penthouse, a mansion on Long Island, a French manor, a villa on the Riviera, . . .), being perennially nominated for *Life* magazine's "Man of Distinction."[114] Because of their social milieu, these designers crossed paths with eugenics supporters, including Rockefeller, Carnegie, Ford, Eastman, Rubinstein, the Resors, and likely many others. Loewy's brother Georges, an accomplished surgeon and medical researcher, worked at the Rockefeller Institute for Medical Research as assistant to Alexis Carrel, an ardent eugenicist whose beliefs on this matter toed the line of Rockefeller interests.[115] When Loewy moved to New York in 1919, he lived with his brother, and letters reveal his interest in Georges's eugenically related research.[116]

A series of advertisements done by Arens in the 1920s for Condé Nast publications (which published *Vogue*, *Vanity Fair*, and *House and Garden*) were particularly revealing of this early class bias, exhibiting also the eugenic equation of intelligence with wealth, as both supposedly reflected superior heredity. Because the series targeted advertisers to try to get their business for Condé Nast magazines, the ads explicitly defined the audience that Condé Nast considered the primary target of stylish goods. Arens configured one advertisement entitled "Why Sell to the Wealthy?" as a letter from Condé Nast to Mr. Advertiser. The text read, "Today there are hands and brains which you can harness to serve your own ends. Properly enlisted to work for you, they can alter the buying habits of the nation. That force is the principle: STYLE PERCOLATES DOWNWARD. Those hands and brains are the hands and brains of THE WEALTHY." The letter concluded by playing to Mr. Advertiser's confidence in his own intelligence: "Are you not also more far-sighted than some of your competitors today?"[117]

Another ad in the series, entitled "What Are the Buying Habits of the Mass Family?" revealed that the mass family, with an income of less than $2,000 per year, spent its money on such necessities as food and clothes and had no extra for frills and travel. Furthermore, Arens stated that mass families read mass magazines, because the "sunny bits of fiction" found therein "take the mass family's mind for a few moments off the hard facts of the struggle for existence." He reasoned that ads for high-priced cars were out of place in mass magazines, not only because the mass family in its dog-eat-dog world had no expendable funds but also because it supposedly did not have "the taste to appreciate" them. On the contrary, class magazines such as those published by Condé Nast were "keyed to the tastes and incomes of the class who have the money to buy and the taste to appreciate" (Figure 2.18). Arens illustrated the income disparity and pur-

The Market
for Quality
Products

CLASS
Families
390,000

Incomes
Millions to
$6,000

The Mass Market
A list of Mass maga-
zines totalling 5 to
10 million circula-
tion, must dip
heavily into the
miscellaneous
field.

MASS
Families
4,116,000

Incomes
$5,999
to
$1,000

MISCELLANEOUS
Families
17,494,000

Incomes
?

Individually representing the
tail end of the country's
buying power

Figure 2.18. Egmont Arens, promotional advertisement for Condé Nast Magazines, "What Are the Buying Habits of the 'Mass Family'?" In folder "Condé Nast, Promotional Materials, Misc., 1921–1922," Box 80, Egmont Arens Papers. Courtesy of the Syracuse University Library, Special Collections Research Center.

chasing power of these groups in pyramidal form, concluding that "the best business this year should be found in the grades of goods bought by the more well-to-do classes rather than laboring classes."[118]

Other ads by Arens as well as one by Teague linked good taste with the upper classes and obviously exposed the roots of this assumption in evolutionary and eugenic thought. Refined sensibilities supposedly were a late evolutionary development, an outgrowth of the capacity for intellectual differentiation, both of which stemmed from and contributed to the upper-class status of those who possessed them. One *Vogue* ad in Arens's archive asserted the magazine as the authority on fashion for the 150,000 "well-bred women" in Europe and the Americas. "Its reputation is solidly founded on its own taste, judgment and knowledge of the life and mind of the well-bred woman whom it serves," the copy read.[119] In 1933, Teague extended this "well-bred" quality to the packaging of an alcoholic product. After

prohibition, the "market for spirits" had become "of distinctly higher class"; through proper packaging, a product, like a human thoroughbred, would not "lose itself in the crowd" but would instead acquire "individuality and dignity" and be "easily recognized," to the extent that "its air of good breeding" would carry it "right through the kitchen and onto the dining table."[120]

Although most designers initially made their reputation through "design for the classes," sometimes using exotic materials as Deskey did and selling at the "foremost department and furniture stores," in the early 1930s a broader audience, though still decidedly of the middle to upper-middle class, became influential. Reviews of Deskey's work noted his newfound interest in "making the masses design-conscious," to the extent that one critic for the *New York Evening Journal* stated in 1933, "we may all expect to find good designs within our limited budgets."[121] By approaching a middle-class market with his designs, Deskey not only increased the sales of his work but symbolically elevated and "modernized" the standard of living of a broader group of Americans. The first review cited this latter hope of Deskey's that mass production of well-designed furniture "will bring about mass acceptance of design and thus *raise the level of public taste.*"[122] The top-down reform of both people and products by eugenicists and industrial designers thus worked on three levels: what was being reformed ("defective" products and people), whom this reform benefited and in what order (primarily middle- to upper-class whites and then a broader audience).

The beginnings of the eugenics movement coincided with the personal maturation of early industrial designers and reached its height contemporaneously with the onset of their profession. As eugenic thought filtered into the general views and language of the public, a few streamline designers became noticeably aware of it while others simply absorbed some of its principles. Because they believed in the power of science, technology, and the designer to help realize an imminent utopia, and because of the allied position of design with the industrial and social elite, both designers and eugenicists naturally developed strategies to restore order to the modern world. Eugenicists' and designers' approaches toward social and industrial design were both ideologically rooted in the application of what they perceived to be universal biological laws. What remains to be shown is how biological models for industrial design (whereby designers approached products in the same ways that eugenicists conceptualized bodies) were reciprocated in industrial models for social design (whereby eugenicists treated bodies as if they were industrial products).

In both eugenic and streamlining literature, social and industrial de-signers used the term "human engineering," albeit to different ends. When used to refer to product design, "human engineering" meant designing a product ergonomically so that it was engineered to fit a human body. Alter-nately, the term referred to bodies themselves engineered through con-trolled breeding. The conceptual conflation between bodies and products, as captured by this phrase, comes as little surprise, for both bodies and products seemed controllable and improvable. Lecturing in 1932 at the Rand School in New York City on the subject "Can Men Be Bettered Psy-chologically and Ethically by Breeding?" biologist Herbert Spencer Jennings elaborated upon some of the similarities he perceived between men and machines.[123] Both men and machines exhibited differences based upon the type of material from which they were made. Jennings explained that "if in an automobile poor steel or cast iron is employed where chrome steel should be used, the machine will work badly or not at all." Just as the "performance and efficiency" of a machine could be altered by changing the material from which it was made, so too would controlled breeding likewise alter the hereditary material and the resultant performance of a human body. Jennings extended the analogy beyond the realm of nature into that of nurture; just as specific production processes on certain materi-als created a specific product, so too did environmental influences on cer-tain hereditary material produce a certain result. "No matter how good the materials, if the method of manufacture is bad, if the materials are not properly mixed, not shaped rightly on correct models, the machine will be poor or a failure. . . . This also is true in large measure of organisms of man."[124]

This mechanistic analogy was familiar enough that a sermon on eu-genics from 1927 compared the eugenic pairing of a man and woman to the adjustments made in a machine shop that brought the various parts of the machine into perfect alignment.[125] Like the products and processes of an assembly line, according to eugenicists, one's "fitness" was gauged by one's intelligence, productivity, character and beauty. Thus, the maker of the chart "Eugenical Classification of the Human Stock" (Figure 2.2) character-ized people as "eugenical end products," showing the purported relative frequency of various types within the "civilized" population.[126] Writers in the February 1939 issue of *Vogue* magazine reaffirmed this idea in their suggestions that desirable qualities might be "ordered like crackers from the grocer"—an idea issued with the reassurance that the resulting female would be more than "an 'assembly-line' product," despite the fact that her

body would be a "perfectly-working machine."[127] According to historian Martin Pernick, in the film *The Science of Life*, "an attractive body" was compared to "a sleek streamlined engine, . . . a gleaming locomotive." Juxtaposed bodies and engines were shot from a low angle that emphasized their "sharp-edged unadorned outlines, looming mass, and efficient motion."[128] As these examples show, technology's processes and products offered so compelling a model of managed production and profit that many of its aspects—from its terminology to its conceptualization and applications—were applied by eugenicists to humans.

The ability of some eugenicists to consider humans as products reveals the conceptual shift on their part to an industrial way of thinking about humanity, one that ultimately permitted the devaluation of those humans deemed less desirable by those in control. Although the terms "product" and "material" were seemingly neutral and anonymous in their valuation and theoretical in their usage, other phrases more pointedly illustrated the slippery slope which this type of thinking inaugurated. One publication of the AES from the mid-1930s proposing a eugenic program for the U.S. promoted the reproductive limitation of "subnormals"; a minister participating in their sermon contest a few years earlier had favored the reproductive management of "certain classes of unfortunate human wreckage."[129] In Germany, the term "Minderwertigen" was used to classify those who were less productive and thus more costly to the state. Translated as the "less valuable," it referred to both their minimal social and productive output and their own worth in the eyes of those concerned with "national efficiency." Historian Sheila Weiss points to this underlying technocratic logic of eugenics, rather than to its racism, as the most ethically perverse and damaging aspect of the movement. Once people were reduced to the status of less valuable products of a nation or considered as "wreckage," their inutility logically demanded their disposal in the interest of efficiency, continued evolutionary progress, and enhanced national strength.[130]

According to Weiss, the conception of humans as products and material for state management and even medical experimentation resulted from the methods and ideology of the Industrial Revolution. Alternately, the application of biological law to architecture and industrial design stemmed from modernists' deep belief in evolution as *the* force shaping all progress—be it biological, social or artistic—to the extent that style was seen as a racial attribute, and buildings and products were made to conform to the dictates of functionalism. Eugenicists and industrial designers thus turned to models from industry and evolutionary biology—two of the most pow-

erful social and scientific systems of the late nineteenth century—as a means to gain control over the rapidly proliferating "disorder" and "degeneracy" infiltrating modern life. Because science and technology were producing such tangible and profitable conveniences as electricity and motorized transportation, which both stemmed from and augmented man's control over the environment, scientific claims regarding the possibilities of controlling human evolution gained greater credibility, especially given advances in the understanding of genetics. The lure of social control through "rational selection," especially when allied with the humanitarian reduction of disease and poverty and the promise of "progress," proved irresistible to both the well-believing public and the scientific, industrial and social elite, as well as to industrial designers applying this same program to mass-produced goods in their burgeoning field.

Chapter 3
Progenitors of the Future:
Popularizing Streamlining and Eugenics
During the 1930s

Although the connection between streamlining and eugenics was first exposed by Egmont Arens in his speech "Creative Evolution of the Printed Word," the surest source for copywriters and the public alike to perceive both as "modern" was certainly the Chicago World's Fair of 1933. Modeled in part after the 1931 Exposition Coloniale Internationale, which was remarkably successful for its exotic displays and architecture popularizing Art Deco and European colonialism, the Chicago fair reiterated the message from Paris that modernity was built upon economic, political, and evolutionary hierarchies. The symmetrical repetition of stylized towers, marked by vertical, triangular fluting or other Deco features, bespoke the power of capitalist corporations driven by technologies of mass-production to stamp the forms of the future.

In contrast, the retardataire Midget Colony and Native American village, featuring Indians making their traditional "arts and crafts" as encouraged by contemporary programs under the Bureau of Indian Affairs, seemed quaint, and the "Darkest Africa" concession on the midway decidedly backward. Configured largely in the aesthetic of the "colonial moderne," whose harsh angularity was, for the first time on such a large scale, regularly refined into smooth, streamlined curves, the evolutionary and machine-age messages of the "Century of Progress" exposition were symbolically heightened by the omnipresent Goodyear blimp, a near perfect example of streamlining a la Geddes's *Horizons*. Social control and social hierarchy, brought about through the power of industry allied with science, was in fact an explicit theme of the fair, dictated by its slogan "Science Finds. Industry Applies. Man Conforms."[1]

In the late 1920s, when the fair was in its planning stages, its Trustees selected as its focus the celebration of the pure and applied sciences. Be-

cause they wanted the exposition's plan to be "worked out in accordance with a definite philosophy by those most competent to formulate such a philosophy," they elected to the General Committee members of the National Research Council (NRC), who prepared the exposition's fundamental plan. Three of these members were eminent scientists on the Board of Trustees of the Rockefeller Foundation—Max Mason, Simon Flexner, and Vernon Kellogg—all of whom were aware of (and, in the case of Kellogg, a strong supporter of) eugenics. Furthermore, George Burgess, chairman of the NRC, wrote to Charles Davenport in 1929 to ask his recommendation for an outstanding zoologist to serve on the committee, and upon his recommendation chose Herbert S. Jennings, whose pro-eugenic, award-winning book of the following year, *The Biological Basis of Human Nature*, proved to be highly popular.[2] Given the accepting attitude toward eugenics by members of the founding committee, the eugenic innuendo of the fair's slogan is not surprising in its reference to science as the law-provider, industry as both model and financier, and mass man as the material being shaped.

The slogan was equally applicable to the rising profession of industrial design, rooted in the scientific principles of evolutionary biology and the physics of air and fluid dynamics, applied by designers to the processes and products of industry, and then bestowed upon consumers for purchase as evidence of their own modernity. As a corporate strategy meant to silence socialist criticisms of the failures of capitalism, so evident after the economic collapse of 1929, the fair's theme and its exhibits worked to reassure the American public that they were under the enlightened leadership of the "most competent," whose plans to control the future were backed by the authority of scientific knowledge. A year before the fair's opening, Geddes expounded the same philosophy when he asserted that planning decisions should be made by the "most capable," and the depth, breadth, logic, and ingenuity of the many designs he proposed in *Horizons* pointed to men like himself as the designers of the future. These assertive proclamations—by designers, fair promoters, New Deal politicians, and eugenicists—won support from a public conditioned by the crises of the Depression to seek leadership, to make self-sacrifices, and to eliminate waste in order to restore health to the American economy.

Both on the midway and in the Hall of Science, fairgoers learned the lessons of eugenics. Students from the Harvard Anthropometric Laboratory, led by professor Earnest A. Hooton and sponsored in part by the Eugenics Record Office (ERO), spent weeks at the Midget Colony measuring

its inhabitants as part of a larger study to determine the developmental and genetic differentiation of various human "types," including "primitive" racial groups, children, and dwarfs. This selection resembled those of earlier studies based upon recapitulation theory, as well as those chosen by eugenics researcher Morris Steggerda in his ongoing anthropometrical investigations of the comparative development of groups of children in Mexico (the Maya), New Mexico (the Navajo), Alabama (African Americans at Tuskegee), and Michigan (Dutch descendants). Steggerda in fact participated in the midget study, and he and Charles Dupertuis of the Anthropometric Laboratory spent days photographing, measuring, and investigating the pedigrees of over seventy-five dwarfs.[3] When not measuring the midgets, however, researchers turned to the fairgoers themselves, measuring their bodies both as a way to obtain general data on the national populace while simultaneously informing the public about anthropometric research, a strategy similar to that used at Fitter Family Contests throughout the previous decade. Richard Post, another Harvard graduate student, wrote to Davenport in 1934 of Hooton's "success at the Chicago World's Fair in getting subjects [to measure anthropometrically]," which impressed Hooton "with the curiosity of our citizens."[4]

Since the 1893 World's Columbian Exposition, midway exhibits had seemingly existed for the sole purposes of entertainment, yet, this entertainment consistently was at the expense of the people on display, deriving in large part from the superior evolutionary vantage points in which visitors (presumably healthy and white) were placed. As shown by the Midget Colony, Native American village, and the "Darkest Africa" concession, midway exhibits still functioned as the evolutionary counter in 1933. In contrast to these sites of "arrested development," the "Century of Progress" on display in the Hall of Science featured the many accomplishments of white Americans and Europeans. Beneath a 176-foot tower which dominated the skyline of the fair and marked the centrality of its exhibits to the fair's theme—"that industries rest upon a foundation of pure science,"—on two floors, the Hall displayed progress in the pure and applied sciences.[5]

The ground floor housed exhibits pertaining to progress in health, including medicine, dentistry, and pharmacy, subjects that had previously constituted only small exhibits at world's fairs in the U.S. but at which German health museums excelled. Committee members planning the fair's exhibits therefore traveled to Dresden to the Deutsche Hygiene Museum, Germany's most prominent health museum, whose highly engaging, interactive exhibits consistently instilled in visitors "the essentials about their

own bodies and the relation of those bodies to the greater body politic," or, in other words, the lessons of both personal and race hygiene, as eugenics was called.[6] They took with them $25,000 to purchase copies of the museum's displays, which included, among others, ones showing how blood circulates through the body, how chest muscles cooperate in breathing, the nature of joint construction and movement, and the mechanisms of digestion and the human voice.[7] Although not about eugenics per se, these exhibits modeled the proper functioning of the healthy human body, accompanying other displays showing how progress in medicine over the last one hundred years had lengthened the lifespan and increased the stature of the average white American.[8] Such progress seemingly promised to transform humanity until it reached perfection, which was embodied in the figure of the Transparent Man, who stood on a raised podium at the center of the exhibits.

Created in Dresden by a team of museum curators and technicians which included Dr. Bruno Gebhard of the Deutsche Hygiene Museum (with whom fair committee members consulted in 1931), the Transparent Man combined "modern technical development" with classical Greek aesthetics. Its pose mimicked that of the "Praying Boy" by Lysippos's son Boedas, c. 400 BCE, yet its highly modern, translucent, cellon plastic body encased colored plastic organs and veins, internally lit by twenty miniature electric bulbs, which glowed in sequence when activated. After its debut at the Dresden Hygiene Exposition in 1930, the Mayo Clinic ordered a copy of the Transparent Man which they then loaned to the Chicago World's Fair. In Germany, however, the original continued to be displayed throughout the decade at numerous exhibitions communicating national ideals of race hygiene, as in Berlin in 1935 at the opening of the "Wonder of Life" exhibition, curated in part by Gebhard, who pointedly described the hairless, transparent sculpture as "[s]ix feet tall, blond, with beautifully molded muscles" (Figure 3.1). A close-up of his cranium and facial features (Figure 3.2) emphasized his streamlined, Nordic attributes that curators at the Buffalo Museum of Science also recognized, describing him as "a universal Caucasian type" in "heroic pose." As a model of the eugenic principle of "fitness," both internally and externally, the Transparent Man gave physical form to the popular notion of the body as a "human machine." As such, it epitomized the ability of science and industry to produce a perfected humanity, earning its central placement in the Hall.[9]

The subtle, eugenic message of the health exhibits on the ground floor paled in comparison to the four panels prepared by the ERO for the main

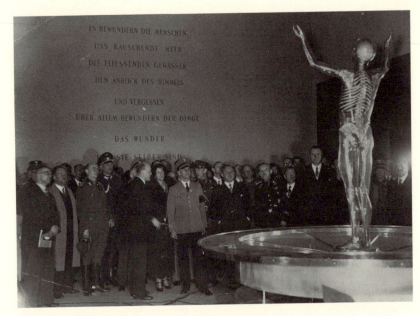

Figure 3.1. "Transparent Man," at the opening ceremony of the "Wonder of Life" exhibition in Berlin, March 1935. Photo GF-6-23, BG Papers. Gebhard is in front to the left of center, beneath the wall text, in profile wearing a dark suitjacket. The man to the right of him is German Interior Minister Dr. Frick. Courtesy of the Dittrick Medical History Center, Case Western Reserve University.

floor of the Hall of Science. Located in the biology section, which stressed the "role of the cell in inheritance, in early development, growth and evolution" as the "starting point for all modern advance in Plant and Animal Breeding," the panels on eugenics extended to man the principles of heredity demonstrated in nearby displays.[10] To make this association, the text of the first panel, "What Eugenics Is All About," was accompanied by an illustration of a tree, yet the text made clear that in contradistinction to plant and animal husbandry, with humans different methods of "reproducing from the best and forbidding reproduction by the most inferior" must be used.[11] Claiming the status of a "science which studies the inborn qualities—physical, mental, and spiritual—in man," it stated as fact that "in the history of families, communities and nations," "some families, some races, and the people of some nations, improve greatly in physical soundness, in intelligence and in character" while "other racial, national and family stocks die out—they decline in physical stamina, in intellectual capacity

Figure 3.2. Close-up of the head of the "Transparent Man," showing him as a Nordic type, from the cover of *Hobbies*, a monthly publication of the Buffalo Museum of Science, 15, 4 (April 1935). This photo was included in the exhibition catalogue for the "Wonder of Life" exhibition in Berlin, which opened the previous month. Courtesy of the Buffalo Museum of Science and the Dittrick Medical History Center, Case Western Reserve University.

and in moral force." Because these qualities were hereditary, the "eugenical future of your community—and in parallel fashion of your family and your nation—depends upon . . . who moves into your community," how community members "both native and adopted" marry, and "how many children the different families have in relation to the excellence of the hereditary stuff of which they are made." It stressed the beneficial role of education on the importance of "blood" and "breed" in affecting personal

choices about mate selection and family size; self-participation was further emphasized by the definition of eugenics as "the self direction of human evolution." The second panel, in the form of a graph, continued these themes, showing how "families, communities, races and nations may change greatly in capacity within a few generations" based upon birthrate percentages from the different stock just described, producing either "race improvement" or "race degeneracy."

The third and fourth panels offered a highly racist comparative study of the "Ishmael" family with that of the "Roosevelt family-stock." The "Ishmaels" were a family of "defectives," like the Jukes, whose care supposedly cost Indiana between one and three million dollars (according to one eugenic study); their name (which was probably fictitious) in relation to the derogatory display, however, must have struck many fairgoers with anti-Jewish and anti-Arabic sentiment.[12] The text above a family tree and "typical Ishmael portraits" in front of shacks described them as a "family-stock which, despite opportunities, never developed a normal life. Shiftless, begging, wanderers, sound enough in body, their hereditary equipment lacked the basic qualities of intelligence and character on which opportunity could work." The Roosevelt family, on the other hand, offered "a type study in superior family endowment . . . a pedigree showing the distribution of inborn qualities in a family which produced two presidents of the United States."[13] Portraits of Republican Theodore and Democrat Franklin Delano framed the family tree, beneath which were photos of well-dressed family members. Robert Rydell documents the popularity of the four panels, citing one fairgoer's letter to ERO superintendent Harry Laughlin who was impressed by the constant "number of people studying the charts."[14] Owing to the high number of requests for copies of these panels after the end of the fair, Laughlin had them reproduced in half-tones and linecuts and sent one set to the Yale University Library for inclusion in their Century of Progress Collection; the panels themselves were presented by John C. Merriam, president of the Carnegie Institute of Washington, to the Buffalo Museum of Science.[15]

The setting of these panels amid displays of biology, physics, and chemistry created by respected American corporations and universities imparted authority to eugenicists' claims. Likewise, the choice by the fair's Architectural Committee (on which Geddes consulted) to house these exhibits in a modern, streamlined building lent authority to this new architectural and design style. The main exhibition areas in the two arms of the U-shaped Hall of Science were encased within two-story, windowless

curved walls, as if inside the hull of a ship; this theme was carried via horizontal striping to the concession areas at the end of each arm, which appropriately faced the lagoon at water's edge and were shaped with the appearance of double smoke stacks atop stepped-back, curved terraces lined with pipe rails. The use of overall horizontality, emphasized by exterior terraces lined with metal railings as well as by curved details accented by horizontal striping, was repeated in both the Agricultural Building and the General Motors building, which like the Hall of Science also featured a tower whose function (of displaying the superior position of the GM logo) demanded vertical stripe detailing.

Functionalist principles also informed the most recent developments in vehicle design on display at the fair. Thousands of fairgoers saw the streamlined blimp and in 1934 witnessed Buckminster Fuller's tear-drop Dymaxion car and the arrival of the streamliner trains, roughly based on Geddes's designs, after their highly publicized tours of the American countryside. The "Wings of a Century" pageant at the fair, showcasing the evolution of transportation over the previous century, climaxed with the arrival of the Burlington Zephyr from Denver, setting record time. In later displays at the fair that lined up past and present locomotive models, the sloped front and stainless steel exterior marked with horizontal details of the streamlined Zephyr attracted long lines, whereas no one waited to see inside its obsolete neighbor.[16] As a result of the public frenzy created by these trains and the huge popularity of the Chicago World's Fair, between 1933 and 1934, streamlining took the nation by storm, symbolizing at once evolutionary progress in science and industry, racial advancement, increased speed and efficiency of bodies and machines, escape from the problems of the Depression, and the onset of industrial design as a national passion.

Whereas previously their audiences had been men in industry and others like themselves, suddenly designers found middle-class Americans to be avidly interested in streamlining. In 1934, Egmont Arens thus began traveling the country on a lecture tour entitled "See America Streamlined," where he presented on "Streamlining in Nature," disclosing the style's aesthetic roots in the principles of evolution and good breeding, as well as on "Streamline for Recovery," a Depression-era pep talk that offered the style as solution to the nation's woes. "Streamlining," he told his audiences, "has so fired the imagination of people in all walks of life, that it has become a *new live word in the American language*." Coming to mean much more than aerodynamic engineers had intended, it reflected "a new attitude," a "national state of mind" that connoted "scientific efficiency," "clean and

flowing line," "simplicity and beauty," "things being *flawlessly correct for a given function*" with nothing extraneous to weigh them down.

Arens earned the rapt attention of his audience when he discussed ideas of drag and progress. "When an automobile achieves a higher rate of speed it is not the push of air ahead of the car that uses up the gas, but the suction created by the vacuum in the rear that holds it back," Arens explained. He then "brought down the house" when he analogized that "the American people are not being held back by anything that is ahead of them." Instead, "they feel themselves perfectly capable of dealing with the future in the characteristic American method of 'going places'—and . . . it is only the suction of the depression which is holding them back from 'full speed ahead.'" Streamlining was an *"expression of the American genius,"* a "sign and symbol" of something that people all over the nation were "ready to get enthusiastic about." "Perhaps this is THE WORD of the great liberation" that "will carry America to its new destiny—'STREAMLINE FOR RECOVERY.'"[17] Arens polled his audiences on what streamlining meant to them, and was told "'modern, efficient, well-organized, sweet, clean and beautiful.'" These qualities matched those used by eugenicists to define social and bodily "fitness," ideas designers applied to products based in part upon their understanding of the workings of genetics. The "great liberation" of America would thus stem from the removal of what held it back, economically and genetically: the "suction created by the vacuum in the rear," which in an evolutionary and a stylistic sense included all that was supposedly "degenerate," inefficient, extraneous, unhygienic and ugly.

Arens's words were prophetic, for over the next ten years, many aspects of middle-class America *were* streamlined. As would be expected, airplanes, automobiles, buses, and trains, whose mobile functions inspired the first adaptations of the style, increasingly displayed tapered curvature and fewer outstanding parts, even down to such extremes as the elimination of rivets in exchange for smooth welded surfaces. Buildings that serviced or sold these products, such as bus and gas stations and automotive dealerships, were streamlined as well, making ample use of curved glass-block walls and triple horizontal "flow" lines. While these changes on vehicles may have produced some economic benefits through increased energy efficiency, their function was more surely inspirational when applied to such recreational vehicles as sleds and tricycles or the outboard motors of motorboats. Inside the home on large kitchen appliances, shiny white enamel, chromed hardware, clean horizontal lines, and smooth curved surfaces replaced dark colors, intricate lines, and ornate decoration. Irons, electric

Figure 3.3. Bullet Light, manufactured by Eagle, c. 1939. Author's collection.

mixers, record players, staplers, desk lamps, and fans all appeared in tear-drop shapes (Figure 3.3), made even sleeker through the use of bakelite and chromed metal fashioned into seamless forms.

By the end of the decade, during the afternoon one could walk through neighborhoods where houses had curved metal awnings and porch roofs, suspended by cables, that overhung curved porches reached by con-centric steps lined with metal railings or stepped-down curved walls. At night, movie theater facades of glass, chrome, and colorful tile, dwarfed by streamlined marquees, lit up the streets of even the smallest towns, and in the morning, breakfast awaited on chrome-lined countertops overhanging streamlined barstools in diners where almost every feature behind the counter bore the mark of the style. Businessmen, commuting via stream-lined trolleycars to downtown buildings that likely had curved chrome and glass entrances, spoke of streamlining their sales curves, and increased con-sumer spending did in fact begin to pull the U.S. out of the Depression prior to wartime production. Advertisers even tried to convince American women that their bodies should be streamlined. Instead of flaunting the bony stick figure of the flapper, women were urged to gain ten pounds and round those Deco angles into smooth curves, accentuated by bras that

shaped breasts like torpedos. Or, if she happened to gain twenty, she could bring her girlish form back into line with a corset, hid beneath a dress cut on the bias, seemingly seamlessly sealed by a streamlined zipper.[18]

Although to the American public, these changes may have seemed as if they just happened, in fact designers, architects, advertisers, and business-men were the primary agents streamlining the modern world, partially in response to public demand. Eugenicists, too, were making every effort to streamline the American populace during the 1930s, building upon their work of the previous decade to increase eugenic legislation and public sup-port through messages broadcast through a variety of media, infusing the realms of popular culture, education and politics.

In addition to those on display at world's fairs, museums across the nation featured exhibits related to race betterment. For example, the Amer-ican Museum of Natural History in New York placed on permanent display its interpretation of racial evolution and recapitulation theory in the Hall of Man, established through the efforts of the Galton Society for installation prior to the Third International Congress of Eugenics in 1932 in what one journalist referred to as the museum's Department of Eugenics.[19] Curators of other natural history museums, including the Field Museum in Chicago and the Buffalo Museum of Science, visited the Congress for ideas for their own eugenics exhibits.[20] Reaching even more people, many of the medical displays created for the Chicago World's Fair by the Deutsche Hygiene Mu-seum went on tour between 1934 and 1935, accompanying a major exhibi-tion on "Eugenics in New Germany" that promoted the Third Reich's race hygiene and sterilization programs to citizens in at least six U.S. cities.

Gebhard, who curated the exhibition, was invited by W. W. Peter of the American Public Health Association early in April, 1934, to compile English versions of racial hygiene displays that he had made for the exhibi-tion "German People, German Work" to show in conjunction with the annual convention of the American Public Health Association in Pasadena that year. German officials were delighted, and Gebhard flew from Dresden to Pasadena in September for the opening of the exhibition, bringing with him a Transparent Man and many other displays from the fair (Figure 3.4).[21] Occupying three thousand square feet in the town's Civic Audito-rium, the show included "celluloid models, posters, charts, graphs and pic-tures depicting the law of heredity, the determinations of hereditary characteristics and the trend of populations in Germany and other Euro-pean countries."[22]

Positive eugenics was emphasized in panels praising the beauty of emi-

Figure 3.4. "Eugenics in New Germany" installation, curated by Bruno Gebhard (second from right), 1934, at the Pasadena Civic Auditorium, California, in conjunction with the annual convention of the American Public Health Association. BG Papers. Courtesy of the Dittrick Medical History Center, Case Western Reserve University.

nent German men and their blond families, raised by stalwart mothers who received upon marriage a trousseau from the state apportioned in quarters for every child born, thereby encouraging at least four children. The need for programs of negative eugenics were graphically illustrated in panels showing the bodily deformities and "defective" offspring caused by hereditary diseases, which, as presented, included schizophrenia, epilepsy, feeblemindedness, criminality, alcoholism, pauperism and, apparently, being black (Figure 3.5); Gebhard left the anti-Semitic displays at home. To prevent their further propagation and diminish state funds spent on their care (Figure 3.6), posters showed that Germany had instigated a national policy enforcing sterilization, as well as castration for repeat sex offenders, and created a Central Register for the Hereditarily Diseased and Court of

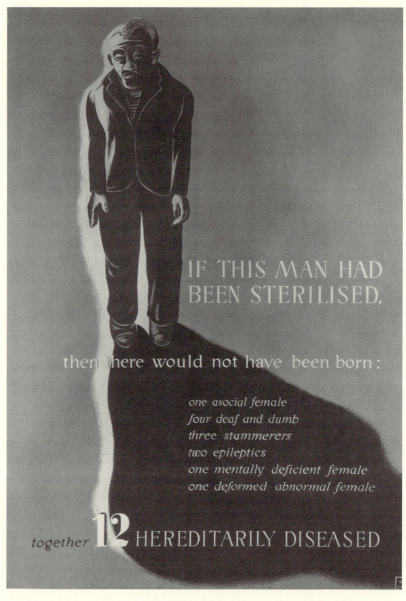

Figure 3.5. "If This Man Had Been Sterilised" panel from the "Eugenics in New Germany" exhibition. Courtesy of the Buffalo Museum of Science.

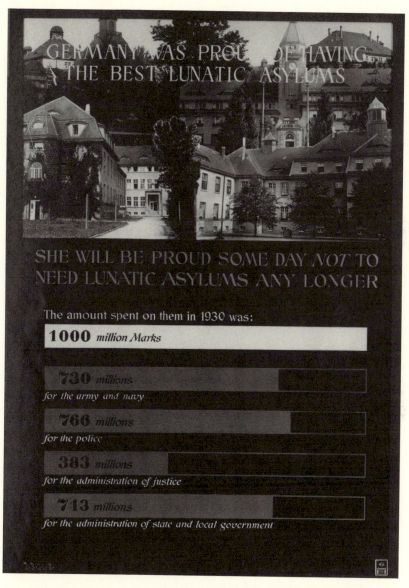

Figure 3.6. "Germany Was Proud of Having the Best Lunatic Asylums" panel from the "Eugenics in New Germany" exhibition. BG Papers. Courtesy of the Dittrick Medical History Center, Case Western Reserve University.

Heredity to offer marriage advice and adjudicate decisions restricting reproduction.

After Pasadena, the exhibition spent a month at the Los Angeles County Museum, extended by another month owing to its popularity, whence it traveled for two weeks to the Armory in Stockton, California. The front page of the Stockton paper encouraged the public to attend, especially school children in "biological and social science classes," stating that its "unmistakable message" was "an urge for the building up of a virile, healthy race." The February and March, 1935, legislators in Salem, Oregon, viewed it at the state capitol while reconsidering their state's sterilization policy. The exhibition also showed at two YMCAs (in Salem and Portland), at Reed College, and at the National Public Housing Show in Portland, finally arriving at its permanent home at the Buffalo Museum of Science in October of that year.[23]

Throughout the 1920s and early 1930s, eugenics was also on display in smaller towns. Eugenic booths at county and state fairs, sponsored most often by local branches of the American Eugenics Society (AES), hosted Fitter Family Contests and presented lectures on heredity, often delivered by professors from nearby agricultural colleges (Figure 3.7). The care with which contest paperwork was filled out by participants, including Individual Analysis Cards and a Pedigree Chart, reveals that many people took eugenics personally and seriously, considering it both an honor and a patriotic duty. Quite a few attached large portrait photographs of themselves, the size and quality of which revealed their dedication and, in some cases, perhaps, their upper-class status during the Depression. Many added notes about their personal ideals, character strengths, and shortcomings. For example, Charlotte Williams self-deprecatingly admitted that she had "too much talent and too much ambition" and that she had been "too generous." However, she insisted that she had "lived a good life and never [given] up hope of success." During wartime, she "did not degenerate by changing from teaching to stitching," despite the fact that "stitching was better money" on her qualifications. She asserted her deep interest in "science and invention," her hatred for "anything shallow, silly, coarse or meaningless," and her love for beauty, refinement and progress.[24]

Displays of "quality" human beings, as promoted through these contests, stripped away public fascination with traditional displays of "defective" ones at fairs and expositions. Freak shows severely declined in popularity during the 1930s. In his history of these exhibits, Robert Bogdan cites the widespread acceptance of eugenic belief as the chief source for this

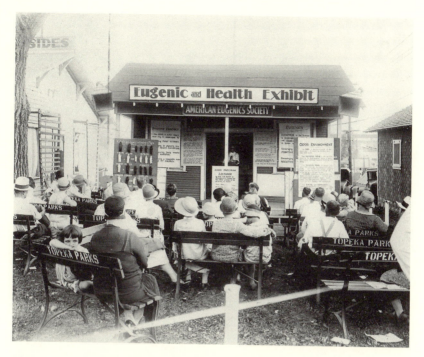

Figure 3.7. Eugenics Building at the Kansas Free Fair, Topeka, 1929. Photo in the scrapbook of the American Eugenics Society, AES Papers. Courtesy of the American Philosophical Society.

decline. No longer amusing or wondrous owing to developments in genetics and increased understanding of glandular disorders, freaks instead were viewed as physically or mentally degenerate individuals who were sick, pitiable, and even pathologically dangerous. Bogdan cites an article in *Collier's* from 1937 entitled "Side Show Diagnosis": "Practically all side show freaks . . . can be found fitted snugly between the pages of some medical textbook. Curiosities they may be, but what they more certainly are is sick."[25] Eugenicists and clearly much of the fair-going public, given the general unpopularity and the decline of the freak show, found freak display offensive. Seclusion, medical attention, and even sterilization were considered more suitable treatments.[26]

These health ideals were communicated to the public through film and radio programming as well. In 1937, American eugenicists promoted two Nazi films for which they had created English captions. One of these,

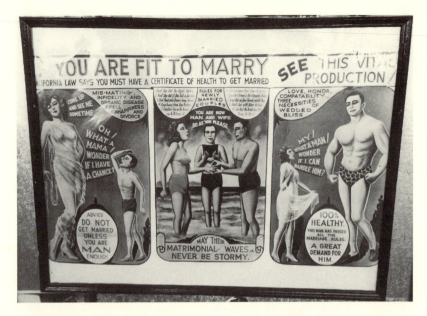

Figure 3.8. Russell Lee, "If You Are Fit to Marry," Farm Security Administration photograph, Yuma, Arizona, 1942. Courtesy Library of Congress.

Hereditary Disease, was advertised by Harry Laughlin to three thousand high schools and churches across the nation (securing, however, only twenty-eight bookings by 1938). Other German films were also shown in classrooms and theaters around the nation, including such titles as *The Curse of Heredity, Survival of the Fittest, Inherited Instincts, The Hygiene of Marriage,* and *The Enemy in the Blood.* Another film, first titled *The Black Stork* and then renamed *Are You Fit to Marry?* after being edited in 1927 (Figure 3.8), ran in small-town theaters between the 1910s and the early 1940s. The film's plot promoted the ideal of eugenic marriage between two physically fit, beautiful whites by contrasting the healthy baby of one such couple against a "defective" one born to parents with hereditary disease; the baby is allowed by the doctor to die, an act of euthanasia blessed by Jesus, who receives its soul into his arms, and effectively upheld by politicians in the film.[27]

In 1928, local airwaves educated Minnesotans in the Minneapolis-St. Paul area through a ten-part series on "Eugenics and Race Betterment," led by activist professor Charles F. Dight. The shows proved so popular that

after the fifth lecture, programmers moved it from its Monday night slot to a prime-time position on Sunday evenings. Two years later, Science Service, Inc., a distributor of scientific articles and programs to newspapers and radio broadcasters, organized a series including talks by Davenport on "What We Inherit," by University of Michigan president Clarence C. Little on "Menaces to Heredity," and by anthropologists Ales Hrdlicka and Melville Herskovits, respectively, on the "Future of Man's Physique" and "Future of the Negro." WRNY covered two AES talks one evening in 1930, including a speech by U.S. Representative Albert Johnson on "Legislation and Race Improvement," and the Columbia Broadcasting System (CBS) aired nationally Davenport's talk in 1931 on "Heredity and Disease" (which was also published in *Scientific Monthly*).[28] Particularly interesting, given the "world of tomorrow" theme of the New York World's Fair in 1939–1940, was Frederick Osborn's "Adventures in Science" program in 1940, also broadcast by CBS in the nation's capital. "Today, let's devote our attention to our country's greatest national resource, the people themselves," the show began. Osborn was introduced as "a student of human eugenics or population trends" who was currently consulting with the Division of Statistics of the Bureau of the Budget on the "population of tomorrow." He discussed strategies that various countries were using to encourage the "mothers and fathers of tomorrow" to raise their national birth rates.[29]

Throughout the decades many groups and club members became familiarized with eugenics through local lectures. In the early 1920s when Mary Watts was organizing the Better Babies and Fitter Family Contests, she visited numerous women's clubs promoting her cause. She wrote to Davenport in 1925, "I think I told you ten years ago that the club women are induced to study eugenics. Now I am sure of it. . . . These women are very responsive and have a much better understanding of what I am trying to tell them than they did when I talked along similar lines even five years ago."[30] In the late 1920s, the Minnesota Federation of Women's Clubs met to discuss the need for marriage laws and better baby contests, while in 1930 the New Jersey Federation of Women's Clubs heard talks on the subject of sterilization and considered passing a resolution in favor of it.[31] Four years later, the magazine of the National Federation of Business and Professional Women's Clubs, Inc., *Independent Woman*, planned a series of articles on the theme of the "brave new world" that would voice the opinions of expert scientists on the imminent wonders of the future. Winifred Wilson, the editor, wrote to Herbert S. Jennings asking for his contribution. "The purpose of the article is to present a biologist's viewpoint of the direction which

social planning should take if we are to improve the caliber of the race," she stated. "A biologist's viewpoint might well offer the key to the whole problem, and I know that no one could present this point of view better than yourself."[32] Men's clubs, including Optimist and Rotary Clubs, also heard lectures on sterilization and "social problems" as well as predictions of "a new era of man."[33] The Town Hall Club and the Lotos Club in Manhattan hosted eugenics speakers throughout the 1920s and 1930s, and in 1937, the former served as the site for numerous AES conferences.[34] In Los Angeles throughout the 1930s, the Southern California Branch of the AES held monthly lectures at the public library on such topics as the "Eugenic Aspects of Social Work," "Preparation for Marriage," and "Quality or Quantity in Race Suicide?"[35]

Youth also learned about eugenics through clubs and organizations. Both the YMCA and YWCA were active supporters of the movement, sponsoring lectures on the woes of impulsive marriage, "Eugenics and Heredity," and "Home Making and Eugenics."[36] If members of the 4-H Clubs missed the eugenic lessons offered by stock breeding through their work with farm animals, at least one Iowa 4-H Girls Club learned them through winning the preliminaries at a Fitter Family Contest (Figure 3.9).[37] Additional opportunities came through participation in the "Health Program of the Boy Scouts of America," which taught boys the values of male leadership and self-control as keys to "happy marriage and leadership of a large family." Not only did scouts learn about sanitation, disease, and public health, they also had to pass periodic health examinations. They kept charts regularly monitoring their development of "hygienic living" skills, for these "life records" could be of use to "current biological sciences, anthropologists, and to doctors." Dr. Ward Crampton, who summarized these activities of the Boy Scouts to the AES Conference on the Relation of Eugenics to Recreation and the Use of Leisure Time in 1937, enthusiastically shared his vision. "With records of whole lives, and of families for a century or so," he declared, "we shall begin to develop a science of understanding and management of human lives individually and collectively, which the world has yet to see, and for which we, in our best scientific and race-minded moments, urgently hunger and thirst. We want life records!"[38]

Many local Parent Teacher Associations and groups of educators heard lectures as well on ways to improve educational curricula by adding discussions of human heredity and character education. Like the life records of the Boy Scouts, character education would teach children the "basic civilization virtues" (including cooperation, health, sportsmanship, patriotism,

Figure 3.9. Winners in the Preliminary Contest of a Fitter Families Contest, 4-H Girls Club, Anderson County, Iowa. Photo in the scrapbook of the American Eugenics Society, AES Papers. Courtesy of the American Philosophical Society.

and self-control, among others). Advocates thought that "school character records will provide ways and means by which those seriously unfit for marriage can be determined."[39] Other suggestions made to educators included their offering differential education programs for students predestined through psychological testing for manual labor, so as not to slow down in class the progress of the intellectually endowed.[40] In many cases these ideas became reality, as shown by the inclusion of character training in elementary schools, the instigation of differential education programs, the inclusion of eugenics in textbooks, and the large number of college courses addressing the topic.

High school and college textbooks testify to the longevity and power of these ideas. *Hygiene of Community, School and Home* (1932) cited mental defectiveness as hereditary and classified as mentally defective 80 percent of all truants, 50 percent of paupers, 25 to 50 percent of criminals, and 50

percent of prostitutes. It characterized slums as disease-ridden and unhygienic and immigrants as "half-civilized."[41] *Health Facts for College Students: A Textbook of Individual and Community Health* (1934) outlined the levels of mental defectiveness and, using the scientifically outdated and faulty example of the Kallikak family as proof, also declared mental defectiveness, broadly defined in the delinquent traits just mentioned, as hereditary. The author exhorted young couples to consider carefully whom to marry.[42] Even a high school text from 1945 described eugenics as popular, mentioned its application in the current policies of sterilization in some states, and promoted the value of purebred stock in its images and questions for review at the end of the chapter on heredity.[43] Steven Selden's recent study of the educational promotion of eugenics through high school biology textbooks and college courses corroborates these findings. In forty-one textbooks published between 1914 and 1948, over 87 percent discussed eugenics and over 70 percent upheld it as a legitimate science.[44] Some high school students received direct input from the ERO, either through visits to the facilities at Cold Spring Harbor or through their teachers' correspondence with Laughlin and Davenport. Although both were extremely busy men, they frequently received and answered letters requesting such things as stereopticon slides on heredity issues, illustrations of mutations, suggestions for laboratory experiments demonstrating eugenic principles, and information for debates on the subject of "Heredity versus Environment."[45]

In 1928, over 375 colleges offered courses with eugenic or genetic content, as shown by 499 responses to a survey sent out by the AES to 527 institutions of higher education. Although this statistic may appear misleading owing to the questionnaire's broad focus on eugenic or genetic content, in fact the returned forms indicated that the vast majority of the colleges returning affirmative answers offered courses with information pertaining to eugenics and human genetics.[46] In many instances, these courses were highly popular with students. At Columbia University in 1928, students rallied for the establishment of a required eugenics course despite coverage of the topic in biology and sociology courses, for, as their campus paper stated, a man was not "truly educated or even fairly aware of his surroundings unless he understands heredity and the progress that has been made in the last decade in eugenics and its related fields."[47] Similarly, the "most popular course among the young ladies of the college" at Sweet Briar was the course on "Social Problems" that stressed eugenic solutions.[48] The questionnaires revealed that eugenics surfaced in courses taught at Ivy League schools, women's universities, state universities, smaller private col-

leges, state normal schools for teachers, industrial arts schools, and agricul-
tural colleges, in such diverse areas as biology, genetics, eugenics, hygiene,
sociology, zoology, evolution, breeding, physiology, medicine, education,
physical education, sanitation, agriculture, psychology, and home econom-
ics. This diversity of schools and subjects revealed the overarching ideologi-
cal appeal, relevance and usefulness of eugenic thought.[49]

Some schools even implemented eugenic admissions policies or estab-
lished departments of eugenics. Since the 1920s, every candidate for admis-
sion to the Eastman School of Music had to receive a high score on a test
measuring "innate ability"; Eastman himself had been a prominent finan-
cial supporter of the AES.[50] Officials at Girard College in Philadelphia noted
in their response to the AES survey that they carefully examined the records
of boys applying to the school.[51] Vassar College was the only school on
record to have actually opened a Department of Eugenics, with Dr. Annie
MacLeod as director, although other schools were attempting to do so. Yale
ultimately opted in 1928 to leave the teaching of eugenics to "those who are
working in Genetics"; the president of Howard University, however, re-
vealed his hopes to begin a eugenics department there in the next few
years.[52] In 1939, an alumnus of the Woman's Medical College of Pennsylva-
nia donated money for a lecture series on medical genetics that the College
used to determine the advisability of establishing a Department of Eugenics.
The series addressed such topics as eugenics, human genetics, and the appli-
cation of genetics to the study of disease and social problems, and four of
the lectures were delivered by Davenport. In his speeches, he obliged Dean
Martha Tracy's request that he minimize his coverage of racial differences,
birth control, and sterilization of the unfit, "these particular issues being
constantly the cause of misunderstanding and acrimony in our area." In-
stead, he spoke on the fundamentals of eugenics in order to establish an
intellectual base in the audience's minds so that later, the "implications . . .
[could] be digested with equanimity."[53]

As this exchange implied, eugenics permeated debates on many con-
troversial social and political issues between the wars, including among
other things miscegenation and marriage health, yet the most important
and long-lasting of these were policies enacting reproductive sterilization.[54]
During the late 1920s and 1930s, laws concerning the sterilization of habitual
criminals and the feebleminded became most widespread in the United
States after the U.S. Supreme Court upheld the right of states to impose
and enforce the sterilization of "imbeciles" in *Buck v. Bell* (1927).[55] Because
both were thought to be hereditary and cost states inordinate proportions

of their annual budgets, states hoped to increase both the genetic and economic efficiency of future generations through enacting sterilization policies.[56] Furthermore, in the case of the marginally feebleminded (particularly females), they were often institutionalized solely for the purpose of segregation during their years of fertility to keep them from becoming pregnant.[57] If instead these "morons," as the semicapable feebleminded were officially termed, were sterilized, they could be cared for at the expense and time of their families and not by the state. During the Depression when state funds were extremely scarce, public support for sterilization increased internationally.

By 1938, twenty-nine states had sterilization statutes on the books. The practice of sterilization, as distinct from mere legislation, actually increased from 1932 to 1941, resulting in a total of almost 36,000 such operations in the U.S. by the beginning of the war.[58] A poll in 1936 by the Human Betterment Foundation in California declared that "the overwhelming majority of Californians supported sterilization laws. . . . [M]ore than 90% of people with some knowledge of sterilization approved such measures; the only critics were those who were ignorant of the issues."[59] Though this poll may have been somewhat biased owing to its source, a more neutral poll the following year by *Fortune* magazine reported that 63 percent of the U.S. population endorsed the compulsory sterilization of habitual criminals while 66 percent supported the sterilization of mental defectives.[60] Newspaper articles and editorials from the early 1930s substantiated these claims for public support of sterilization.[61] Wendy Kline, in *Building a Better Race*, describes in depth a highly popularized court case from 1936 followed by millions of Americans, in which heiress Ann Cooper Hewitt sued her mother for having her sterilized without her knowledge and consent. At issue were questions of "fitness," female sexuality, and proper mother-daughter relations, as well as the legality of sterilizations of non-institutionalized individuals carried out by private medical practitioners.[62]

As discussion about the case showed, some supporters of sterilization criticized statutes on the books because they felt that they limited sterilization to only those defectives who happened to be in state institutions. These laws discriminated against the poor, who could not afford to place their loved ones in private institutions. On the same premise, other critics wanted the laws expanded to cover *all* defectives, regardless of economic status; in their opinion, not enough of the poor fell under these policies because only those in state institutions could be considered for the procedure. States such as Iowa considered remedying this shortcoming of the law

by having the members of the Eugenics Board of the state's Board of Control (who then decided if sterilization was warranted) "get their lists of defectives from the social welfare organizations in Iowa cities as well as from the charitable and corrective institutions."[63]

Undoubtedly, some citizens opposed sterilization for its inhumane and undemocratic violation of an individual's constitutional rights. Dr. Abraham Myerson recognized this contingent in his talk at the Conference on Medicine and Eugenics in 1937 held by the AES, stating that "Public opinion is sensitive to this situation. . . . [W]hether sterilization is legalized on a voluntary or on a compulsory basis it tends, in this country at least, to become voluntary because of public opinion" (although the historical legacy proved him wrong).[64] One editorial mocked the eugenic ambition to control the production of human beings as one controlled a machine: "To listen to eugenistic ravings, one would think that the outcome of a family line could be as definitely determined, as the operation of a new type of locomotive."[65] Others blamed poor environmental conditions rather than poor heredity as the chief factor contributing to criminality. These urged euthenic measures to be applied both in society at large as well as within institutions, where the "food [was] not worthy for a dog" and the nurses and doctors were "heartless" and "inefficient."[66] Congregational minister H. H. Hester, in the only sermon that criticized eugenics that was submitted to the AES's sermon contest of 1926, took issue with some of the fundamental assumptions behind the reproductive sterilization of criminals. Citing contemporary scientific and popular publications, he argued that psychological testing had failed to determine tendencies toward criminality and that some of the studies proving that criminality was hereditary had been methodologically flawed. Contradicting the standard eugenic line, he concluded that for one to be well-born, "there is but one certain answer as yet: Improve the social milieu. . . . Provide better surroundings. After all, it isn't blood that counts."[67]

Thus, through reading about eugenics in newspaper coverage of contemporary political debates such as sterilization, through studying eugenics in school, through hearing a radio program, sermon, or lecture on it, or through seeing an exhibition expressing its principles, many Americans were familiar with its doctrines of social and economic streamlining. The implementation of eugenics, after all, promised to increase the productivity, beauty, and intelligence of the national populace and to save funds that would be "wasted" on the care of the unfit (by redirecting spending toward the fit), through eliminating hereditary "defects" that were out of line with

supporters' visions of national and evolutionary progress. Although it is impossible to know how many Americans associated these eugenic principles with streamlining in design, and to what extent, one writer for *Scientific American* in 1938 came even closer to expressing this association than Arens had in his speech five years before, which linked the creative evolutionary process of streamlining in typography to the processes of natural selection weeding out the slow and cumbersome. In his article, "Streamlined Plants: Professional Plant Breeding" (Figure 3.10), Keith Barrons explained how breeders, through selecting for certain desirable genetic traits, were "streamlining" the products and processes of agriculture, "mold[ing] the *plastic* plant material, with which Nature has endowed us," to provide "better living for everyone," lower costs for "the housewife," and higher profits for the industry. Although he never explicitly used the word "eugenics" (using "superior heritage" instead), the benefits of plant streamlining that he asserted, and the traits which the industry considered desirable in vegetables, point both to streamlined product manufacturing and eugenics as inspirational models for plant breeding.[68]

For example, through producing "superior heritage in agricultural crops," breeders were "streamlining" plants in a number of ways. In a few instances, streamlining literally referred to the shape and aesthetic appearance of vegetables. Like streamlined eugenic bodies, such as that exemplified by the Transparent Man, carrots were being transformed from "short, chubby roots" into "far" more "attractive" "long slim beauties." The newest "model" of the Chippewa potato (Figure 3.11), while not being molded into a teardrop, was having its eyes and divots bred out so as to level its "mountains and valleys," in order to "eliminate waste" and shorten the amount of time required for peeling (time which, ironically, would have been *increased* by the greater length of the new carrot).[69] Similarly, other crops, like dewberries, wheat, and barley, were having their barbs, thorns, and "beards" removed, thus smoothing out-standing parts and making them more comfortable to handle. Other fruits and vegetables were being bred to conform to the size of mass-produced refrigerators and shipping crates. Monstrous, thirty-pound watermelons were being shrunk so as to fit onto a fridge's bottom shelf, while naturally streamlined cucumbers were being turned out "uniformly eight inches long," not only for beauty and to minimize rejection at the grocery store, but also to efficiently maximize the number of cucumbers that could be packed into standardized boxes for shipping. Such uniformity in size and shape caused natural produce to appear as if it were an artificial product made on an assembly line;

Stock-seed plots on a California flower seed farm. As seed from these plots is to be used for seed-production purposes the following year, every effort is made to eliminate during the blooming season all plants but those with desired characteristics

STREAMLINED PLANTS

Professional Plant Breeding . . . Benefits the Farmer, the Housewife, Many Others . . . Finer Fruits, More Beautiful Flowers, Tastier Vegetables

By KEITH C. BARRONS

THE work of the professional plant breeder is not designed to aid the farmer alone. Everyone who produces, processes, or consumes plants and plant products is benefited in no small way by the breeder's efforts to mold superior heritage in agricultural crops. This includes everyone from the grower, whose yields are increased and income made more certain by improved varieties, to the housewife who finds better fruits and vegetables at her local market, made possible by the breeding of superior new strains. Between these two are the canners, the millers, the bakers, and the shippers, all of whom have had varieties bred to meet their specific requirements. As in the case of other lines of agricultural progress, John Public reaps the real harvest in the form of better living and lower costs.

"Streamlining" of cars may not have suggested the streamlined potato, yet such a variety is one of the chief goals of potato specialists everywhere. This streamlining is the elimination of deep eyes that cause such waste during peeling. Besides being more economical, the newer shallow-eyed varieties may be peeled with greater speed. Like the streamlining of cars, the elimination of deep eyes in potatoes is a gradual process. Our latest varieties are improvements, but still shallower eyes may be expected in later models.

Carrots used to be short chubby roots, far less attractive than the long slim beauties seen on many markets today. By careful breeding, a deeper orange color has been developed and the core has been made more tender or practically eliminated. The modern carrot, if well grown, has as little in common with the carrot of former years as a modern streamlined car with a pre-war gas buggy.

The shape of many vegetables has been altered for the sake of beauty or to fit modern needs. A new cucumber which is uniformly eight inches long, if properly grown, is ideal for the shipper. Small Hubbard squash to fit the modern kitchen have made their appearance on some markets. Appropriately enough, the variety is called Kitchenette. It is predicted that smaller varieties of watermelons better suited to the modern refrigerator will gain favor with the housewife as a logical successor to the 30-pound monsters so common in the past.

Nature decreed that certain plants should have barbs or spines either for purposes of protection or seed dissemination. Often those individuals with sharpest weapons of defense were the

Figure 3.10. Title page of Keith C. Barrons, "Streamlined Plants: Professional Plant Breeding . . . Benefits the Farmer, the Housewife, Many Others . . . Finer Fruits, More Beautiful Flowers, Tastier Vegetables," *Scientific American* 158 (March 1938): 133.

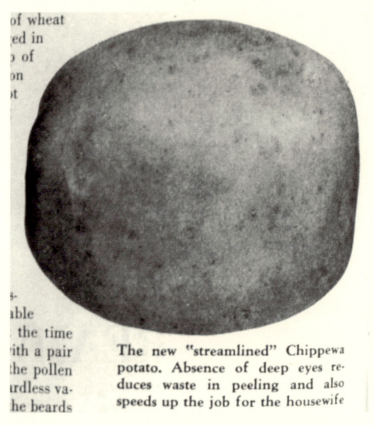

of wheat
ed in
of
on
t

ble
the time
ith a pair
the pollen
rdless va-
he beards

The new "streamlined" Chippewa potato. Absence of deep eyes reduces waste in peeling and also speeds up the job for the housewife

Figure 3.11. The New Streamlined Chippewa Potato, in Keith C. Barrons, "Streamlined Plants: Professional Plant Breeding . . . Benefits the Farmer, the Housewife, Many Others . . . Finer Fruits, More Beautiful Flowers, Tastier Vegetables," *Scientific American* 158 (March 1938): 134.

consumer habits of purchasing artificial mass-produced goods were already influencing the ways in which scientists were altering organic produce to increase sales.

Flowers, too, were being rationally selected so as to maximize their "showy beauty," scent, and number of blooms over those of their "relatively unattractive wild" relatives. Weak plants were being eliminated in favor of hardier, disease-resistant varieties, resulting in the ability to expand the growing regions of certain crops, as well as in a more predictable yield and income for farmers since crops succumbed less to viruses and insects.

Growers also eased their labors and increased their profits through having uniform genetic quality in seed (seed purity). Pure seed produced pure crops, free from those "few wild-type" genetic renegades that caused "the grade, and likewise, the price" of an entire crop to be lowered, because they increased the amount of labor required to sort and process it.

Barrons recounted an experience he had had while researching his article that aptly demonstrated the means and morals of plant streamlining. He met a farmer who had paid a high price for an "excellent strain" of cabbage seed, a price justified by the purity and quality of the seed. The farmer's neighbor, however, who grew the same variety of cabbages, purchased cheaper seed. The first farmer raised a healthy crop of large, uniform, beautifully shaped cabbage heads that were all ready for harvest within a ten-day period, thus greatly easing his labor in harvesting and packaging and increasing his profit owing to his easy labor and the high price drawn by his premium cabbages. The neighbor's crop, however, produced cabbages of different sizes and shapes that matured over a thirty-day period; this "dragged out" his harvesting for a month, increasing his labor and minimizing his profit, in part because of the low price brought by his variable crop. Clearly, the production of pure, "excellent strains" maximized efficiency and profit for the farmer, whereas the use of mixed seed maximized labor, drag, and waste. Agricultural eugenics therefore *was* agricultural streamlining, which "resulted in better living for everyone through standardized and uniform quality." Streamlining and controlled breeding in agriculture were both tied to the processes of technological mass production, whether of artificial or natural goods, which produced a uniform output of beautified, improved goods at lower costs for consumers, at greater profit for producers, in order to increase the standard of living for all.

It is not surprising, therefore, that at the New York World's Fair, opening the following year, corporate executives and industrial designers—who created all the major exhibits—used streamlining as the architectural and design medium through which to promote the benefits of free enterprise and democracy as the roots of American progress and economic recovery. Nor is it surprising that when streamlining and eugenic ideology came together in exhibit after exhibit at the fair in New York, few people commented on their marriage, as they were mesmerized instead by their offspring— the "world of tomorrow."

Take, for example, the ceremonial culmination of the Westinghouse Time Capsule exhibit. Grover Whalen, the president of the fair, joined

A. W. Robertson, Chairman of the Board of the Westinghouse Corporation, to insert an ultra-streamlined, seven-foot-long chrome-alloy Time Capsule into the "Immortal Well" that Westinghouse had drilled into the earth of the fairgrounds (Figure 3.12). With the fair's emblem—the phallic Trylon and ovoid Perisphere—as architectural backdrop and banner to the ceremony, the missile descended the fifty-foot shaft. Mimicking a scientific instrument, it contained a glass tube filled with photos and blueprints of American culture at its height in 1939, including accomplishments in architecture, technology, medical and scientific knowledge, communication processes, and entertainment. Engraved on its side was a message not to disturb its contents until A.D. 6939, the year in which the gestation period of this frozen embryo, implanted as if having undergone in vitro fertilization, would reach its fruition. The rationale for the capsule belied its creators' deep faith in the value of American achievements thus far; in case "civilization" had "perished by then, it can be rebuilt with the time capsule as a text." In such a scenario, its contents would serve, if need be, as DNA for the future world's social and mechanical body.[70]

The not-so-subtle sexual innuendos of the ceremony and the fair's architectural symbols perpetuated a theme that had permeated the visual imagery of streamlining since its inception. Indeed, in a contemporary review of the fair, Lewis Mumford described the Perisphere as "the great egg out of which civilization is to be born" (Figure 3.13).[71] He astutely picked up on the metaphor of the building that served as the "feminine" half of the architectural and symbolic center of the fair. Inside, Henry Dreyfuss's Democracity diorama materialized his orderly vision of future urban planning. That at some point in developing his scheme he considered the biological, embryonic metaphor intended by the exhibit's location at the interior of the "great egg" is suggested by a cell-like sketch he made of the city's layout.[72] He centralized industrial, economic, and political activity in the city's nucleus, and surrounded and supported it with the cytoplasm of neighborhoods and connecting arteries. Through housing this microcosm of future possibilities, the feminized architectural space thus served as a passive vehicle for the conception of one male's vision of the future world, an organizational schema repeated in other exhibits by designers at the fair.

Given Mumford's insightful characterization of the Perisphere, how could he have missed Geddes's masterful embodiment of the sexual act itself, culminating in birth, within the architectural layout of the Futurama, the exhibit Geddes designed for General Motors (Figure 3.14)? Unless he was issued a special guest pass, a visitor could not avoid the foreplay of the

Figure 3.12. A. W. Robertson and Grover Whalen inserting the Westinghouse Time Capsule into the "Immortal Well" at the New York World's Fair, 1939. In Donald Bush, *The Streamlined Decade* (New York: George Braziller, 1975), 168. Image originally published courtesy of the Westinghouse Corporation.

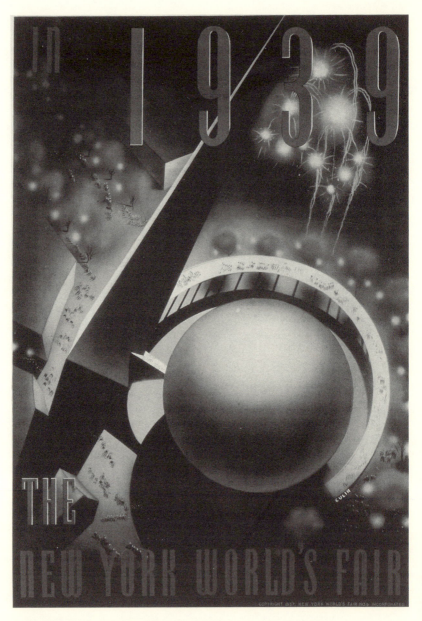

Figure 3.13. Nemhard N. Culin, *In 1939, The New York World's Fair* poster (1937), ink and paper on linen. Courtesy of the Wolfsonian-Florida International University, Miami Beach, Florida, Mitchell Wolfson, Jr., Collection.

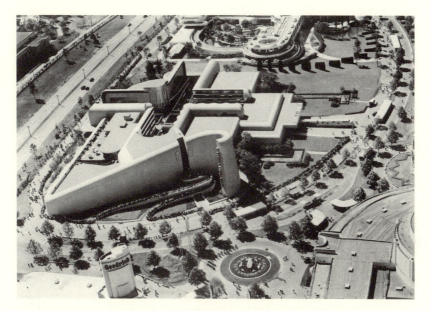

Figure 3.14. Photo of the General Motors Building (the Futurama), New York World's Fair, 1939. In File 381, NBG Papers. Courtesy of the Harry Ransom Humanities Research Center and the Estate of Edith Lutyens Bel Geddes.

approaching ramp, which then slipped through the "mysterious" vaginal slot that was painted "vermilion red" and was "spotlit along its entire length with concealed fluorescent lights."[73] He then glided down a cool dark ramp into what Geddes described as a "misty," mystically lit room containing a wall-sized map of the United States, replete with a diagram proposing a national interstate highway system which served as the theme for, and chief outcome of, the General Motors exhibit. While visitors waited in this room for their turn to board a conveyor that would carry them through the area housing an immense model of the U.S. in 1960, a familiar male voice, that of a famous radio commentator, H. V. Kaltenborn, imparted Geddes's futuristic vision of the world of tomorrow.

This soothing authoritative voice emanating seemingly from out of nowhere revealed that the upcoming revelation was "Norman Geddes's *conception* of the many wonders that may develop in the not-too-distant future," thereby dispelling any doubts about the paternity of the future world. Mounting the original conveyor of its type, the visitor shared his gently vibrating "loveseat" with a partner, and they glided up and down in

a spermatic "serpentine" pattern over the model of a "world without slums" laid out on the floor below.[74] Almost everyone noticed the "climax," however, the literal birth of a new world when the model came to life and existed in reality before their eyes and feet. Near the end of the conveyor ride, after a close-up view of a particular street intersection in the model (Figure 3.15), their seats spun around to deliver the very intersection, life-size, within the layout of the building. Or, perhaps the real birth was yet to come: the intersection "was more than a small-scale model; it was a full-scale fragment of a new reality . . . an embryonic cell for a yet unborn world, a world sustained in the windowless, womblike building."[75]

Coupled with the overtly phallic diesel train which marked the second entrance to the building and, appropriately, the area housing the science exhibits, it seems that such a gendered structuring of "masculine" and "feminine" space could hardly have been unintentional. It must be noted, though, that even on the "feminine" side, as in Dreyfuss's exhibit, the journey taken by visitors was metaphorically that of a male sperm entering a womb. Following this theme, the principal exhibit on the educational scientific side of the building was entitled "The Birth of Industries." Additionally, although in 1939 Stuart Chase connected the Futurama to Aldous Huxley's *Brave New World* through the title of his review of the Futurama, "Patterns for a Brave New World," he failed to mention the most obvious correlation between the two. In both the Futurama and Huxley's Central London Hatchery, humans were transported on a conveyor through a building dedicated to male birth, as all female agency had either been surgically removed or was only activated by male force (shown in the Futurama through the "passivity" of the "feminine" womblike space that became impregnated by Geddes's "conception").[76]

From the smallest details in the model—the tiny plastic autos on two ball-bearings that moved mechanically along the distant highways of the world of 1960—to the largest architectural detail of the building, to the social message the exhibit projected, Geddes streamlined his presentation of the future. Toy tear-drop "pleasure cars" with tear-drop windows, enclosing miniature white couples in business attire, raced along the highways of the model, or, in the intersection outside, sat stationary, life-size, beneath the overpassing pedestrian walkways. Almost every architectural surface on the exterior and interior curved into the next; some even tapered downward to a near-vanishing point, mimicking the slope of the vehicles. Geddes described these curved surfaces and the spaces they created as "really thrilling," noting that they radiated a "sense of power, which is a strange word

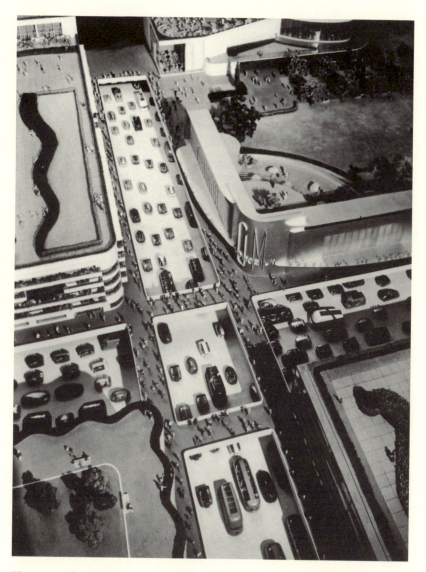

Figure 3.15. Photo of the street intersection in the model of the Futurama exhibit (which was built life-size into the layout of the General Motors Building). In File 381, NBG Papers. Courtesy of the Harry Ransom Humanities Research Center and the Estate of Edith Lutyens Bel Geddes.

to use architecturally"; he thought the solidity of the structure put to shame the "cardboard appearing buildings within sight of it."[77] Geddes's script and model for the exhibit similarly communicated his powerful, eugenic vision for urban planning: "whenever possible the rights of way of the express city thoroughfares have been so routed as to displace outmoded business sections and undesirable slum areas." The dislocation of these racially and culturally different neighborhoods created the impression in Chase's eyes of a "civilization which had been cleaned, garnished, and ordered. Waste, clutter and ugliness were out of it." In his review, he even posited that in cities such as Geddes's based upon the Greenbelt plan, their residents would further the trend of higher birth rates that was being evidenced in Greenbelt communities.[78]

Like Dreyfuss's egg and embryo and Geddes's materialized narrative of sex and birth, Arens also structured his proposed design for the Hall of Public Health around a sexual theme. Visitors would have walked through a low entry into the cavernous streamlined space of the Hall of Man, through which they could then access the Hall of Public Health (Figure 3.16). The organic shape of the hall and its two vulval, "egg shaped" displays for "pit exhibits" (splayed, ovarian-like, one on each side of the main axis) would have placed fairgoers entering the building metaphorically in a position of vaginal penetration (Figure 3.17). In essence, visitors once again would have walked into a powerful, dwarfing, architectural re-creation of a female reproductive system. Arens strengthened the sexual metaphor by positioning the "Transparent Adam and Eve," as he called them, directly opposite the main entrance in the visitor's initial line of sight; the couple stood naked, completely visible inside and out, holding hands, over the doorway into the Hall of Public Health (Figure 3.18). Otherwise referred to as the Transparent Man with his recently created counterpart from Dresden, the Transparent Woman, the rendering of the couple by Arens was simply an interpretive sketch in the designer's mock-up. Yet, it shows he envisioned the union of these two "fit," idealized figures as a model of eugenic pairing for all fairgoers entering the Hall, and thus as a model of the path to public health.

As had been done for the Chicago World's Fair, in preparation for the creation of the public health exhibits and for the designs of the building, Robert Shaw, of the New York Museum of Science and Industry, traveled to Europe in 1937 under the auspices of the Carnegie Corporation to visit prominent museums of science and hygiene. His lengthy report, which Arens saved, described the Palace of Discovery at the Paris International

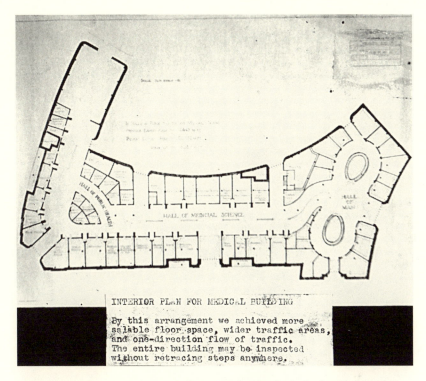

Figure 3.16. Egmont Arens, Proposed interior plan for the Hall of Public Health, Hall of Medical Science, and Hall of Man, New York World's Fair, 1939. In folder "World's Fairs," Box 28, Egmont Arens Papers. Courtesy of the Syracuse University Library, Special Collections Research Center.

Exposition, whose Biology section drew the largest audience. In the center of this section was a "comprehensive exhibit on evolution, tracing the development of the various species up to their present state"; the section also contained exhibits on "cells, embryos, heredity, sex, [and] experimental biology." Shaw photographed the heredity display, which demonstrated Mendel's principles through taxidermed guinea pigs and chickens in much the same fashion as had eugenic didactics at state fairs (Figure 2.6). In fact, the Hall of Man and Hall of Public Health were not built according to Arens's plan; instead, in their layout, they almost exactly materialized proposals made by Gebhard, who was invited to the U.S. from Germany after September, 1937, to participate in the planning meetings for the public health exhibits in the Hall of Man.[79]

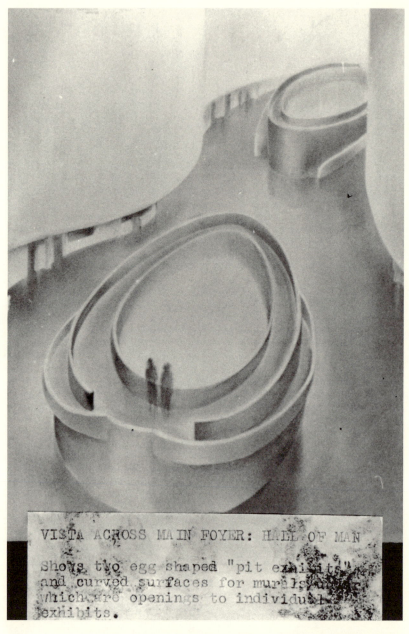

VISTA ACROSS MAIN FOYER: HALL OF MAN

Shows two egg shaped "pit exhibits"
and curved surfaces for murals under
which are openings to individual
exhibits.

Figure 3.17. Egmont Arens, Proposed vista across main foyer of the Hall of Man, New York World's Fair, 1939. In folder "World's Fairs," Box 28, Egmont Arens Papers. Courtesy of the Syracuse University Library, Special Collections Research Center.

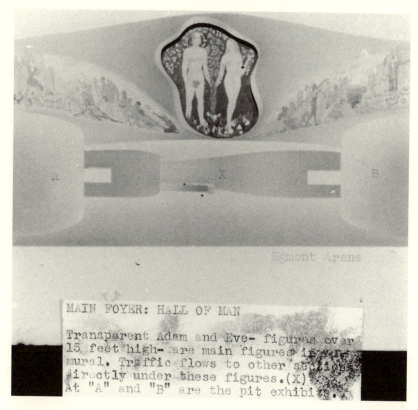

Figure 3.18. Egmont Arens, Proposed main foyer of the Hall of Man, New York World's Fair, 1939. In folder "World's Fairs," Box 28, Egmont Arens Papers. Courtesy of the Syracuse University Library, Special Collections Research Center.

Gebhard proposed a layout for the Hall which almost replicated a highly successful display he had created for the "Wonder of Life" exhibit in Berlin (Figure 3.1), in which the Transparent Man stood in a "large, high ceilinged, dimly lighted room" beneath wall-text quoting Saint Augustine: "Man wonders over the restless sea, the flowing water, the sight of the sky, And forgets that of all wonders Man himself is the most wonderful."[80] Visitors to the Hall of Man walked into a building with the same general plan Arens followed, minus the pit exhibits, through one of three doors. Yet, instead of seeing the transparent couple in front of them over the doorway into the Hall of Medicine and Public Health, in the alcove to the far right of Arens's plan, a "biorama" featured the Transparent Man beneath a huge,

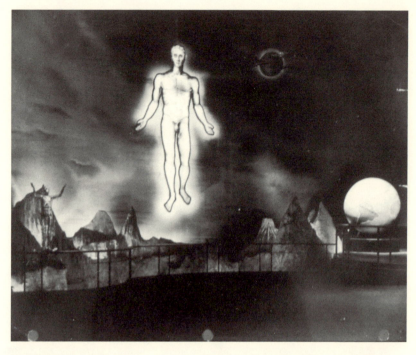

Figure 3.19. Photo of the "Biorama" of the Transparent Man in the Hall of Man, Hall of Public Health, New York World's Fair, 1939–40. BG Papers. Courtesy of the Dittrick Medical History Center, Case Western Reserve University.

classical, blond, Christ-like male of the Nordic type, ascending into heaven on the thirty-four-foot wall, whose beating heart glowed red (Figure 3.19), to the right of which was Augustine's quote. The Hall was filled with seventy-five biological displays showing bodily organs functioning properly, again purchased from the Deutsche Hygiene Museum, this time by the Oberlaender Trust of Philadelphia in 1937 for what was intended to become the American Museum of Health in New York after the fair.[81]

As with the medical exhibits at the Century of Progress, the most explicitly eugenic part of these displays was their showing the functions of a "fit" human body, idealized in the Transparent Man as the Nordic type. This idealization was accentuated at the New York World's Fair through the repetition of this type in the Christ-like figure overhead, as well as through its opening ceremony and organizational background. In 1937, when the Fair's Committee on Public Health was planning its exhibit, Fred-

erick Osborn, then a prominent spokesman for the AES, served on its Sub-Committee on Demography and Eugenics. In this capacity, he had planned a eugenics exhibit intended for the hall and urged the AES to solicit funding for it.[82] Although the costs eventually proved prohibitive, Osborn remained influential in the public health exhibits and gave the opening dedication for the "American Museum of Health" exhibits in the Hall of Man, which was sponsored by the American Public Health Association and marked through the recognition of National Health Day. Both the museum and festivities of the special day were noted as broadening the influence of eugenics in the "Report of the Activities of the AES" from 1939 to 1940, which also mentioned AES participation in the dedication of the Maternity Center Association Exhibit at the fair.[83]

In his opening address, Osborn stressed the "deeper significance" of the Hall of Man and the "very serious question raised in connection with this building." "Every other serious exhibit at the Fair is concerned with the relation of science . . . to improving the environment of the man of tomorrow," he stated. "This building and these exhibits," however, "are concerned with the relation of the sciences of man to improving the men and women and children of tomorrow." Osborn felt that the question raised by the exhibits was whether or not Americans would possess the "intelligence and the character and the intellectual integrity and patience to develop the sciences of man and make use of them in such a way that, working through science, the men and women and children of tomorrow may be more fit," by which he meant "in good health, in intelligence, in cooperative personality, and in happiness, to inhabit an improved world of tomorrow."[84]

Other major exhibits at the fair, however, also broadcast eugenic messages: Geddes's Futurama and the Typical American Families Contest. The latter, a highly popular exhibit at the fair, culminated almost two decades of Fitter Family Contests that upheld healthy, native-born white families with two or more children as the proper eugenic norm to which American couples should aspire. At the New York fair, the contest was sponsored by Ford Motor Company, the Federal Housing Administration, and the Johns Manville Company.[85] The Futurama likewise conveyed a potent eugenic subtheme, as hinted at by Stuart Chase's association of the exhibit with the higher birthrates of Greenbelt planning and with Huxley's *Brave New World*. To a certain extent, both Huxley and Geddes envisioned masculine control of the birth of a future eugenic world through the scientific industrial production of human beings, powerfully visualized by Huxley and ac-

tualized by Geddes by placing human beings on a conveyor, *assembly-line* fashion.

Did Geddes purposely structure the masculinist sexual narrative and invent the first conveyor of its type, which he deemed "essential" for the Futurama, in order to literally materialize Huxley's imagined eugenic scenario?[86] He did carefully arrange the lighting of the visitor's journey over the model to shift from morning to midday to night so that "the observer is unconsciously borne [born?] through a day's journey in eighteen minutes." The eugenic theme fit not only Geddes's personal interests but his mode of creativity as well. In his ongoing work for the theater, he continually brought fictive settings into material existence, not only on the stage but also within theater auditoriums so that the audience themselves became participants in the play.[87] In this scenario, the American public riding the conveyor, inside a male-dominated feminized space devoted to the theme of birth, metaphorically assumed the position of the embryos in Huxley's novel. Just as the model intersection of 1960 came to life in the architectural layout of the building, so that visitors walking into it claimed that they had "seen the future," so too might eugenic control over human reproduction become a future actuality.

Brief intimations exist that fair planners and General Motors at least were not resistant to Geddes's progressive vision. Historian Roland Marchand states that the exhibit would have suitably expressed the "forward-looking social vision" of the company, and Mr. Beesley on the Board at the Fair acknowledged the viability of a subtheme: "And while the main theme of the Futurama is transportation, its broader subject is human progress. . . . Of course, the philosophy stuff will have to be carefully imparted rather than expounded, but I think that will be very easy to do with the material at hand."[88] One critic missed the eugenic theme, but expressed the need for it, arguing that the Futurama promoted a world without slums while omitting to show "how the human mind should improve. . . . If the dumbbell mind is not improved in the world of tomorrow, civilization will not have advanced."[89]

Human progress, it seemed, was considered integral to the overall advance forecast by the technological and scientific exhibits at the fair. The aforementioned edition of *Vogue* magazine from 1939, created especially to promote the fair, clearly asserted as much, as did the messages of many of the main exhibits.[90] In each of these, the leading industrial designers promoted their streamlined, eugenic visions as the cure for America's social ills, positioning themselves (along with eugenicists and geneticists) as the

progenitors of the future. Regardless whether they enacted their visions through a static feminine entity (such as the feminized spaces of the exhibits at the New York World's Fair or, as in some geneticists' fantasies of controlling birth, in ovaries separated from women's bodies) or through themselves out of sheer vitality, designers and some geneticists conceived of themselves as midwives of a new world to which they were giving birth. Teague, in *Design This Day*, repeatedly asserted this when expounding on how to make an orderly world and maintain form in design. "Some man by his own conscious thought and effort must supply the vital force that brings ultimate form to birth, and he must act as midwife in delivering it," he wrote. "There is a non-rational, non-volitional element in design, and this element is the vital one. It is the spermatic force contributed by the designer himself out of his own vitality, and without it the work, however intelligently planned, never comes to life."[91] Such a description aptly describes Geddes's boundless energy and frenetic activity that brought about the realization of his visionary futuristic child, the Futurama model, a mere two years after its conception. That he was perceived as father, midwife, and mother is apparent from an unusual publicity photo in which he is working on his beloved model of the U.S. in 1960 (Figure 3.20). Geddes, glancing up from tending his progeny, is framed between the legs of a man whose coat hangs down to suggest both an oversized phallus and a fetus being born.

This idea of the masculine control of the future world surfaces repeatedly in the literature on streamline design. Teague mentioned elsewhere that the designer's role was to "be the spearhead of ideas and inspiration and the active directive head of its affairs."[92] He described a product as a "mere anatomical specimen" until the designer infused it with "superabundant vitality." This process of "conception is full of joy, or at least fun, no matter how painful delivery may be; and the offspring of any artist's creative urge should be illuminated with some of the emotion he feels in giving it life." Teague's pro-sensuality-as-inspiration stance caused him not to settle for "artificial insemination" in the arts, by which he meant pure, dry, functionalist design, design produced formulaically instead of individually and with the spark of creation. He advocated instead an art of "health and vigor, not sterility."[93] Like Teague's virile approach, Raymond Loewy's evolutionary charts (Figure 2.9) presumed the invisible, controlling hand of the designer himself in effecting future progress. Similarly, an article describing Donald Deskey's merchandizing techniques described the indus-

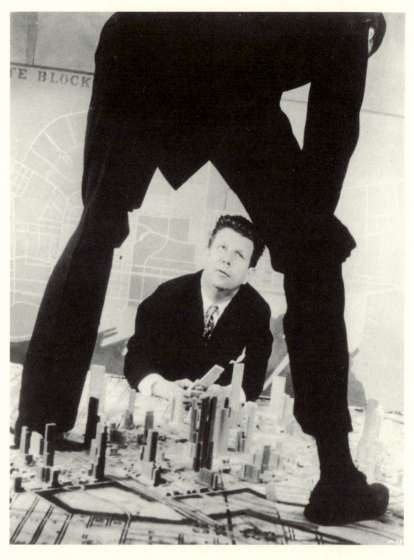

Figure 3.20. Norman Bel Geddes working on the model of the Futurama. In File 381.69, NBG Papers. Courtesy of the Harry Ransom Humanities Research Center and the Estate of Edith Lutyens Bel Geddes.

trial designer as one who had "'mothered' many products through from their inception to reality."[94]

Although clearly some designers and eugenicists were enchanted by their own virility, why their forced correlations between masculinity and birth? Why the strong assertions of masculine control, even if only metaphorical, over this seemingly ultra-feminine realm? Perhaps designers and scientists were simply furthering the longstanding view of sexuality in which passive feminine entities were the recipients of male force. Such was the message of the "'Better *Sires*, Better Stock' Campaign" (Figure 2.17), promoted by the U.S. Department of Agriculture, in the 1920s. Perhaps they were unconsciously countering what they perceived as the social threat posed by women with liberated sexuality, the right to vote, and greater prominence in the workplace. Many eugenicists did in fact work hard to return women to the home; by contrast, however, many designers' wives were accomplished in business. Or, perhaps their vision of progress, in an evolutionary sense, had to be a male vision (race was of an assumed whiteness), for only white males supposedly occupied the apex of evolutionary development and intellectual advancement. Regardless of the answer, through their efforts to exert rational control over the varied processes of reproduction, designers and eugenicists both worked in the public spotlight to shape the world of tomorrow to fit their visions of perfection, which demanded maximizing biological efficiency, increasing hygiene and sterilization, and creating the "ideal type."

Chapter 4
"Flow Is the Word":
Biological Efficiency and
Streamline Design

This age needs streamlined thinking to keep pace with our streamlined machines.

—*Egmont Arens, in notes for his speeches*
on streamlining in the mid-1930s

In 1937, in an advertisement for a laxative (Figure 4.1), Petrolagar Laboratories, Inc., of Chicago, attempted to capitalize on the popularity of streamliner trains by invoking their promptness and regularity as the model for the ideal intestinal functioning of a modern urbanite.[1] Caught up in "high speed living" that encouraged "unfavorable eating and working conditions" and contributed to "neglected habits," commuting businessmen frequently suffered from "faulty elimination" and "chronic constipation." Unlike the on-track, on-time regularity of the modern streamliner train, the contents of modern man's intestinal tracts typically ran late, if they arrived within the day at all. The educational advertisement therefore suggested seeing a physician who could prescribe the necessary changes to one's schedule, diet, and exercise program, as well as the laxative Petrolagar, to restore regularity to one's system.

In its use of the streamliner as a symbol for intestinal efficiency, the advertisement built upon a metaphor popularized by health enthusiast John Harvey Kellogg throughout numerous publications, including his three-hundred-page book, *The Itinerary of a Breakfast* (1918, 1926). Kellogg subtitled his book *A Popular Account of the Travels of a Breakfast Through the Food Tube and of the Ten Gates and Several Stations Through Which It Passes, also of the Obstacles Which It Sometimes Meets.* In it, he described the "nor-

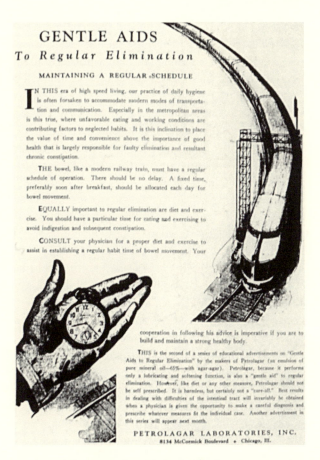

Figure 4.1. Laxative advertisement for Petrolagar Laboratories, Inc., Chicago, 1937.

mal itinerary of a meal" passing through the "food tube," otherwise re-
ferred to as the "alimentary subway." "Train Late: Held at Stomach Station
for 2 hours. Bowel Gate (No. 5) refused to open. Losing Time: Wreck at
Colon Gate (No. 7). Ileocecal valve refuses to close, track obstructed with
rubbish. 8 hours late. Losing Time: Collision with heavy train backing
up. . . . Losing Time. . . . 35 hours late." Finally, "Train arrives at last, after
clearing track with dynamite (castor oil), forty hours late."[2] Besides the
visual imagery, the pun of track/tract, and the popularity of streamliners,
what drew health-conscious individuals of the interwar period to such anal-
ogies? One answer surfaces when considering the broader cultural and ideo-

logical pursuit of "smooth flow," a pursuit that conjoined notions of the efficiency of bodies and products with the eugenic idea known as "national efficiency." Consider, for example, the conceptual similarities between these different loci—eugenics, constipation, and streamline design—of the concern for smooth flow.

As is clear from previous chapters, efficient living had been a primary pursuit of eugenicists and Progressives alike, many of whom based their life's work and even their daily habits upon its principles. Efficiency could be physical, concerned with minimizing the use of time or space in a daily routine, or economic, aimed at maximizing profits through minimizing waste or adjusting work practices to increase worker health and productivity. It could be moral, tied to values of living simply so as to charitably share with others, or biological, measured in terms of bodily energy, function and output and enhancing the chances of evolutionary success. Because of this wide range of potential applications, efficiency as pursued by eugenics supporters took several forms, shaping both the overall direction of the movement and the arguments used to win support for its causes.

The term "national efficiency" specifically referred to strategies of human management intended to maximize the nation's resources in terms of labor productivity, economic expenditure and its biological bequests to the future. The term "unfit" reflected this fundamental concern, as it was applied to those deemed unable to positively contribute to the nation's economy as well as to its genetic inheritance. During the Depression when funds were scarce, eugenic propaganda played upon public concerns about national economic waste in order to strengthen acceptance for policies that would eliminate those who were "born to be a burden on the rest" (Figure 4.2). One display used at state fairs possessed red lights that flashed periodically to mark the intervals explained by the sign's text: how often a person was born in the U.S., how frequently large amounts of tax dollars were wasted on the care of "defectives," and the comparatively slow rate at which "high grade" people who were "fit for leadership" arrived on the scene. Lectures at museums and local fairs in the 1930s, like the sermons delivered for the American Eugenics Society (AES) contests of the late 1920s, described how the nation's blood "stream" was being "blocked" and "polluted" by an influx of undesirable genes from "degenerates," whose high rate of reproduction was supposedly flooding the nation with "poisonous" blood. This poison imposed a "drag" on the forward progress of the nation by threatening to halt the rise of national intelligence and by draining state coffers of financial reserves; hence Henry Fairfield Osborn's reference to

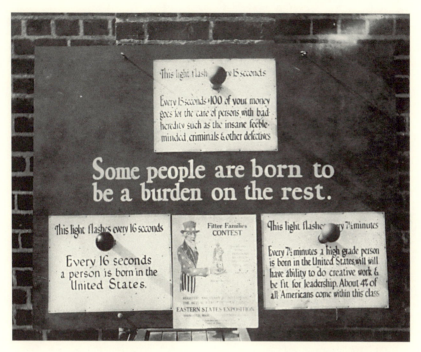

Figure 4.2. "Some People Are Born to Be a Burden on the Rest," exhibition panel from a Fitter Families exhibit. Photo in the scrapbook of the American Eugenics Society, AES Papers. Courtesy of the American Philosophical Society.

these "parasitic" individuals as "dragnets . . . on the progress of the ship of state."[3] Smooth flow could be restored to the nation's evolutionary stream and political economy only by shifting the balance of the national birthrate from the dysgenic to the eugenic in the interest of national efficiency.

The outward concern for smooth flow on a national level extended inward as well, manifesting in the broad-based, early twentieth-century revolt against constipation. Otherwise referred to as "civilized colon," owing to the fact that it seemingly occurred only in the "civilized" due to their heightened rationality, weak physical condition, and business occupations, constipation was causing "the American people" to almost universally suffer "from a food blockade in the colon." Instead of being merely an "inconvenience," according to health reformers and eugenicists, these blockades posed "a menace to life and health" and were "one of the most prolific of

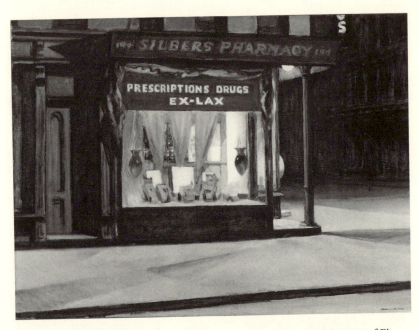

Figure 4.3. Edward Hopper, *Drug Store*, 1927. Photograph © 2003 Museum of Fine Arts, Boston.

all causes of disease."[4] Issue after issue of the *Saturday Evening Post* in the late 1920s and early 1930s contained advertisements for remedies for constipation and its accompanying symptoms, while the mundane prevalence of the malady was captured by Edward Hopper in his painting *Drug Store* (1927) (Figure 4.3).[5] From the 1910s onward, Americans consumed massive amounts of Kellogg's breakfast cereals, Quaker Oats, laxatives, agar and paraffin, olive oil and yeast in their pursuits of personal colonic efficiency. Some of the wealthier attended Kellogg's Battle Creek Sanitarium for diagnosis; after they ingested a meal tinctured with bismuth, x-rays of their intestines revealed problem areas where the colon was prolapsed or kinked and thus blocked the flow (Figure 4.4). These "crippled" or "delinquent" colons were thought to cause "autointoxication," a disease whereby "putrefactive poisons" and "toxic" ptomaines released by rapidly reproducing bacteria in slow-moving feces were absorbed into the bloodstream, causing "poison in the blood."[6]

Autointoxication produced a plethora of negative symptoms ranging from "chronic disease" to "premature senility." One frequently experi-

Reverse Peristalsis. Incompetent Ileocecal Valve.

Figure 4.4. Colon x-rays, in John Harvey Kellogg, *The Itinerary of a Breakfast* (New York: Funk and Wagnalls, 1918, 1926), 125.

enced "headache, depression, skin problems, chronic fatigue, damage to the liver, kidneys and blood vessels." More specifically, it was thought to cause "colitis . . . gall stones, . . . neurasthenia, . . . paralysis, insomnia, . . . and even insanity."[7] Of these ills, those in the mental realm were some of the most feared, though others also offered significant cause for alarm. According to medical texts, these maladies arose in large part from the "inefficiency" of a blocked digestive tract. If one's digestion were slow, the poisons constantly being produced unnecessarily and excessively overworked the other "poison-destroying" organs in the body, such as the kidneys and liver, causing their eventual collapse in addition to an overall generally "lowered bodily efficiency" that increased sickness and lessened productivity.[8]

Yet, even more seriously, constipation was seen as stunting national evolutionary advancement by slowing the mental, moral and racial progress of the nation. "Poison in the blood" not only increased mental lethargy and degeneracy; it seemingly blurred the moral conscience of those under the influence. For example, the editor of *Health Culture* magazine, W. R. C. Latson, envisioned how the "food intoxication" caused by a feast including meat (he was a vegetarian) might "lead to acts of violence or immorality, at the memory of which the perpetrator looks in horror and amazement.

The diner leaves the table intoxicated with a dozen poisons. A heated argument, a word too much, a moment of frenzy, a sudden blow; and the next morning he awakens to find himself a criminal." Alternately, a hand could be "laid on his arm, a voice whispers in his ear; and he turns aside to follow the scarlet woman—the scarlet woman whose steps lead down to hell."[9] Ministers also emphasized the ungodliness that came from polluting one's body, the "Temple of the Holy Spirit," by eating indigestible food or incompletely masticating it: "a man who through irregular or gluttenous eating ruins his health, is not offering to God such a sacrifice."[10]

Furthermore, in 1932, British doctor Ettie Hornibrook, in her book *Restoration Exercises for Women*, revealed that constipation was hindering "civilized" woman's sexual desire, thus lessening the eugenic birthrate. In her opinion, prolonged constipation was the root cause of women's frigidity owing to the position of the bowels in relation to the vaginal canal. As the lack of sexual fulfillment was the primary cause of divorce, and as divorce posed a chief reason for the declining "civilized" birth rate, she perceived the prevention of constipation in modern women to be one of the chief medical issues of the decade.[11] Because constipation was considered a damper on the productivity, sexual interest, mental clarity, and morality of the "fit," no wonder it was claimed in a eugenics sermon that "the greatest problem, whether we think in terms of the physical, moral, or spiritual life, is the food problem. The decadence of the modern home, the tragedy of disease are great problems, but food is fundamental. All social progress is dependent upon this. Diet and evolution are inseparable."[12]

Perhaps diet and evolution seemed so interrelated in part because of the multiple ideological parallels between concepts of national and bodily efficiency. Kellogg spoke of the "civilized colon" as a "poor cripple, maimed, misshapen, . . . infected, paralyzed, inefficient, incompetent," descriptors that were commonly applied to the "unfit," who like the colon were the site of waste in the national body.[13] Through his word-choice—in which he described the gustatory nerves at the entrance to the digestive system as regulators at "the inspector's gate" that afforded "important and intelligent protection against injury from foreign substances not intended by nature to be taken into the body"—Kellogg compared the regulatory digestive function of the individual body to immigration officers at U.S. consulates and Ellis Island who probed the backgrounds of prospective immigrants to reject those whose blood they thought would pollute the bloodstream of the national body.[14]

The parallels between immigrants and waste continued inside each

respective "body." Internal bodily flow only should progress forward; once it backed up due to blockage, autointoxication began. Likewise, the nation's genetic heritage and evolutionary progress were seemingly being blocked and poisoned by the inclusion of those of lesser evolutionary standing, whose development had been obstructed, arrested or had even degenerated backward to its current "defective" state.[15] Utilizing the principles of "colon hygiene," however, one could purify the intake through dietary reform, sterilize bacteria-infested intestinal walls through the regular use of soapy enemas, and even resort to surgery to cut away obstructions to internal efficiency.[16] Similarly, proponents of "race hygiene" closed the nation's doors to immigration and turned to surgical sterilization to halt the rapid reproduction of those who were thought to be a hindrance to national efficiency. Thus, the causes, consequences, and cures of constipation became a site where the broader goals of smooth flow and national efficiency were telescoped downward and turned inward.

It was during this period of national obsession over bodily and national efficiency that streamline design began. Norman Bel Geddes's illustration of the progress of various shapes in a flowing stream (Figure 2.1) can be interpreted as diagramming the concerns of all three. The streamline form could roughly model: a graphic distribution of the "eugenical classification of the human stock" (Figure 2.2), consisting predominantly of persons of "genius," "special skill," and the "normal middle class" with the goal of phasing out the "socially inadequate"; the shaping process that occurs in the intestines as a result of peristalsis; or, the motion of a vehicle through a flowing stream. Design historians Ellen Lupton and J. Abbott Miller have gone so far as to interpret streamlining as an "excretory aesthetic" because the ideal streamlined form so closely resembles the products of bodily elimination, and because as the first major industrial design style, it encouraged the production of waste through planned obsolescence and the processes of consumer purchasing and discarding.[17] Raymond Loewy's evolution charts (Figure 2.9) further elaborated the process of streamlining, for as forms became more evolved and more streamlined, they became not only less ornamented per Loos's proscription on ornament as "degenerate," but also less fussy and intricate as, according to Geddes's definition, all projections were eliminated. Streamline designers, like eugenicists and health reformers, thus worked to restore smooth flow by eliminating the poisonous suction caused by "parasite drag" by bringing into line all disabling, out-standing features that were thought to hinder the forward evolutionary progress of their respective areas of reform.

Clearly, the pursuit of smooth flow permeated American culture on a variety of levels, from ideological notions of national efficiency and progress and eugenic beliefs about racial purity, to individual concerns for colonic efficiency and streamline designers' obsession with the tapering curve. The style thus resonated with and reinforced these contemporary concerns, many of which were overlaid with eugenic implications regarding enhanced speed, intelligence and power. Did streamline designers understand these implications and this resonance? Let us return to the advertisement for the laxative Petrolagar targeting the commuting businessman to begin examining the correlations between streamlining and constipation.

By comparing the "civilized" colon with a streamliner, a highly popular symbol of modernity, the advertisement established an analogy that highlighted both the strengths and a key weakness of "civilized" man supposedly brought about through evolution. While his highly evolved rationality had permitted the rapid developments in technology and cultural advance symbolized by the train, these developments seemingly had come at a cost to the modern body. His ever-increasing distance from nature, seemingly dictated by an evolutionary paradigm built upon a philosophical split between mind and body, was exacerbated even further by a regimented business schedule that was not conducive to answering nature's call. He therefore had had to learn to apply his great rationality and self-control to restraining his own bodily urges, and in the process acquired the "crippled state of the colon" that was "an almost universal condition among civilized men and women."[18] After breakfast, for example, instead of automatically going to the toilet and waiting, the businessman hurried to catch a commuter train which carried him off to his day's work. Similarly, "the ideal of the college girl or the secretary is to go to bed late and then get up as near as possible to the time when she must check in at school or office. . . . Such girls might cure themselves of constipation if they would only get up a little earlier."[19]

The sedentary urban lifestyle, "concentrated foodstuffs," lack of abdominal exercise and strength, and high amount of mental preoccupation all contributed to this "disease of civilization," which the "lesser evolved" seemingly never suffered from owing to their presumed lack of rationality, self-consciousness, and inhibition.[20] Offering a classic application of recapitulation theory and the evolutionary paradigm, Kellogg equated the "bowel habits" of "wild animals, wild men, healthy infants and idiots," all of whom in their "natural" state supposedly "lack the intelligence necessary to disturb their normal functions" and "have better sense than to interfere

with the normal promptings of nature." The Japanese, however, according to many westerners including Kellogg, occupied a middle position on the evolutionary ladder, and accordingly, they still exhibited healthy "colon customs." Although they were "rapidly becoming sophisticated," they were "not yet so far away from the influence of their primitive life as to have become obtuse to their physical needs as are the people of the older civilizations."[21]

As Kellogg's comments partially show, "lesser evolved" peoples did possess two bodily qualities desired by the "civilized": fertility and smooth internal flow. Popular health writers and doctors, including Kellogg, Hornibrook, and others, thus thought that by emulating certain primitive practices, civilized man could regain these lost qualities that were so crucial to maintaining his evolutionary edge. After visiting with the superintendent of the Bronx Zoo about the daily habits of the "higher apes" and inquiring about the "regularity" of the "feeble-minded" charges at Randall's Island, Kellogg determined that "Three bowel movements a day, indeed, is the prevailing habit among primitive people and the higher apes," with chimpanzees and orangutangs going as often as four to six times daily. Recommending that "we must choose our bills of fare from the coarse [vegetarian] products on which our primitive ancestors subsisted and on which our forest cousins still live," he warned that "One bowel movement a day is very marked constipation."[22]

Similarly, because "savages," "semi-civilized people, and the peasantry of civilized nations" evacuated in a "crouching or squatting position," Kellogg strongly suggested that "toilet seats should be low and should have a backward slope." However, given the absence of these qualities in the "ordinary closet seat" of the 1920s, a "stool about eight inches high" could be placed in front of the seat in order to support the feet, so that one's thighs on the abdomen could "compress the bowel."[23] Hornibrook, in *Restoration Exercises for Women* (Figure 4.5), concurred, favoring the use of a stool to produce stool; in a humorous note in the text, Geddes, who gave this copy to his second wife Frances, was unclear precisely which stool should be between ten and eighteen inches in size. Additionally, the author promoted abdominal exercises that mimicked the primal swivel of the hips and rejected the jerky, machine-like motions that supposedly came so easily to civilized, white people. By restoring themselves to primitive regularity, modern man and woman would be assured not only of increased vitality and fertility (given Hornibrook's belief in the link between constipation and sexual desire), but also of less likeliness for disease. A "speedy passage"

54 EXERCISES FOR WOMEN

is also a useful habit, and if the sitter always places her buttocks well into the chair-back, her body is much better supported than in the " leaning back " position.

When doing these movements, *don't hold the breath.*

Finally, let it always be remembered that—

Abdominal Movement is a daily necessity to prevent Abdominal Stagnation.

POSTURE IN EVACUATION

FIG. 14.
Showing natural posture for efficiently emptying the lower bowel.

POSTURE IN EVACUATION 55

FIG. 15.
Showing best substitute in civilised life for the natural posture, viz., use of small stool in lavatory. If preferred, hands may be clasped just below the knees. Stool should be about 10 inches high and about 16 inches to 18 inches long.

Figure 4.5. Norman Bel Geddes's copy of Ettie A. Hornibrook's *Restoration Exercises for Women* (London: William Heinemann, 1932), 54–55. In NBG Papers. Courtesy of the Harry Ransom Humanities Research Center and the Estate of Edith Lutyens Bel Geddes.

through the bowels ensured that "any putrefactive bacteria chancing to enter the body would be swept through the colon before they had time to establish a footing."[24]

The lore on constipation surfaced in a multitude of popular venues. In addition to learning its woes from lectures and sermons on eugenics, a businessman such as Egmont Arens, who was aware of the line of "Harper Books for Business Men, Spring 1932," could have selected to read *Functional Disorders of the Large Intestine* by Jacob Buckstein or *Peptic Ulcer* by I. W. Held and A. A. Goldbloom.[25] If he happened to work for a large corporation such as U.S. Steel, the Sherwin-Williams Company, or others trying to promote the good health and productivity of their employees, he might have had distributed to him *How to Live: The Nation's Foremost Health Book*. The book (prepared by Yale eugenicist Irving Fisher and Dr. Eugene Fisk under the Hygiene Reference Board of eugenicist Paul Popenoe's Life Extension Institute) contained chapters on "The Danger of Hasty Eating" and "How To Relieve Constipation Without Drugs," in addi-

tion to "Heredity and Mate Choosing" and "Eugenics and Birth Control."[26] In 1939 and 1940, a visitor to the New York World's Fair could have studied the model of the human digestive process created by the Deutsche Hygiene Museum, or the Saraka laxative exhibit at the Hall of Pharmacy. The latter contained a "new mechanical device," created by Donald Deskey, "consisting of turning disks and flashing lights" that showed "how peristalsis induces rhythmic flow of waste through the colon."[27]

Furthermore, the metaphor of bodily efficiency was applied to one role that the profession of industrial design played during the Depression. Streamlining in product design was considered to be a lubricant to the national economy that restored regular economic flow. Articles and advertisements in trade magazines in the plastics industry, for example, claimed that companies that shifted from handmade ornamental molds to streamlined machine-cut ones would not only save money through having less costly molds that took less material to fill, but also would increase sales through the resultant lower pricing, as well as through the use of innovative colored materials and modern styling. As company after company made this transition and saw increased sales, their competitors were forced to follow suit, creating an abundance of commissions for industrial designers as well as a constantly increasing number of streamlined products. Furthermore, designers actively promoted the economic benefits of planned obsolescence, to the extent that having a new model each year became standard company procedure as a way to increase consumer desire and spark sales. Whether or not the rise of industrial design actually boosted the gross national product is debatable and difficult to prove historically, as Jeffrey Meikle has shown. Yet, in the mid-1930s, some corporations undoubtedly did claim that redesign had in fact increased their sales, a fact that was due in part to the elimination of waste in materials and production processes.[28]

The familiarity of streamline designers with bodily process and metaphor, as suggested by the previous examples, is confirmed in their archives, almost all of which reveal that health, fitness, diet, and constipation were common concerns of theirs.[29] Although Raymond Loewy and Walter Dorwin Teague did not leave records of any of their digestive problems, both took pride in keeping fit and eating lightly, Loewy regularly having "an apple and saccharin-sweetened coffee" for lunch and indulging frequently in Turkish baths, ultraviolet rays, calisthenics, massages, and rubdowns at the elite New York Athletic Club.[30] Deskey's wife wrote home from Europe to his mother in 1926 that "Donnie" was "sick at his stomach. . . . [T]he dear boy has suffered from one of those refined and discussable maladies

140 *Chapter 4*

this winter called chronic constipation and then he's awfully careless about looking after himself and won't take exercises in the morning as I've started to do, because we get none except a bit of walking to keep us in trim." She lamented how hard he was working, sighing, "If he'd only follow my advice I think he'd be a lot better off, but this very condition makes him too tired and indolent to do the things he needs."[31]

Arens, however, struggled with his colon far more than the others on record. With his flat feet, "poor heart and 'wind,'" he could not "stand violent exercise" and became overweight. From boyhood on, he had been "exceedingly constipated Constipation would cause pounding in his ears—lassitude, loss of energy, general malaise." After visiting several doctors and trying "all kinds of cures . . . Bran—Japanese Seaweed—various gelitenous [sic] preparations . . . cod liver oil in beer" and mineral oil taken through various orifices, still "nothing worked" until he discovered that "Feen-a-mint—double dose—would liquefy" the bowel. In 1946, he received advice from a doctor at the Johns Hopkins Hospital to take laxatives and enemas, made of two quarts of water and a teaspoonful of metaphorically poignant Ivory soap flakes or oil, three times a week. He proceeded to do so for the next ten years, and complained of "headache and nausea" only if he washed his lower colon and failed to go deeper. Sounding like an advertisement for Ivory soap, he affirmatively declared, "the soapy water seems to get past the bottle neck."[32]

Although rarely ill, Henry Dreyfuss, on the other hand, lived the life of a typical "civilized" businessman that was so frequently bemoaned by health reformers, with one exception: he abstained from alcohol. Breathing "only the barest minimum of fresh air necessary to sustain life" while constantly working in his office, loving "good food," and getting "about as much exercise as a hibernating tortoise," he resorted to diet fads such as the "Clark Gable" to trim down. This oscillating health pattern continued throughout his life. However, whenever he thought a friend was "thickening too much in the midriff," "with a tactlessness he never display[ed] in business," Dreyfuss would "send him a neatly-typed caloric regimen and a portable bath scale." In his path-breaking book on ergonomic design, *Designing for People* (1955), he thrice mentioned digestion, noting that one of the designer's responsibilities was to lessen those things that impaired digestion. He set a formidable precedent with his sloping toilet seats (Figure 4.6), a design that matched Kellogg's recommendations in *Itinerary of a Breakfast*.[33]

Clearly realizing the demand for such a product in the sophisticated

Figure 4.6. Photograph of the Criterion Closet for Crane Co., c. 1936, designed by Henry Dreyfuss (American, 1904–1972). Henry Dreyfuss Collection, Cooper-Hewitt National Design Museum, Smithsonian Institution. Gift of Henry Dreyfuss, 1972.

"modern" home, in the late 1930s with the help of medical doctor Janet Travell, Dreyfuss designed a "cleanlined" saddle-seat toilet classily named the "Criterion." The toilet's design dramatically enforced the "hygienic correct posture" during evacuation; the sloped seat angled backward, achieving the "natural" position every time.[34] Only a few years earlier, another designer had heeded Kellogg's advice on toilet design by creating the "toi-lo-let," which hung from the wall "lower than the normal toilet, thus creating an important aid in the relief of constipation. A new patented toilet seat

registers the sitter's weight."[35] Various designs by Arens at this time also reflected his desire for smooth flow (Figure 4.7). Suggestively, given his personal experience, he designed a postwar bathroom that would break the "Bathroom Bottleneck" that many families experienced right before breakfast while everyone was readying themselves for the day. His design facilitated multiple people's use of the room at once by isolating the toilet and the shower in separate enclosures for privacy.[36] Earlier, in 1935, he had promoted a national highway system as the cure for America's "communications constipation." According to Arens, the country was "cramped and paralyzed by an obsolete transportation system. There are no veins through which the blood of National Energy may flow sufficiently strong and fast to keep this great sprawling body nourished."[37] Other designers and clients also expressed their need for smooth flow through streamlined styling. Expatriate Austrian architect Frederick Kiesler complained of the "constipated" spatial flow of certain floorplans, and Henry Luce of *Time* and *Life* magazines solicited Dreyfuss for suggestions on how to streamline the magazines' layouts. The designer suggested making *Life* "easy and comfortable to read" in part by having the pictures lead "from one to the next by their arrangement, cropping and selection. Flow is the word."[38]

Dreyfuss's apt statement captures equally well the concerns of eugenicists, health reformers, and designers. Both "civilized" bodies and the streamline style aimed for speed, regularity, and overall systematic efficiency. A body having these qualities was "fit," and therefore eugenic. It could seemingly forestall disease, increase economic productivity and fertility, prevent mental degeneracy, and serve as a catalyst for national efficiency and racial progress. Like bodies, modern buildings and products were also classified according to their "fitness," the level to which their forms suited their functions. Streamlined products bearing the traits of speed, regularity and efficiency, made the grade. The curved forms increased speed in mobile products by lessening drag, and in immobile products otherwise contributed structural strength, demanded fewer materials, and promoted sales owing to their popularity, thereby increasing economic flow to their designers and producers. Flow was indeed the word.

These traits of the style are all well-known and do not require understanding the popular concern with national and bodily efficiency for them to make sense, especially from an economic standpoint and from the standpoint of the physical laws of air and fluid dynamics. Given the style's theoretical roots in biological evolutionary theory, however, and designers' familiarity with literal and metaphoric constipation and products designed

BATHROOM BOTTLENECK is broken by Egmont Arens' new design for Post-War homes.

"DESIGN FOR LAVING," executed by top-flight industrial designer Egmont Arens of New York, like the recent "Maidless Kitchen" design, is challenging nation-wide attention of editors, architects, builders, prospective manufacturers of kitchen equipment and house furnishing retail merchants. Allegheny Ludlum, producer of stainless and other basic high-alloy steels, does not manufacture bathroom or kitchen equipment. The series of inspirational designs for postwar living is a service to its customer fabricators.

Mr. Arens borrows from the ancient Greek baths for inspiration and calls this glorified bathroom a lavatorium. One of its chief aims is to break up the prebreakfast hour bathroom traffic bottleneck, so exasperatingly familiar to most families. (Continued on page 175)

lights. (14) Drawers of "Pluramelt" stainless steel inside, porcelain enamel outside. (15) Clothes chute to basement. (16) Stainless steel top for wash basin and cabinet area. (17) Twin wash basins with drawers at either end. (18) Pedal control for water. (19) Stools swing out from under basins. (20) Built-in ash trays. (21) Closed space between bowls for towels, tooth-brushes, cleansing tissue, etc. (22) Spray head for shampoo. (23) Electric outlets between wash basins. (24) Built-in radio. (25) Fluorescent no-shadow face illumination. (26) Overhead lights at wash basins and tub.

(1) Closet for storing hair dryer, vibrator, etc. (2) Sun lamp and couch with waterproof covering. (3) Shelves over tub. (4) Extra high tub for ease in bathing children and cleaning. Has concave sides to prevent splashing. Made of porcelain enamel or stainless. (5) Thermostatic control for tub. (6) Pullout closets, may be reached from either side. (7) Three-way mirrors. (8) Separate tile or stainless shower room has three features; shower spray from three sides, shower convertible for steam bath, thermostatic control. (9) Separate toilet room. (10) Drying closet with slide-out racks, heated and ventilated for quick drying. (11) Built-in scale folds into the wall. (12) Pull-out stainless medicine chest reached from either side with safety compartment for poisons, etc. (13) Adjustable magnifying mirror with built-in

Figure 4.7 "Design for Laving: Postwar Bathroom," *House Furnishing Review* (Dec. 1944). In Box 46 "Clippings About Egmont Arens," Egmont Arens Papers. Courtesy of the Syracuse University Library, Special Collections Research Center.

to alleviate the condition, the possibility that the rhetoric of "speed," "efficiency" and "flow" in streamlining literature intimated eugenic notions of national and bodily efficiency must be considered. Their archives suggest that some designers did in fact correlate speed, intelligence, progress, and the reduction of drag with enhanced evolutionary progress.

Arens most clearly spelled out these connections in his speeches, beginning with "Creative Evolution of the Printed Word," his speech from 1933 whose title changes reflected Arens's belief that evolution was ultimately responsible for the increased tempo of modern times to which streamlining responded. The high level to which speed, streamlining, and evolution were interconnected was borne out through other talks of his, and in some instances, almost exactly mirrored contemporary eugenicists' concerns. In his lectures on "Streamlining in Nature," Arens showed his audiences slides of a variety of "high speed conveyances," which he then contrasted with an image of oxen. The oxen exemplified "early transportation" methods such as those used by "the first covered wagons that crossed the continent." His made his point clearly: "To drive a team of oxen does not necessitate fast thinking. A country yokel's slow wit is good enough at [three] miles per hour." Then he flashed a slide of a popular, record-setting racecar driver: "Compare that in your mind with Malcolm Campbell going at 300. As soon as he sees an obstruction he has to swerve—or else he hits it. He has to think 100 times as fast."[39] A few years later, Ellsworth Huntington, the Yale University professor who was also president of the American Eugenics Society, reiterated this idea in his presidential address in 1937. He stressed that "as life becomes more complicated the need of intelligence and character becomes greater. The drivers and mechanics who operate and care for a fleet of buses need greater intelligence, sobriety, and reliability than did the men of a former generation who drove stage coaches and cared for the horses. . . . Civilization constantly demands higher ability."[40] He had begun this analogy in print in *Tomorrow's Children* (1935), where he argued that, like "driving an automobile at sixty miles an hour . . . the greater the speed, the greater is the need for the utmost perfection" in "good inheritance, good training, and good health." Because "modern civilization has struck a sixty-mile gait," the need for a eugenic society was "greater than ever before."[41]

This idea of the greater rapidity and intelligence brought about by evolution was further elaborated by Arens, who was convinced that certain linguistic developments evidenced racial superiority. In his speech on typography, he described how picture writing was "the most important single

step in the history of human evolution," making "civilized society" possible, but that as society had become more complex, writing had shifted from pictures to symbols to words to letters. He attributed "the difference between Western civilization and Eastern" to this latter development. Because the eastern nations had not made the shift from having separate characters for each word to having letters make up the various words, Arens thought that "A Chinese scholar has to spend all his energy learning the language. There is no energy left for creative thinking. He has to learn hundreds of thousands of symbols."[42] On the other hand, Arens argued that "We learn twenty six, which are mastered at the age of ten years. That is the enormous economy of the phonographic system."[43]

Etymologist Paul Hugon agreed that efficient language was a trait of the "civilized." He opened his article "What Makes a Language Easy?" a copy of which he sent to Arens, with this reasoning. "Because language is the means of interpreting the whole human mind, any language that is adequate to that task in a highly civilized society can never be entirely easy to a savage," he wrote. "It is only in Teutonic languages, for example, that an electric switch can be simply and conveniently marked 'On' and 'Off.' The Latin languages have no such words. It is only in English that you can say, using the same word 'Go' unchanged in any position: 'Go! You can go! Why don't you go?'"[44] This efficiency, Arens believed, had been produced through the processes of "natural selection" that had weeded out all that was too "slow" and "cumbersome" and increased the tempo at which a text could be read. "This speed increment takes place exactly in proportion as the tempo of life advances."[45]

One such change, ironically, was the shift from text to photographs utilized by magazines such as *Time*. A critic of these photographic magazines explained that "carefully chosen pictures multiply the speed with which words can explain or describe an event. . . . [S]till and motion pictures speed up our learning processes, and tell a story more quickly and effectively than words." But, he warned, "let's be on our guard; for the mental effort required to absorb a story in pictures is slight indeed. . . . Pictures and signs were used by prehistoric man; the ability to use words, or language, is the chief distinction between civilized men and savages." Therefore, "If you are wise, if you wish to gain distinction as a civilized man, *words* will be your tools of thought, you will use *pictures* merely to help you clarify and visualize what you are learning."[46]

Other textual changes to increase reading speed included the rejection of capital letters in graphic design, employed by Bauhaus typographers in

their "universal" typeface as well as by an anonymous graphic designer creating the layout on the brochure for the "House of Tomorrow" at Chicago's Century of Progress Exposition. The designer constructed the text without capital letters at the start of sentences to avoid halting the reader's eye. In his text, he highlighted as well the efficient features of the house's design.[47] Still another was the "recognition of the non-sentence" extended by Dr. Janet Aiken, a linguist at Columbia University. Having learned of her accreditation of sentence fragments as proper writing, Arens wrote to her late in 1934 to commend her for making "a very important step in speeding up language to the needs of a fast-moving civilization. . . . We are already consuming too much energy climbing over the mountains and valleys of traditional speech when, as a matter of fact, we should have some straight and graded highway, so that ideas may travel a little faster than they did in the days of the ox-cart." She responded, "While language moves slowly, it does adapt itself to modern needs, does go streamlined to suit the modern tempo."[48]

Arens wanted to increase the pace at which ideas moved presumably so that more ideas could be absorbed in ever shorter amounts of time, as was demanded by the rapid evolutionary advance of the age.[49] Many people accepted this latter notion, believing even that evolution itself was even accelerating, thanks in part to eugenicists who were rationally controlling the selection process. Huntington captured this idea with an analogy to a race horse: "The difference between man as he might be under a sane eugenic regime and man as he actually exists is like the difference between an ordinary old-fashioned carriage horse that can only go a mile in four minutes, and a race horse that goes the same distance in less than two minutes."[50] Geneticists such as Thomas Hunt Morgan, who discovered the ability of x-rays to cause genetic mutations, were also seemingly speeding up "evolutionary changes over 1000 per cent."[51]

To some, this increased speed demanded increased intelligence, as well as streamlined fonts to further facilitate the increase of intelligence. As Arens asserted so clearly, "This age needs streamlined thinking to keep pace with our streamlined machines."[52] One reviewer of the Futurama at the New York World's Fair concurred by advocating the improvement of the "dumbbell mind" as a crucial step toward advancing the "world of tomorrow."[53] To this end, Arens praised the typeface used in the body of the *New York Times*. Although the Gothic script of the paper's title emphasized "the long-established *tradition* of the *Times*," the text was composed of "a very *fast-reading* type. . . . It is vibrationless, quiet, streamlined for speed."[54] The

civilized person reading it, therefore, could cover many of its articles during a coffee-break, acquiring knowledge while at the same time keeping his or her much-needed mental muscles in tone.

Yet, at a round-table discussion on "Fashion in Typography" that included Egmont Arens, René Clark and Joseph Sinel, an anonymous young man in the audience asked a significant question: "Why all the speed? . . . I know when I read a beautiful book, I don't want to rush through it." The panel members all agreed that, for commercial purposes, speed was essential. Clark explained, "We are up against right now a speeding up of our whole civilization—our whole life. The tools we have to control with regard to speed have to be sharpened and have to be made as effective as possible so that we can handle this amazing machine which is tearing along at a great speed. We have to perfect the machinery that holds it in order," and he might have added, lest it fall apart.[55] Arens, in fact, concluded his lecture on "Tempo in Typography" with this very idea: "Our whole civilization may come to a standstill unless we can develop faster tools for thinking." As a style permeating U.S. industrial, graphic, and architectural design, streamlining offered just the tool he desired to maintain the nation's economic and evolutionary edge.

At the same time that the greater intelligence and productivity supposedly brought through evolutionary advance was capturing the public spotlight, corresponding attention was being paid to increases in the area of physical speed based upon heredity. A book review of *Fishes and Their Ways of Life* (1935) caught Arens's eye by stating, "Prof. Roule discourses on the connection between blood and speed (the fastest fishes have the richest blood streams)."[56] Arens was already generally aware of this principle, for as mentioned previously, his lectures on "Streamlining in Nature" included examples of purebred animals, such as the greyhound, whose speed was "in the blood."[57] Harry Laughlin, superintendent of the Eugenics Record Office, had been making similar determinations as well in his study of the inheritance of racing capacity in the thoroughbred horse. Despite the genetic complexity of the inheritance of traits involved in racing capacity, Laughlin still was certain that "all of the hereditary units which make up racing capacity are inherited in accordance with chromosomal behavior." In the display showing his results at the Third International Congress of Eugenics at the American Museum of Natural History in 1932, he included his discovery that racing speed itself was seemingly accelerating. Based upon statistical studies of one hundred and fifty years of records of racehorses, he determined that "selectively breeding swift horses has progressively pro-

duced swifter ones."[58] Whether in horses or humans, swiftness and slow-
ness were derived from one's ancestry, eugenicists believed, and were
related to how streamlined one's physique was.[59] "In industrial societies,
natural selection favored brain power," writes historian James Whorton.
"Heavy musculature work was for 'animals or the lower races.' Greater
than usual bulk was thus a burden in the 'race of life;' 'piles of parasitic
muscles' required 'an undue amount of nourishment,' lowering bodily ef-
ficiency (and thus brain power)."[60] A svelte, streamlined body with an intel-
ligent mind, such as that represented by the Transparent Man, represented
the evolutionary ideal.

The public thrill for physical speed during the late 1920s and 1930s is
apparent in the large amount of news coverage awarded to champions—be
they pilots, racecar drivers, trains, horses or dogs,—which showed that the
breaking of speed records had become a national fascination.[61] The Trans-
atlantic flight of eugenics-supporter Charles Lindbergh in 1927 evoked na-
tional and international hysteria partly because it beautifully symbolized
the technological and racial advance of Euro-American civilization. In 1934,
multiple newspapers headlined the successes of American planes and trains,
which won international races and shattered domestic transcontinental
records.[62] More local speed thrills were obtained at the racetrack and show
ring, where thoroughbred horses and greyhounds competed to the joy and
chagrin of betters and breeders. The *New York Herald Tribune* and other
newspapers offered regular coverage of champion dogs and horses (Figure
4.8), of which Arens and Teague saved numerous clippings.[63] Illustrations
and advertisements in *Vogue* magazine depicted "well-bred" men and
women wearing their finest fashions (such as "Whippet" gloves and clothes
made from "thoroughbred" fabrics) at the horse and dog races, at times
symbolically holding purebred pets at arm's length on a leash (Figures 4.9
and 4.10).[64]

The greyhound, in particular, caught the attention of sculptors, de-
signers, advertisers and businessmen alike as an apt symbol of evolutionary
acceleration, streamline sophistication and good breeding. Diana sculptures
graced the gardens and vacation ships of the wealthy, serving less as a re-
minder of the hunt than as an affirmation of the beauty and fitness of
the Euro-American purebred.[65] In 1928, preeminent animal sculptor and
feminist Katherine Lane Weems captured the spirit of the race in her *Grey-
hounds Unleashed*, subtly giving a female greyhound the edge over her male
competitor (Figure 4.11).[66] Greyhound Bus Company used the racing figure
for its name and logo; when Loewy began designing for them in the late

Figure 4.8. Newspaper clipping of racing greyhounds. In folder "Animals—Dogs, Cats, Wild Birds," Box 3, WDT Papers. Courtesy of the Syracuse University Library, Special Collections Research Center.

1930s, one of his first steps was to make the logo less bulky and more streamlined by reducing the greyhound's weight and musculature. Throughout the 1930s, hood ornaments of striding greyhounds, anchored only by their back legs, graced Ford and Lincoln Zephyr automotive models. Teague streamlined them even further in his 1940 design for the Lincoln Zephyr Continental and Custom by enclosing the animal's form within the metal ridge marking the hood's center (Figure 4.12).[67]

Other automobile designers took notice of the greyhound as well, structurally placing their engines in such as fashion as to mimic the anatomical arrangement and weight distribution of a greyhound. For a postwar Studebaker design, Loewy wanted the car to "look fast, whether in motion or stationary. I want it to look as if it were leaping forward. . . . I want one that looks alive as a leaping greyhound."[68] Visitors to the New York World's Fair could "Greyhound through the Fair" by riding the buses provided; some likely even saw a float of "America" (Figure 4.13), symbolized as a mammoth white racing greyhound, setting a fast pace for the world to follow in both technology and racial purity.[69] By the time this float was made in the late 1930s, European countries (Germany in particular) had already grabbed the torch of eugenics from the U.S. and sprinted into the lead. However, enough Americans were still absorbed with increases in speed, intelligence, and genetic purity that, from a historical vantage point,

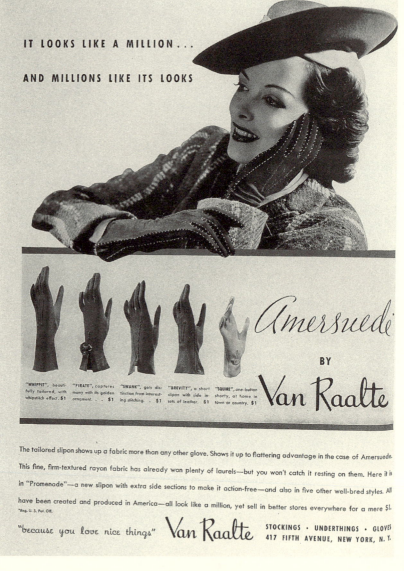

Figure 4.9. Van Raalte glove advertisement, *Vogue* (15 Aug. 1939), showing the "Whippet" as one of "five other well-bred" styles.

The Sporting Thing
at Belmont

Casual Clothes .. in Enka Fashion Approved Rayon

To the selection of her casual clothes, the smart woman gives meticulous care. Here, where distinction of fabric and line are of such tremendous importance, fine fabrics of Enka Rayon are always regarded as thoroughbreds.

• At famous Belmont Park where gather women who know fine horses and clothes.

At Saks Fifth Avenue ... each $29.95

Prominent in new sports clothes is a dull, slightly rough crepe woven with Enka Rayon. The crisp lines and veering chain-tucked skirt of the dress on the left use to excellent advantage this rich fabric texture.

Jersey, so important in the sportswear picture for fall, is at its best in this new version, knitted with Enka Rayon and combining textural interest, correct drape, and exciting color combinations. The dress at the right shows an adroit use of stripes in this jersey.

The FATE OF A FABRIC HANGS BY A THREAD

Fashion APPROVED

ENKA Rayon

This Enka Fashion Approved tag on clothes is the symbol of verified quality and authentic fashion.

THE FASHION NAME IN RAYON
STANDARD OF SUPERFINE YARNS

ENKA RAYON

206 MADISON AVENUE · NEW YORK

Figure 4.10. Enka Rayon advertisement, *Vogue* (1 Sept. 1939): 24, which characterized their "fine fabrics" as "thoroughbreds" for the "smart woman."

Figure 4.11. Katharine Lane Weems, *Greyhounds Unleashed*, bronze, 1928. Collection of Brookgreen Gardens, Pawleys Island, South Carolina.

the thoroughbred greyhound seems to have been on its way to becoming a prominent national symbol.[70]

After all, the American Birth Control League founded by Margaret Sanger had been working throughout the 1920s "To Breed a Race of Thoroughbreds," as their slogan declared, and W. E. D. Stokes envisioned his nephew, Anson Phelps Stokes, Jr., a potential candidate for the presidency of Yale University in the 1920s, turning the school into a "Stud Farm for boys" which would "graduate men with healthy bodies and healthy minds, trained to realize their duties to their country, themselves and their offspring."[71] Fitter Family Contests across the nation had been promoting this ideal to the middle class by hanging out signs that asked, "Are You a Human Thoroughbred?" (Figure 4.14), while Chesterfield Cigarettes took up the theme of the thoroughbred in their advertisements as a way to market their goods to the elite. Church congregations learned not to breed from "'scrubs' but from pure blood . . . and pedigreed stock," and that "whether it be the live stock at the fair, the horses on the track, or a brilliant assemblage of men and women, there is nothing in the world so striking, so inspiring as a thoroughbred. Nature, unaided, . . . produces no thoroughbred class," yet, through cooperating with Nature, man could produce

Figure 4.12. Walter Dorwin Teague, Radiator ornament for the Lincoln Zephyr Continental and Custom. On Microfilm Roll 35-6, WDT Papers. Courtesy of the Syracuse University Library, Special Collections—Research Center.

the "perfect type, whether it be an American Beauty Rose, . . . a seedless orange, . . . a Morgan or a Clysdale, an Ayrshire or a Jersey, a champion in the Olympic games, or a gentleman and a scholar."[72] Through cooperation with the natural principles of streamlining, designers likewise strove to create the "ultimate type" for each design through "the perfect adaptation of form to function" and the removal of drag-producing impurities.[73] The smooth flow they literally and metaphorically achieved thus had to have resonated, consciously or unconsciously, with the widely popular belief that greater intelligence, speed and evolutionary progress would come through thoroughbred bloodstream lines.

Overlaps in the language and ideas of national, bodily and product efficiency—as embodied in the theories and writings of eugenicists, health reformers, and streamline designers—were multiple and apparent in the interwar period. As Dreyfuss declared, "Flow is the word," and all three utilized the terminology and metaphor of the "stream." Yet in all, the stream was blocked by "massive obstacles" which hindered efficiency and forward evolutionary progress.[74] These protrusions, which were socially,

Figure 4.13. "America" float, New York World's Fair. Photo developed by Charles Dreyer in 1939. In Box 68, Egmont Arens Papers. Courtesy of the Syracuse University Library, Special Collections Research Center.

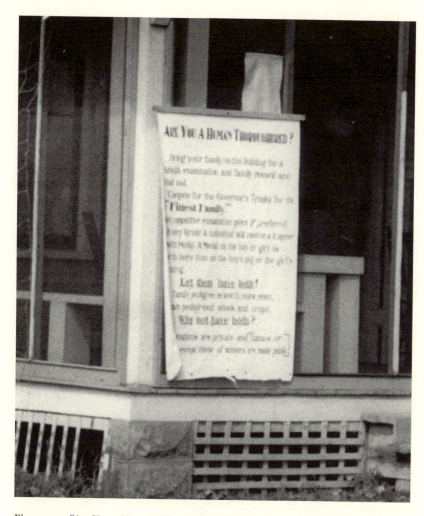

Figure 4.14. "Are You a Human Thoroughbred?" detail of a photo of "Fitter Families for Future Firesides" exhibit. Photo in the scrapbook of the American Eugenics Society, AES Papers. Courtesy of the American Philosophical Society.

genetically, intestinally, or artistically "out of line," caused "parasite drag" (i.e., "autointoxication"), a poisonous condition that exponentially decreased productivity by robbing the host of its efficiency, energy and profits. Affected social groups, colons, and products were termed "delinquent" and their presence evoked fear for the mental stagnation and degeneracy that were thought to accompany them.

To further evolutionary progress, therefore, politicians, health reformers, and designers turned to streamlining as a means of restoring purity to their respective areas of reform. By trimming the waste/waist and reforming the "tail end"—be it an evolutionary "inferior," an obstinate colon, or a non-tapering product design—efficiency experts in each case eliminated drag and restored smooth, speedy flow, thereby ensuring continued mental and racial progress.[75] Both designers and eugenicists demanded an overall increase in physical performance, mental speed and national intelligence as a necessary accompaniment to the seeming increase in the pace of evolution and its increase of the speed of products and production processes. Designers' visions of a speedy, progressive, streamlined technology thus worked hand in hand with the corresponding social amelioration proffered tantalizingly through the implementation of eugenics and health reform. In this process, however, hygiene—whether "race hygiene," colon hygiene, or "cleanlining" in product design—played a crucial role, as the next chapter shows.

Race Hygiene, Product Hygiene: Curing Disease Through Sterilization

In the early 1920s, when Harry Laughlin mailed out the "Eugenics Instruction Questionnaire" to hundreds of colleges throughout the U.S. asking them what courses they taught pertaining to eugenics and human heredity, more than a few schools replied that courses in "Sanitation and Hygiene" treated the subject. At the University of Kentucky at Lexington, for example, a "new department of Hygiene in the College of Arts and Sciences" was being planned "in which the subject will be treated more fully."[1] Such a department would likely have offered courses on social hygiene (which focused on public health issues surrounding the spread of tuberculosis and sexually transmitted diseases), mental hygiene (psychological health and the prevention of feeblemindedness), race hygiene (eugenics), personal hygiene (nutrition, cleanliness, bodily health and efficiency), and community hygiene (hygiene in the home, office and city).[2] Clearly the term "hygiene" entailed more than the basic cleanliness and germ prevention practices we attribute to it today.

Although scientific discoveries from the late nineteenth and early twentieth centuries had for the most part disproved the Lamarckian theory of the inheritance of environmentally acquired characteristics, the implications of this knowledge filtered very slowly into everyday understandings. The result was a certain vagueness on the distinction between the roles of external environmental influences (germs) and internal hereditary constitution (germ plasm) in the production of disease, a vagueness captured in part by the similarities of the terminology used.[3] To those who continued to hold to outdated neo-Lamarckian thought, germs and germ plasm were equally viable and mutually influential sources of disease. Hygiene, therefore, encompassed both; cleanliness often referred as much to having a pure hereditary lineage and unblemished moral record as it did to keeping one's body and home free from dirt. One minister explained that "health is a

much more capacious word than we may imagine. There can be no health in the best sense of the term which does not include mental health and moral health. Health and holiness are kindred words. . . . But not every child is holy. Not every child has a clean biological history. . . . [W]e owe it to them, as to ourselves, to keep clean the blood-stream that must carry our gifts to the future."[4]

Despite the fact that race hygiene sometimes comprised a specific category within the larger field of hygiene because it entailed its own set of concerns and approaches, eugenic thought had long played a prominent role in *all* of the branches of hygiene reform, in part because of the explicit correlations between personal habits and hereditary acquisition suggested by neo-Lamarckian theory. For example, the prevention of reproduction through segregation and sterilization of the institutionalized had long concerned mental hygienists. Meanwhile, social hygienists, who dealt primarily with civic issues in relation to transmissible sexual diseases, emphasized the race-destroying effects of venereal diseases; syphilis could induce insanity and blindness in its late stages while gonorrhea rendered its victims sterile. Many social hygienists also supported state-initiated "healthy marriage" statutes that prevented inflicted individuals from marrying and presumably, therefore, from reproducing and passing on their diseases to their future spouse and children. Furthermore, because prostitutes, whom many eugenicists classified as de facto mental defectives, were thought to be the primary source for the contraction of venereal diseases, social hygienists and eugenicists worked together for the "prevention of vice" and the expurging of the moral, mental, and physical damage it was thought to bring upon the race. Even colon hygienists such as Kellogg and his associates upheld the race-improving effects of good internal hygiene. Additionally, advocates of personal and civic sanitation considered cleanliness a mark of high evolutionary status, for by avoiding disease the health-conscious individual increased personal and national productivity, fitness, and superiority.

The term "race hygiene," first coined in 1895 by German scientist Alfred Ploetz, made explicit these implicit correlations between eugenics and hygiene.[5] Ellsworth Huntington explained in *Tomorrow's Children* that eugenics was called "race hygiene" because "it will do for the race what personal hygiene does for the individual. . . . [D]efectives . . . may be compared to an insidious disease affecting the body politic," such as tuberculosis.[6] Just as the tubercular at first were simply isolated to prevent the spread of the disease, and then doctors attempted to cure and ultimately eliminate the disease, so Huntington reasoned that "defectives" were initially segre-

gated to prevent the reproduction of their defects. This institutional phase, however, was far from being the ultimate goal. Through reproductive sterilization, American eugenicists hoped to rid the race of its defectives forever.[7] This comparison of humans with disease was furthered through use of the appellation "social parasites" that eugenics supporters gave to the "socially inadequate," which to some in Germany included Jews and in the U.S., African Americans and immigrants.[8] The ultimate solution for the insidious germ reproduction of both disease-causing parasites and "social parasites" lay in sterilization: the use of reproductive sterilization for defective "germ plasm" and disinfectants for germ-infested environments. Hence Earnest A. Hooton's reference to the sterilization of habitual criminals and the feebleminded as the nation's much needed "biological housecleaning."[9]

Given the wide social, political, and ideological range covered by the term "hygiene," the eugenic aspects of its various fields, and the numerous overlaps between eugenics and streamline design (including the concept of "parasite drag"), designers' concerns with the sanitary aspects of "clean-lined" design demand closer examination. The closest designers and critics came to associating hygiene in design with eugenic ideals was through their correlation of hygienic design with the ideals of "civilization," and through utilizing an approach to product design intended to ease the sterilization of germs, an approach that conceptually paralleled that of eugenicists aimed at sterilizing the human germ plasm. These correlations made sense, and perhaps derived from a similar set of ideals, given the popular ideological continuation of neo-Lamarckian ideas that held quality of environment to be a significant agent in hereditary alteration.

By the 1920s and 1930s, however, the popular switch from neo-Lamarckianism to Mendelism marked a corresponding shift in which the predominant emphasis upon hereditary improvement moved from outward environmental agents (the "nurture" side of the nature-nurture split) to inward genetic manipulation. The effect of this shift can be seen in industrial design through designers' determinations that product "disease" could be cured by making fundamental changes on the inside (in terms of both a product's interior mechanisms and its production processes), which were then carried through to the exterior of a product's appearance and packaging. Streamline design, therefore, marked this shift in popular scientific theory in that it theoretically embodied both the residue of neo-Lamarckian rhetoric of the power of hygienic design to effect "civilization," as well as a Mendelian approach to product reform.[10]

In the decades preceding the advent of streamline design, social reformers, eugenicists and architects alike promoted hygiene of the body, home, and environment as a predominant influence on and symbol of the advance of "civilization." Although the civilized were thought to have frailer physiques and thus be more susceptible to certain diseases, this weakness was more than compensated for by their highly developed rational powers that continued to secure successes over nature's setbacks, including disease, through scientific research and technological innovation. To this end, Louis Pasteur's, Robert Koch's, and other investigators' discoveries in the 1860s and 1870s of the role of specific microbes in the cause and spread of deadly communicable diseases led to the formulation of the germ theory of disease. This theory strengthened an already well-known tool for disease prevention. Although antimicrobial drugs were not available until the 1930s and 1940s, in the interim, hygienic practices applied to the dirty, dusty environments where germs flourished helped to control the proliferation of disease.[11]

Reformers, including architects and designers, who were disseminating this theory and applying hygienic techniques, first targeted the "civilized" classes and races as the primary beneficiaries of hygienic knowledge.[12] Many lower-class whites and African Americans only learned about hygiene second-hand from working for their "upper-class 'betters,'" and especially around the turn of the twentieth century, this practice for some was part of a broader Social Darwinist strategy of letting disease work its way among certain populations, weeding out the "unfit."[13] Because hygienic practices offered the chief means for combating the spread of disease and germs through sterilization, those who were "in the know" gained an edge in the struggle for the survival of the fittest. One's being "hygienic," therefore, became almost equivalent to one's being civilized and even American; it further marked one as highly moral, for according to some, "cleanliness was next to godliness."[14] When compared to what they perceived as the cluttered, unkempt tenement quarters of the newly immigrated, the sparse, clean whitewashed interiors of the single-family homes of "native" whites bespoke their superiority and established a visual language that historian Nancy Tomes refers to as "cultural eugenics" (Figure 5.1).[15]

The association of cleanliness with the "civilized," especially around the turn of the century, likely stemmed in part from neo-Lamarckian thought; over time, one would internalize the cleanliness of the exterior environment in which one lived, manifesting in turn the qualities of physical health, hygienic habits, and perhaps even morality. Although George

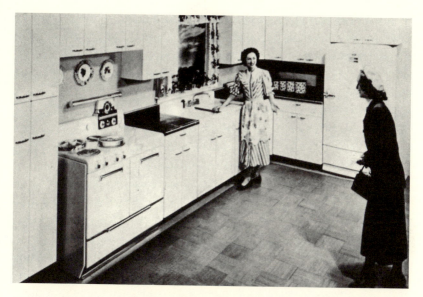

Figure 5.1. Advertisement for Frigidaire kitchen appliances designed by Raymond Loewy, in Loewy, *Industrial Design* (Woodstock, N.Y.: Overlook Press, 1979), 114.

Stocking, Jr., writes that by the end of the 1920s social scientists generally had accepted the new notions of heredity and culture which stemmed from Mendelian principles, some respected biologists and eugenicists, as well as eugenics followers, were still discussing the hereditary nature of acquired characters well into the 1930s.[16] For example, opening a 1924 lecture on the "Inheritance of Acquired Characteristics," Herbert Spencer Jennings admitted that his subject had become "disreputable" among experimental biologists, to the extent that if one defended the theory, "colleagues begin to look sideways at you, and expect . . . that you will wind up in a psychopathic ward if not in jail." Despite this denial of validity to the theory, however, Jennings claimed that in fact many biologists "do lean toward the idea that inheritance of acquired characters does play a part in evolution."

He proceeded to present the evidence in its favor. Some chemical agents (he mentioned alcohol) did directly affect the germ cells, and some environments did produce functional and structural changes in multiple generations of an organism.[17] In part because of this evidence, eugenics researcher Wilhelmine Key wrote to Charles Davenport the same year about her work at the Battle Creek Sanitarium: "Once more the vexed

question of the inheritance of acquired characters!" Key was trying with little success to reproduce results in favor of the theory from genetic experiments first demonstrated by Professor Paul Kammerer.[18] Professor Alfred Lane at Tufts University was also giving the subject thought, and in correspondence with Davenport he even elicited a surmise from the respected eugenicist on the matter. Davenport had noticed that "so often the children of naturalists are artists," which led him to wonder if the parents' "highly developed aesthetic sense" that led them to study nature was imparted to the child as a "desire to reproduce the forms and colors of nature. Whether a specific hormone can influence a specific gene I do not know."[19]

Regardless of most scientists' beliefs on the subject, much of the public still adhered to Lamarckian interpretations into the late 1920s and 1930s.[20] In his history of dietary reformers from the turn of the twentieth century, James Whorton emphasizes that these reformers connected dietary improvement with race betterment precisely because they believed in the inheritance of acquired characteristics. He writes that despite Weismann's discoveries, "The absolute distinction between the innate and the acquired was a concept so novel, so contrary to traditional common sense, that it was not generally assimilated until the second decade of the [twentieth] century," or as the evidence suggests, even later.[21] In 1920, the inheritance of acquired characters and mental traits were topics treated by theses in the Zoology department at the University of Colorado at Boulder.[22] In 1926, a less academic audience in Sterling, Massachusetts, learned the law of acquired characteristics at church. Because the next generations supposedly would be directly impacted by one's present actions, one should conscientiously make a "contribution of purity" to the "Stream" of the "Human Germ Plasm."[23] Another congregation was told that "As the germ plasm embodies every change in the individual, Isaac, the son of Abraham, inherited a greater capacity for faith than his father began with."[24] And, at a eugenics meeting in Houston in 1928, Leonard Darwin (Charles Darwin's fourth son, who presided over the Eugenics Education Society in Britain) told the women in attendance that the effects of spanking could be multigenerational: "If it is producing heritable effects, it will in the future make children slightly more tractable by nature as each generation makes its appearance."[25]

Architects in the early twentieth century also held on persistently to the belief that environment influenced inherited traits. As late as 1925, in *The Decorative Art of Today*, Le Corbusier proclaimed that if a state were to mandate that all interior walls of its citizens' homes were whitewashed in

place of the current practice of decorative wall-hangings, that this outer cleanliness would then produce an inner cleanliness and enhance the morality of the home's residents.[26] According to such a program, he described how a citizen's "*home* is made clean. There are no more dirty, dark corners. . . . Then comes *inner* cleanness, for the course adopted leads to refusal to allow anything at all which is not correct, authorised, intended, desired, thought-out: no action before thought. . . . Whitewash is extremely moral."[27] Such a decree would have had lasting effects, for according to Herbert Spencer, whose writings had popularized this idea in the late nineteenth century, "Hereditary transmission applies to psychical peculiarities as well as to physical peculiarities. While the modified bodily structure produced by new habits of life is bequeathed to future generations, the modified nervous tendencies produced by such new habits of life are also bequeathed; and if the new habits of life become permanent, the tendencies become permanent." From this he deduced that one "needs only to contrast *national characters* to see that mental peculiarities caused by habit become hereditary."[28]

While Le Corbusier aimed to improve the French character through whitewash, almost thirty years earlier in 1898, Adolf Loos had argued in his essay on "Plumbers: Baths and Kitchen Ranges at the Jubilee Exhibition," that state-initiated improvements in Austria's hygiene would raise Austrians' evolutionary level of "civilization" to where they would be racially and economically competitive with the citizens of Britain and the United States. Loos posited that the evolutionary progress of cultural and racial advance obtained by people of Germanic background during the Middle Ages, as shown by the great German bathhouses, had been halted through the influence of the French under Louis XIV. The attitude of the "enameled" French nobility—that only commoners got dirty and hence needed an occasional bath—became the Austrian creed to Loos's day, as revealed by the pitiful showing of Austrian plumbing goods at the Jubilee Exhibition. Voicing the same harsh evolutionary judgment as he did for those Austrians producing "primitive" ornamented products, he declared that, in the area of plumbing, "We are behind the times." While Austrian development had remained stagnant for centuries, Loos felt that England and later the United States had become the site where Germanic culture had continued to advance, as evidenced in part through their deep commitment to cleanliness.[29]

In order to remedy Austria's backwardness, Loos asserted that it was "in the state's own interest to raise the level of cleanliness among the population" by pouring money into plumbing instead of the arts. Such a pro-

gram would ostensibly make Austria evolutionarily and economically competitive with the English. As Loos stated, "A people can keep pace with the English in economic matters only if they come close to them in water consumption; a people can oust the English from their position of world domination only if they exceed them in water consumption." Thus, to "increase the amount of water we use is one of the most urgent tasks facing our civilization." Loos pleaded with Viennese plumbers to "do their utmost to bring us closer to our goal of achieving the same level of civilization as the other advanced nations of the West," for if they didn't, "something rather unfortunate and very embarrassing might happen." Because he believed that "Germanic culture" (in English hands) had "set out on a triumphant progression all around the world" and that "Those who accept it become great and powerful," the possibility that "the Japanese might attain Germanic culture before the Austrians," if Japan and Austria continued to "advance at the same rate," was insulting to him and his idea of western superiority.[30]

Did modern architects and streamline designers really believe, Lamarckian-style, that hygienic environmental reforms would produce a corresponding genetic improvement in the people living in that environment? Loos's statements on hygiene were likely based upon this premise, as evidenced by his literal interpretation of the theory of the inheritance of acquired characteristics in his essay on "Footwear" of the same year, in which he stated that changes in walking speed had narrowed the "modern" foot.[31] By living in clean environments and having clean bodies, Loos thought that Austrians could internalize cleanliness, becoming genetically less susceptible to disease and hence more productive, efficient, and competitive on the international scene. A similar but contrary belief occurred in the U.S. in the late 1800s regarding the impact of unhygienic conditions upon lower-class tenement dwellers, in which it was argued that prolonged exposure to a filthy environment weakened a body's overall resistance and increased disease susceptibility.[32]

By the time of Le Corbusier's writing and the birth of streamlined design in the late 1920s and 1930s, however, such a literal Lamarckian interpretation of the workings of improved environmental hygiene was unlikely. Le Corbusier may have thought that whitewash enhanced morality and streamline designers may have thought that living in a "cleanlined" environment reduced the likeliness of disease or improved character, but in doing so they likely either relied upon a residue of implicit Lamarckian assumption, or else they considered the correlations to be "cultural" or due

to a decrease in the number of germs and not a decrease in a person's genetic susceptibility. A statement by Walter Dorwin Teague, however, like Le Corbusier's on whitewash, is sufficiently vague on the issue. Referring to the influence of his interior designs, Teague stated that "Inevitably the people who live behind the facades we create assume these characteristics we give them, to the betterment of themselves and the world—that is, if they do not have them already, which usually they do."[33] Henry Dreyfuss, too, rephrased this question in his book *Designing for People* (1955), captioning one section, "Is good taste inherent or acquired?" Although he concluded that "for most people, the ability to select things in good taste is cultivated," he makes it clear that the upper classes develop the "judgment" of good taste far more easily than those "persons in low-income brackets."[34] Because various aspects of streamline designers' theories *were* in fact derived from neo-Lamarckianism (for example, functionalist principles), however, the hygienic aspects of cleanlined design and its associations with "civilization" need to be considered from this perspective.

Large-scale public health crusades during the first two decades of the twentieth century heightened public awareness that tuberculosis and other diseases were caused by ingesting microbes in the dust and air that were spread by flies and other insects, as well as through spitting, coughing, sneezing, sharing drinking cups, and eating with unclean hands.[35] Such attention focused concern on the environment not only for its role as an agent of future change but also as a harbor of germs affecting the present. Experiments that successfully grew bacteria by exposing warm broth or petri dishes to outdoor air and dust emphasized the all-pervasive presence of germs.[36] Numerous popular magazines, including Kellogg's health tracts, reinforced these lessons by warning against various activities, such as sleeping with one's mouth open at night. The "numerous bacteria and microbic forms found in the air are deposited upon the tongue . . . and grow rapidly," producing overnight "a thick foul coat upon the tongue, a disagreeable, unpleasant tasting slime."[37] To combat bacterial growth and the spread of disease, Americans implemented sanitation and sterilization measures on a variety of levels, from the personal use of mouthwash to civic adoption of urban sanitation crusades. Women's magazines particularly stressed the importance of personal hygiene of the body and home to their predominantly middle- to upper-class white readerships, who held themselves socially responsible for moral and domestic leadership. These women understood that unsanitary bodies, homes, and neighborhoods only in-

creased the concentration of germs and the likeliness of disease, in addition to manifesting low morality.

Yet, despite their frequent desire to do so, rural whites, lower-class immigrants, and African Americans, among others, who often lived in areas devoid of plumbing and who maintained strenuous work schedules that precluded constant home maintenance, found it difficult to maintain high standards of cleanliness. As wealthier parts of cities became cleaner, therefore, disease became more and more associated with slums and tenement areas. Tuberculosis shifted from being considered a "house disease" to being a "*tenement* house disease," and slums became known as "breeding grounds"—for both germs and "defective" germ plasm—and as "blighted" areas. Blight, a disease caused by parasites, bacteria, or bad environmental conditions that hinders the progress of a plant's growth, offered an apt metaphor not only for the actual diseases in the slums but for the "diseased" immigrants themselves, who resided there and supposedly reproduced themselves (as did parasites) "with the reckless prodigality of rabbits."[38]

Because of the association of disease with slums, physicians and sanitarians expressed concerns that the wealthy, who lived in homes replete with the latest plumbing advances, could still become ill from a "zephyr" blowing over a nearby urban slum carrying disease germs in through an open window.[39] The inability of tenement dwellers to stay clean proved to some their preexisting, innate inferiority as members of the "lower" races. Critics claimed they were "careless" and "unteachable," unable even to learn sanitation "skills," owing to their limited intellectual capacities that had seemingly been demonstrated by poor performance on intelligence tests biased in favor of "native" middle- to upper-middle-class Americans.[40] The filthiness of slums not only evidenced residents' inferiority but also ensured their continued degeneracy, for "filth bred chaos and barbarism while cleanliness ensured order and advancement."[41]

Advertisements from the 1920s and 1930s for cleaning products such as Fels Naphtha soap, therefore, specifically targeted immigrant women by addressing the hypothetical "Mrs. Orozco" and "Mrs. Kowalski." These "Americanizing" ads promoted their product as the cure for the immigrant woman's "primitive," "squalorly" cleaning techniques.[42] In a similar attempt to Americanize immigrants by changing their domestic and bodily cleaning habits to those of "native" whites, Henry Ford instigated a company hygiene policy in which managers investigated workers' homes to insure the families' ardent use of soap and water.[43] Although cleanliness came

to be seen not only as a way to prevent disease but also as a route to white-collar status and American citizenship, this route was only open to some. For many African Americans, "Once they removed their dirt, whites found it nearly impossible to forgive them their color."[44] Although neo-Lamarck-ian ideas were applied in the opposite direction, whereby whites living in proximity to African and Native Americans supposedly would inherit a "downward pull that is contagious like a disease" (as Carl Jung asserted in 1930 in *Forum* magazine), the reverse often remained an impossibility. Although cleanliness was tantamount to being "civilized" and bodily clean-liness was attainable, "civilization" largely remained the sole prerogative of whites.[45]

Based upon such an understanding of the dust and germ theories, the issue of disease around the turn of the century was debated in design through hygienic approaches to interior design, as well as through segrega-tion and slum clearance in urban planning. Known generally as euthenics, the movement that promoted racial improvement through environmental reforms had many followers. As the root idea contributing to the rise of home economics programs, euthenics was taught in 1920 in college courses across the country, Laughlin's survey showed.[46] Architects and reformers, such as Loos in Austria and proponents in the U.S. of the stripped-down Mission style and the work of Frank Lloyd Wright, ordered their interiors according to euthenic principles. They replaced the "frilly home furnish-ings" typical to Victorian-style interiors, including carpets and upholstered furniture that harbored "bacteria-laden dust," with sparer furnishings. Gaining prominence were bare wooden furniture, fewer decorations and moldings to catch dust, wooden floors with easily cleanable throw rugs, tiled floors in kitchens and bathrooms for easy mopping and sterilization, and walls painted with disinfecting hygienic paint (such as Du Pont's Sani-flat paint) or whitewash.[47] White enameled surfaces on plumbing fixtures highlighted dirt and grime, which could be easily wiped away, and stronger flushing mechanisms in toilet bowls added cleanliness by dislodging waste residue from the interiors.[48] Numerous windows increased ventilation, en-couraging the exchange of stale air for fresh.

In some polluted urban areas, however, opening windows only in-creased the amount of dust, dirt, and wind-borne germs inside home interi-ors and even allowed entrance for disease-carrying vermin.[49] Regardless how clean middle- to upper-class whites kept themselves and their neigh-borhoods in their efforts to lessen disease and further "civilization," if the hundreds of thousands of immigrants settling in urban areas prior to the

federal anti-immigration act in 1924 failed to conform to the same hygienic standards, the health of all could be imperiled.[50] This unsettling idea prompted many of the Americanization efforts by social workers to improve immigrant sanitation, efforts made all the more difficult because many immigrant families often preferred to decorate their homes in the styles of their homeland that included "dust-gathering stuffed furniture, feather beds, heavy carpets, long lace curtains, and draped mantles."[51] Despite Americanization efforts, however, disease continued to prevail in slum areas for a variety of reasons, including residents' limited amount of time and money for cleaning, screens, plumbing devices, and medical care, overcrowded conditions allowing the quick spread of disease and limiting the amount of sunlight and fresh air, and germ-harboring interior spaces.[52]

To this list many eugenicists added the prevalence of hereditary "degeneracy," stressing that the over-abundance of bodies with weak physical, mental, and moral constitutions offered fertile breeding grounds for disease and caused the continual pauperism of tenement residents. For example, Huntington promoted "the elimination of slums, and their replacement by healthful houses in wholesome surroundings of the suburban type with plenty of open space" as a proper route for limiting the number of "low-grade people." Implicitly associating the proliferation of disease in unhealthy areas with the reproductive proliferation of residents, he warned that "Slums are great breeders of all sorts of social evils, including the careless, shiftless spirit which leads parents to produce children recklessly."[53] Multiple eugenics sources cited Sydney, Australia, as the prime example of the negative urban effects of "degenerate" stock, saying that the city had the "largest slums in the world" because it "was largely peopled by criminals and lower stocks deported from England one hundred and fifty years ago."[54]

As Huntington made clear, spacious, green, healthy, sun-filled suburbs stood in stark contrast to dark, overcrowded, dirty, disease-ridden slums in the inner cities. Charles Davenport, too, stressed the eugenic role of suburban development and praised real estate agents for their noteworthy service of luring people into the suburbs.[55] Such service was eugenic for its positive health impact upon middle- to upper-class white residents and because selected minorities (almost always including African Americans) as a rule were excluded from participating in suburbia's modernity. Applications for residence by African Americans, for example, were rejected regularly into the 1960s and beyond.[56] This type of urban residential segregation between different races and classes, whereby different segments of the urban social

body comingled part-time through service industry contact or perhaps in public transportation but largely occupied separate spatial domains, was common practice. Both Egmont Arens and Raymond Loewy retained this type of division, for example, in their separate visions of how to rebuild New York City.[57]

Showing how little his views changed in the postwar era, in his ideal design for Manhattan spelled out in 1960, Loewy would have reserved the island of Manhattan for "professional Newyorkers, a distinct and privileged minority." He proposed replacing Harlem with "open-space residential areas" of "delightful low buildings scattered like villages," reserved exclusively for this elite group. Although he claimed he wanted to preserve "the unmeltable nationalistic neighborhoods of this so-called melting pot," he would have banished all "bartenders with Irish brogues," cabdrivers, elevator operators, and mechanical workers from the island, forcing them to live in the peripheral cities on Long Island and the Jersey shore. Here, he planned to house them in "healthy quarters where, blessed with emotional stability and sufficient intellectual stimulation to stir an oyster," they could "safely and peaceably simmer in the grey juice of banality." Similar to his treatment of the lower classes, he would have relegated the ill to hospitals at the edges of Manhattan, for "illness must not be all around us—both for the patient's sake and for those who happen to be well."[58]

In its separation between income groups and focus on the more privileged, this plan resembled a market planning research report completed by Raymond Loewy Associates in 1944 for the Associated Merchandising Corporation. The report discussed the removal of urban "blight" that was damaging business for downtown department stores by targeting the "run down, antiquated, overcrowded, unsanitary" areas occupied by low-income groups who "cannot even support the basement store." These areas frequently formed a ring around the downtown urban shopping district, acting "as a noose slowly tightening, slowly strangling all business out of existence." Because "suburbanites" disliked traveling great distances to stores in the downtown areas only to have to "pass through unpleasant depressing areas of blight whose streets [were] narrow and congested," the report proposed a variety of solutions, from razing the blighted zones to make way for parking and greenbelt areas, to enhancing the highway system between suburbs and the central city and increasing downtown parking facilities for quick access and convenient shopping by the income groups with purchasing power.[59]

Arens's revitalization plan for New York City, a plan that was actually

proposed in 1935 as the Roadway-Housing Plan, shared the goal of Raymond Loewy Associates of reorganizing "obsolete, blighted areas" into "efficiently modern plants for doing business" by actually "grafting a living, well-organized modern city into the heart of our palsied metropolises." He, too, wanted to raze slum areas and dramatically improve the express highway system "to provide quick entrance and egress from the great congested centers" to suburban areas and outlying cities. His plan, however, also proposed improvements for the "under-privileged" through the construction of high-rise low-income housing in the central city. Arens envisioned subsidizing the cost of high-value ground rents for these housing units by charging highway and parking tolls. His plan was notable for its integration of the needs of the larger urban social body into the downtown infrastructure and its impartation of the benefits of modernization to all.[60]

His exhibit at the New York World's Fair in 1939 titled "Three-Thirds of a Nation—The Problem of Distribution" addressed an even larger problem with a similar solution. The exhibit proclaimed that the way to preserve democracy was to improve the income, health benefits, nutrition, and sanitation of the "dispossessed" lowest portion of society so that everyone could share in the "good life" offered by the economic benefits of mass production. The exhibit displayed photographs that contrasted the plight of low-income groups with the comfort of middle- to upper-income groups that were captioned by pointed criticisms of such things as infectious and diseased tenement environments and the inadequate housing that faced "good American kids" from families who were "the salt of our earth."[61] This seemingly egalitarian approach and commendation of the character of lower-class whites—tellingly, the only "race" included in the exhibit photographs—sharply differed from his dismissal in the early 1920s of this group as the "tail end of the country's buying power" in his promotional advertisements for Condé Nast, a difference prompted perhaps by the economic collapse of the Depression that leveled many of the previous sharp economic class differences of the preceding decade.[62]

In what ways can these plans by Loewy and Arens be classified as "cleanlined" urban design, and what relation do they bear to contemporary thoughts on disease and eugenics? When eugenics is considered in a way it was commonly used—as promoting all things that improved the number and vitality of middle- to upper-class whites and discouraged the same for other groups—some urban development plans such as Loewy's upheld these ideals by giving the former group the healthiest and most spacious arrangements separate from other racial or lower-income groups.[63] His

urban vision for New York maintained this class segregation and its accompanying presumption of intelligence differences. Furthermore, his earlier plan specifically removed the drag on economic spending and travel time caused by "blighted" areas, thereby improving urban efficiency for middle- to upper-income groups while lessening the costs of relocation for retail business corporations. Arens's plan, on the other hand, fits with a slightly more inclusive eugenic vision, one that aimed to increase national efficiency, quality and taste by reducing disease and improving environmental conditions and opportunities perhaps for *all* races and classes, but especially for all *white* races and classes. Besides, in the late 1930s, even many eugenicists who formerly had unreservedly viewed class as an accurate marker of genetic inheritance and potential had begun to readjust their views based upon the drop in economic status of individuals such as themselves whom they deemed to be well-bred. Despite the greater inclusivity of Arens's over Loewy's vision regarding who could benefit from modernity, both designers conceived of modernity as vital, healthy, and high-class in contrast to the "blighted," "palsied," "unsanitary" lower-income environs, and through their work they aimed to increase the former and decrease the latter.

This goal and designers' approaches to it were further revealed in "cleanlined" interior and product designs. Streamline design arose in part as a response to the widespread fear of dust and germs as a dysgenic factor contributing to national inefficiency, in terms of increased sickness and hereditary degeneration, and in terms of the time it took women to clean their homes. Hence the style's nickname, given by Dreyfuss, of "cleanlined" design. Industrial designers worked with long-accepted and newly developed sanitary materials (wood, enamel, tile, glass, metals, chrome, sanitary paint, and plastics), replacing fabric and other dust-catching materials with smooth, impermeable, highly finished ones that could be easily sterilized.[64] As one article in a New York newspaper enthusiastically declared, "Gleaming tile and fixtures with simple lines can be wiped spotless in minutes. No digging into nooks and crannies for pockets of grime."[65] Smooth materials were matched by seamless construction. Designers integrated protruding parts into the whole to remove all "dust-catching interstices" and covered joints and mechanical parts with panels, often using rivets instead of bolts and screws.[66] At times, entire products such as the Royal Typewriter were "almost wholly enclosed to keep out dust."[67] Plastic was particularly useful in this respect. Poured into seamless molds, once it hardened it produced parts and shells entirely free of crevices.[68] In the form of transparent, sparkling cellophane packaging, it further contributed a "sanitary, sterile, and

fresh" appeal to products on retailers' shelves.[69] Designers consistently used these materials and approaches for streamline designs to such an extent that they remain hallmarks of the style.

Specific products and design ideas for homes, trains and airplanes deserve special mention, however, for what they reveal about contemporary hygienic concerns and solutions. Numerous products were created during the 1930s and 1940s to facilitate high sanitation in homes of the middle and upper classes, where either the housewife or, in rarer instances, a hired maid did the cleaning. These women welcomed the arrival of the streamlined vacuum cleaner (Figure 1.3), for it eliminated the need for sweeping and rug-beating, a process that stirred up so much dust into the air that over the years many hygienically conscious women had learned to sweep a few hours prior to meal preparation in order to avoid contaminating their family's food with germs.[70] The appliance therefore increased hygiene and at the same time streamlined women's work, in a Taylorist sense, allowing them to clean and cook to a speedier rhythm exemplified by its "flow" lines, narrow rails, and sleek housing. When used on carpets and rugs, vacuums proved superior to traditional methods because its brush became a mechanical, intermediary agent, beating out the "greasy grit at the bottom of the rug" that collected "millions of germs, which are removed when the grit is removed" by suction, thereby saving women from ingesting them.[71] Similarly, health in the modern bedroom could be increased through the installation of streamlined ultraviolet lights that killed bacteria in the air and imparted "health-giving radiation while we sleep." As its Westinghouse creators claimed, these "lamps of tomorrow" showed that the evolution of lighting had "passed the stage of purely utilitarian use" and was entering the era in which it could give man a "longer, healthier life."[72] Super-flushing, stainless steel Crane toilets, designed by Dreyfuss, increased bathroom sanitation if not comfort, due to the cold feel of the metal seat. These toilets were designed to flush by use of a foot pedal so that hands could remain free from touching the contaminated handle, and could be suspended from the wall (at a low level, to be sure, so as to aid in elimination) so that they could be easily mopped under.[73]

The visions of designers for the "home of tomorrow" incorporated these and other sanitary products into the structure and systems of the house. Arens believed that postwar homes should be constructed with floors built so that they could be washed "quickly and efficiently by hose" and that its occupants should breathe "germ and dust-free air."[74] In 1958, Dreyfuss echoed Arens's earlier concerns, proposing a more technically so-

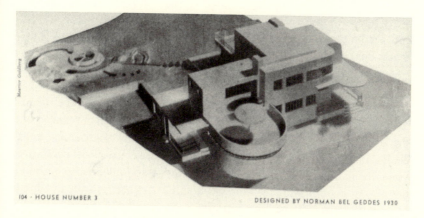

104 · HOUSE NUMBER 3 DESIGNED BY NORMAN BEL GEDDES 1930

Figure 5.2. Norman Bel Geddes, "House Number 3," 1930, in Geddes, *Horizons* (Boston: Little, Brown, 1932), 131. Courtesy of the Estate of Edith Lutyens Bel Geddes.

phisticated solution to the latter problem by installing a vacuum-filtering system. As one entered through the doorway at the entrance to the house, "loose dirt particles" would be "imperceptibly removed not only from your shoe leather, but from the fibers of your clothing, and to some extent from your hands, face and hair." The house, therefore, would remain free from "dust, bacteria, pollen and smog-fumes."[75] In the 1940s, Raymond Loewy Associates envisioned adapting air-filtering systems that were used in hospitals for the home and softening interior seats with foam rubber cushions covered with synthetic fabrics amenable to soap and water. Because the home would be so sterile, "Consequently windows may be sealed."[76]

"Hermetically sealed" windows were included as well in 1932 in Norman Bel Geddes's streamlined House Number Three (Figure 5.2), his model home of the future, serving only the function of admitting "light and the beneficial sun rays."[77] Geddes believed that the "proper location" of a house should be oriented to the sun, giving "morning sun to bedrooms, south or western exposures to living rooms and kitchens, while staircases and bathrooms face north." Similarly, all bedrooms were accompanied by curved terraces for health-giving "sun-baths," except the maid's (she was allotted a "service porch"). Her quarters were located "directly under the child's room, so that she can hear the cries of the child when the family is away." Geddes made sure that the children's section could be closed off in "complete isolation in case of contagious diseases." He also designed the interiors with built-in furniture in order to ensure the psychologically and

aesthetically "beneficial results of properly coordinating the architecture and decoration of a house," as well as "the elimination of dust-catching spaces behind and under them."[78]

Many of the hygienic amenities for the home, as well as the associations of evolutionary progress they embodied, were used and invoked by industrial designers and transportation authorities for trains and airplanes. In both modes of transportation, windows were permanently sealed and the air was "changed every four minutes" through air conditioning to exclude "dirt, dust, soot or pollen" and ensure freshness. Passengers were therefore guaranteed to "Arrive in Condition"—not only in air-condition, but also in good health and fitness, a bodily state that resonated with eugenic notions of "fitness." To this end, some streamliners even provided passengers with the services of a nurse-stewardess.[79] The Pullman Company vigorously fumigated and scrubbed down their sleeping cars after every trip, insisting that bedding be "hung in the open air for the action of that greatest of all purifiers, the sun." These procedures imparted a "slight, acrid odor," owing to the liberal use of disinfectants, that was noticeable upon entry.[80] Brochures for streamliner trains consistently showed that due to their streamlined designs, an exterior stream of smoke and dirt was deflected upward "so as to clear the locomotive and train" and its windows and air intakes.[81]

Capitalizing on their superior position to trains in this regard, airlines such as TWA and American Airlines advertised that they would transport passengers "high above the dust and grime of surface travel." [82] Like "all-room" trains such as the Twentieth-Century Limited that catered exclusively to those who could afford a sleeping berth, these planes served a "civilized" clientele such as the white business man and his wife who were almost always depicted in illustrations (Figure 5.3).[83] As the travel photos and advertisements for streamliners and airplanes showed, if this well-off couple traveled by plane, they would most likely be waited on by a beautiful white stewardess, well-suited to her position on the most technologically advanced and sophisticated method of travel (Figure 5.4). If they chose to travel by train, however, they would likely be served by African American male porters who were sometimes symbolically made to wear white gloves that assured passengers they would not have to come into direct contact with this potentially "dirty" source (Figure 5.5). In situations such as putting ice into the car's cold-water dispensers where passengers might have been afraid that black porters were using their bare hands and that they might have ingested diseased germs as a result, Pullman authorities as-

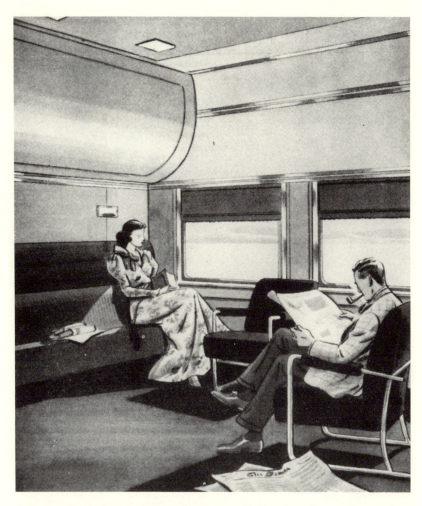

Figure 5.3 Illustration of a private compartment in a brochure "Announcing the New Streamlined 20th-Century Limited," 15 June 1938. In Box 16, WDT Papers. Courtesy of the Syracuse University Library, Special Collections Research Center.

suaged travelers' hygienic and racial concerns by forbidding porters from using their hands. Officials openly declared that they exercised "remarkable discipline over [their] negro porters," discipline that was "remarkable" no doubt because of their presumably "primitive" state that supposedly limited their own capacities for self-control and inhibition.[84]

As the foregoing examples have shown, manufacturers, designers, and

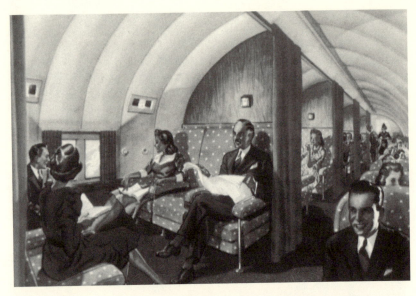

Figure 5.4. Interior of the Boeing 303 TWA Stratoliner airplane designed by Raymond Loewy, 1938, from *Collier's* (6 June 1940).

advertisers paid close attention to the hygienic attributes of modern design as direct benefits to middle- and upper-class whites. As Roland Marchand makes clear, advertisers, who in many cases either became industrial designers or promoted designed products, continually depicted the "typical consumer" as having the home, dress, country-club habits, and income of an upper-middle-class white. For example, in 1931, one hypothetical family with a supposedly "moderate" income earned $5,000 per year and possessed a large house with all the indoor plumbing amenities, as well as an "electric-sweeper, washer and ironer, automatic refrigerator, telephone, and radio." In reality, this type of income and the goods it could purchase were available only to the top 12 percent of the American populace, and that even in the economically booming years prior to the Depression.[85] By 1940, when approximately 65 percent of U.S. homes had electricity, little more than half had vacuum cleaners and just over 60 percent contained refrigerators and washing machines.[86]

This focus on middle- to upper-class urban whites as the initial primary beneficiaries of hygienic products is confirmed by historians of American cleanliness. In the decade prior to 1900, the price of water filters and

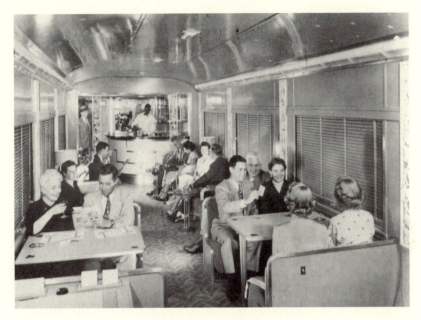

Figure 5.5. Photo of the lounge interior of the Southern Pacific, 2990, in James W. Kerr, *Illustrated Treasury of Budd Railway Passenger Cars, 1931–1981* (Alburg, Vt.: Delta, 1981), 146.

white china toilets placed them far beyond the reach of any household that was less than affluent, and even in the mid-1920s, one survey showed that nearly half the rural homes in upstate New York did not have running water or indoor toilets, the same situation faced by African American school children in Chicago at this time.[87] Well into the 1930s, most working-class families could not afford flush toilets, clean running water, or refrigerated milk.[88] In Pittsburgh, the city's sewer system was extended into the poorer, heavily populated South Side in 1914, but the very poorest areas where most African Americans lived were not touched until the 1950s.[89] One historian even states that most rural whites and African Americans were only able to participate fully in the middle-class culture of cleanliness—a culture that included use of personal hygiene products, kitchen appliances, and bathroom fixtures—beginning in the 1960s and 1970s.[90] For these reasons, Tomes concludes that "the ability to conform to 'antiseptic' standards of cleanliness differentiated rich from poor, educated from un-schooled, American-born from foreign-born," a list of adjectives that was

generally applied as well to those groups considered by eugenicists to be eugenic in contrast to dysgenic. Hygienic products and interior designs thus not only provided this privileged group with ever more sanitary environments but also served to symbolically distance "native-born" Americans from recent immigrant groups.[91]

Advertisements did not shy away from presenting these "classy," health-conscious, educated Americans as the eugenic ideal that middle-class whites should strive to emulate. Numerous ads both appealed to and promoted a general desire of Americans to be part of the "world's elect," a social aristocracy that according to the Willys-Knight Motor Car Company included "those who by *birthright* move in America's most select social orbits."[92] Camel Cigarettes concurred by appealing to those who were "To the Manner Born."[93] Other ads contained eugenic rhetoric without necessarily including some form of the word "birth" in combination with exclusive social references. For example, a 1935 advertisement in the *Saturday Evening Post* for the Shelvador refrigerator extolled both the refrigerator and its owners as "the finest," noting the owner's "knowing," "critical" intelligence and "good taste" (shown by their having selected the Shelvador) and the refrigerator's "Enduring *Beauty*. Care-free *Performance*. *Through-and-through Quality*" (Figure 5.6).[94] This list of attributes (beauty, performance, and innate quality) mirrored the eugenic complex of traits that "fit" individuals supposedly possessed, the same complex of traits promoted by Teague as the basis of good genetic and industrial design.[95]

Other promotional texts simply referred to a product's high evolutionary status in terms that echoed numerous cultural references to well-born whites as the apex of biological evolution. For example, the producers of the Florida Tropical Home exhibit at the Century of Progress Exposition in 1933 selected the most recent model of the Hoover vacuum as "the highest example of electric cleaner development." In this case, the product's mechanical and stylistic progress were fittingly allied to hygienic advancement.[96] Advertisements that promoted the "class" ideal (whether for a "class" or "mass" audience) often forthrightly stated, as eugenicists did, that those with this distinct "social lineage" inherently possessed "an 'instinctive' sense of taste." So far was advertisers' hypothetical "typical consumer" above the truly average American—again, whom some eugenicists had determined possessed the intelligence of an adolescent—that one critic classified him biologically as a "separate genus of man."[97] It almost goes without saying that in advertisements of the 1920s and 1930s, as well as in the social visions of many eugenicists, the working class appeared mostly in

Figure 5.6. Advertisement for Shelvador Refrigerators, from *Saturday Evening Post* (23 March 1935): 92.

supportive, functional roles such as the "garage mechanic, house painter, truck driver, store clerk, or household servant."[98]

By promoting the ownership of modern products and hygienic design as a natural part of membership in the eugenic elite, advertisers furthered the redemptive mission shared by eugenicists to elevate the nation's cultural, intellectual, and aesthetic standards to "civilized" ideals. Although in at least one press break room an editor-in-chief had posted a sign reminding his writers that "You *cannot* underestimate the intelligence of the American public," and advertisers in general considered the "mass" audience to be quite unintelligent, advertisers practiced wise economic and psychological strategy by treating this group with expendable income as if they were part of the elite, thereby using their desire to be so as a prime incentive for purchasing modern goods.[99] Cleanlined design acted as a lingering Lamarckian tool for reform aimed at the "mass" audience, for the underlying message communicated by designers and advertisers was that by living in a modern home with all the hygienic amenities (assuming one had enough taste and "good breeding" to choose such a home and enough money to purchase it in the first place), "mass" man would to a certain extent internalize its civilized qualities.[100]

Similarly, cleanlined environments served as an appropriate reflection of this high state of "civilization" attained by the eugenic elite. Early twentieth-century reformers had stressed the need for sanitary environments, and streamline industrial designers responded with cleanlined reforms that transformed "diseased" products and interiors into civilized, ideal types. Precisely because of these correlations between hygiene and civilization and the eugenic inclinations of designers and advertisers, the promoters of cleanlined design did not target the lower classes or African Americans because they did not consider these groups to be part of "modernity." Rather, these groups more frequently were blamed, either explicitly or implicitly, for holding back progress and contributing to American sickness and degeneracy. Metaphorically speaking, rather than tackling broader external urban problems such as smog pollution and disease in the outside environment, designers instead envisioned for an upper-class white clientele cleanlined homes, trains, and planes with windows that were hermetically sealed shut. Cordoned off from the germ-producing, degenerate world outside, civilized men and women could flourish in environments outfitted with the most up-to-date technology that increased their health and leisure and continually affirmed their rational abilities to triumph over Nature.[101]

In their attempts to elevate public taste, therefore, by targeting middle-

and upper-class whites, designers and advertisers perhaps marketed to the only groups who they felt were actually capable and desirous of attaining their goal of "civilization" (in addition to these being the only groups that could financially reward their efforts). Eugenicists certainly focused on these groups for this reason. Although pro-eugenic minority leaders such as Booker T. Washington preached eugenic and hygienic ideals to African Americans, most eugenicists and hygiene reformers were not trying to improve the hereditary and environmental conditions of groups lacking Anglo or European ancestry.[102] Rather, they focused their efforts on policies limiting their reproduction and increasing the racial segregation of these "dirty," "dysgenic" groups. Yet, as Clarence C. Little pointed out in a *Scientific Monthly* article in 1928, if sociologists (and I would add designers, architects, and advertisers) had even unconsciously been resorting to neo-Lamarckianism as a scientific theory lending credence to their environmentally inclined ideals for reform, by 1928 they had "been prevented from enjoying uninterrupted rest by a nasty and continuous noise." This noise was "the insistent voice of those all over our country who notice the rapidly rising cost in the care of mental and social defectives."[103] Whether this outcry was due to public concern over state expenditures resulting from the stringent economic pressures of the Depression, or whether it was the sound of eugenicists' stressing the Mendelian power of the chromosome as the most successful route to national genetic improvement, in either case those who sought to further "civilization" through environmental reforms at the very least had to consider that progress toward their goal might be aided by internal, hereditary reforms.

For example, although eugenics publicist Albert E. Wiggam considered the understanding of hygiene as a crucial base for understanding eugenics, in 1927, he discounted as "biological bosh" the role of hygiene to "*in itself* produce a race of people *naturally* healthier and stronger in their inborn mental and physical characteristics." Instead, improvement could come only by preventing the "weaklings" from reproducing.[104] Even the germ theory of disease, which since its discovery had spurred environmental sanitation as a key to disease prevention, began to be minimized in its importance as the implications of Mendelism took hold. Because scientific studies showed that microbial forms were found throughout the exterior and interior of a healthy human body, germs alone could not serve as the cause of illness. Scientists therefore reasoned that the human constitution with its individual (and sometimes "racial") hereditary makeup had to be primarily responsible for the contraction of illness.[105] Like a sown seed,

germs had to find receptive soil in a weakened constitution to be able to sprout and flourish.[106]

This shift to considering the inner constitution as the determining factor of quality—granted, quality that still showed on the outside owing to the interrelated complex of traits—carried over theoretically into the fields of industrial design and product advertising. In part this was due to designers' adherence to functionalism, for many learned as Geddes had, in his sculpture class at the Cleveland Institute of Art, the principle that external forms were produced by the workings of muscles beneath a body's surface.[107] Designers' explanations of this concept, however, went beyond the anatomical, pointing to genetics as the true source of beautiful exterior forms. To achieve product "fitness," therefore, designers insisted on holistically considering a product's inner functional mechanism in relation to its external appearance, sometimes even tackling the production processes itself, for only by targeting these areas together could they pinpoint deficiencies and effect a lasting cure.

For example, when Geddes was asked by the Standard Gas Equipment Corporation in 1930 to design a stove, he began by weighing against possible solutions the deficiencies of other models (Figure 5.7), not least of which were their ornamented, dark, and dirty appearance. He even went so far as to consult a consumer questionnaire that showed ease of cleaning to be users' primary concern. Having seen one or two models that were not made of the usual material of cast iron, whose pitted surface harbored grease and grime, Geddes considered ways to replace the heavy material and the molds that shaped it with inexpensive, lightweight, enameled sheet metal used in combination with a tubular metal frame. To determine placement of the various compartments, he created a series of generic block units representing the oven, broilers, cooktops, utilities, and bases, which he then theoretically shuffled into various combinations, all of which could have become separate models in consumers' eyes but which, from the production standpoint, were remarkably uniform.[108] As an early example of modular design for flexible production, which in this case only materialized in a single model, Geddes considered the entire process of production, distribution and merchandising, successfully improving "the appearance of the product . . . without increasing the cost of manufacture." His careful attention to detail resulted in a trend-setting streamlined design (Figure 5.8), one in which the functional, protruding mechanisms of the stovetop were hid under a curved, enameled cover, thus further facilitating cleanliness. As he designed from the inside out, with consumer satisfaction in mind, his proc-

Figure 5.7. Magic Chef Gas Stove, 1929, in Norman Bel Geddes, *Horizons* (Boston: Little, Brown, 1932), 251. Courtesy of the Estate of Edith Lutyens Bel Geddes.

ess and results epitomized his philosophy of organicism, thus meriting the stove's inclusion in *Horizons*.[109]

In another instance cited in the book, Geddes could not restrict himself to only redesigning a scale for the Toledo Scale Company, as stated in his commission, but surprised his clients by presenting them also with complete designs for rebuilding their entire factory, at a cost of only a million and a half dollars during the Depression. Company officials, "in a wonderstruck moment, paid him a fee for complicating his assignment," but didn't gratify his compulsion that a "first-rate product" could only be produced in a first-rate factory.[110] Other designers followed Geddes's example, though

Figure 5.8. Norman Bel Geddes, Standard Gas Equipment Corporation Gas Stove, 1932, in Geddes, *Horizons* (Boston: Little, Brown, 1932), 252. Courtesy of the Estate of Edith Lutyens Bel Geddes.

in more pragmatic fashion. When asked to design an electric motor for the Louis Allen Company in 1936, Teague insisted on designing the casing based upon the "necessary insides" rather than the other way around as his clients requested.[111] Ten years later, when Dreyfuss was designing his classic model for Bell Telephone, he shaped the handset based upon ergonomic principles in order to conform its shape to its function.[112]

Although this principle in most cases held fast, streamline designers at times fell short, for example, when applying aerodynamic streamlined styling to immobile products, or when streamlining solely for external appearance while disregarding a product's internal functional mechanisms.[113] Critics hostile to the popular style jumped on these instances to fault streamline designers as "pseudomodern" "stylists." In doing so, they

turned designers' self-proclaimed dictum upon themselves, for as Donald Deskey had proclaimed, if only surface "styling" were accomplished, a product would be dishonest, like make-up hiding a woman's blemishes.[114] Because external appearance in both bodies and products served as a surface marker of inner genetic fitness (Teague compared it to the "uniting cells with which our lives begin"), designers working to cure product "sickness" and "blight" had to proceed upon the principle that good design was "more than skin deep." As Teague stated, "beauty must be built in, not applied."[115]

An advertisement for Camp girdles from 1939 (Figure 5.9) played upon public awareness of the idea that a beautiful external appearance stemmed from a sound inner structure, both arising ultimately from good genetics. However, because their product was created specifically for those whom nature had endowed with a less than perfect figure, they altered the standard rhetoric in order to position their girdle as that which could restore what nature had omitted. "External Beauty depends upon Internal Order," the copy began, stressing that the Camp support, like all good designs, "goes far deeper than superficial figure moulding." Targeting women with "[n]atural obesity, poor posture, fatigue, strains, prolapses, muscular weakness, maternity" as those most in need of the "aid of a Camp Support," the advertisement claimed the girdle would bring true beauty, inside and out, by using the Transparent Woman (Figure 5.10) as if it were a simultaneous projection of the torsos of both the Venus de Milo and a "modern" woman. Through its use, such women could transform their figures into both the Greek ideal of beauty and the ideal Caucasian model, whose figure epitomized a eugenic body as envisioned by its creators in Dresden.[116]

One final example of this reformist vision must be given, for it exemplifies key features of cleanlined design. In 1950, Henry Dreyfuss published his dreams for redesigning New York City's subway system in the *New York Times Magazine*. He opened his article by asserting the modernity of New York, so evident in its "modern architecture and its imposing skyline. But New York's beauty is only pavement deep," he continued, turning to the eugenic analogy; "Its subways are ugly and primitive." He faulted the current trains for their narrowness and general design that caused poor air circulation and made the trains a "health hazard." To remedy these shortcomings, he proposed to use plastic on the seats that would be "dust free . . . and washed down each night with some mildly antiseptic solution." Furthermore, he would install "ultra-violet projection to keep down germ-breeding in cars" and "better ventilation to insure constant intake of fresh

Figure 5.9. Advertisement for Camp Supports, featuring a photo of the "famous Camp Transparent Woman," *Vogue* (15 Jan. 1939): 9.

Figure 5.10. The Transparent Woman on view at the Buffalo Museum of Science. Photo from the BG Papers. Courtesy of the Dittrick Medical History Center, Case Western Reserve University.

air." As the prophet of cleanlining, Dreyfuss understood its principles well. Most interestingly, however, his concluding improvement was to demand "changes in personnel. The knee-and-elbow school of guards would give way to *college* Joes, or girls, well-trained and *well-bred* youngsters." By beginning with the subway system, making it more sanitary, and replacing lower-class employees with educated, well-bred youth, Dreyfuss's holistic design imagined improving New York from the inside out, endowing it with the all the qualities requisite of "civilization."[117]

In the 1930s, popular scientific beliefs on issues of heredity and race betterment were frequently allied with beliefs about hygiene and disease, and the nexus of these concerns served as a context that likely informed designers' considerations about hygienic design. An underlying question that has run throughout this discussion, and one that was (and still is) prevalent in the popular understanding of the time, was whether disease was caused by forces in the external environment or by hereditary susceptibility owing to a weak inner constitution. The supporting role of designed objects within the environment shifted depending on the answer to this question. This dichotomy (nature *or* nurture) was criticized by contemporary scientists as too exclusive, for in reality *both* environmental and hereditary aspects were acknowledged to be contributing factors.[118]

Yet, regardless whether "disease" was prevented and cured through environmental or reproductive sterilization, designers and eugenicists—by working for both environmental and hereditary improvements—believed they were hastening the long-imminent arrival of an earthly utopia. After all, euthenics and eugenics had proceeded together hand-in-hand since the latter part of the nineteenth century. As German eugenicist Wilhelm Schallmayer had phrased it, eugenics was "genotype hygiene" (meaning hygiene that cleansed the inner realm of the gene) while euthenics was "phenotype hygiene" (meaning hygiene that purified external conditions).[119] Yale professor Irving Fisher, who was also president of the Eugenics Research Association, stated a similar idea in 1921. "Hygiene and Eugenics should go hand in hand," he said. "They are really both hygiene—one individual hygiene and the other race hygiene—and both, eugenics—one indirectly through safeguarding the quality of the germ plasm and the other directly through breeding."[120] In the 1920s and 1930s, however, when environment and heredity were talked about by eugenicists and geneticists as "different sides of the same shield"—a protective metaphor beautifully resonant with the idea of houses with hermetically sealed windows—the interdependence of the two did not by any means imply an equality of influence.[121]

Geneticists who called themselves "anti-hereditarian" believed that both environment and heredity were influential, while "hereditarian" geneticists generally imparted "the sovereign and commanding role" to the gene.[122] For both viewpoints, however, heredity formed the bottom line. As Davenport stated, "Bad conditions may lead a person predisposed into criminality but not his brother who is not predisposed."[123] Advertisers thought the converse to be true: good conditions might lead a person predisposed into "civilization" but not those who were not predisposed. Even if euthenics—the environmental reforms offered through industrial design—could not reform those who were not inherently predisposed, it could provide the final touches to a nearly eugenic individual, such as advertising's "mass" man, bumping him over the edge into the "typical consumer" or even the "class" category. Schallmayer aptly considered the role of euthenics to be the improvement of the present generation and the role of eugenics to be the improvement of future generations. Industrial design and eugenics worked together under the same pretext. But, whether present or future, clearly both designers and eugenicists worked together to increase national efficiency, taste and "civilization," all the while eyeing the prize of a seamless society made up of perfected people and products.[124] Their utopic visions are examined in the next chapter.

Chapter 6
Future Perfect?
The Elusive "Ideal Type"

At his dedicatory address of what was intended to become the American Museum of Health in 1940, in the Hall of Man at the New York World's Fair, Frederick Osborn affirmed the importance of working toward the improvement of both the people and their environment for the world of the future.[1] This dual approach toward reform that was taken by designers and eugenicists at the New York World's Fair, discussed in the previous chapter as the marriage of euthenics and eugenics, formed the ideological girders upon which rested the fair's theme, "Building the World of Tomorrow." Not surprisingly, fair participants assumed the future would be an improvement upon the present, if not the final attainment of ideal civilization. By 1939, the economic suffering caused by the Depression had heightened Americans' longing for the arrival of more ideal conditions. Social and scientific developments over the previous decade had whetted these desires by seemingly placing their realization just within grasp. Since the late 1920s, newspaper headlines had proclaimed that geneticists were on the verge of being able to produce "supermen" or different human "types" at will. Industrial designers had reformed "degenerate" products into their "civilized," "cleanlined" counterparts. And, eugenic social policies had effected the sterilization of more than thirty thousand individuals.[2]

These "achievements," as well as the exhibits at the fair, reaffirmed the popular conception of modern scientists, designers, and engineers as almost godlike, creative rational beings whose abilities had enabled them to gain control of the modern world, its populations, and even the laws of nature. To this end, industrial designers, scientists, and corporate manufacturers created the fair's exhibits to be more than mere models of future possibilities. Because they were backed by organizations with social and political power and prestige, economic resources, and vision, the exhibits seemingly foretold future *probabilities*. Norman Bel Geddes was most ex-

plicit about this in his Futurama exhibit for General Motors through his actualization of the model's intersection into the layout of the building itself. This realization offered fairgoers the chance to walk into a future-space-made-present-reality, an experience that strongly implied that the present vision would in turn become that reality.

Despite the tantalizingly good prospects for controlled (re)production to produce ideal humans and products, social and industrial designers faced some serious setbacks. For example, when a writer for *Country Gentleman* asked Charles Davenport in 1935 for "data regarding the number of perfect physical specimens in the total population or of any particular group of it," Davenport replied, "It is difficult to answer your question because of the lack of definition of 'perfect specimens.'"[3] This problem of defining perfection continually plagued eugenicists for a variety of reasons. Even if they had been able to agree upon which characteristics were "ideal," their assumptions that different racial, class, and social "types" existed, were genetically "fixed," and therefore able to be controlled, had been extraordinarily difficult to prove. Individuals rarely, if ever, precisely fit their allotted categories or "norms," which had been ascertained largely by anthropometric and psychometric measurements based upon imprecise and nonstandardized techniques. Furthermore, if society were ever made up completely of "ideal types," who among this intellectually, physically, and economically fit group would perform menial labor? After filling most of their textual space with explanations of the need for, means of attaining, and characteristics of an ideal human, many eugenic tracts and articles (excluding those by socialist eugenicists) returned to the goal of scientists to be able to produce various "types" at will in order to preserve a differentiated capitalist economic and social structure led by the "fittest."

Designers likewise had difficulty achieving the "ultimate form" of particular product types despite their continual references to the concept, owing to the preferences of the public and manufacturers for ever-new designs, as well as to the complex and varied contexts that any given product encountered. This problem of the rhetorical discrepancies between futuristic ideals and changing present realities, faced by eugenicists and designers alike in their steps toward euthenic and eugenic reform, is illuminated through an examination of the development of the concept of the "ideal" and its ideological precursors, the "norm" and fixed "type." Eugenically sponsored anthropometric and psychometric studies of the 1920s and 1930s, which were often motivated by fears of the loss of racial "purity" owing to the mixing of different racial "types," contributed significantly to

this development and to public perception of these concepts. By determining representative "types" for different population groups, these studies subsequently offered biologically and ergonomically minded industrial designers a useful tool contributing to product standardization and "human engineering." Streamlined products thus served as physical and ideological extensions of streamlined bodies.

In the early 1880s when Francis Galton first created the term "eugenics" and proposed improving the human race through marriage and birth rate regulations based on the hereditary traits of parents, he based his understanding of heredity not on a precocious knowledge of genetics but rather on statistical analysis of countless bodily measurements attained through physical anthropometry. His work not only forwarded contemporary understandings of heredity, which, granted, were fraught with race and class biases, but at the same time helped establish the base for the modern field of statistics. In his efforts, he was aided by Karl Pearson and William Weldon, who joined him in the 1890s to found the study of "biometrics," an approach toward understanding evolution through mathematical measurement and analysis.[4] Through determining the mathematical norms for numerous bodily traits of certain racial "types" (*pre*determined based upon the visual appearances and reported ancestral lines of the people being measured), biometricians and physical anthropologists hoped to gain insight into questions of racial origin and formation through comparison of these norms. They interpreted the mathematical norms they derived for certain racial "types" to reveal information about past racial development and divergence, and then used these norms as a gauge against which to compare contemporary individuals for personal divergence from the standard for their racial "type."[5]

This circular approach, whereby a predetermined notion of types affected selections of groups from which norms were then derived and against which individuals were then measured, set a precedent followed by physical anthropologists and psychologists over the next forty years, whether in their analyses of anthropometric or psychometric data such as that obtained at state and world's fairs or through intelligence testing. One large-scale study initiated by Harvard psychology professor Robert Yerkes used incoming World War I army recruits as its population, measuring both their bodies and minds to determine the level of "fitness" of the U.S. military. His findings,—that Nordics were most intelligent, followed by southern and eastern Europeans, with African Americans in last place, and that the "average mental age" of white American adult males stood at thir-

teen years,—were publicly criticized as impossible shortly after their publication in 1921. Yet, they still profoundly affected the viewpoint of a significant portion of the American public.[6] For example, the results were used as strong evidence of the need to drastically slow southern and eastern European immigration, a restriction that became federal law in 1924. Journalists, advertisers, and museum curators also responded to the results of the army tests by adjusting their copy and exhibits down to the mental level of a young teenager in order to be understood by the American public.

Although these mental "norms" were undoubtedly the most debated aspect of the army studies, anthropometric measurements taken on 100,000 white army recruits similarly established the physical "norms" for the average white American male.[7] Based upon these measurements, in the early 1920s and in conjunction with the Second International Congress of Eugenics, Charles Davenport's daughter created a sculpture for the American Museum of Natural History that embodied and displayed the measured "norms" of this hypothetical "Average Man" (Figure 6.1). Like the disappointing results of Yerkes's psychological analysis, her sculpture showed that the average white male's physical fitness left much to be desired. His pudgy stomach, slouching posture, heavy hips, and undefined muscles drew the criticism of journalists, who interpreted the figure as a symbol of American "degeneracy."[8] Despite such criticism, however, the sculpture proved so instructive that it remained on display at least through the Third International Congress of Eugenics, held at the museum in 1932, prompting one Chicago high school teacher to write to Davenport inquiring about the source of the composite anthropometric measurements.[9]

Following the army tests, numerous anthropometric and psychometric studies were conducted throughout the interwar period, often in conjunction with each other, adding to the store of scientific and popular knowledge about racial "types" and the effects of their intermixture. Charles Davenport's and Morris Steggerda's study *Race Crossing in Jamaica* (1926), for example, seemingly proved that individuals of "mixed" race fared worse on intelligence tests than those of the "pure" races, implying that hybridity produced degeneracy.[10] Yet, other international studies on the interbreeding of the various white races (such as between Germans and Jews, who were considered by some less racist German geneticists to be *similar* in their traits) had shown that their offspring proved superior to the parents; "race-crossing" of this sort, therefore, could produce "hybrid vigor."[11] Despite the theory of "hybrid vigor," eugenicists more frequently

Figure 6.1. Mrs. Jane Davenport Harris, *The Average Man*, plaster sculpture on display at the American Museum of Natural History based upon the measurements of 100,000 white World War I army recruits. Photo #311716, American Museum of Natural History Library. Courtesy of the American Museum of Natural History Library.

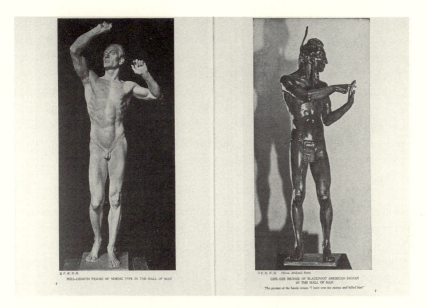

Figure 6.2. Malvina Hoffman, "Full-length figure of Nordic Type in the Hall of Man" and "Life-size bronze of Blackfoot American Indian in the Hall of Man," in Malvina Hoffman, *Heads and Tales* (New York: Bonanza Books, 1936), 7.

publicized the deleterious effects of "race-crossing" and emphasized the distinct differences of separate races.

This idea of the existence of "pure" racial types was reaffirmed to the public through numerous sculptures created in the 1930s similar to that of *The Average Man*.[12] Although only fifteen thousand visitors viewed the exhibits at the eugenics congress in 1932, in conjunction with the Century of Progress Exposition the following year, over two million people saw the Chicago Field Museum's Hall of Man, which contained sculptures by Malvina Hoffman representing eighty of the world's different racial types. Hoffman had been commissioned by the museum in 1930 to travel the world, documenting in sculptural form one hundred types that she depicted at a moment when she "felt each one represented something *characteristic of his race, and of no other*"; she adjusted the material (stone or bronze) and its patina to accurately match the skin color of each. Recounting the creation of the Hall of Man sculptures, her book *Heads and Tales* (1936) opened with two examples: the "Nordic Type" and the "Blackfoot American Indian" (Figure 6.2). The Blackfoot, made of bronze, was shown in the savage

act of making a gesture that meant "I have seen my enemy and killed him," whereas Nordic man, displayed in his plaster (rather than bronze) form so as to emphasize his whiteness, held his head high, opened his eyes, and raised his fist in the air, partly in a gesture of dominance and partly as if awakening from a long sleep to a position of pride.[13] Although the choice of gesture, character, and pose was Hoffman's, at times she relied upon models and the use of anthropometric measurements for the proportions of the different types. For example, in creating her sculpture of a representative Maya, she used Steggerda's numerical data from his measurements of one hundred Maya Indians.[14]

Displays throughout the decade of the Transparent Man and Woman further reinforced to the public the existence of racial "norms," yet, as these classically posed, perfectly fit "universal Caucasian" types showed, a racial "norm" often simultaneously functioned as an "ideal." The murky relationship between these concepts was best exemplified in two sculptures, fittingly named *Norma* and *Normman*, created in 1942 by Dr. Robert Latou Dickinson in collaboration with sculptor Abram Belskie, Hoffman's student (Figure 6.3). Posed with their arms at their sides, shoulders back, posture erect, gaze directly forward, and facial expression neutral but focused, the figures stood as if at military attention or under medical examination. Their feet rested upon a pedestal topped with the base of a classical column, symbolizing their supposed evolutionary ancestry in Greek civilization. Their facial features unnervingly resemble those of blond German Nordics displayed by Bruno Gebhard at various exhibitions he curated for the Deutsche Hygiene Museum throughout the previous decade in Germany, and their names upheld this type as the essence of humanity.[15] Gebhard and Dickinson had become good friends in 1937, when they worked together on the Hall of Man for the New York World's Fair in which Dickinson's "Birth Series"—lifesize models showing the process of healthy fetal development and birth, sculpted from composite x-rays—captured the attention of 700,000 viewers. Both men were strong supporters of eugenics and sterilization legislation; Dickinson used his position as an eminent gynecologist and sexologist to study female fertility as well as to promote birth control and eugenic euthanasia, founding the Euthanasia Society of America in 1938.[16] In 1945, out of recognition of his respect for Gebhard, Dickinson gave his entire collection of models, including *Norma* and *Normman*, to the Cleveland Health Museum, of which Gebhard had been director since its opening in 1940.

Normman and *Norma* embodied anthropometric studies of "native

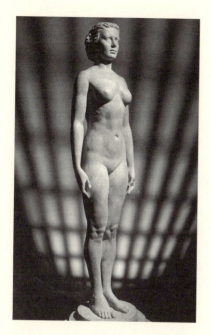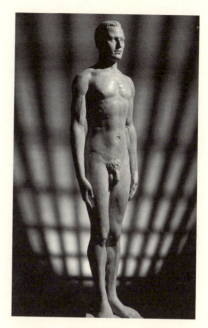

Figure 6.3. Abram Belskie (sculptor) and Dr. R. L. Dickinson (researcher), *Norma* and *Normman*, 1942, plaster composite sculptures based upon measurements of 15,000 "native white Americans." Courtesy of the Cleveland Museum of Health.

white Americans" of the previous two decades. A recent study by the Bureau of Home Economics carefully measured 15,000 white females for use in sizing ready-made garments, and Dickinson compiled additional information from the World War I army recruit statistics, studies of college men and women at both elite and state universities, "special studies of the old American stock," insurance company records, and data from measurements of visitors to the Chicago World's Fair in which he may have participated, for he recounts that five thousand people waited twenty minutes in line every day without objection.[17] After the sculptural couple's unveiling in Cleveland, an article by anthropologist Harry Shapiro hailed them as "distinctively American" "physical types" showing our recent "national evolution," who exemplified not what "ought to be," but rather "what is."

On this point he equivocated, however, for he thought the beauty of the figures imparted far too favorable an impression to match his own everyday experiences. "In fact, Norma and Normman . . . exhibit a harmony of proportion that seems far indeed from the usual or the average.

One might well look at a multitude of young men and women before find-ing an approximation to these ideal standards. We have to do here then with apparent paradoxes," which he then specified: "the average American figure approaches a kind of perfection of bodily form and proportion; the average is excessively rare."[18] This paradox was made even clearer by the results of an ongoing contest called "The Search for the Living Norma," sponsored by the Cleveland *Plain Dealer* starting in 1945 as a gimmick to increase their circulation (Figure 6.4). Offering war bonds as a prize for "the perfect specimen," the newspaper lured in almost four thousand parti-cipants the first year from all over Ohio by publishing *Norma*'s photo and running stories for ten consecutive days. Very quickly, "everybody was talk-ing about Norma," including her hereditary constitution, after the paper ran one story entitled "Norma's Husband Had Better Be Good."[19] As can be seen from comparing *Norma* to the winner of the 1946 competition, Shapiro was correct, for even though she resembled the sculpture, her fig-ure was not an exact match.

All these sculptures and contests communicated to the public physical forms for statistically average "types" that in actuality did not exist or cor-relate with any one specific individual, despite serious attempts to locate one. As historian George Stocking, Jr. points out, anthropologists conduct-ing anthropometric research began by assuming the existence of "pure" races in which each individual race member supposedly manifested the same assemblage of traits without variations owing to time or different circumstances. By selecting and measuring individuals who visually ap-peared to belong to a certain "race" and whose genealogical record sug-gested as much, they created statistical "types" that gained a life of their own. Yet, as no single individual of that "race" exactly matched the "type," why, Stocking asks, had anthropologists "settled on one combination of traits rather than another" to describe the "type"? In doing so, they were assuming a "fixity in relationship of the several race traits" that their data did not substantiate.[20] Even though viewers could not see a living person who literally embodied Norma or the "Nordic type," however, they could use these sculptures as a basis by which to judge others and as an ideal toward which to strive. They could also understand their implication that, just as the sculptor had initially shaped clay to create the sculpture of a racial "type," so too were scientists, and the viewers themselves through their own mate selection, shaping human material through eugenics.

Other journalists and illustrators during this period built upon this metaphor. In 1929, the *New York Times* ran a full-page article, "Science

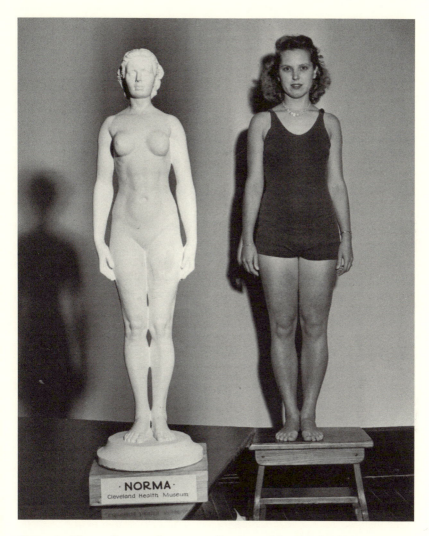

Figure 6.4. Norma Contest winner, 1946. Courtesy of the Cleveland Museum of Health.

Pictures a Superman of Tomorrow," that described "all living matter" as "plastic" and captioned the large accompanying illustration with "The Man of Tomorrow will Be a Sculptor with the Power Not Only of Fashioning the Race, but of Controlling Its Destiny and Purpose in Life" (Figure 2.8).[21] This "Man of Tomorrow" was depicted in the illustration as a scientist-

aviator (perhaps evidence of Lindbergh's continuing popularity and current role as scientific researcher at the Rockefeller Institute of Medical Research), replete with goggles and scarf, who utilized modern scientific equipment to study mankind. His office contained collections of human skulls and preserved fetuses in jars, in front of which the illustrator placed a scale as if the scientist's role were also to weigh the relative worth of different human beings. Looming over it all, however, was a massive, Hellenistically-styled, nude male sculpture, almost in the pose of Rodin's *Thinker*, which presumably was to be the eventual ideal outcome of the scientist's efforts. As the Thinker was to the future ideal male, so the Venus de Milo was to the future ideal female; the advertisement for Camp girdles likewise compared the "maker of a scientific support for a living woman" to a sculptor "working with inanimate clay," for both produced beautiful forms (Figure 5.9).[22]

The *New York Times* illustration remarkably resembles a drawing by Charles Allan Winter, published six months earlier in *Popular Science Monthly*, that illustrated the article "Someday We'll Look Like This" (Figure 6.5).[23] Both images included skulls or busts of various racial types in the top-left corner, a microscope on the table, and the scientist in the center with male Greek statues behind him. In this instance, the scientist was depicted as a physical anthropologist (the article was about the predictions of Dr. Ales Hrdlicka), tape measure in hand, measuring the leg length of "the man of the future." This future man ambiguously looked both like a living human when compared to the statue of Apollo Belvedere in the background, and like a sculpture statically posed upon a pedestal. If considered as a sculpture, the physical anthropologist measuring him then assumes the role of sculptor doublechecking his work to make sure it matched the recorded measurements from which he worked (much as Hoffman and Belskie might have done), and that, like the Apollo Belvedere, his work had reached "the acme of physical perfection." If considered as a living human, then, like Geddes's model of the "world of tomorrow" that became a reality in the Futurama, the "man of the future" envisioned by scientists such as Hrdlicka had indeed become a reality, the drawing proclaimed. Either way, his physical features revealed him to be the "Nordic type" perfected to the point of divinity; the artist placed his hand in the gesture of blessing reserved in Renaissance art for Christ and God the Father, though usually made with the right hand.

Egmont Arens clipped and saved this article, writing at the top "File Lecture Material—Art." It is likely that he therefore was aware of the eugenic intent of scientists' goals to "produce mental or physical supermen at

File picture material art

Someday We'll Look Like This

Future Man Will Be a Handsome Apollo with Long Legs and Short Arms, Dr. Ales Hrdlicka Predicts

By

ARTHUR A. STUART

A MAN of commanding stature, short-armed but long-legged, will be the future inhabitant of the earth. His appendix and his fifth toe will have dwindled nearly to nothing; his forehead will be high and intelligent. He will be an Apollo for beauty.

These predictions are made by Dr. Ales Hrdlicka, curator of the division of physical anthropology at the National Museum, in Washington, D. C. Mankind, he told the American Philosophical Society recently, is racing ahead as fast as ever in the process of evolution that began with man's birth some 300,000 years ago. And he challenged statements of some biologists that evolution has stopped as far as man is concerned. A few thousand years, he says, should alter the appearance of human beings considerably.

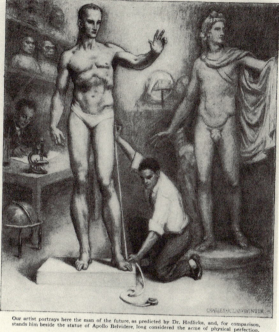

Our artist portrays here the man of the future, as predicted by Dr. Hrdlicka, and, for comparison, stands him beside the statue of Apollo Belvidere, long considered the acme of physical perfection.

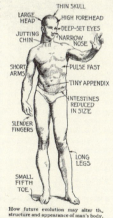

How future evolution may alter the structure and appearance of man's body.

Labels: THIN SKULL · LARGE HEAD · HIGH FOREHEAD · DEEP-SET EYES · JUTTING CHIN · NARROW NOSE · SHORT ARMS · PULSE FAST · TINY APPENDIX · INTESTINES REDUCED IN SIZE · SLENDER FINGERS · LONG LEGS · SMALL FIFTH TOE

Deep-set eyes, a prominent, narrow nose, and jutting chin will characterize the typical man of tomorrow, according to Dr. Hrdlicka. His skull will become thin—largely because his jaw muscles, put less strenuously to work to eat refined foods, will exert less force. His face will reflect increasing handsomeness and character from this cause, as well as from intelligent breeding and increased brain size. His hair probably will be thin, for baldness will increase. The fate of his beard hangs in doubt. His body, slender in youth, will show the greatest outward change in length of limbs. Shortened arms and lengthened legs will terminate in narrow hands and feet. Fingers and toes will be slender; the fifth or "baby" toe, in particular, will shrink. The future man will be taller, though not a giant.

Internally, important changes will occur. Highly digestible food, made possible by civilization, will reduce the size of the future man's intestines. His appendix will wane in size. His pulse rate will speed up as a result of more lively body activity.

Mentally he will be a superman, endowed with keen and sensitive intelligence. This will be only partly reflected in a bigger brain, for he will be smarter than that alone would indicate.

For all this, Dr. Hrdlicka believes, man must pay a price. He will live longer, but he will be ridden by disease. Bad digestion may trouble him; sleeplessness may make his nights hideous. Diabetes and skin troubles will probably increase, as well as insanity. Heart trouble and cancer will threaten him until they are mastered by medicine. Another danger appears in the low birth rate among people most advanced in intelligence, which may mean that society's lowest strata will have to provide the geniuses of the future.

PERHAPS by that time, however, we shall have learned to create geniuses and giants as they are required. Dr. Oscar Riddle, of the Carnegie Institution, Washington, D. C., has recently made the prediction that through gland extracts and laboratory methods of control, science may be able eventually to produce mental or physical supermen at all.

Figure 6.5. Arthur A. Stuart, "Someday We'll Look Like This," *Popular Science Monthly* (July 1929): 47. In folder "Art Education," Box 58, Egmont Arens Papers. Courtesy of the Syracuse University Library, Special Collections Research Center.

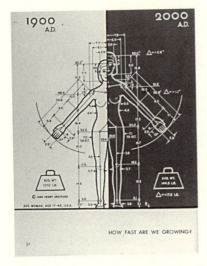
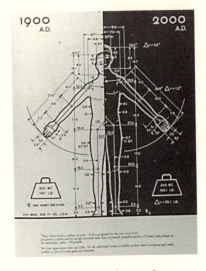

Figure 6.6. Alvin Tilley for Henry Dreyfuss Associates, Drawing of Joe and Josephine in 1900 A.D. and 2000 A.D., in Henry Dreyfuss, *Designing for People* (New York: Paragraphic Books, 1955), 32, 33.

will," as the article concluded. Henry Dreyfuss, however, was the first designer to make use of standardized "norms," established by physical anthropologists and prominently materialized by sculptors over the previous two decades, as the basis for ergonomic designs, a process he called "human engineering." Utilizing World War II Army statistical studies and the publications of eugenically-minded anthropologists such as those by Earnest A. Hooton, in the mid-1950s Dreyfuss created two "percentile anthropometric partners" for his design firm (Figure 6.6).[24] Although he could have named them Normman and Norma, instead he chose the more military G. I. Joe and Josephine, which were more appropriate to his sources and his postwar audience.[25] Before even beginning a design assignment, Dreyfuss and his associates would consider the ways that the design would act as "an extension or an appendage" of some part of Joe's or Josephine's body. "Ignoring for the moment which [was] flesh and bone, which [was] plastic and metal," they would consider "the entire linkage as an integrated unit." They would then adjust the design to the range of Joe's or Josephine's bodily dimensions, shape it so as to produce the minimum amount of strain (thereby maximizing worker productivity and happiness), and finally consult with a medical doctor for verification.[26]

Ergonomic designs thus became extensions or appendages of statistical "norms" established by anthropologists studying average racial "types." Joe and Josephine, however, were based upon a *range* of numerical figures and proportions (not upon a single "norm"), for Dreyfuss realized that designed products needed to fit the wide variety of people who might use them. This more realistic and balanced approach on Dreyfuss's part, however, did not evidence a complete rejection of the notion of the human "ideal," for as the text beneath his illustration of Joe in 1900 and 2000 indicated, Dreyfuss thought that by the year 2000 Joe and Josephine might be producing "a race of Greek gods and Amazons."[27] Yet, it seems natural that by considering products as extensions of bodies and industrial design as "preventive medicine" for both products and the people who used them, that designers would approach product design with a similar perspective to how they viewed the evolution of human bodies. Throughout the 1930s, numerous designers including Dreyfuss did in fact profess to be striving for the creation of "pure forms" and "ideal" product types suitable to the "world of tomorrow," sculpting plastic and metal much as eugenicists were seemingly sculpting flesh and bone.

Both in the popular culture of the 1930s and throughout eugenic literature, the theme of "tomorrow" was so widespread that it seems, from the historical vantage point, to have served as an ideological lighthouse, tacitly warning national leaders and the American public away from the difficult, degenerating conditions of the present while steering them toward a more secure, predictable future. Scientists, designers, corporate leaders, politicians, and ministers were the ones most vociferously promoting a better future in part because they possessed the vision, power and means to inspire, define and create the world of tomorrow. Understandably, they publicly represented their dreams of utopia not as a self-aggrandizing tool for gaining popular support during the Depression but rather as a primordial (and sometimes divinely ordained) urge for betterment that had existed "From the dawn of history, when the primitive man strolled from his cave." One New York columnist wrote that "mankind has dreamed of achieving the superman," and "Now science provokes serious thought by envisioning real *probabilities* of a superior race of human beings."[28] An insert in *Superman #1* (Figure 6.7), published in 1939, similarly informed its readers that "It is not far fetched to predict that some day our very own planet may be peopled entirely by Supermen!" a prediction made likely by the fact that eugenicists were speeding up the processes of evolution in order to achieve what on Krypton had taken "millions of years."

Figure 6.7. Jerry Siegel and Joe Shuster, *Millennium Edition: Superman 1* (December 2000, originally published as *Superman No. 1*, Summer 1939). Courtesy of DC Comics.

Although some fair-minded ministers, most industrial designers, and socialist eugenicists promoted a "democratic" utopia where everyone would receive at least some benefit and be raised to a "higher plane," more common among eugenically minded visionaries was the dream of a perfected world of, by and for the "fit."[29] One minister aptly summarized this latter viewpoint: "Surely the Kingdom can never come in all its fullness among a people descended from the Jukes. Whether we like it or not God does not perfect his Kingdom among such. The Kingdom on earth can be realized only among the sort of people who have come down to us from the [Jonathan] Edwards line."[30] Yet, even supporters with this exclusive viewpoint often acknowledged the future need for a diversity of social (which some equated with "racial") "types" to fit the numerous roles that would together comprise the complex, highly civilized future. For example, in 1928, Clarence Campbell, president of the Eugenics Research Association, sent a memo to the Policy and Research Committee of that organization, explaining his vision of a eugenic society and the goals toward which eugenics researchers should work. Campbell believed that "all walks of society are inevitably organized into leaders and followers, into those who direct and those who are directed, into those who make intellectual contribution and those who make physical contribution to the social economy." He foresaw the creation of a small "genius class" that would oversee the masses of physical workers, and predicted that "eugenicists will find that they can best serve racial interests by defining various racial types that are consonant with the various social needs." Like many others, he also hoped that scientists would be able to create these different "types" at will.[31]

Despite the theory that numerous "types" might be necessary in the world of the future, eugenic tracts focused predominantly upon the elimination of the "unfit" (who had no place in future society) and the improvement of the "fit," who ultimately would approach and even become "supermen." Just what traits were the perfected man, woman, and child of tomorrow supposed to possess? Almost all eugenics supporters agreed first and foremost that they would be geniuses. As Dr. Charles Mayo phrased it, they would be "a race of super-intellects, men with brains of machine-like efficiency."[32] Following closely upon the heels of genius as desired traits were increased beauty, morality, and efficiency (traits referred to by an Iowan pastor as "the married harmony of form and function") and freedom from disease and mental and physical deformities.[33] Many thought that the "superman of tomorrow" would be taller, stronger, and more hygienic, live longer, and have the power to select the sex of his children.

Furthermore, he would possess the socially beneficial traits of greater self-control, self-discipline, self-sufficiency, cheerfulness, and "goodwill and brotherhood," traits that would almost certainly guarantee the end of criminality and an increase in loving marriages.[34] Predictions such as that by Hrdlicka, that the "man of the future" would see an increase in baldness, bad digestion, insomnia, and diseases such as diabetes, cancer, and even insanity, were exceptionally rare. Hrdlicka balanced this dismal picture by his prediction that future man would also be a mental superman, "endowed with keen and sensitive intelligence" due in part to his "increased brain size," and that he would have "commanding stature" and be an "Apollo for beauty."[35] Many hoped he would attain and even surpass the Greek ideals for physical beauty and social perfection; in eugenic literature, visual and textual references to Apollo, the "Periclean Age," and the "Golden Age" abound, to the extent that the classical comparison functioned as a trope of the eugenic ideal.[36]

How did eugenicists propose to accomplish the creation of the "ideal type"? First, they stressed the powerful contribution every "fit" individual could make toward this goal through selecting his or her mate based upon a rational, disciplined, eugenic choice instead of upon the emotional whims of falling in love. Accordingly, "tomorrow's children" would at the least contain fewer deficiencies than was likely for children of dysgenic unions. Although race betterment would largely come through more and more individuals making eugenic mate selections (a strategy stressed in eugenic social and educational policies), eugenic tracts and media coverage liked to emphasize the creative power of the scientist to realize the "ideal type" purely through scientific control. Novels and futuristic publications by J. B. S. Haldane, Hermann J. Muller, and Aldous Huxley, as well as reports of scientists' actual research, put forth the idea of control of birth and child development by male scientists as key steps for controlled human reproduction.[37]

Huxley's description in *Brave New World* matched reports from prominent newspapers such as the *New York Times* that printed stories such as the one described above—"Science Pictures a Superman of Tomorrow"— quoting scientists explaining the goals of contemporary research into the powerful developmental roles played by the hormones of the ductless glands, including the pituitary and thyroid. For example, gland researcher Oscar Riddle asserted in 1929, "When the pure hormone is obtainable, it unquestionably and immediately will be used to increase the growth of stunted or dwarfed human beings. A long series of injections during the

period of growth will probably be necessary." He thought that there was "valid reason to expect that with this gift the physician, or perhaps the experimentalist, will also have the power to add a cubit or two to the stature of the offspring of all of us." Although Riddle did not see how experimental science could bring about "a higher order of intelligence," he argued that "the mind of man is so tied with his physical structure that . . . [o]nce man is able to exercise control over his physical development, it seems to me unlikely that the tantalizing matter of mental development will escape the influence of the experimenter." Citing Haldane, the same article also reported that hereditary changes could come through scientists' manipulation of the human gene, either through finding a "chemical substance which will attack one gene and not another" or through the application of "ultra-violet rays on a fraction of a chromosome." Furthermore, scientists thought that they would soon be able to control the sex of offspring either through selecting only male- or female-producing sperm, or through controlling the metabolic rates of a developing fetus.[38]

The previous year, the *New York Times Magazine* had run a similar story entitled "The Superman: Eugenics Sifted. New Discoveries in Biology and Chemistry Lead Fanciful Minds to Predict Such Control of Human Evolution that Genius Can Be Produced at Will; But the Scientists Are Still Skeptical." The writer, Waldemar Kaempffert, considered that "there is no prospect of biology's ever so controlling the interaction of the genes that supermen can be created according to specifications, like automobiles or houses," owing to the complexity of the human gene. He did, however, muse that if Muller's method of altering chromosomes through the application of ultra-violet rays could be used, the "fix" would be permanent, and "genetre superman mated with the superwoman" would always produce "superchildren."[39] Yet, regardless of when and how scientists would control human development to eliminate deficiencies and increase desired traits, and regardless of whether or not one believed that their ideals could in fact be actualized, believers and nonbelievers, scientists and popular writers alike believed in the power of modern man to achieve greater and greater conquests over nature. In this conquest, the "ideal" had played and would continue to play a starring role, as Reverend Frederick Adams vehemently declared to his congregation. "It is the pure and righteous in every age that will endure and conquer in the end," he asserted, for "Such is the power of an Ideal. We must then implant similar ideals for the body, mind and soul. Herein is the hope of our race."[40]

Although Dreyfuss in 1966 conveyed the possibility that by the year

2000 Joe and Josephine would produce a race of Greek gods and Amazons, and Raymond Loewy in 1967 proudly spoke about the work of his brother Georges at the Rockefeller Institute for Medical Research to enhance the longevity of man and "upgrade" him into "a more perfectly operable machine," during the 1930s, industrial designers focused less upon the men and women of tomorrow than upon their environment and the products they would use.[41] Still, their interest in the world's future citizens was considerable, especially around the time of the New York World's Fair. Deskey, George Sakier, and Loewy all referred to the perfecting power of eugenics in the 1939 issue of *Vogue*; Geddes materialized Huxley's vision in the layout of the Futurama. Arens designed a space for the Hall of Public Health that would have featured the eugenic union of "Transparent Man and Woman."[42]

In *Design This Day*, published shortly after the fair, Teague expounded his design philosophy, discussing fundamental forms, materials, techniques, proportion, rhythm, line, balance, and the role of dynamic symmetry. From his discussion, however, it was clear that his vision and the role he gave the designer transcended product design and aimed ultimately at rebuilding the world into a Utopia. He believed this was possible in "advanced" parts of the world, such as western Europe and North America, because of the "great concentration of knowledge and technological equipment to supplement abundant natural resources." His vision included not only feeding, clothing, and housing everyone, but also "creating that race of fair, godlike men who have been dreamed about and talked about for ages. . . . Conditions would seem to be all set for the dawn of that well-known day."[43] In *Land of Plenty: A Summary of Possibilities* (1947), he further elaborated his social visions, including ways to improve the physical and mental quality of the American people through economic, environmental, and educational reforms. In the words of one reviewer, the latter was a "highly creative, very inspiriting view of a Brave New World we have barely glimpsed" that mapped the way to "make our nation and eventually the world a mechanized Utopia."[44]

If these visions of the world of tomorrow did not proclaim clearly enough the imminent arrival of the "ideal," designers unabashedly proclaimed that modern society stood on the "threshold of a new epoch," when "man's century-old dream" would at last be fulfilled because he could "control his own environment." Richard J. Harper of Walter Dorwin Teague Associates reasoned that, because of his newfound power to work good or ill, modern man stood "either at the beginning of the end of the

human race, or at its entrance into a new level of semi-human, semi-divine competence."[45] In many ways, designers positioned themselves on the divide between these two possibilities—as reformers allied with industry halting the spread of product "degeneracy," ushering in instead an era of unparalleled beauty and functional efficiency. Yet, if they were on the divide or, as Teague described it, if they were the "primitives" of a new era, their beliefs in their own power as designers to improve the future world and tip the scales toward utopia were manifested through their frequent implementation of the rhetoric of the "ideal." The literature on streamlining and designers' own writings and speeches about their work were riddled with references to the "perfect" design.

For example, Chrysler boasted of creating with the Airflow in 1934 the "first . . . truly streamlined car, a car that comes the nearest to being a perfect oval from stern to stern," a perfection in design which made that automobile "the most beautiful . . . ever built in this country." For as a design approximated "true streamlining," Chrysler believed it simultaneously came "nearer and nearer to true beauty of appearance. . . . [P]erfectly designed automobiles will have more eye value than one that in some measure falls short of perfection."[46] Despite how strongly Chrysler felt about the near-perfection of its De Soto design, six months later Teague announced in a speech to the Society of Automotive Engineers that "the ultimate motor car has not yet been built." He did, however, agree that "the industry has steadily progressed toward their realization."[47] Toward this end, in his series of five motor car designs from the late 1920s, Geddes modified each design 20 percent over the previous (Figure 6.8), advancing "by degrees toward a definite ideal standard," arriving at least in model form at the "Ultimate Car," which he considered to be aesthetically and technically perfect. Similarly, others recognized his streamlined ocean liner design as an "idealized solution," and even as late as 1953, Carl Otto was still working toward "evolving the 'ideal' tv package."[48]

Without a doubt, planned obsolescence played a key role in preventing the permanent production of "ideal" designs. Even if both designers and manufacturers considered a design to be perfect and advertised it as such in order to impress consumers, almost by definition as well as by marketing necessity, the true "ideal" remained just around the corner. Jeffrey Meikle gives two superb examples of the latter situation. Although Loewy's design for the Sears Coldspot refrigerator in 1935 was reportedly considered by its manufacturers to be "a 'perfect' refrigerator" to the extent that they doubted his ability to design "a new and better looking box" each year,

41 · MOTOR CAR NUMBER 8 DESIGNED BY NORMAN BEL GEDDES 1931

Figure 6.8. Norman Bel Geddes, "Motor Car Number 8," in Geddes, *Horizons* (Boston: Little, Brown, 1932), 54. Courtesy of the Estate of Edith Lutyens Bel Geddes.

Loewy denied the 1935 model was a "masterpiece," considering it instead "a step in the evolution toward perfection."[49] Two years before, Teague had achieved "perfection" in his gas heater design for American Gas Machine, yet he was asked to redesign it each year to satisfy customer and manufacturer demand. Subsequently, his model for 1937 was acclaimed as the "inherently 'right'" design, to the extent that Teague himself judged its design exemplary of his Platonic design philosophy that there was "only one right solution . . . not a dozen solutions, but one right one" to any design problem.[50]

Although all this talk of perfection made good marketing copy, even outside the marketplace most of the prominent streamline designers held to the theory that only one "ideal" design existed for any given product, with each of their designs being the most "advanced" thus far in any given product's design evolution. As the previous example shows, in Teague's case this notion of the "ideal" strongly resonated with Platonic philosophy, to the extent that his theoretical fascination with the "one right solution" and with "ultimate form" (and Le Corbusier's as well) has been interpreted almost solely in this light. When his words and ideas are placed next to those of eugenics supporters discussing the "ideal" human "type," however, especially when considered in relation to the multiple parallels between streamlining and eugenics and designers' utopian social visions, the close parallels strongly suggest that the social and scientific pursuit of the eugenic ideal offered at least an overlapping pattern, if not an out-and-out

rationale, for designers' obsessions with ideal product designs. For example, just as eugenicists proclaimed that the "man of the future" would approach or even attain the level of "an Apollo in beauty," so too did Teague and Le Corbusier intend for modern design at its basis to follow the same artistic principles that gave such "purity" and "vitality" to works of Greek art and architecture. Accordingly, as the Greek temple had evolved from Paestum to the Parthenon, manifesting "the progression toward 'perfection,'" so too would modern designs follow the same pattern, especially because modern machinery offered the long-lacking precision needed to attain geometric perfection and its attendant beauty in mass-produced designs. In this way, the evolution of products would keep pace with the evolution of its creators.[51]

Just as eugenicists predicted the dawn of a new Golden Age, so did Teague hope that by redesigning "everything from a match to a city" based upon the "right" principles of design (by which he meant a return to the underlying patterns of nature as revealed through dynamic symmetry and the processes of evolution), designers would usher in a Golden Age.[52] Further parallels between eugenic ideals and streamline rhetoric were expressed through the avoidance of what critics and designers referred to as "mongrel" forms in their designs. In a draft of a biography about Deskey, one of his associates used the term to describe pre-design-era products of the 1920s, that in his estimation were also "contorted species" with "vestiges" that still lingered on into the late twentieth century. One of Deskey's furniture critics also referred to "dishonest" designs, such as those made of metal painted to simulate the appearance of wood, as "mongrel" forms.[53] Interestingly, Dreyfuss's use of the term resonated with Teague's concerns, owing to their common interest in the Greek principles of dynamic symmetry. To Dreyfuss, any design that was not geometric in its basic shapes, principles and proportion constituted a "mongrel" form.[54]

When "mongrel" designs are contrasted against "ideal" product types, with the difference stemming largely from how closely a product design adhered to what were considered by designers to be the fundamental design laws of nature, it is not surprising that designers insisted upon studying nature and the design of living organisms as the basis for their bringing about "pure form" in streamline product design (such as that exemplified by the blimp or Dreyfuss's dynamically symmetrical forms).[55] For example, Arens upheld the whale as the best model for ship design, and designers closely studied the intricacies of the salmon and the Pacific plover in order to better understand the streamline adaptations of fishes and birds. As Ray

Holland, Jr., pointed out in his *Scientific American* article on "Streamlining in Nature," "If [a designer] believes a particular design is *the ultimate*, he should stop to consider the forms found in nature."[56] The "ideal types" toward which designers strove were in fact almost uniformly based upon biological forms and principles. Take, for instance, the aforementioned comparison between designers and breeders, and Teague's insistence that the "*ultimate form* is latent in the thing itself, as the color of our eyes and the shape of our fingers are latent in the uniting cells with which our lives begin."[57]

Despite Teague's dogmatic insistence upon the use of the Platonic forms as the basis of good design and his idea that there was only "one right solution" to any functional design problem, at least one of the associates in his firm in the postwar years loosened the reins enough to admit that the "functionalist formula" did not always provide the all-encompassing key to a problem's solution. "Nobody doubts the validity of the formula, as a basic principle," he wrote, for "it's plain to see it demonstrated in the most successful work of all other ages as well as our own." Every artist knew, however, that a "basic form" derived simply from the formula "is a mere anatomical specimen until the artist's creative imagination has clothed it with flesh, breathed life into it, given it the sparkle and vivacity of independent existence." He characterized the design process in the terms of birth—conception, delivery, and offspring—arguing that good design required emotional inspiration and not just "mental processes and self-restraint" for it to come to life. If only the latter process were used, the result would be "sterility," whereas if both rational and emotional aspects were imparted to the design, "health and vigor" would ensue.[58]

In the early 1930s, Arens was also concerned about "sterility" in design, although he proposed a slightly different solution, one that reflected contemporary eugenic concerns. In his essay "Creative Evolution of the Printed Word," although the evolution of typefaces had ostensibly been his topic, based upon changes he made to the title and to more inclusive references throughout the text to the evolution of automobile and clothing designs, Arens used this address to formulate his theory of design evolution. He envisioned the role of the artist (really the designer) throughout history being that of a refiner, one who took newly invented and hence still crudely imagined forms and transformed them into beautiful, dignified results. Although he espoused the idea of "pure form," he believed that, without recurring changes in automobile, clothing or type-face fashions brought about by the designer, "we would all go mad with the monotony of mass

production." Just as seriously, without "the changes in language that come from vulgar speech, speech would become sterile." In other words, if only "pure forms" were mass-produced, the excess of "purity" would impart monotony and sterility. Social monotony threatened, too, if eugenicists failed to produce a variety of "social types." Yet, as his example about speech showed, Arens was not afraid of "vulgar" forms, which in his speech referred to crude yet brilliant inventions. In fact, he reasoned that just as in history "the bastard offspring had more vitality than the parent," such hybrid vigor was also possible in design, provided that designers still added the final, dignifying touches.[59]

Designers' rhetoric strongly suggests that their conceptions of "ideal types" in product design were intricately, ideologically entwined with eugenicists' pursuits of the same goal in social and biological design. Although in both the "ideal" served as the always elusive evolutionary endpoint for a never-ending process, social and industrial designers' devotion to the concept produced very pragmatic results; as Ellsworth Huntington realized, "A practical end is best served where there is the highest devotion to an ideal."[60] Eugenicists' characterizations of the "ideal human" offered standards whereby one could personally determine whom to marry or alternately, whom to sterilize, depending upon one's position. Alternately, advertisers' and designers' rhetoric of the ideal bolstered strong consumer sales owing in part to its effect as a good marketing slogan. Furthermore, the proclamation of the imminence of the "ideal" in both the realms of eugenics and industrial design proffered "semi-divine" status for industrial designers and scientists who were "lifting" modern civilization toward Utopia, alternately referred to by ministers as the Kingdom of God on earth. As the actual existence of "perfect designs" such as Teague's gas heater and Loewy's Sears Coldspot refrigerator showed, the "ideal type," like *Norma* and *Normman*, lived a dual existence, one in the visionary, heavenly realm of the imagination or the future, and the other (almost) in material form on earth in the present.

In many ways, mass production furthered the idea of the actual existence of the "ideal type." Once a design was complete for a certain model for a certain year, it was reproduced ad infinitum, offering no variation at all, save for color perhaps, between one product and the next behind it on the assembly line. Precisely because of controlled, machined production, then, "ideal types" *were* actualized, a result of both the uniformity and the geometric precision attained by means of the machine. Not unrelatedly, eugenics also arose as an offshoot of the Industrial Revolution's shift to

controlled mass production, with the political state assuming the place of the corporation controlling its human resources for utmost profit, productivity, and efficiency. The discovery of Mendel's formula offered entirely new possibilities for "product" reform and controlled reproduction, including a simple procedural ladder leading upward to the ideal type. The material embodiment in sculpture of white racial norms masquerading as the ideal, like the existence of perfected goods, not only affirmed the superiority of "native whites" (by proclaiming them to be the average man or woman, thereby effectively excluding other races from participation in humanity) but, like product advertisements, held out a lure enticing further support for the eugenic cause, if only as a way to improve "tomorrow's children."

The concept of the "ideal type," however, was unique to neither eugenicists or industrial designers. Both understood the concept to be a primordial urge that had tugged at humanity "[f]rom the dawn of human life."[61] This primordial aspiration seems to have assumed a primordial form: the duality lived by the ideal type in its dialectical future and actual manifestations. Although throughout his life Geddes believed that "the imagination creates the actual," it was the material manifestation of the ideal—whether in Dickinson's sculptures or Geddes's Futurama intersection of the world-of-1960-actualized-in-1939—that imparted credibility to designers' and eugenicists' rhetoric, turning possibilities into probabilities and winning them the economic support and personal commitment of the American public in their pursuit of a streamlined world.[62]

Despite the fact that both eugenics and streamlining were founded upon the principles of evolutionary biology, owing to their personal investment in their respective ideals, designers and eugenicists both missed an important lesson on streamlining in nature. Whether for the purposes of determining eugenic "norms" or the streamline "ideal" for industrial design, the attempts by scientists to measure animate forms had posed considerable difficulties. Even if they could get their human subjects to hold perfectly still while measurements were being taken, physical anthropologists struggled to attain a uniformity of body position and angle of certain measurements from subject to subject; hence Richard Post's attempt to standardize techniques for making anthropometric measurements. Post was one of Hooton's graduate students at Harvard, whom Davenport solicited in 1929 to travel to Europe to query fellow anthropologists regarding their methods of taking anthropometric measurements in hopes of convincing them to follow an international standard. Without a rigorous standard that

all could follow in their measurements of the physical, mental, and temper-amental qualities of man, data on various groups and races of people would not be comparable, eugenics researchers feared, and thus their attempts at determining the evolutionary patterns and traits of the various "types" immeasurably slowed.[63]

Apparently these measurement problems were not unique to anthro-pometry. As the *Scientific American* article on "Streamlining in Nature" revealed, scientists measuring the curves and angles of salmon and plovers to ascertain the natural model for true streamlining (i.e., what specific ad-aptations minimized the resistance of natural forms in motion) faced even greater challenges, for they lacked the cooperation of their subjects. Invari-ably, when a salmon was removed from water, the aerodynamic slime cov-ering its scales that created an almost perfectly smooth surface began to dry; its "eyes become shrunken, the fins curl up and split, and the mouth and gills remain open," researchers complained. Even worse, if the fish were lying on a flat surface, it would "take the form of that surface on one side and be bowed excessively on the other," throwing the fins out of align-ment as well. Birds proved even more difficult to measure, for their entire surface was variable depending upon the precise airflow at any particular moment. These two examples showed, the writer argued, the difficulties "the scientific investigator is confronted with when he attempts to learn quantitatively *just how well streamlined a bird or fish actually is.*" Although these natural forms purportedly offered the streamline "ideal," to the extent that successful measurement of their forms would have offered designers specific proportions and strategies for vehicular design, as the italicized words reveal, in reality the streamline "ideal" originated and remained within the minds of designers and scientific researchers, acting as the stan-dard against which natural forms were then judged.[64]

Eugenically minded physical anthropologists and psychologists also operated under numerous preconceptions: that "innate intelligence" and "racial" differences existed, first of all; that they were hereditary; that hered-ity posed insuperable barriers that could not be crossed during one's devel-opment, regardless of environmental conditions; and that they knew the traits that would eventually constitute the "ideal type." Despite these nu-merous preconceptions, any one of which would stand as a questionable scientific premise today, they proceeded to test thousands of individuals under the pretexts of compiling data from which to create "norms" and classifying individuals into their allotted categories when measured against

that "norm," so that no penny would be wasted in bringing the "ocean of culture" to those who had "only quart measures to carry it in."[65]

Although the researcher studying salmon and birds struggled with the innate variability of their forms, he at least was able to recognize that flexibility and adaptability were their strongest assets, in essence the qualities that enabled them to be truly streamlined. Would that social designers in the U.S. and abroad admitted as well the fluidity and resiliency of human beings even under the direst of circumstances and celebrated their human differences, instead of enacting highly restrictive policies of eugenics intended to physically, mentally, and genetically streamline the human race. If in hindsight this lesson is obvious, then questions remain about the continued appeal of both streamlining and eugenics and all that they represent: controlling evolution; increasing biological efficiency, health, and hygiene; the rhetoric of the "ideal type" based upon nonexistent norms; allegiance to capitalist corporations and allied designers as the progenitors of the future; and the association of all of these interests with "progress" and the advance of "civilization." The ongoing allure of these ideals is examined in the last chapter.

Conclusion: Pseudoscience? Pseudostyle?

In January 2000, in the spirit of the millennium, *Wired* maga-
zine published a story entitled, "Don't Die, Stay Pretty," that heralded the
imminent ability of genetic and medical technologies to immeasurably
lengthen the human lifespan and redesign the human body. The story cov-
ered a conference on this topic held in the San Francisco Bay area spon-
sored by the Extropy Institute, a group of believers in the power of science
and technology to upgrade human beings. Natasha Vita-More, the Insti-
tute's co-founder, described the body as a canvas, "'the next fashion state-
ment,'" designed like products "'in all sorts of interesting combinations of
texture, colors, tones and luminosity.'" Through a combination of plastic
surgery and genetic engineering, she envisions altering her body periodi-
cally in the mode of contemporary fashion. "'Maybe I can look like a Re-
naissance painting for a while, or maybe a pointillist image, or maybe
Cubist, like a Picasso. . . . I'm a bodybuilder, so I love sculpting muscle. . . .
[O]ur future bodies will have streamlined muscles in all sorts of interesting
shapes—new types of limbs, new types of carved skeletal structures.'"[1] Al-
though she hopes her body will be able to be made ageless on the genetic
level, whereby the process that seemingly triggers aging within cells is hal-
ted, should that not be possible, developments in organ growing technolo-
gies might offer her salvation. The author of the article describes how, late
in life, she might be able to check herself in for an "overhaul. . . . Our new
organs will be manufactured the way Ford makes crankshafts."[2]

Early the following year, two separate individuals in the United States
publicly announced their intentions to clone a human being. One is Panos
Zavos, an in vitro fertilization (IVF) specialist at the Andrology Institute
of America who also teaches reproductive physiology at the University of
Kentucky at Lexington, and the other is Brigitte Boisselier, a dual-doctoral-
degreed professor of chemistry at Hamilton College in northern New York
who also directs Clonaid, a research center at an unspecified location run
under the aegis of its umbrella organization, the Raëlians. Like the Extropi-

ans but with an extraterrestrial twist, the Raëlians were created by former French journalist Claude Vorilhon, now called Raël, after an encounter he claims to have had with an alien; the group upholds the power of technology to create everlasting life through reproductive and genetic technologies, cloning in particular. Having been given $500,000 and the necessary genetic material by a grieving American couple seeking to "re-create" their dead ten-month-old son, Clonaid asked female members of the Raëlians to undergo the necessary medical procedures to become egg providers and then surrogate carriers for the genetically engineered embryo-clone of this child. Over fifty women volunteered, including Boisselier's daughter, providing Boisselier with an abundance of the material that is necessary for making this very difficult process a possibility, or, as Boisselier and others claim, a probability.[3]

To accomplish this, Clonaid researchers plan to use the process of somatic cell nuclear transfer, whereby the nucleus from a somatic cell, which in this case was taken from the boy's body and frozen, is removed and transferred into an egg from which the nucleus has been removed; the resulting embryo is then jolted into development through electric shock or chemicals. They will then monitor the progress of these embryos, instilling ones that appear normal into an assembly line of waiting surrogates. "If one pregnancy failed, another surrogate would automatically step into line; there would be no need to wait another month, as you would have to if you were dependent on the cycles of just one woman."[4] On December 26, 2002, Boisselier announced success with the birth of Baby Eve, cloned from the baby's mother, as well as the birth of four others since, although many people believe these clones are a hoax. Boisselier claims that no proof has been offered in order to protect Clonaid and the clones, but that as soon as the United Nations resolves that human cloning is not a crime against humanity, DNA tests will be conducted to prove these children are clones.[5] Although human cloning may be closer at hand than technologies of medical genetics that could theoretically be used to enhance genetic traits through germline engineering, research on the latter technologies surpasses that on human cloning as the focus of numerous scientists and scholars working in the field of genetic engineering. In germline engineering, the DNA sequence in the chromosomes of the egg and sperm or early embryonic cells would be altered prior to implantation in a woman's body so that every cell in the resulting body, created through IVF, would contain the alterations. Gregory Stock, who directs the Program in Medicine, Technology and Society at UCLA, and who participated in the Extropian conference

in 2000, predicts that the use of germline engineering is "only a decade or two away," followed by what he sees as the very real possibility of creating "designer children."[6]

As these examples show, the proliferation of a designing mentality predicated upon enhancing consumer choice, that began in the U.S. during the 1930s as a result of the success of streamline industrial design, has continued into the present. If the profession of design began as an alliance with industry, to the extent that designers were employed primarily to improve the aesthetics and functioning of mass-produced goods in order to increase corporate sales and profit, the effects of industrial design have gone far beyond this context, even to the point of influencing the daily decisions of American consumers. Mass participation in the cycle of production, consumption, and disposal of designed goods, spurred on by advertising and media promotion of the countless ways that Americans can exercise their power of choice to improve their lives and their bodies, has extended the influence of design beyond the realm of the artificial or manufactured and into that of the natural. From the furniture, dishes, lamps, and appliances we use, to the clothes we wear, to the foods we select at the grocery store for their brilliant color and uniform size and shape, we surround ourselves with and literally consume design on a daily basis. In some ways, it is therefore not surprising that consumer choice has also entered the realm of human reproduction through IVF and other reproductive technologies and prompted visions of fashionable body design and enhanced designer children. This is especially so in light of the historical precedents demonstrated by the theoretical overlaps between streamline design and eugenics during the 1930s, as well as by other examples of Americans' ongoing belief in technology's ability to empower and improve their bodies.[7]

How do we begin to understand the trajectory of these ideas from the 1930s to the present, a trajectory that leads at its outset from the shared ideologies of controlling evolution through streamline design and eugenics, to the stylistic diversity and changing conceptions of design today as separate from but also related to the new eugenics resulting from developments in reproductive technologies and genetic engineering? If, as some contemporary critics and historians have asserted, streamlining was damned by an elite few as a "pseudostyle" at the height of its popularity in the mid-1930s, and then largely rejected in the 1940s by the public and designers alike for its totalitarian implications of its bringing all parts under the sway of a uniform, dominating line, then what happened to make design, after having its first major boost in streamlining, become as pervasive as it is today? Did

streamlining as an aesthetic and a philosophy disappear, or did it morph into something related but more palatable to the public?

Similarly, eugenics was also under fire during the 1930s, to the extent that its supporters adopted a policy of silence as a cloak for their continued work. As early as 1929, Charles Davenport realized that the Carnegie Institute in Washington may need to "abandon the term 'eugenics'" in its research goals and that the Eugenics Research Office might be wise to change its name to "something else, like the 'Laboratory of Human Genetics.'"[8] At the Conference on Publicists held by the American Eugenics Society in 1937, Albert Wiggam encouraged writers to avoid using the term "eugenics" but instead to incorporate eugenics into their work, "so that it may consciously or unconsciously enter into the consciousness—or at least subconsciousness of their readers." Due to the controversy surrounding eugenics, he felt that "eugenic propaganda will go furthest if it is treated as incidental to all other social advance."[9]

Particularly after the horrific revelations of the Holocaust, eugenics became widely known as a pseudoscience for the way that its unproven scientific methods were applied prematurely and powerfully to society through devastating political policies, both in the U.S. and abroad. Eugenics was largely disassociated from the U.S. in subsequent discussion and historical inquiry, however, until the 1970s when it again made headlines as a result of controversial assertions by such figures as Arthur Jensen and William Shockley connecting race and intelligence to genetics, as well as the debates over the legalization of abortion and the creation of the first IVF "test-tube" baby in 1978. If eugenics was so thoroughly discredited and abhorred by the postwar public, then what happened in the intervening years to renew public support for eugenic measures today through the use of genetic engineering? A 1993 poll revealed that 43 percent of Americans queried said they would use genetic engineering to enhance the physical appearance or intelligence of their child, should that become a possibility.[10] These results reveal an impressive if naive trust in the ability of scientists to fulfill their claims and, presumably, to fix any mistakes they make, for positive answers in the poll depended upon a willingness to permit irreversible intervention on the most fundamental level of humanity. As shown by the examples opening this chapter, the commodification of American culture started by the success of streamline industrial design has contributed significantly to renewed public acceptance of eugenics today, despite the fact that the explicit overlaps between streamlining and eugenics in the 1930s

no longer pertained after the postwar rejection of the negative aspects of eugenics and the change in design aesthetics that occurred in the 1950s.

To begin, then, when did streamlining as a style go into decline, and for what reasons? In contemporary sources that discussed the style's faults in relation to the tenets of modern architecture and design, particularly those of the International Style, the reaction against streamlining occurred for reasons that turned on the issues of functionalism, commercialism, and the supposed superiority of European over American art and design. In the 1930s, many American designers who practiced streamlining themselves at times judged other streamline designers for their inconsistent adherence to functionalism. The most infamous example that they cited was Raymond Loewy's ultra-streamlined pencil sharpener prototype, for by applying the aerodynamic, teardrop shape to a immobile product, Loewy disavowed the function of a pencil sharpener to be stable, attached to a table or wall. Even on the part that did move, the handle, the teardrop was not oriented properly in the direction of the motion.

The weightiest and most influential criticism of this sort came from curators at the major museums, including the Museum of Modern Art (MoMA), the Metropolitan Museum of Art, and the Art Institute of Chicago.[11] As early as 1934, the split was obvious between those in favor of commercial design, whose work was exhibited at the Industrial Arts Exposition at Rockefeller Center, and those who thought that designing for commerce caused designers to automatically favor public recognition and a product's external appearance over "pure" design principles, such as those seemingly embodied in the anonymous machined parts on display at MoMA's Machine Art exhibition.[12] In their collections, therefore, the major museums featured the works of recently immigrated European artists, architects, and designers, works that were reproduced on a much smaller scale and appealed to a more sophisticated clientele.[13]

These criticisms of the style were debated among a rather small circle of experts in the fields of architecture and design, and they offer little explanation for why, after the New York World's Fair where virtually everything was streamlined in the "world of tomorrow" on display, the style never actually succeeded in pervading American material culture to the great extent designers had envisioned. Some historians have suggested that the changing political context, owing to the escalation of the war in Europe over totalitarianism, may have caused the style to become unfavorable because of its own tendencies in this direction. Undoubtedly, some prominent advertisers and designers during the streamline era promoted strongly hier-

archical, even racist and classist viewpoints in their speeches, advertising copy, and urban planning visions.[14] Such interpretations of the style's totalitarian leanings are supported by the top-down approach of streamline designers and advertisers, by which they considered the upper classes to be more "civilized" and "modern" and their goal to be the elevation of national taste to an upper-class ideal, as well as by the eugenic implications of the style's features as discussed throughout this study. These interpretations of dismissal because of totalitarianism, however, are not backed by a close analysis of the actual products and advertising of the 1940s, in part because most studies chronologically focus on the previous decade, and in part because, upon U.S. entry into the war, almost all manufacturing for the domestic context was redirected to the war effort. Streamlined goods were not being produced in the same amounts as previously, and therefore were not as available for purchase. Most histories of American design therefore skip the early to mid-1940s and move directly into discussion of postwar production and the exaggerated, open-ended streamlined styling of the 1950s, such as the addition of tail fins and bullet-shaped taillights to automotive designs.

For example, Jeffrey Meikle compares the "new variant" of streamlining of the 1950s with that of the 1930s, stating that both derived from the aesthetics of flight. The teardrop curves of 1930s styling that copied the shape of a cross-section of a wing, however, shifted into an angularity in 1950s styling that more closely mimicked jet fighter wings as seen from the ground than from the side. According to one critic in 1957, these angles made 1950s designs appear as though they were " 'exploding into space.' " Similarly, instead of the bulbous shapes of the 1930s whose lines all coalesced toward the closure of a taper, those of the 1950s "ran without visual hindrance toward an ever-receding infinity point." Meikle characterizes these traits as representing America's political independence and accelerated economic growth "along an open road of limitless progress." Designer Peter Müller-Munk's interpreted these features as examples of Americans' refusal " 'to accept any condition or product as static and to whom progress, experimentation, and the sheer excitement of production are a necessary part of their self-confidence.' "[15] When combined with the vastly larger market for designed goods in the 1950s, which resulted from the fact that full employment during the war greatly enlarged the American middle class, these changes further symbolized the power of American free enterprise and democracy, in contrast to totalitarianism, to raise the standard of living for its citizenry.

The work of Cynthia Henthorn is very helpful in understanding this transition from tapered "totalitarian" streamlining of the 1930s to open-ended "democratic" streamlining of the 1950s. She counters previous interpretations by showing that in the early 1940s, traditional streamlining of the rounded, teardrop variety was projected by advertisers as *anti*-totalitarian long before its new aesthetic variant arrived on the postwar scene. Based upon the minutes of meetings held by the National Association of Manufacturers during the late 1930s and early 1940s, she reveals the long-standing animosity of corporate manufacturers and some of the leading industrial designers to what they perceived as the totalitarianism of the New Deal, whereby the federal government was regulating the role of free enterprise in the American economy. Before the U.S. even entered the war, at their meetings members had begun strategizing how to prevent the continuation of the New Deal after the war to the extent that by 1943, they had devised a specific plan to convince the American public through advertising campaigns that free enterprise, rather than the American government, had won the war.[16]

Henthorn discusses many examples of advertisements in line with this campaign, including one by Western Brass Mills captioned "When It's Toasters Instead of Torpedos," accompanied by an illustration of a gleaming, 1930s-style streamlined toaster surrounded by a halo of light caused by an explosion of a torpedo fired by a barrel at the top of the image.[17] Many other advertisements focused on the white middle-class housewife, celebrating her contribution to the war effort through maximizing efficiency in the home by encouraging her family to live a pared-down, streamlined lifestyle, symbolized by her streamlined kitchen, which, if she didn't have one then, she would after the war. The overriding message of these advertisements, especially when considered as a whole, was that progress in American technology prior to the war, epitomized in streamlined products, not only had enabled the U.S. to win the war (for example, jet fighters and the streamlined torpedo), but through the process of this triumph had generated even better technologies that in turn would translate into greater prosperity through consumption for middle-class whites after the war. Thus technology and design, particularly as manifested in streamlined products for the middle-class home, came to symbolize national superiority accomplished through democracy and free enterprise in contradistinction to totalitarianism at home or abroad. This was in essence the crux of the famous "kitchen debate" between Soviet Premier Nikita Khrushchev and Vice President Richard Nixon in 1959 at the U.S. Exhibition in Moscow,

where each official claimed national political superiority as evidenced by an abundance of designed appliances in the average home.[18]

Thirties-style streamlining was thus promoted through wartime advertising and reinstated upon the war's end. This continuity was a natural result of many different factors, including that some of the main designers who were active before the war—including Raymond Loewy, Walter Dorwin Teague, Normal Bel Geddes, and Henry Dreyfuss—participated in creating wartime advertising strategies and postwar housing and product designs. Streamlining had hit its stride at the New York World's Fair just prior to the war. Designers' promotion of their ability to improve the "world of tomorrow" and public acceptance of this idea caused the war to serve only as an interruption and, in fact, as the means of fulfillment, of designers' promises to extend participation in the streamlined future to more and more Americans. Furthermore, the equipment that was producing streamlined products before the war in many cases was reinstated after the war, as few industries had the funds to finance major retooling efforts for reconversion despite the fact that the federal government had covered much of the cost of retooling for conversion upon entry to the war. Designers and manufacturers enacted a conscious strategy to convince the public of the desirability of regular streamlined products, like ones they had seen before the war but improved through new technologies and new materials. Only as the consumer cycle got back into full swing did manufacturers begin to use their profits to retool for new and innovative styling, such as the 1950s variations on streamline design.[19]

Most interesting in relation to my argument connecting streamlining with eugenics, Henthorn asserts the continuation into the 1940s of the eugenic ideology inherent in streamlining of the 1930s, a claim that she substantiates through describing the "human engineering" strategies of manufacturers and designers, and through analyzing the advertising rhetoric of social evolution of the 1940s.[20] Just as the familiar streamline aesthetic was held forth as a symbol of the triumph of democracy and free enterprise over totalitarianism, instead of as an expression of corporate and scientific control aiming to streamline the American populace, so too were the style's positive eugenic connotations construed in wartime and postwar advertising as a major goal for which we were fighting: to maintain the preeminence of America's social evolution so as to be able to extend our level of evolutionary sophistication to greater numbers of people. This rhetoric seems to validate Albert Wiggam's hunch in 1937 that for eugenic ideas to succeed, they had to become inseparable from ideas about social advance.

Such a shift in meaning could only be accomplished precisely because so many people, including designers, advertisers, and the general public, really believed that evolutionary progress was what eugenicists claimed even if they disagreed with eugenicists' coercive methods. People believed, and still believe, that evolutionary progress and "civilization" had been furthered through American inventiveness and intelligence, as embodied in professional experts who had not only produced technologies maximizing efficiency and hygiene but promised that these technologies would soon usher in a utopia. People believed that political and economic competition—in free enterprise and in an international war—had proven that survival of the fittest was a true principle, since America was victorious. Yet, in addition to these deeply held beliefs, the shift in meaning could also only be accomplished through disassociating the negative methods of eugenics from American ideals while upholding the positive goals of eugenics as an American ideal. This was done by attributing the compulsory enforcement of negative eugenics to totalitarian countries while associating the abilities of raising oneself to the eugenic ideal to be the ultimate potential benefit proffered to American consumers through free enterprise and the creation of new technologies. If the unconstrained, open-ended lines of 1950s styling symbolized American independence and freedom in contrast to totalitarianism, by buying into consumption of mass-produced goods as a means of elevation, ironically, middle-class Americans furthered social conformity as manufacturers and designers had intended, since the latter profited from the perceived social need of "keeping up with the Joneses."

In her discussion of the strategies manufacturers and designers used to try to convince consumers to purchase a prefabricated, postwar "house of tomorrow," Henthorn dramatically highlights this specific irony. What appears to be individual choice on the part of consumers to select mass-produced goods, a process that is portrayed as a means of expressing and creating individuality, in reality fosters cultural normalization and corporate profit because consumers select mass-produced goods and therefore choose items that many other people also have. The postwar homes advertised during wartime were to have mechanical cores, prefabricated from plastic or metal, in which the kitchen, bathroom, plumbing, and heating elements were combined into single, streamlined units, in order to maximize ease of construction and facilitate domestic hygiene through seamless, sterile surfaces, as well as increase a housewife's efficiency through a Taylorized layout. In addition to this unprecedented feature, owing to their roots in mass production, many homes of tomorrow were built using modular pan-

els and standardized parts for the interior and exterior, which lent themselves to variable arrangements, but only within certain prescribed limits.

A prefab home designed by Norman Bel Geddes in 1941 for Revere Copper and Brass Incorporated clearly illustrates these principles. Presented as if the "house of tomorrow" were already a "reality" and the pick of the four white middle-class Americans depicted in the ad, Geddes downplayed the fact that every home and person shown in the advertisement, located on Main Street, basically looked alike. Featured in a photo hovering over a model of the home he had created (much like the photos of him with his Futurama model), exemplifying "our inventive and productive genius," he acknowledged consumers' desire for individuality. "'We who are planning these homes know that Americans do not want standardized designs," he stated. "So the basic parts of this [prefabricated] house are made so that they can be assembled in various ways to form no less than 11 distinct homes—*all different.*'" In case having a prefab mechanical core seemed strange, the text and illustrations emphasized its benefits (inexpensive, and "free from repairs") and implied that consumers wouldn't even be able to see the difference, a normality that was emphasized by showing "Mom," replete with apron and printed dress, making dinner, smiling. Geddes declared that mass production is "the secret of our famous standard of living" that has allowed Americans to "enjoy more comfort, more freedom, more fun than any other people on earth." He characterized free enterprise as the root of democracy and freedom, since it seemingly allowed "even the lowest income" to "buy living fit for a king," if only they worked hard and purchased consumer goods. This definition of democracy closely resembled that promoted by eugenicists who wanted to raise the quality of the common man to the level of his betters. Instead of truly celebrating individuality and diversity, manufacturers, designers, and eugenicists effectively redefined individuality as self-selected conformity to a set of idealized standards that they established and portrayed as the norm, and then offered for sale.[21]

Despite these many claims, in fact many prefabricated homes did look alike, were cheaply made and needed repairs, and were stigmatized by consumers as symbolizing anti-individuality. "'[T]he unconvincing accomplishments of the industry as a whole have prompted many observers to rhyme prefabrication with prevarication,'" stated an article in *Architectural Forum* in 1940.[22] The image put forth by advertisements of the happy housewife in her "house of tomorrow," fulfilled by working in her streamlined kitchen, belied the fact that "higher standards of household efficiency

and cleanliness" that came through "revolutionary" household technolo-
gies "were actually harnessing more of her attention on household chores,
not less, and were boxing her into orthodox feminine roles."[23] Henthorn
points out that in the 1940s these technologies and advertisements were
predicated for the most part upon a notion of the "sexual division of prog-
ress," whereby men were the inventive geniuses creating the technologies
that supposedly extended leisure to their women at home, a notion which
failed to acknowledge the fact that many women were no longer just house-
wives but had begun working during the war.[24]

This case study of manufacturers' and designers' promotion of the
prefabricated, internally streamlined "house of tomorrow" is of significance
for multiple reasons. First, it reveals a conscious strategy on the part of
producers to attempt to convince the public to buy into a vision of a some-
what extreme version of "progress," as manifested through designs that
were not yet a reality or flawless, despite being described as such. Henthorn
summarizes her findings by stating that, "at heart, visions of the postwar
world were contrived in order to tempt consumers into unfreezing their
war bond savings and igniting (virtually by themselves) the 'better America'
which manufacturers, ad men, and designers had promised themselves to
fulfill."[25] This marketing strategy has continued to this day. Second, it dem-
onstrates consumer hesitance toward mass-produced, rational, sterile
homes that were streamlined at their core. These were costly, long-lasting
purchases of significant scale and personal impact so as to not be easily
altered or discarded, like a faulty home appliance or an article of clothing.
This is important to consider in relation to the last reason, which is that
the methods and claims that designers and manufacturers used for the
"house of tomorrow" strongly resemble the approaches being used today
to promote the use of new reproductive technologies and germline engi-
neering to create the eugenic "human of tomorrow," confronting consum-
ers with a similar, but far more profound, decision to make.

Tracing the paths of eugenics since the Holocaust—what Daniel
Kevles refers to as the "new eugenics"—is not as simple as doing the same
for the streamline style, which was sufficiently altered by the end of the
1950s as to have largely disappeared, until it was recently revived as a retro
style. Although public renunciation of eugenics was nearly universal after
the revelations of the Holocaust, the accusation of eugenics as a pseudosci-
ence had begun much earlier, being voiced mostly by geneticists who dis-
approved of mainline eugenicists' race and class prejudice and their
oversimplified methods.[26] In particular, geneticists faulted eugenicists for

acting as if traits such as intelligence or character were controlled by one or a few genes that followed Mendel's laws; for discounting the influence of environment in shaping individual characteristics; for assuming that all individuals who appeared to belong to certain races or classes shared genetic coding for prescribed traits; for underestimating and misrepresenting to the public the time it would take to make an actual difference in the national gene pool through careful breeding, even for traits that did manifest themselves according to Mendelian ratios; and for prematurely pushing for social and political policies based upon these unproven, oversimplified scientific assumptions.

Although these criticisms on the surface may seem to demarcate eugenics from genetics, upholding the former as illegitimate and the latter as legitimate, in fact these criticisms in no way precluded geneticists from agreeing in principle with the goal of eugenics to understand human genetics and use that knowledge to work to improve human heredity and control evolution. As shown by Davenport's suggestion in 1929 that eugenics research centers could just substitute the words "human genetics" for "eugenics" in their names to avoid stigmatization, the separation of eugenic values from people who call themselves geneticists cannot be so easily accomplished. For example, two of the most recognized scientists of the twentieth century, James Watson and Francis Crick, who discovered the double-helix structure of DNA in 1953, have both expressed eugenic views. In 1963, Crick put forward the possibility of a governmental " 'licensing scheme' " whereby " 'if the parents were genetically unfavorable, they might be allowed to have only one child, or possibly two under certain special circumstances.' "[27] Early in 2003, Watson, who currently is president of the Cold Spring Harbor Laboratory, located on the same site and utilizing the former facilities of the Station for Experimental Evolution and the Eugenics Record Office (ERO), echoed almost verbatim an idea promoted by supporters of the earlier eugenics movement about the "submerged tenth" (Figure 2.2). "If you are really stupid, I would call that a disease. . . . The lower 10 percent who really have difficulty, even in elementary school, what's the cause of it," he asked. He dismissed the approach of improving environmental influences and material equalities: "A lot of people would like to say, 'Well, poverty, things like that.' It probably isn't. So I'd like to get rid of that, to help the lower 10 percent," by using germline engineering to remove the "genes" for stupidity and replace them with the "genes" that influence intelligence.[28]

Recent histories of science have thus worked hard to dispel the myth

of a clear-cut separation between prewar eugenics and human genetics, in part accomplishing this through the use of different categories—for example, mainline versus reform eugenics, the latter of which contained many geneticists,—based upon variations in the eugenic ideals to which these different groups adhered.[29] From the mid-1930s on in the U.S., debates over eugenics were dominated by reform eugenicists, who tempered the racism of the earlier, mainline movement by arguing that the biological differences between individuals were much greater than the differences between groups. Despite this shift in genetic research, many scientists in this group still generally believed in the inherent inequality of man. As Herbert Spencer Jennings stated, "on the average, a greater proportion of poor genes will be found in the delinquent groups, a greater proportion of better genes in the self-controlled or self-supporting group," in other words, in the middle and upper classes.[30] Although reform eugenicists were less racist and perhaps more politically savvy than earlier popularizers, at root they still believed that human intelligence, character, and personality were largely determined by heredity, beliefs still being expressed today.[31] Through better understanding the relative contributions of heredity and environment, as scientists they hoped to be able to contribute to human betterment.

Historians now agree that in the 1930s, and even after the end of the war up to the present, eugenic ideology was not defeated but rather entered into a period of redefinition and reformulation.[32] A few American scientists spoke in the late 1940s of resuscitating parts of the old eugenics movement, and the American Eugenics Society has remained in existence to this day, changing its name in 1972 to the Society for the Study of Social Biology.[33] Sociobiology, including population studies, has become the primary academic disciplinary home for eugenic ideology as well, though its tenets are stated in slightly different terms. Couples seeking marital, family, and genetic counseling at various centers throughout the U.S. encountered eugenic ideas with little interruption, and state sterilization statutes remained in operation, with over 20,000 individuals being sterilized in the U.S. since the early 1940s (over 63,000 total).[34] Only in the 1960s did some states begin to change their laws to authorize voluntary rather than compulsory sterilization, with the last compulsory sterilization law in practice being repealed in Oregon in 1983.[35] In the last two years, the governors of Virginia, Oregon, and California have made public apologies to victims of their states' laws.[36]

Despite these continuities, after the war most geneticists took a hiatus from outwardly expressing eugenic ideals even if they meshed with their longterm research agendas. In his history of the new eugenics, which ex-

tends up to the mid-1980s and addresses scientific as well as ideological developments, Kevles quotes a few scientists expressing eugenic sentiments in the 1950s in relation to Cold War concerns. These were followed by a much wider discourse in the 1960s and 1970s, however, perhaps as a backlash against the women's and civil rights movements.[37] Owing to what some scientists perceived as the inability of environmental amelioration to effect real change in social problems (for example, the continued disparity in standardized test scores that reflect minority disadvantage despite supposed equal opportunity to education), as well as to the huge financial investment in the Human Genome Project, genetic research, and biotechnology in the last decades of the twentieth century, there has been an increase in the number of scientists asserting biological determinist views that discount the role of the environment in producing human differences. The completion of the Human Genome Project in 2000 and the debates over germline engineering today have sparked a new outbreak of claims by scientists of their ability to "seize control of evolution" through "conscious design."[38]

Assuming a role almost identical to that claimed by early industrial designers, when describing the onset of germline engineering Gregory Stock echoes almost verbatim statements made by designers in the 1930s. To alter human genes will be "no less than a birth. The occasion may prove messy and painful, but it carries the wonder of new life and new possibilities." He describes this birth in evolutionary terms: "Conception took place long ago when we first chipped stone tools and used fire. Quickening came with early agriculture, writing and the formation of larger human communities. Now the contractions are forceful and rapid. The head is beginning to show. Will we suddenly lose our nerve because of the realization that life will change forever and because we can barely guess the character of this child of our creation?"[39] His statement, like Raymond Loewy's charts, implies that the coming of these technologies is an inevitable part of the process of evolution, and that he and others like him are simply the midwives attending the birth, rather than the ones creating and pushing for the use of these technologies in the first place, which almost across the board are characterized misleadingly as if they pose no difficulties to women but rather offer them freeing, beneficial reproductive choices.[40]

The technocratic logic at work in the early eugenics movement, whereby people were viewed as products to be scientifically managed and improved according to cost-benefit analysis, is even more blatantly expressed today with regard to reproductive technologies and genetic engineering, in part because of the escalation of a consumerist mentality within

American culture. Different aspects of industrial production processes have become models for various types of "human manufacturing."[41] For example, reproductive technologies including IVF, surrogacy, and prenatal testing through amniocentesis are based upon " 'an assembly-line approach to the products of conception, separating out those products we wish to develop from those we wish to discontinue.' "[42] For couples who need assistance, egg and sperm are for sale, from banks or through advertisements, going for as much as $50,000.[43] Cloning, too, depends upon an abundance of eggs in which to implant the desired nucleic material, with chances for success increasing if an abundance of surrogate carriers are in line to receive the manufactured embryos. Other genetic engineering techniques, such as the possible addition of an extra, artificial chromosome for germline enhancement (so that "enhanced" humans would have 47 instead of 46 chromosomes), which subsequent generations could upgrade from "version 2.0 . . . to the new version 5.9" with "patches" for glitches in earlier versions, mimic flexible systems production in manufacturing today and the techniques used by the computer industry to remedy problems they did not foresee.[44] Genetic engineers are also working to create human organs from stem and somatic cells, which could be used as replacement parts to allow longer lives for the human vehicles in which it they are placed.[45] This idea of conceiving of human bodies as a system of parts that can be controlled separately is being replicated on the microcosmic level of the gene. An article in *Newsweek* about the Human Genome Project featured a four-page chart showing the "Human Parts List," which mapped out the locations on particular chromosomes of genes that have been identified as being linked to certain diseases. The accompanying text stated that "Biologists will be able to use the genome as a parts list—much as customers scour a list of china to replace broken plates—and may well let prospective parents choose their unborn child's traits. Scientists have solid leads on genes for different temperaments, body builds, statures and cognitive abilities."[46]

Vague assertions such as this—of "solid leads on genes for" personality and intelligence—in addition to being deceiving by implying that one or a few genes control these characteristics, without reference to genetic systems complexity or the role of the environment, lead consumers to believe that they will receive the products they order and pay for. Instead of being faced with the age-old options of accepting infertility or adopting, couples can now opt to have a child made according to traits they consider to be desirable, through selecting particular egg or sperm and using IVF or a surrogate. Should we choose not to prevent germline engineering, couples

are already being led to believe that soon they can have "designer children," "made to order" to (attempt to) satisfy their prejudices for certain racial, gender, physical, intellectual, or athletic characteristics.[47] With cloning, too, an individual such as Arnold Schwarzenegger, who told a reporter a couple of years ago that he would "'have nothing against cloning myself,'" can order a replica based on belief in his own superiority, or, as in the case of the dead boy the Raëlians may have cloned, people can opt to try to bring back a "preapproved model" to life, regardless of the fact that it could never be the same person despite external appearances and others' expectations.[48]

Underlying these consumer choices and production processes is the fact that they are for sale and for profit. Janice Raymond writes that surrogacy turns women, who are often racially and economically disadvantaged, into a breeder "stock," whose children then are "commodities to be bought and sold."[49] This technocratic language, where humans are seen as "stock," "products," or "capital," reveals economic motives for human management by whomever pays almost identical to those that were expressed during the 1930s. Arguments in favor of human genetic engineering today assert that eugenic improvement is necessary to alleviate the burden of cost of care on families, society, health care providers, insurance agencies, and national governments. Stock reasons that money spent for the cost of caring for individuals with cystic fibrosis, which he estimates at one billion dollars, could be used to help pay for "gene therapy," by which he means germline engineering, thereby saving "private pockets" and "public coffers" money that would be redirected into the genetics industry. Similar arguments were extended in the mid-1970s to support the use of prenatal diagnosis, then a new technology, though this time the costs that were paid "by society" for the care of "hundreds of thousands of chromosomally defective offspring" were estimated at two billion dollars per year.[50] A central debate today, stemming from the ability to screen DNA taken from body fluid samples to diagnose a predisposition for genetic diseases, surrounds issues of privacy, because prospective employers and insurance agencies want access to this information to save costs they otherwise might have to spend for care.[51] On the governmental level, some states in the early 1990s debated legislation requiring longterm birth control, in the form of Norplant, for women on welfare, or for women having children while addicted to drugs, arguing that its use would lessen the state's financial burden of caring for children considered by the state to be undesirable.[52]

The economic arguments surrounding the use of reproductive technologies and genetic engineering—over saving money by preventing the

"waste" of funds on care for the genetically "diseased," or over making money through the greater productivity of "enhanced" individuals,—are at times phrased in terms of concerns about success in competition between families, corporations, and nations. William Gardner, who is opposed to germline enhancement, argues nonetheless that we may not be able to prevent it, because unless there is an international ban, once one country allows it and families begin to use it, assuming that it is beneficial, there is nothing to stop it from spreading, "since parents compete to produce able children and nations compete to accumulate human capital in skilled workers. . . . The argument for the importance of human capital in international economic competitions is that it is a form of investment that may provide a country with a persistent competitive advantage."[53] He advances the argument that, since high tech goods like electronic equipment have the largest markets, the nations that have more "clever engineers and skilled workers" created through germline enhancement will make the greatest profit, especially because a skilled worker "may be even more productive if placed in the company of other able people," and because the effects are heritable to future generations.[54] Furthermore, both Gardner and Stock argue that a major reason for germline enhancement for intelligence is to enable human evolution to compete with the evolution of machines. Since "the abilities of machines are increasing faster than those of humans," "germline manipulation is biology's bid to keep pace with the rapid evolution of computer technology."[55] Apparently, seventy years after Arens declared it, some still think that we need "streamlined thinking to keep pace with our streamlined machines."[56]

The new eugenics, like the old, faces methodological problems in defining crucial terms of classification. What "unfitness" and "defectiveness" were to earlier eugenicists when ascribed to living individuals, "disease" is to current geneticists when interpreting the human genome. By moving the site of "disease" manifestation inward to the gene, scientists striving to implement negative eugenics have avoided the issue of consent (from children-to-be), as well as for the most part the accusation of violating human rights, since surgically removing a "diseased" gene has not yet been equated with sterilizing a living individual.[57] Early eugenicists ascertained "defectiveness" and "feeblemindedness" through comparison to social and statistical norms, through personal evaluations of general functioning or through such quantitative means as intelligence testing. Decisions to sterilize overlooked the fact that these "defective" individuals may have also had many positive qualities, as well as the fact that the appearance of the undesirable

trait in the next generation depended on external influences, such as who the partner was; depending on how the trait followed Mendelian patterns, offspring may well have been "normal." Similarly, to determine a "normal" human genome—what is being called "the" human genome—the Human Genome Project has used computers to statistically analyze chromosomal fragments submitted by various individuals, each of which has individual variations that are being overlooked in favor of creating a statistical norm that stands for the pure genome.[58] George Stocking's question about race is pertinent here: If no single individual matches the genomic "norm," then why are certain sequences considered to be more definitive than others?

Yet, in analyzing the genome, which according to one industry estimate contains between one million and ten million variances, these variations are being targeted as the site of "disease," despite the undetermined role that the other 3.1 billion nucleotides and their various sequences and combinations in the genome may play.[59] Many articles give the impression that "A variation in just a single nucleotide in a gene can make a person susceptible to a particular disease or immune to a specific drug compound."[60] This impression is, again, misleading, however, for not only are there "very few diseases that are caused by a single gene mutation," but variations can be completely asymptomatic (never manifesting in any disease) or even beneficial (for example, the gene associated with cystic fibrosis also gives resistance to typhoid).[61] Furthermore, even if a gene or variation seems to predispose for a disease, environmental influences are crucial in determining whether the disease will manifest or not.[62]

From diagnosis based upon comparison to norms, to denial of beneficial traits that may accompany what are perceived as harmful variations, to denial of the influence of environmental or external influences as decisive in determining whether traits appear in the next generation or not, so as to be able to definitively predict a controllable outcome and thereby win public confidence—point for point, determination of genetic "disease" today mirrors the methods and assumptions that early eugenicists used to determine "defectiveness."[63] The end result of associating genetic variation with disease, when variations are determined by being measured against a statistical but actually nonexistent norm, is that *difference becomes defined as disease*, and the norm in essence functions as an ideal. Phillip Davis and John Bradley make this point in describing how the word "normal" is used in the field of medicine. Among other meanings, "'medicine has come to understand normal as a 'description of the ideal.' . . . Defining the norm as an ideal leads to significant problems. . . . Disease and ill health are a normal

part of the human condition," but more important "are the problems that result from defining variation from the ideal as 'abnormal.' . . . When the ideal is taken as the norm, variation becomes defined as disease—an especially peculiar circumstance insofar as much variation has no particular clinical significance or biological consequence.' "[64] A major result of eugenics, therefore, both then and now, is to enforce normalization.

The same assumptions and decisive oversimplifications behind the new negative eugenics, with regard to defining and eliminating "disease," apply to the new positive eugenics as well. Taken together, they reveal either a conscious strategy to mislead the public or else a profound, and naive, faith in biological determinism. Assertions like the *Newsweek* statement that the genes for intelligence and temperament have almost been decoded abound in statements by avid supporters of genetic engineering. Stock offers some of the most egregious examples. Unabashed about asserting such things as the "genetics of religiosity, criminality, intelligence, addiction, and sexual orientation," as well as athletic and musical ability, memory, temperament and personality, he offers (wide-ranging) statistics to back some of his assertions: "IQ is anywhere from 45 to 75 percent heritable"; 40 to 60 percent of our personalities are genetically determined; "Even whether a person says that religion is important in his or her life is about 50 percent heritable."[65] Gender, too, for him is "natural" and innate. That "Men compete more for status, power and wealth—key ingredients in attracting women—" and tend to be "drawn to" beautiful young women, whereas "Women tend to care more about how they look—a key ingredient in attracting men—" and are "drawn to men possessing status, power and wealth," are qualities that come "from deep within us. We do not have to act upon these urges, but we cannot escape them." These types of biologically determinist assumptions have been closely analyzed and disputed by numerous scholars working in the social sciences, humanities, and gender studies over the last few decades, yet Stock makes no serious effort to engage either their criticisms or the issue of culture.

Instead, because he believes that so much of who we are is genetic, Stock confidently asserts that "Armed with greater knowledge about our genome, we might even be able to capture for our children a hint of the musical talent of a John Lennon, a touch of Einstein's genius, a wisp of the physical prowess of Michael Jordan."[66] His choice of three highly commodified icons, men whose faces have been repeatedly used in advertisements that, like Stock, reduce their complex personalities to single, marketable qualities (iconoclast, genius, and superathlete), points to the influence of

culture on our choices, and, more precisely, to marketing media as the source creating frameworks of desirability from within which we choose. Yet, instead of recognizing the role of culture on his *own* choices, Stock locates choice in the genes (for example, the statistic he offers on the heritability of religion). Sounding exactly like Charles Davenport's assertion that the "ability to be Americanized" was a genetic trait, he even asserts that "any combination of personality and temperament that predisposes people to embrace biological selection and enhancement will be highly represented among those who use germinal choice. To the extent that the personality attributes that lead to this are genetic in nature, the technology is likely to reinforce them in successive generations."[67]

If the tendency to embrace germline engineering is genetic, so is the probability that, when given a range of attributes to choose from, "we might be surprised at how much we ourselves would be drawn in" the directions of the "stereotypes of beauty, strength, and intelligence" put forth in advertisements, Stock believes. "It is no fluke that advertisements so frequently employ these themes. They work," because these desires are "deep within us."[68] The cover of his book (Figure 7.1) depicts a blue-eyed child with blond eyebrows and eyelashes beneath the title, which strongly implies that this child represents the "designer child" who is "our inevitable genetic future." The supposed ease with which blond hair or blue eyes can be made to order is suggested by the one nucleotide that encircles the pupil of the eye, as if a desired trait were attainable by just a single alteration. In his acknowledgments, he praises the jacket designer for doing a "great jacket," and multiple times throughout his text he implies that these physical traits (blond hair and blue eyes) are the ones that parents will want, parents who themselves are wealthy and white.[69] The youthfulness of the child on the cover—genetically engineered so as never to age—also represents an ideal that others, in addition to Stock, agree is a highly desirable goal of genetic engineering.[70]

As if sensing the controversy his ideas might cause, Stock dismisses presumed accusations that his ideas resemble the old eugenics movement and might lead to abuses such as those perpetrated by Hitler in the Holocaust, never once mentioning those done in the United States: "the cauldron of World War I and the Great Depression that enabled Hitler to take power is gone." Unlike the "pseudoscience of the eugenics movement of the 1920s," which he characterizes as a fringe movement run by "mad scientists pouring over copies of *Mein Kampf*," he believes acceptance of "the coming capabilities will flow from research deeply embedded in the main-

Figure 7.1. Cover from Gregory Stock, *Redesigning Humans: Our Inevitable Genetic Future* (Boston: Houghton Mifflin, 2002).

stream, research that is highly beneficial," and "enjoys widespread support." Despite the fact that "Hitler's brutal attempts to create a master race are far too vivid to ignore," he feels that "they should not determine our future in a realm where the possibilities and challenges are so enormous."[71] As this study has shown, eugenics in the 1920s and the 1930s in the U.S. *was* a mainstream movement that enjoyed widespread support precisely because many people believed it was beneficial and progressive.

Despite his acting like the old eugenics was a pseudoscience while the new eugenics is legitimate science, some of same mistakes for which the old eugenics was declared a pseudoscience are being repeated by some genetics professionals today. These include presenting to the public the idea that traits such as intelligence, character, and even disease are controlled by only a few genes; discounting genetic complexity and the role of environment in producing these traits, as well as in producing disease; acting as if "normality," "disease," and "defectiveness" are absolute rather than relative categories; implying that genetic engineering offers a quick and efficient solution to very complex scientific and social problems; and presenting the science as virtually ready for public acceptance despite the fact that "our knowledge of developmental genetics is still quite incomplete."[72] Despite these very serious setbacks and reasons for great caution, James Watson, who attended the 1998 conference at UCLA organized by Stock on "Engineering the Human Germline," reportedly pushed for moving ahead in applying germline engineering to humans. "If scientists wait for conventional genetic engineering to success [sic] before trying germline engineering, Dr. Watson said, 'We might as well wait for the sun to burn out.'" If the "methods are ready, . . . why not try germline genetic engineering . . . ? 'If you could cure a very serious disease, stupidity, that would be a great thing for the people who otherwise would be born seriously disadvantaged.'"[73]

As Stock implies, it is highly unlikely that in the U.S. the new eugenics will be imposed upon citizens by a totalitarian regime. Yet, in opposition to his assumption that therefore the abuse of the new eugenics is unlikely, the technocratic values that undergird eugenic ideology are even stronger and more diffused today than they were in the 1930s. If germline engineering were to become a reality, abuse would more likely be corporate than governmental, and the technology would be presented as consumer choice rather than as political coercion. Under this scenario, if the new positive eugenics were to take hold, powerful corporations controlling the technology would likely implement successful marketing schemes to convince Americans that the choice for success was theirs, for a price well worth it.[74]

They could finally purchase the realization of their American dream to become the person they've always wanted to be, or, at least, for their children to become who they themselves have always wanted to be. In similar fashion, the new negative eugenics would slip in through being institutionalized within the medical, pharmaceutical, and insurance companies, where the only options presented would be genetically engineered options, portrayed to trusting patients as the height of progress in technology and cost-efficiency, despite the billions of dollars currently spent on genetic research rather than on investigating and alleviating environmental causes of disease. If someone's genetic profile failed to match the norm because his or her parents conceived naturally, instead of using IVF and germline engineering, insurance coverage could be denied because of a "preexisting" genetic condition. Thus eugenics and normalization would take hold and be paid for by consumers under the guise of individual choice, despite the fact that in the case of negative eugenics, these choices would be economically coerced by corporate regulations, and in the case of positive eugenics, consumers would be able to, and might only *want* to, select from within a limited range of choices because they believed those choices represented the ideal that would raise them to the height of social evolution.

Yet, as with the prefabricated, streamlined "house of tomorrow," consumers may well find that the "human of tomorrow," produced through germline engineering, is faulty and needs repairs that can only be accomplished by genetic professionals, much like problems with the new computerized automobiles that preclude the ability to fix one's car oneself.[75] Autonomy and individuality are therefore limited under the guise of "progress," not only by forcing reliance upon a professional elite, but also through the processes of social normalization that are endemic to the tried-and-true methods of maximizing corporate profit through mass marketing and mass production. Although many Americans might act as if "difference"—in this case, human cultural and genetic variability—is tantamount to "disease" or disadvantage, conformity to the cultural and genetic norm might well be conformity to the "ways of doing things that are preferred by the dominant classes and to which we have therefore become accustomed," as well as conformity to the statistical genetic norm established by the Human Genome Project despite genetic *variability actually being what is normal.* Feminists, poststructuralists, and disability theorists, as well as many Americans fighting to preserve space for "difference," therefore are resisting these processes of normalization, for however well-intentioned they are, they "threaten not to equalize but to preserve existing patterns of

functional dominance and privilege."[76] Thus, with regard to the effect of the new reproductive technologies and genetic engineering specifically upon women, feminists are protesting that they promise to increase a woman's burden and her reliance upon technology in order to be "the best mother she can be," much as postwar technologies raised the bar of cleanliness for the working housewife under expectation that she would conform.

Whereas in the 1930s and early 1940s, streamline industrial design and advertising for corporate profit seemingly occupied a separate cultural realm than the science and politics of eugenics, despite their sharing a common ideological base and goals, today those promoting the new eugenics have coopted the discourse and marketing strategies of design. Despite the fact that postwar Americans abhorred eugenics, continuities in other cultural forces have softened this abhorrence into current considerations of the new eugenics. These continuities include the highly problematic yet commonly accepted beliefs in "social evolution" and technological "progress," in free enterprise and consumer "rights" as defining features of "democracy" in contrast to "totalitarianism" (when, in fact, corporate executives are more powerful than U.S. government officials, and "we, the people" are their consumers), in the American way as the ability to raise oneself to the normal ideal, and the actualities of the daily practice of selecting and consuming designed goods. These continuities undergird what Victor Margolin has referred to as the "expansion model" of industry, namely that since many people believe that human experience and progress is enhanced through the invention and use of new technologies and consumer products, and since corporations profit from the sale of these, that therefore the goal of industry is to promote the cycle of creating more goods for larger markets in order to increase private profit and social "elevation" to stimulate more consumption.

Design in the service of the expansion model—originating in the rise of industrial design in streamlining and catalyzed by its financial success—set the precedent being followed by genetic engineers and biotech companies today. Yet, the environmental destruction and social and economic stratification that this model has produced, in addition to the cultural commodification and homogenization it has fostered, do not bode well for its extension into the realm of genetic engineering. Although elitist contemporary critics called streamlining a "pseudostyle" because it was supposedly dishonest design, and although eugenics was rightly ostracized as a pseudoscience for many reasons, I want to suggest that *both* design in the service of industrial expansion *and* the old and new eugenics are "pseudo" forms

for another reason: because both have aided the unlimited expansion of technology under corporate control, in order to maximize private profit, through environmentally destructive processes that promote normalization and the commodification of the natural and human in exchange for the artificial. Their continued implementation threatens to irreversibly alter our selves and our world, not least through genetic engineering's modification of DNA, which stands as a superb model of a complex, variable, sustainable system as determined by evolutionary processes over millenia. Design professionals today have the chance to establish a new precedent, what Margolin refers to as design in the service of sustainability.[77] Through directing their efforts to restore balance and diversity to complex ecological and social systems that are out of balance and threatening to collapse, designers can offer a new model for the biotech industry to follow, one that demonstrates ways that industry can use technology to different ends that will be highly beneficial and sustainable over the long term for humanity and for the natural systems of the earth.

Notes

Preface

1. Robert Rydell, *World of Fairs: The Century-of-Progress Expositions* (Chicago: University of Chicago Press, 1993); Martin Pernick, *The Black Stork: Eugenics and the Death of "Defective" Babies in American Medicine and Motion Pictures Since 1915* (New York: Oxford University Press, 1996); Steven Selden, *Inheriting Shame: The Story of Eugenics and Racism in America* (New York: Teachers College Press, 1999); Wendy Kline, *Building a Better Race: Gender, Sexuality, and Eugenics from the Turn of the Century to the Baby Boom* (Berkeley: University of California Press, 2001); Stefan Kuhl, *The Nazi Connection: Eugenics, American Racism, and German National Socialism* (Oxford: Oxford University Press, 1994); Edwin Black, *War Against the Weak: Eugenics and America's Campaign to Create a Master Race* (New York: Four Walls Eight Windows, 2003); and Betsy Nies, *Eugenic Fantasies: Racial Ideology in the Literature and Popular Culture of the 1920's* (New York: Routledge, 2002).

2. Jeffrey Meikle, *Twentieth-Century Limited: Industrial Design in America, 1925–1939* (Philadelphia: Temple University Press, 1979), and Meikle, *American Plastic: A Cultural History* (New Brunswick, N.J.: Rutgers University Press, 1995).

3. Daylanne English's *Unnatural Selections: Eugenics in American Modernism and the Harlem Renaissance* (Chapel Hill: University of North Carolina Press, 2004), for example, counters conventional assumptions about eugenics in the 1920s by comparing eugenic discourse in the writings of both Anglo and African American modernist authors.

4. World War II was not fought over eugenics, though, but over political totalitarianism. Many countries and powers, including the U.S. and the Catholic church, did not intervene in the processes of the death camps despite having knowledge about them since the late 1930s. Although the atrocities of the Holocaust in retrospect seem the worst result of the war, the fact that they occurred in defeated Germany offered reason for dismissal and denial of the fact that democratic countries were also very inovlved in eugenic practices and continued enforcing them after the war. This is discussed in more detail in the concluding chapter of this book, as well as in Edwin Black's and Stefan Kuhl's books.

Chapter 1. Introduction: Controlling Evolution

1. Norman Bel Geddes, *Miracle in the Evening, an Autobiography* (Garden City, N.Y.: Doubleday, 1960), 344, 347.

2. See Job File 336.1, "'Aquarium' Correspondence 1933–35," NBG Papers. See specifically letter from Geddes to G. Kingsley Noble, 28 June 1934; letter from Geddes to the Southwest Zoological Supply Warehouse, 30 Oct. 1934; and letter from Geddes to Mr. Austen Brearley, 19 Aug. 1935; order on 1 Jan. 1931, from the Southern Biological Supply Co., Inc., in New Orleans; and order of 1000 animals on 11 Dec. 1934, from R. T. Berryhill in Lakeland, Georgia.

3. Job File 336.6, "Notebook," NBG Papers.

4. Turtox leaflet, no. 15, 1931; letters from G. Kingsley Noble to Geddes, 12 June 1935, and from A. Pierce Artvan to Geddes, 12 Dec. 1934; all in Job File 336.5, NBG Papers.

5. Letter from Geddes to the Southwest Zoological Supply Warehouse, 30 Oct. 1934.

6. Geddes, *Miracle in the Evening*, 19, 39–40.

7. Ibid., 227, 229. His war game was so realistic that military generals came to play, and during World War II, Geddes worked as a consultant for the Army and Navy to create photographic simulations of maneuvers.

8. Ibid., 98, 107–8, 117.

9. By "establishing the profession," Geddes meant that he was "the first designer of national reputation to surround himself with a staff of specialists and offer industrial design services"; *Miracle in the Evening*, 344. Geddes's films are included in the NBG Papers. Their fragile condition prevents current researchers from viewing many of them; however, they are in the process of being converted to video. Edwin Neal, who was a curator of the Collection during the 1970s, stated in a telephone conversation with the author in April, 1997, that he had viewed at least some of them. He mentioned that the large series of films titled by the names of different species are about mating, which is confirmed by a letter from Geddes to Mr. Brearley, 19 Aug. 1935, in Job File 336.1, and in a memoir written by Garth Huxtable in the 1970s in the possession of Jeffrey Meikle, University of Texas at Austin. Neal also stated that no scripts accompany these films. On the Graham-Paige designs, see Jeffrey Meikle, *Twentieth-Century Limited: Industrial Design in America, 1925–1939* (Philadelphia: Temple University Press, 1979), 53.

10. At the time I began this study, such sources included Daniel Kevles, *In the Name of Eugenics: Genetics and the Uses of Human Heredity* (New York: Knopf, 1985); Diane Paul, "Eugenics and the Left," *Journal of the History of Ideas* 45 (1984): 567–90; Robert Rydell, *World of Fairs: The Century-of-Progress Expositions* (Chicago: University of Chicago Press, 1993); and Marouf Hasian, *The Rhetoric of Eugenics in Anglo-American Thought* (Athens: University of Georgia Press, 1996).

11. Walter Dorwin Teague, *Design This Day: The Technique of Order in the Machine Age* (New York: Harcourt, Brace, 1940), 233–34. Rydell, *World of Fairs*, 145, actually quotes Loewy's reference to eugenics in *Vogue* (1 Feb. 1939).

12. While I was doing research at the American Philosophical Society, Rob Cox presented me with little perused scrapbooks made by Leon Whitney containing hundreds of newspaper clippings about eugenics from American newspapers between 1928 and 1932. The scrapbooks are in the papers of the American Eugenics Society, and were a huge assistance in arguing for popular awareness of eugenics.

13. George Marcus, in *Design in the Fifties: When Everyone Went Modern* (Mu-

nich: Prestel, 1998), 55, quotes Edgar Kaufmann, Jr., using the term "bastardized" in his article "Good Design '51," *Interiors* 110 (March 1951): 100.

14. Hereafter I will not always put the terms "civilized," "primitive," "modern" (when referring to "civilized"), "degenerate," "feebleminded," etc. in quotations, even though they are historical ideological constructions based upon faulty presumptions.

15. On Darwin in America, see Carl Degler, *In Search of Human Nature: The Decline and Revival of Darwinism in American Social Thought* (New York: Oxford University Press, 1991); James R. Moore, *The Post-Darwinian Controversies: A Study of the Protestant Struggle to Come to Terms with Darwin in Great Britain and America, 1870–1900* (Cambridge: Cambridge University Press, 1979). On Spencer's influence, see J. D. Y. Peel, *Herbert Spencer: The Evolution of a Sociologist* (New York: Basic Books, 1971); Kathleen Pyne, *Art and the Higher Life: Painting and Evolutionary Thought in Late Nineteenth-Century America* (Austin: University of Texas Press, 1996), 22; James Turner, *Without God, Without Creed: The Origins of Unbelief in America* (Baltimore: Johns Hopkins University Press, 1985); Richard Hofstadter, *Social Darwinism in American Thought* (Boston: Beacon Press, 1992). Also, George Stocking, Jr., in *Race, Culture, and Evolution: Essays in the History of Anthropology* (Chicago: University of Chicago Press, 1982), adeptly discloses the nuanced history of the implementation of evolutionary ideas by anthropologists in their attempts at reconstructing primitive society and the mental evolution of man. He examines the idea of an "evolutionary paradigm" and the influence of Spencer and Lamarck in the United States.

16. The best history of this idea is Stephen J. Gould's *Ontogeny and Phylogeny* (Cambridge, Mass.: Harvard University Press, 1977).

17. Loos, "Ornament and Crime (1908/1929)," in Loos, *Ornament and Crime: Selected Essays* (Riverside, Calif.: Ariadne Press, 1998), 167.

18. Claude Bragdon's recapitulative beliefs included the plant kingdom as well, for he wrote, "We love and understand the trees because we have ourselves passed through their evolution, and they survive in us still, for the arterial and nervous systems are trees, the roots of one in the heart, of the other in the brain. . . . Has not that trunk its tapering limbs which ramify into hands and feet, and these into fingers and toes, after the manner of the twigs and branches of a tree?" Claude Bragdon, *Architecture and Democracy* (New York: Knopf, 1918), 193.

19. See letter from Claude Bragdon to Cleome Wadsworth, 7 Oct. 1932, Box 1 "General Correspondence," Claude Bragdon Archives, Library at the University of Rochester.

20. Loos, "Ornament and Education (1924)," in *Ornament and Crime*, 186.

21. Like Horatio Greenough's mid-nineteenth-century association of "ill-digested and crowded embellishment" on mass-produced items with "the sympathies of savages," Loos and Le Corbusier both assigned ornamentation a low rung on the evolutionary ladder. In *The Travels, Observations, and Experience of a Yankee Stonecutter* (Gainesville, Fl.: Scholars' Facsimile and Reprints, 1958), 74–89, Horatio Greenough reveals his own racist beliefs that African Americans were a lower and separate race. Influenced by Loos, Le Corbusier concurred, attributing modern man's penchant for decorated primitive artifacts as "a captivating encounter by our

animal spirit with its own image lingering in the products of a developing culture. . . . Gilt decoration and precious stones are the work of the tamed savage who is still alive in us." See also Horatio Greenough, "Form and Function" in *Roots of Contemporary Architecture,* ed. Lewis Mumford (New York: Grove Press, 1959), 55; Loos, "Ladies' Fashion (1898/1902)," in *Ornament and Crime,* 109; Le Corbusier, *The Decorative Art of Today,* trans. James Dunnett (London: Architectural Press, 1987, 1925), 10–12.

22. Loos, "Ladies' Fashion (1898/1902)," 109.

23. Loos, "Ornament and Education (1924)," 187.

24. Gina Lombroso-Ferrero, *Lombroso's Criminal Man* (Montclair, N.J.: Patterson Smith, 1972, 1911). This text is a summarized version by Lombroso's daughter for American readers of *Criminal Man.*

25. Ibid., x–xi. Lombroso himself is speaking here in his introduction to his daughter's book.

26. Loos, "Ladies' Fashion (1898/1902)," 109.

27. Loos, "Ornament and Education (1924)," 186.

28. Le Corbusier, *The Decorative Art of Today,* 96.

29. Adolf Loos, "Footwear (1898)," in *Ornament and Crime,* 95, 96.

30. Loos, "Ornament and Crime (1908/1929)," 169–70.

31. Loos, "Footwear (1898)," 94.

32. Stocking, *Race, Culture and Evolution,* 241.

33. Ibid., 242–46.

34. Ibid., 245, 351, n. 14, in which Stocking cites Frederick Jackson Turner, "The Significance of the Frontier in American History (1893)," reprinted in *The Frontier in American History* (New York: Henry Holt, 1920), 23.

35. Gould, *Ontogeny and Phylogeny,* 81, citing Ernst Haeckel, *Generelle Morphologie der Organismen: Allgemeine Grundzuge der organischen Formen-Wissenschaft, mechanisch begrundet durch die von Charles Darwin reformirte Descendenz-Theorie,* vol. 2 (Berlin: Georg Reimer, 1866), 298. On habits and instincts, see Stocking, *Race, Culture and Evolution,* 246.

36. Richard Hofstadter, *The Progressive Movement, 1900–1915* (Englewood Cliffs, N.J.: Prentice-Hall, 1963), 85–86. For other examples, see Ellen Fitzpatrick, *Endless Crusade: Women Social Scientists and Progressive Reform* (New York: Oxford University Press, 1990), 66, on Florence Kellor; Stocking, *Race, Culture and Evolution,* 249–50 on John Dewey; and Hofstadter, *The Progressive Movement,* 87, on Jane Addams.

37. Degler, *In Search of Human Nature,* 38, citing Robert Dugdale, *The Jukes, a Study in Crime, Pauperism, Disease, and Heredity,* 4th ed. (New York: G. P. Putnam's Sons, 1910), 11.

38. Stocking, *Race, Culture and Evolution,* 253.

39. Ibid. On the length of time required for change, see Degler, *In Search of Human Nature,* 19.

40. Stocking, *Race, Culture and Evolution,* 255.

41. Degler, *In Search of Human Nature,* 24; italics original.

42. Steven Selden, *Inheriting Shame: The Story of Eugenics and Racism in*

America (New York: Teachers College Press, 1999), 4, citing L. C. Dunn, ed., *Genetics in the Twentieth Century* (New York: Macmillan, 1951), 60–65.

43. On David Starr Jordan, see Kenneth Ludmerer, *Genetics and American Society: A Historical Appraisal* (Baltimore: Johns Hopkins University Press, 1972), 17. Many of these individuals persisted as key leaders of the eugenics movement in the U.S. into the 1930s.

44. The Station for Experimental Evolution (SEE) was originally incorporated by the CIW into the Department of Experimental Biology and has since become the current Department of Genetics at the CIW.

45. Three good sources on the organizational history of the American eugenics movement are Garland E. Allen, "The Eugenics Record Office at Cold Spring Harbor, 1910–1940," *Osiris* 2 (1986): 225–64; Selden, *Inheriting Shame*, 1–38; and Kevles, *In the Name of Eugenics*, 51–69.

46. Two individuals, Frederick Osborn and Yale economist Irving Fisher, also gave thousands of dollars in personal contributions to the national movement. Numerous others supported their local organizations, funded lectures and exhibits, etc. In the late 1920s, along with George Eastman and Fisher, Rockefeller contributed substantially to the American Eugenics Society, raising its annual budget to almost forty thousand dollars. Throughout the 1920s and 1930s, the Rockefeller Foundation played an integral role in the international development of scientific research on human genetics. In 1924, the Foundation funded the first central institute for eugenics research in Germany, the Kaiser-Wilhelm Institute (KWI) in Munich, directed by psychiatrist and leading eugenicist Ernst Rudin. Additional funding established the Kaiser-Wilhelm Institute for Anthropology, Human Heredity and Eugenics in Berlin in 1927, headed by Eugen Fischer. See Kevles, *In the Name of Eugenics*, 55, 60, and throughout, as well as chapters in Edwin Black, *War Against the Weak: Eugenics and America's Campaign to Create a Master Race* (New York: Four Walls Eight Windows, 2003).

47. On police records, see letter from William Moseley Brown, Advisor to the National Commission on Law Observance and Enforcement, to Charles Davenport, 23 April 1930, folder "William Moseley Brown," CBD Papers; letter from Charles Davenport to Edwin Embree, 13 Aug. 1926, folder "Edwin Embree," CBD Papers.

48. Herbert Spencer Jennings, folder "Lecture #48: Can Men Be Bettered Psychologically and Ethically by Breeding?" (given 17 Oct. 1932 at the Rand School in New York City), HSJ Papers. In the same lecture, Jennings made the argument common to Socialist eugenicists that without equality in outward resources and environmental conditions, biologists could not really determine which traits were hereditary and which learned behaviors.

49. Letter from Charles Davenport to Sidney Gulick, secretary of the National Committee for Constructive Immigration Legislation (along with John Collier and Herbert Parsons), 21 June 1920, folder "Sidney Gulick," CBD Papers.

50. Minutes, 3 May 1923, of a talk by Davenport on "Heredity and Race Eugenics," folder "Galton Society, #2: 1923–25," CBD Papers.

51. "Memorandum on the Utility of Following the Physical Development of Patients at Letchworth Village Routinely by Means of Repeated Measurement," folder "Letchworth Village, Edward J. Humphreys, 1938"; also, letter from Charles

Davenport to C. S. Little, superintendent of Letchworth Village, on 27 May 1927, folder "Letchworth Village, C. S. Little, #2, 1927–1932"; letter from Davenport to Little, 4 Sept. 1925, folder "Letchworth Village, C. S. Little, #3, 1933–36," all CBD Papers. In a similar study a few years earlier, he had also examined the "incidence of disease in relation to body build," presumably to discover connections between weak bodies and disease susceptibility. Davenport mentioned this study in a letter to John Harvey Kellogg, 18 July 1930, folder "John Harvey Kellogg, #4, 1923–1930," CBD Papers.

52. For complimentary reviews of the dwarfs, see Benjamin Klein, "Modern Lilliputia," 1933, folder "Notes, 1934," Box #1: Series XII "Midget Schedules"; "Midget Village Graduates into Midget City," *Progress* 4,10 (a semi-monthly publication of the Exposition), folder "Clippings, 1933–34, 1938, n.d.," Box #1: Series XII "Midget Schedules," all ERO Papers.

53. Martin S. Pernick, *The Black Stork: Eugenics and the Death of "Defective" Babies in American Medicine Since 1915* (New York: Oxford University Press, 1996), 61–62. A copy of the film series *The Science of Life* is in the National Archives, Motion Picture Division, College Park, Maryland location.

54. "Minutes," 26 May 1921, folder "Galton Society, #1, 1918–1921," CBD Papers.

55. On films, see Pernick, *The Black Stork,* 53, 57, 61; Albert E. Wiggam, *Fruit of the Family Tree* (Garden City, N.Y.: Garden City Publishers, 1924), 272, 279.

56. "Beauty on Parade," *Glen Falls (New York) Post*, 15 June 1929, in Leon Whitney Scrapbook, AES Papers. Ellsworth Huntington, *Tomorrow's Children: The Goal of Eugenics* (New York: J. Wiley and Sons, 1935), 16, wrote, "Moreover, physical and mental superiority tend to go together, and superiority in one mental trait tends to be accompanied by a similar condition in others. Therefore improvement of the population in any important trait will bring improvement in other traits."

57. Louis Sullivan, "Towards the Organic," in *Roots of Contemporary American Architecture*, ed. Lewis Mumford (New York: Grove Press, 1959), 76–77; italics original.

58. Claude Bragdon, *Architecture and Democracy* (New York: Knopf, 1918), 149, citing Sullivan's essay "What Is Architecture? A Study in the American People of Today," *American Contractor* (6 Jan. 1906). Sullivan's essay title here also equates a people's architecture with their character.

59. Sullivan, "Towards the Organic," 78.

60. Le Corbusier, *Towards a New Architecture* (New York: Payson and Clarke, 1927), 9.

61. Le Corbusier, *The Decorative Art of Today*, 168.

62. Carlo Ginzburg, "Style as Inclusion, Style as Exclusion," in *Picturing Science, Producing Art*, ed. Peter Galison and Caroline Jones (New York: Routledge, 1998), 35, quoting Flaxman.

63. Claude Bragdon, *Projective Ornament* (Rochester, N.Y.: Manas Press, 1915), 9.

64. Claude Bragdon, *The Beautiful Necessity: Seven Essays on Theosophy and Architecture* (Rochester, N.Y.: Manas Press, 1910), 17.

65. Sullivan, "Towards the Organic," 79.

66. Louis Sullivan, *Autobiography of an Idea* (New York: Peter Smith, 1949), 11, 16.

67. Louis Sullivan, "Natural Thinking: A Study in Social Democracy," 34–35, address before the Chicago Architectural Club, 13 Feb. 1905, Louis Sullivan Papers.

68. Sullivan, "Natural Thinking," 35–53.

69. David S. Andrew, *Louis Sullivan and the Polemics of Modern Architecture* (Urbana: University of Illinois Press, 1985), 3–4. Sullivan differed from Loos in his view on ornamentation, although in his reasoning in favor of ornament, he too relied on evolutionary ideas. Sullivan, like Darwin, thought an excess of ornamentation showed sexual vigor, attractiveness, and vitality.

70. Ibid., 49, quoting Sullivan from "Natural Thinking," 53. In his most helpful analysis of Sullivan's ideological influences, Andrew discusses the deep impact that evolutionary thought had on Sullivan in the development of his architectural theories. "It is well to bear in mind that Sullivan's vision of history was informed more by the idea of progressive evolution than by any other single concept. Every form that has existed and every event that has occurred has been the result of a sequential, lawful pattern operating throughout the universe: a pattern that has perpetual, ineluctable improvement as its underlying purpose. Without this obsession with organic as well as social evolution, many of Sullivan's ideas could not have come into being" (38).

71. Ibid., 45, 62.

72. Sullivan, "Natural Thinking," 68–69.

73. Ibid., 61.

74. Ibid., 69–70.

75. Ibid., 151–52; italics added.

76. Ginzburg, "Style as Inclusion, Style as Exclusion," 33–39.

77. Greenough, "Form and Function," 35.

78. Ibid., 51.

79. Ibid., 37.

80. Sullivan, "Natural Thinking," 152–53.

81. Sullivan, "A Tall Office Building Artistically Considered," *Lippincott's Magazine* 57 (March 1896): 403–9.

82. Andrew, *Louis Sullivan and the Polemics of Modern Architecture*, 69.

83. Geddes, *Miracle in the Evening*, 93, 162. Geddes describes Wright as stubborn.

84. Norman Bel Geddes, *Horizons* (Boston: Little, Brown, 1932), 283–84.

85. I suspect that Geddes's ideas were influenced through regular reading of *Scientific American*, which ran an article by J. H. W. Kerston in March 1925, entitled, "Streamline Bodies Save Power" (473). This article includes pictures of the streamline autos designed by airship designer Paul Jaray, along with a diagram showing the eddies caused by a vehicle in motion and how they supposedly vanish with the use of streamlining. This is one of the earliest descriptions of streamlining published in the U.S., and although Kerston focused on aerodynamics for motor cars, he also pointed to their biological and technological precedents: "Why should we neglect to apply these principles to the motor car? Why not imitate the shape of the fish, the dirigible airship, the fast-flying goose?" The magazine published many articles

during the 1920s on airships and airplanes in relation to aerodynamics and stream-lining; I therefore think this may have been a primary influence on industrial de-signers. Although I have found no evidence that Geddes saw the 1925 article, he may have read the magazine for personal as well as educational reasons, for his own work for the theater was featured in two articles in 1924 and 1928. Furthermore, other articles throughout various issues promoted ideas that Geddes was imple-menting in his work and hobbies. See Albert Hopkins, "A Theater Without a Stage," *Scientific American* 130 (April 1924): 223–29; Oliver Sayler, "Theater Delays Shortened," *Scientific American* 138 (March 1928): 248–49; Heinz Rosenberger, "Micro Motion-Pictures," *Scientific American* 136 (March 1927): 166–67; and "The 'Inhabited Wing' Plane of the Germans," *Scientific American* 144 (Jan. 1931): 8. The latter presents ideas that Geddes proposed in his Airliner No. 4.

86. "The New Viking," *Saturday Evening Post* (13 April 1929), 38–39.

Chapter 2. Products or Bodies? Streamline Design and Eugenics as Applied Biology

1. Norman Bel Geddes, *Horizons* (Boston: Little, Brown, 1932), 4, 5, 284–85.

2. Ibid., 16.

3. Ibid., 17–18, 48. On Geddes referring to himself as an "amateur naturalist," see his letter to Nat Hutchins, 18 Sept. 1934, Job File 336.1 "'Aquarium' Correspon-dence 1933–35," NBG Papers.

4. Geddes, *Horizons*, 50.

5. H. Ledyard Towle, "Projecting the Automobile Into the Future," *Society for Automotive Engineering Journal* 29, 1 (July 1931), a copy of which is in folder "Streamlining: Airplanes, 1932, 1935, n.d.," Box 59, Egmont Arens Papers.

6. Geddes, *Horizons*, 18.

7. Ibid., 27, 45–46, 48–50.

8. Others with influence in New York were Wolfgang and Pola Hoffman, Ilonka Karasz, William Lescaze, Paul Lobel, Raymond Loewy, Peter Müller-Munk, Eliel Saarinen, John Vassos, Walter and Margaretta Von Nessen, and Kem Weber. For brief biographies of these designers, see J. Stewart Johnson, *American Modern, 1925–1940: Design for a New Age* (New York: Harry Abrams, with the American Federation of the Arts, 2000), 177–82; also, Paul T. Frankl, *New Dimensions* (New York, 1928) and *Form and Reform: A Practical Handbook of Modern Interiors* (New York, 1930). In the latter, showing the influence of his compatriot Adolf Loos, Frankl discussed the criminality of ornament and stated that "The history of civili-zation is recapitulated in the evolution of the chair."

9. On Geddes's redesign of the Century Theater, see Albert Hopkins, "A The-ater Without a Stage," *Scientific American* 130 (April 1924): 223–29.

10. Geoffrey T. Hellman, "Profiles: Design for a Living—I" and "Profiles: Design for a Living—II," *New Yorker* (8 Feb., and 15 Feb. 1941), 24–28, 22–29.

11. On Sanger and eugenics, see Daniel Kevles, *In the Name of Eugenics: Genet-ics and the Uses of Human Heredity* (Cambridge, Mass.: Harvard University Press,

1995, 1985), 94, 96; on Emma Goldman, see Kevles, 90 and 106, as well as Goldman, *Mother Earth* 2 (1916–17): 459.

12. Norman Bel Geddes, *Miracle in the Evening, an Autobiography* (Garden City, N.Y.: Doubleday, 1960), 174.

13. Ibid., 269.

14. Ibid., 11, 17.

15. Ibid., 14, 28–29.

16. Garth Huxtable memoir in the possession of Jeffrey Meikle, University of Texas at Austin. Kevles, in chapters 2 and 4 of *In the Name of Eugenics*, discusses the rise of American outspokenness about sex during this period as one notable byproduct of the cultural power of eugenics.

17. Geddes, *Miracle in the Evening*, 71.

18. Ibid., 314. The psychological study was popularized by Carl Brigham's *A Study of American Intelligence*, 1923; see Kevles, *In the Name of Eugenics*, 82–83, and Stephen J. Gould, *The Mismeasure of Man* (New York: W.W. Norton, 1996).

19. File SC-6, y-2, NBG Papers, contains his notes for his Design Course. Geddes did not underline the second "animal" in the above citation. He had written simply, "Life began on a one dimensional basis." When he edited it, he inserted "Animal" to clarify his specifically biological evolutionary intentions.

20. See folder "Minutes 1936–37 #1, 21 April 1936" AES Papers.

21. Leon Whitney, *The Basis of Breeding* (New Haven, Conn., 1928), and Norman Bel Geddes, "Ten Years from Now," *Ladies Home Journal* (Jan. 1931), reprinted in *Rassegna* 60 (1994): 19–21. Martin Pernick, in *The Black Stork: Eugenics and the Death of "Defective" Babies in American Medicine Since 1915* (New York: Oxford University Press, 1996), 83–84, discusses surgical procedures on the brain that attempted to remove the offending sources of abnormal behavior. Bel Geddes's prediction is eugenic in its attempt regardless of the procedures to which he was referring.

22. The book was Ettie Hornibrook's *Restoration Excercises for Women* (London: Heinemann, 1932). In 1938, the two were given a copy of Margaret Sanger's autobiography, just published by W.W. Norton, by a friend.

23. Letter from Geddes to Mr. Austen Brearley, 19 Aug. 1935, and to Dalton Schools, 18 Sep. 1935, to whom he sold it, File 336, NBG Papers.

24. Barbara was Geddes's second daughter by his first marriage to Bel Schneider. Bel's sister, Florence, married Dr. Frank Morley, and Buel was their son. See letter from Geddes to Morley, 26 Sep. 1938, and reply from Morley, 1 Oct. 1938, PF 960 "Family Correspondence," NBG Papers.

25. The eugenic implications of the Futurama exhibit will be discussed in Chapter 3.

26. Robert Rydell, *World of Fairs: The Century-of-Progress Expositions* (Chicago: University of Chicago Press, 1993) 145, also discusses this issue of *Vogue*.

27. Donald Deskey, "Radically New Dress System for Future Women Prophesies Donald Deskey," *Vogue* (1 Feb. 1939): 137, and David A. Hanks and Jennifer Toher, *Donald Deskey: Decorative Designs and Interiors* (New York: E. P. Dutton, 1987), 74.

28. Walter Dorwin Teague, "Nearly Nude Evening Dress Designed by Walter Dorwin Teague," *Vogue* (1 Feb. 1939): 143.

29. George Sakier, "No Mechanistic Clothes for Future Women Predicts George Sakier," *Vogue* (1 Feb. 1939): 144. Italics added.

30. Raymond Loewy, "Raymond Loewy, Designer of Locomotives and Lipsticks, Creates a Future Travel Dress," *Vogue* (1 Feb. 1939): 141.

31. Allene Talmey, "A World We'll Never See," *Vogue* (1 Feb. 1939): 90, 91, 164. Near the end of her article, she envisioned that in 4000 A.D., "all race-problems will be solved. Through genetics, natural amalgamation, and some force that no one can put his finger on, there will be one race. Man will be pale, with a coffee-coloured skin, Mongoloid eyes, and he will be only a little shorter than the average Englishman to-day. Woman, however, will be about six feet tall, with muscles bulging like a bag of oranges, and she will definitely be the sum of enchantment."

32. "To-morrow's Daughter," *Vogue* (1 Feb. 1939): 61. Three other references to eugenics in this *Vogue* issue deserve mention. An article on "Good Form in America," which plugged the use of corsets, began by stating that "It is not just an accident of Nature and heredity that American women, as a group, have the most admirable figures in the world" (114). Another article praising the cleanliness of the American woman, entitled "Bathing Beauty: An American Institution," asserted that "we are born and bred in the tradition of cleanliness" (95). Another, "Clothes America Lives In," extolled her fashion sense, extending her eugenic qualities to her clothing: "These are the clothes born out of our own background, that we love, that we live in, that we do better than any one else in the world . . . which have given us our 'mass' reputation for being a race of extraordinarily well-dressed women" (101).

33. Ruth Benedict, *Patterns of Culture* (Boston: Houghton Mifflin, 1934).

34. Letter from Charles Davenport to Frederick Osborn, 13 Feb. 1930, folder "Frederick Osborn," CBD Papers.

35. Kevles, *In the Name of Eugenics*, 106, 115–16. More information on eugenic legislation during the 1920s and 1930s is discussed in Chapter 3 of this book.

36. H. Gordon Garbedian, "Science Pictures a Superman of Tomorrow," *New York Times*, 8 Dec. 1929, folder "Oscar Riddle, 1929," CBD-CSH Series. The second quote is drawn from Arthur A. Stuart, "Someday We'll Look Like This," *Popular Science Monthly* (July 1929), in folder "Art Education," Box 58, Egmont Arens Papers.

37. Norman Bel Geddes, "Streamlining," *Atlantic Monthly* 154 (Nov. 1934): 555, 556, 553, 563; italics original.

38. "Sermon 47" (delivered at the Temple Emanu-El, Roanoke, Va.), folder "George Benedict," AES Papers; italics added.

39. Walter Dorwin Teague, "Art of the Machine Age" (address to the Art Week Luncheon in Boston, 10 April 1934), folder "Writings—Articles"; Teague, "Why Disguise Your Product?" *Electrical Manufacturing* (Oct. 1938): 3, in folder "Writings—Articles"; Teague, "Industrial Art and Its Future" (address to the Annual Reception of the School of Architecture and Allied Arts at New York University, 18 Nov. 1936), folder "Writings—Articles"; all in Box 79, WDT Papers.

40. Henry Dreyfuss, *Designing for People* (New York: Paragraphic Books,

1955), 75, and Dreyfuss, "Reveal the Subject and Conceal the Art" (talk given at the 15th International Design Conference, Aspen, Colorado, Sept. 1966), folder "Lectures/Articles by Dreyfuss, 1956–1960," on Microfiche #9, Henry Dreyfuss Papers; also, Teague, "Industrial Art and Its Future," folder "Writings—Articles," Box 79; Teague, "The Basic Principles of Body Design" (talk presented at the Society for Automotive Engineers, Saranac Inn, New York, 17–22 June 1934), folder "Miscellaneous," Box 58, both in WDT Papers.

41. Teague, "What Industrial Designers Can Do: A Leading American Designer Writes Frankly about Functions and Limitations," *Barron's, The National Financial Weekly* (31 March 1941), in Box 79, WDT Papers; Teague, "Industrial Design and the World of Machinery," reprint from *Western Machinery and Steel World* (March 1946), in folder "Writings—Articles," Box 79, WDT Papers. On Wiggam's comment, which is quoted in Chapter 1 of this book, see "Beauty on Parade," *Glen Falls (New York) Post,* 15 June 1929, in Leon Whitney Scrapbook, AES Papers.

42. Teague, "The Basic Principles of Body Design"; italics added. In the same speech, he clarified that by the term organism, he was referring to living forms: "The aim of design is a perfectly functioning organism, and objects are beautiful just in so far as they function perfectly: this is true of race horses . . . oak trees . . . airplanes and motor cars."

43. Teague, "Art of the Machine Age," folder "Writings, Articles," Box 79, WDT Papers.

44. Towle, "Projecting the Automobile Into the Future," in Box 59, Egmont Arens Papers.

45. L. G. Peed, "Streamlining—The Auto Industry's Answer to Public Demand: Refinements in Streamlining Represent Greatest Improvement in all Forms of Transport" (De Soto press release, 16 Jan. 1934), Box 59, Egmont Arens Papers.

46. Donald Deskey, "The New Role of the Industrial Designer in the Planning and Development of New Products," likely from the 1940s or early 1950s, folder "Writings/Philosophy," Donald Deskey Papers.

47. William F. H. Purcell, "The Industrial Designer; Practical Idealist" (talk to the Faculty Club, University of Southern California), on Microfiche #6 "Lectures/Articles by Dreyfuss, 1933–49," Henry Dreyfuss Papers; Teague, "Industrial Design and the World of Machinery," Box 79, WDT Papers; and Henry Dreyfuss, "Reveal the Subject and Conceal the Art," on Microfiche #9, Henry Dreyfuss Papers.

48. Geddes, *Horizons,* 206.

49. Henry Dreyfuss, "Industrial Design: The Art of Being Practical" (address to the Harvard Graduate School of Business Administration, 11 May 1954), section "Lectures/Articles by Dreyfuss, 1950–55," on Microfiche #8, Henry Dreyfuss Papers.

50. Teague, "Art of the Machine Age," Box 79, WDT Papers; italics added.

51. Teague, "Why Disguise Your Product?" folder "Writings," Box 79, WDT Papers. See also Teague brochure pertaining to the U.S. Steel exhibit at the New York World's Fair on Microfilm Roll 16–30, WDT Papers, in which he described that corporation as a sick patient who had found its cure through industrial design consultation.

52. Raymond Loewy, "Office of an Industrial Designer," folder "Architectural

and Interior Design Division, Contemporary American Industrial Arts Exposition of 1934, New York Metropolitan Museum of Art," Container 98, Raymond Loewy Papers, Library of Congress; see also "The Place of Industrial Design in American Industry," written by a member of Loewy's staff in March 1953 for Lever Bros., folder "Executive Papers, General Office Files, Speeches and Writings by Staff, 1953–66, n.d.," Container 1, Raymond Loewy Papers, Library of Congress. In his redesign of the Schick electric shaver in 1939, he used the same analogy; see John Kobler, "The Great Packager," *Life* (2 May 1949), in Raymond Loewy Papers, Cooper-Hewitt National Design Museum.

53. Raymond Loewy, text to "Corner of an Industrial Designer's Office and Studio," folder "Architectural and Interior Design Division, Contemporary American Industrial Arts Exposition of 1934, New York Metropolitan Museum of Art," Box 98, Raymond Loewy Papers, Library of Congress. Loewy stated: "The office of the Industrial Designer should be adapted to its function. It is really a clinic—a place where things are examined, studied and diagnosed. . . . The designer's studio must be a place that can be cleaned easily."

54. Henry Dreyfuss, "Industrial Design: The Art of Being Practical," on Microfiche #8, Henry Dreyfuss Papers; also, Ellsworth Huntington, *Tomorrow's Children: The Goal of Eugenics* (New York: J. Wiley and Sons, 1935), 45.

55. Geddes, "Streamlining," 553.

56. Egmont Arens, "Creative Evolution of the Printed Word," or "Streamlining the Printed Word: or Tempo in Typography" (address to the Eastern Arts Association, 28 April 1933), Box 51 "Writings," Egmont Arens Papers.

57. "Sermon 31," folder "Percy Allan Davis"; "Sermon 35," folder "Sermon Contest, 1926, #3"; "Sermon 36," folder "Sermon Contest, 1926, #4"; "Sermon 19," folder "Sermon Contest, 1926, #2"; and "Sermon 43," folder "Sermon Contest, 1926, #5," all in AES Papers.

58. "Sermon 43," folder "Sermon Contest, 1926, #5," AES Papers.

59. "Sermon 37" (delivered by K. C. MacArthur in Sterling, Mass.), folder "Sermon Contest, 1926, #4," AES Papers; italics added.

60. See the instructions to those administering the contests, "Fitter Families Examination," folder "Printing Orders, 1926–42," AES Papers.

61. Many thanks to Robert Cox, expert librarian at the American Philosophical Society, for directing me to this photo and for first suggesting its interpretation as streamlined.

62. Photos of this mock-up for the medal are in both the Henry Fairfield Osborn Papers at the American Museum of Natural History, as well as in the scrapbook of the AES in the AES Papers. Correspondence between Leon Whitney and Osborn, on 15 and 16 April 1926, contains discussion of the medal, which is different from the one most frequently reproduced in histories of eugenics. See folder 19 "AES Letters," Box 32, Henry Fairfield Osborn Papers; italics added.

63. Letter to the author by Gloria Rollins Hoot, 4 Aug. 2003, and Hoot, "Life Amid the Bloomers—A Journal of my Life," both of which are in the author's possession and copies of which were submitted by the author with Hoot's permission to the American Philosophical Society. Regarding her description of the back of the medal, since the biblical parable of the "wheat and the tares" was another

favorite of eugenicists, the two wheat sheaths may have symbolized the blessed genetic crossing of only those of superior stock, as well as racial purity as only like paired with like.

64. Text of Walter Dorwin Teague's talk on typography, 2 Feb. 1925, folder "Proceedings: Art Director's Club," Box 1, WDT Papers.

65. On "natural selection" and the role of "bastard offspring" in typography, see Egmont Arens, "Creative Evolution of the Printed Word," Box 51 "Writing," Egmont Arens Papers. On "mongrelism" in design, see Henry Dreyfuss, *Designing for People*, 96, and Russell Flinchum, *Henry Dreyfuss, Industrial Designer: The Man in the Brown Suit* (New York: Rizzoli, 1997), 102, n. 40, 108, citing an inter-office memo.

66. Egmont Arens gave versions of his streamlining lectures at: General Electric in Schenectady, NY, in late 1936; the Lions Club in Bridgeport, Conn., in late 1935; the Auditorium High School Building in Owatonna, Minn.; the Rhode Island School of Design; a public school in Providence, R.I.; the Design Laboratory, part of the Works Progress Administration in New York City; the Advertising Club of Wilmington, Del., with Du Pont advertisers in attendance; the Dayton Art Institute in late 1936; and the Youngstown, Ohio, Junior League. See various folders, including "See America Streamlined, 1935–36," Box 51 "Writings," and folders "Streamlining Out of Depression," "Publicity," and "Clippings about Egmont Arens," Box 46, all in the Egmont Arens Papers.

67. All information about Arens's series "Streamlining in Nature" can be found in Box 51 "Writings," and Box 57 "Writings/Lecture Notes/Slide Captions," Egmont Arens Papers; italics added.

68. Sometimes the word was written "streamline," sometimes "stream-line," and here "stream line."

69. Walter Dorwin Teague, "Prophetic Design: How the Element of Chance Can Be Eliminated," *Automobile Topics* (6 Jan. 1934), folder "Writings—Articles," Box 79, WDT Papers. Also, Teague, *The Marmon Sixteen: From the Notes of the Designer, Walter Dorwin Teague*, a small self-published book from c. 1932, a copy of which is at the Cooper-Hewitt National Design Museum.

70. Blue Sunoco advertisement in folder, "Streamlining—1933–1936," Box 59, Egmont Arens Papers.

71. Alexander Klemin, "Streamlining and Your Automobile," *Scientific American* (Feb. 1934), folder "Railroad #2," Box 16, WDT Papers; also, see O. G. Tietjens and K. C. Ripley, "Air Resistance of High-Speed Trains and Interurban Cars," *Applied Mechanics* 54,23, folder "Railroad #2," Box 16, WDT Papers.

72. Ray Holland, Jr., "Streamlining in Nature: How Man May Learn from Nature," *Scientific American* (May 1935), Box 59, Egmont Arens Papers. Holland stated, "Apparently Nature knows more about compounding forms to produce a low over-all drag than man will know for some time. . . . Improvement has been rapid, but there is still a long way to go."

73. Klemin, "Streamlining and Your Automobile," folder "Railroad #2," Box 16, WDT Papers.

74. William Engle, "This Dwindling World," *New York World-Telegram*, 27 June 1934, Box 16, WDT Papers.

75. Fargan Hathway, "Aerodynamics and Streamlining," undated General Motors brochure in Box 49, Egmont Arens Papers.

76. Charles Kettering, "Research—An Eye to the Future," undated General Motors brochure in folder "Streamlining: Airplanes, 1932, 1935, n.d.," Box 59, Egmont Arens Papers.

77. J. Stirling Getchell, Inc., "Engineers Go Back to Nature for Airflow De Soto Design: Streamlined Cars Take Shape from Birds, Fish and Greyhounds" (press release by De Soto Motor Corporation, a Division of the Chrysler Corporation, 15 Feb. 1934), Box 59, Egmont Arens Papers.

78. Towle, "Projecting the Automobile Into the Future," Box 59, Egmont Arens Papers.

79. Peed, "Streamlining-The Auto Industry's Answer to Public Demand," Box 59, Egmont Arens Papers.

80. John Wright, "The Beginning of the Streamlined Dream, 1919–1934," in *Streamlining America*, ed. Fannia Weingartner, Ex. Cat. (Dearborn, Mich.: Henry Ford Museum, Sept. 1986—Dec. 1987), 16.

81. "Zephyr in Service," folder "Streamlining, 1933–36," Box 59, Egmont Arens Papers.

82. "Streamlined Beauty Treatment in the Evolution of Railroad Locomotives," *New York Herald Tribune*, 5 March 1936, file "Railroad," on Microfilm Roll 16.20, WDT Papers.

83. Raymond Loewy, *Locomotive* (London: The Studio, 1937), unpaginated section at the back; italics added. Thanks to Jeffrey Meikle for bringing this reference to my attention.

84. Notes for the catalogue "Rugs and Floor Coverings," held at the Newark Museum, 4 March—10 April 1930, in the library at the Newark Museum.

85. Throughout various issues of *The Diagonal*, Jay Hambidge published an ongoing series on "The Dynamic Symmetry of Man." In this article, 1, 3 (1920): 52, he mentions that the measurements he is basing his argument on for the conformity of the human skeleton to the principles of dynamic symmetry come from the normal measurement "of the white race."

86. Jay Hambidge, "The End of the Diagonal," *The Diagonal* 1, 12 (1920): 235–36, 126.

87. Letter from Theo Fruchtman to Walter Dorwin Teague, 12 July 1948, on Microfilm Roll 16.31, WDT Papers.

88. Walter Dorwin Teague, *Design This Day: The Technique of Order in the Machine Age* (New York: Harcourt, Brace, 1940), 143. Here he cites D'Arcy Thompson, *On Growth and Form* (1917; Cambridge: Cambridge University Press, 1963), and A. H. Church's *On the Relation of Phyllotaxis to Mechanical Laws* (London: Williams and Norgate, 1904).

89. Jeffrey Meikle discusses Teague's interest in dynamic symmetry in *Twentieth-Century Limited: Industrial Design in America, 1925–1939* (Philadelphia: Temple University Press, 1979), 45–46.

90. Teague, *Design This Day*, 141–42.

91. Letter from Quynn [illegible signature] of the Warner and Swasey Co., to Robert Hose of Henry Dreyfuss Associates, 16 Nov. 1953, file "Anecdotal Letters,"

folder "Designing for People: Correspondence, Office," Box 1 "Publications," Henry Dreyfuss Papers.

92. Teague, "The Basic Principles of Body Design," folder "Miscellaneous," Box 58, WDT Papers.

93. Egmont Arens, "What Makes Designs That Click?" *Electrical Manufacturing* (April 1938), Box 49 "Articles/Writings," Egmont Arens Papers.

94. Brochure designed by Arens, "The Art of Fundamental Rhythmic Movement as Taught by Louise Revere Morris," 1923, folder "Samples of Work," Box 85, Egmont Arens Papers.

95. Harold van Doren, *Industrial Design* (New York: McGraw-Hill, 1940), 112–26; quotes from 115, 124.

96. Jeffrey Meikle, "Domesticating Modernity: Ambivalence and Appropriation, 1920–1940," in *Designing Modernity: The Arts of Reform and Persuasion, 1885–1945*, ed. Wendy Kaplan (London: Thames and Hudson, 1995), 148–49.

97. *Collier's* advertisement, 1935, in folder "Streamlining, 1933–1936," Egmont Arens Papers; italics added.

98. For examples of eugenicists' use of the term "drag" to refer to the effect on human evolution and society caused by the "degenerate," see the brochure "Eugenics at Work," 1931, folder "American Eugenics Society: Printing Orders, 1926–1942," AES Papers; George Benedict, "Sermon 47," folder "Rufus Baker, Sermon 21"; "Sermon 19," 1928, folder "Henry S. Huntington," all in AES Papers; Charles Davenport, "Some Social Applications of Modern Principles of Heredity" (speech to the International Congress of Hygiene, 1912), folder "Heredity Lectures," file "Charles B. Davenport," CBD Papers.

99. Adolf Loos, "Ornament and Crime," in *Ornament and Crime: Selected Essays* (Riverside, Calif.: Ariadne Press, 1998), 169–170.

100. Brochure for the "Better Sires, Better Stock" Campaign, U.S. Department of Agriculture, c. 1921, in folder "W. S. Anderson," CBD Papers. On Laughlin's exhibit, see *A Decade of Progress in Eugenics: Scientific Papers of the Third International Congress of Eugenics, held at American Museum of Natural History, New York, August 21–23, 1932* (Baltimore: Williams and Wilkins, 1934), 488, 503.

101. Henry Dreyfuss, "Notes for Boston Lectures," 1933, on Microfiche #6 "Lectures/Articles by Dreyfuss, 1933–49," Henry Dreyfuss Papers.

102. On the valuation of industrial design as a "lower" art, see Nancy Austin's work, particularly "Industrialization and the Language of Art and Design" (talk given at the annual convention of the College Art Association in Chicago, 2 March 2001).

103. "Wiggam Advocates Cousin Mating to Produce Genius," *Indianapolis Star*, 30 Aug. 1930, Leon Whitney Scrapbook, AES Papers. The article describes his speech.

104. Donna Braden, "Selling the Dream," in *Streamlining America*, ed. Fannia Weingartner, Ex. Cat. (Dearborn, Mich.: Henry Ford Museum, Sept. 1986—Dec. 1987), 51. She writes, regarding streamlining at the New York World's Fair: "The Fair's rhetoric of unity, cooperation, and harmony among all classes of people reflected the streamlined ideology at the peak of its popularity."

105. Louis Sullivan, "Natural Thinking: A Study in Social Democracy," 34–35 (address to the Chicago Architectural Club, 13 Feb. 1905), Louis Sullivan Papers.

106. "Sermon 17," folder "J. B. Hollis Tegarden," AES Papers. Sullivan's beliefs are discussed more fully in the Introduction to this book.

107. Frederick Osborn, "Human Ability—Democracy's Basic Defense," excerpted in press release dated 31 March 1941, folder "15th Annual Meeting of the AES," AES Papers.

108. Frederick Osborn, "Characteristics and Differential Fertility of American Population Groups," 10 May 1933, folder "Frederick Osborn, Papers I, #2," AES Papers.

109. Frederick Osborn, "Characteristics and Rates of Increase of American Population Groups" (speech delivered 12 May 1933), folder "AES: Minutes, 1925–35, #3," AES Papers.

110. Frederick Osborn speech at the Town Hall Club, New York, 11 Dec. 1937, folder "Conference on Publicists, 1937," AES Papers.

111. For example, see Sheldon and Eleanor Glueck, *Five Hundred Delinquent Women* (New York: Knopf, 1934), 310.

112. Letters from Albert E. Wiggam to Charles Davenport, 25 Aug. 1922 and 4 Sept. 1922, folder "A. E. Wiggam #3," CBD-CSH Series.

113. Flinchum, *Henry Dreyfuss, Industrial Designer*, 39.

114. Kobler, "The Great Packager," 114, 116.

115. Edwin Black, *War Against the Weak: Eugenics and America's Campaign to Create a Master Race* (New York: Four Walls Eight Windows, 2003), discusses in depth Rockefeller Foundation support for eugenic research.

116. On Mrs. Stanley Resor, see folder "Minutes, 1936–37, #1," AES Papers. On Loewy, see Raymond Loewy, "S. P. I.," 9 Nov. 1967, folder "Speeches and Writings," Container 2 "Executive Papers," Raymond Loewy Papers, Library of Congress. A retrospective account written by Loewy in 1967 revealed that over the years, he and Georges had remained close friends, sharing with each other ideas about their careers. In the account, Loewy recounted Georges's optimism regarding the power of science and medicine to improve human beings: "But if machines continue to drive the human beings they are supposed to serve, perhaps something can be done about the human being himself. . . . My brother, Georges . . . tells me that leading physiologists, biologists, agree that longevity will be appreciably extended by 2000 A.D. . . . But if we tamper with lengthening life we must in parallel make it more enjoyable. . . . Soon, scientific men of integrity working in the labs of great universities and research centers will take charge again and extraordinary things will happen. . . . So, man . . . will himself be a more perfectly operable machine, a more receptive and efficient sensor. Until we can get our man upgraded, may I appeal to you to protect him in the meantime, to improve his lot in our present physical context to help him into the kind of world our research and technology can promise." Although this account described medical goals in the 1960s, as Carrel's assistant throughout the 1920s and 1930s, Georges could not have escaped participating in eugenically related research and discussion, and it is likely that Loewy himself was at least aware and quite possibly supportive, given his comment in

Vogue in 1939. Given Georges's profession, Loewy's characterization of himself as a "doctor curing product disease" offered a telling metaphor for industrial design.

117. Egmont Arens, "Why Sell to the Wealthy," 6 May 1922, folder "Condé Nast, Promotional Materials, Miscellaneous, 1921–22," Box 80, Egmont Arens Papers. On the "class" and "mass" markets of advertising, see Roland Marchand, *Advertising the American Dream* (Berkeley: University of California Press, 1985), 61–80.

118. Arens, "Why Sell to the Wealthy," Box 80, Egmont Arens Papers; italics added. In one of his projects, Donald Deskey specifically disparaged the mass market for most low-cost, prefabricated housing. He characterized this market as "the truck driver and green grocer, the low salaried white collar worker, and I should say that group of people who, through the women's publications, the newspapers and department stores have been educated to want something that aped the romantic background created by the architect of dwellings in the period mentioned before." Instead, Deskey primarily concentrated his efforts on designing sophisticated, high-class interiors and furnishings for the wealthy. For the weekend enjoyment of this clientele, he created the Sportshack, a prefabricated dwelling "that a wealthy person could buy, possibly for cash, and put up in Canada for shooting or fishing, or down in Florida." See Deskey, "Production and Distribution of Modern Shelter," c. 1941, folder "Speeches and Writings," Donald Deskey Papers. Ironically, Sportshacks were erected largely in middle-class suburbia; see Jeffrey Meikle, "Donald Deskey Associates: The Evolution of an Industrial Design Firm," in *Donald Deskey: Decorative Designs and Interiors*, ed. David Hanks and Jennifer Toher (New York: E. P. Dutton, 1987), 124–26.

119. *Vogue* advertisement, folder "Condé Nast, Promotional Materials, Miscellaneous, 1921–22," Box 80, Egmont Arens Papers.

120. Walter Dorwin Teague, "The Packaging Problem," *Spirits* (Oct. 1933), folder "Writings," Box 79, WDT Papers.

121. "Modern Art for Everyman's Home," *New York Evening Journal*, n.d., n.c., and Alice Hughes, "Ready-Made Furniture Hailed as a Triumph of Industrial Designer," 17 Dec. 1933, both in folder "Donald Deskey Associates," Donald Deskey Papers.

122. Gertrude Bailey, "Donald Deskey, Pioneer in Modern Furniture Field, Says Americans Will Become Design-Conscious," *New York World Telegram*, 15 Aug. 1935, folder "Speeches and Writings," Donald Deskey Papers. Italics added.

123. For a broader discussion of the historical conflation of men and machines, see Linda Henderson, *Duchamp in Context: Science and Technology in the Large Glass and Related Works* (Princeton, N.J.: Princeton University Press, 1998), 33–37.

124. Herbert Spencer Jennings, folder "Lecture #48: Can Men Be Bettered Psychologically and Ethically by Breeding?" (17 Oct. 1932), HSJ Papers. He had developed this theme earlier in "Lecture #46: The Biological Background of Social Work" (speech to the Center for Family Welfare, University of Maryland, 14 Oct. 1930), HSJ Papers.

125. "Eugenist Talks on Adjustment of Marriage," *Harrisburg (Pennsylvania) News*, 8 Nov. 1927, Leon Whitney Scrapbook, AES Papers.

126. Lennard Davis discusses this notion of the uniform type in *Enforcing Normalcy: Disability, Deafness, and the Body* (London: Verso, 1995), 36.

127. Aldous Huxley, *Brave New World* (New York: Harper and Row, 1932); "To-morrow's Daughter," *Vogue* (1 Feb. 1939): 61.

128. Pernick, *The Black Stork*, 62.

129. "Notes for a Eugenic Program," 14 Nov. 1934, summarized in the Mehler Guide, AES II Papers; "Sermon 25," folder "A. Wakefield Slaten," AES Papers. Slaten gave his sermon at a Unitarian Church in New York City in 1926.

130. Sheila Weiss, "The Race Hygiene Movement in Germany, 1904–1945," in *The Wellborn Science: Eugenics in Germany, France, Brazil and Russia*, ed. Mark Adams (Oxford: Oxford University Press, 1990), 26, 49.

Chapter 3. Progenitors of the Future: Popularizing Steamlining and Eugenics During the 1930s

1. On "colonial moderne" and the Chicago World's Fair, see Robert Rydell, *World of Fairs: The Century-of-Progress Expositions* (Chicago: University of Chicago Press, 1993), 61–91, and Jeffrey Meikle, *Twentieth-Century Limited: Industrial Design in America, 1925–1939* (Philadelphia: Temple University Press, 1979), 153–57. Geddes held the title Designer of Illumination for the Buildings and Grounds for the fair, which was originally planned to open in 1930 but was delayed by the stock market crash.

2. Letter from George K. Burgess to Charles Davenport, 30 April 1929, folder "George K. Burgess," CBD Papers. Frank Lillie served on the committee in a similar capacity; see also folder "National Research Council Executive Board, 1929," CBD-CSH Series.

3. Letter from Harry H. Laughlin to C. W. Dupertuis of the Harvard Anthropometric Laboratory, 16 July 1934, folder "Clippings, 1933–34, n.d.," Box #1: Series XII "Midget Schedules," ERO Papers; letter from Morris Steggerda to Jack Fine, Manager of the Midget Colony at the Century of Progress Exposition, 26 Sep. 1933, folder "Morris Steggerda, 1933," CBD Papers; "Copy," 5 Nov. 1934, folder "Harry H. Laughlin, 1934, #2," CBD-CSH Series.

4. Letters from Richard Post to Charles Davenport, 9 March 1934, and "Easter Sunday," most likely 1934, folder "Richard H. Post, #5, 1931–38," CBD Papers. On Harvard and Hooton, see letter from Charles Davenport to Alfred Kidder, 4 March 1929, folder "Alfred V. Kidder," CBD Papers.

5. "Hall of Science at a Century of Progress" flyer, Box 3, folder II-46, BG Papers.

6. Waldemar Kaempffert, "The Week in Science: A 'Miracle of Life' in Berlin," *New York Times*, 14 April 1935, Box 8, BG Papers. Bruno Gebhard, Scientific Director of the German Hygiene Museum in Dresden, became the director of the Cleveland Health Museum in 1940.

7. Letter from Eben Carey, on the committee for medical exhibits, to Bruno Gebhard, 1 Aug. 1945, folder II-47, Box 3, BG Papers; "A Century of Progress in

Medicine: An Editorial," reprint from *Hygeia, The Health Magazine* (1933–1934), Folder II-46, Box 3, BG Papers.

8. Ibid. Charts included in this reprint show the average woman of 1893 and 1933 in profile, as if made as a shadow drawing, and her features are decidedly Anglo.

9. Bruno Gebhard, "Art and Science in a Health Museum," reprint from *Bulletin of the Medical Library Association* 33, 1 (Jan. 1945), in folder III-2 "Lectures and Published Articles, 1941–1949," Box 4, BG Papers. See also the *Official Guide Book of the Fair* (Chicago: Cuneo Press, 1933), 39, and "Reunion in Buffalo: Transparent Man and Woman, Made in Dresden, Meet Here," *Hobbies* 17, 4 (April 1937).

10. "Hall of Science at a Century of Progress" flyer, folder II-46, Box 3, BG Papers. See also Rydell, *World of Fairs*, 55.

11. "A Century of Progress in Medicine: An Editorial," contains a photo of a mural in the Hall of Science, likely between the Ground and Main floors, that depicted the relationship between the pure and applied sciences in the form of a tree, where the pure sciences composed the roots and the applied sciences the branches. The eugenics panel with the tree almost exactly mirrored this mural, listing both pure and applied sciences in the roots of the tree with nothing in the branches, as if to imply that eugenics united *all* the sciences into a healthy unified organism.

12. E. S. Gosney and Paul Popenoe, *Sterilization for Human Betterment* (New York: Macmillan, 1929), vii. Gosney and Popenoe list the "tribe of Ishmael" as being similar to the Jukes, the Nams, the Zeros, and other "defective" families. The Kallikaks, too, were of this genre, and their name was fictitious. As Ishmael was the illegitimate son of Abraham and Hagar, they were probably given this name by the eugenicist writing about them. See also Arthur Estabrook, "The Tribe of Ishmael," in *Eugenics, Genetics, and the Family: The Second International Congress of Eugenics* (Baltimore: Williams and Wilkins, 1923), 398–404, plate 18.

13. Harry H. Laughlin, "Annual Report, Harry H. Laughlin, for Year Ending June 30, 1933," section "The Eugenics Exhibit at the Chicago Century of Progress," 20, folder "Harry H. Laughlin, 1933, #2," CBD-CSH Series.

14. Rydell, *World of Fairs*, 55.

15. Letter from Sherman Kent, Curator of the Century of Progress Collection at the library at Yale University, to Harry Laughlin, 8 Oct. 1934, folder "Harry H. Laughlin, 1934, #2," CBD-CSH Series. On the Buffalo Museum, see letter from Henry Fairfield Osborn to Charles Davenport, 26 Sept. 1932, folder "Henry Fairfield Osborn," CBD Papers, and also Rydell, *World of Fairs*, 55–56. Photos of these four panels taken at the Buffalo Museum of Science (BMS) are in the archives of the BMS.

16. Meikle, *Twentieth-Century Limited*, 154–63. Elevation drawing and plans of the Hall of Science are included in the "Hall of Science at a Century of Progress" flyer, folder II-46, Box 3, BG Papers.

17. Egmont Arens, "Streamline for Recovery" (speech written and delivered before Dec. 1934), in folder "Streamline for Recovery," Box 48, Egmont Arens Papers; all formatting original.

18. On the widespread popularity of streamlining, see Meikle, *Twentieth-*

Century Limited; J. Stewart Johnson, *American Modern, 1925–1940: Design for a New Age* (New York: Harry Abrams, with the American Federation of the Arts, 2000); Fannia Weingartner, ed., *Streamlining America*, Ex. Cat. (Dearborn, Mich.: Henry Ford Museum, Sept. 1986–Dec. 1987); Richard Guy Wilson, Dianne Pilgrim, and Dickran Tashjian, *The Machine Age in America, 1918–1941* (New York: Harry Abrams, in association with the Brooklyn Museum, 1986); John Perreault, ed., *Streamline Design: How the Future Was*, Ex. Cat. (New York: Queens Museum, 28 Jan.–6 May, 1984); Claude Lichtenstein and Franz Engler, eds., *Streamlined: A Metaphor for Progress* (Princeton, N.J.: Princeton University Press, 1995); Donald Bush, *The Streamlined Decade* (New York: George Braziller, 1975); Adrienne Berney, "Streamlining Breasts," *Journal of Design History* 14, 4 (2001): 327–42; Robert Friedel, *Zipper: An Exploration in Novelty* (New York: Norton, 1996). I spend less time documenting the popularity of streamlining because these texts have already established this.

19. E. A. Jewell, "The Masterpiece and the Modeled Chart," *New York Times*, 18 Sept. 1932, xx9, refers to the "Department of Eugenics" at the American Museum of Natural History in which the sculpture of *The Average Man* stood.

20. Letter from Henry Fairfield Osborn to Charles Davenport, 26 Sept. 1932, folder "Henry F. Osborn," CBD Papers. According to the letter, the Field Museum was planning to open a hall of eugenics, while the Buffalo Museum of Natural History already had an exhibit.

21. "'Transparent Man' Sensation of Chicago Fair Will Be Exhibited Here Next Week," *Pasadena Post*, 1 Sept. 1934, Box 8, BG Papers. For more on this exhibit, see a co-authored essay "The Nazi Eugenics Exhibit in America, 1934–43," by Robert Rydell, Christina Cogdell, and Mark Largent, in the author's possession.

22. "Famous Exhibit From Germany Seen in Armory," *Stockton Record*, 16 Jan. 1935, Box 8, BG Papers.

23. Exhibition checklist and photos of the panels and their German prototypes can be found in the folder "Eugenics in New Germany," BG Papers; correspondence about the exhibit between officials of the American Public Health Association, the Buffalo Museum of Science, elected officials in Oregon, and customs officials who destroyed most of the exhibition in 1942 are split between the BG Papers and the Buffalo Museum of Science Archives, 042(3), F3, per copies I received from Claire Cronin at the U.S. Holocaust Memorial Museum.

24. "Individual Analysis Card—Charlotte Williams," 7 June 1928, folder "Individual Analysis Cards," Box #5: Series VI "Fitter Family Studies," ERO Papers. The folder contains Individual Analysis Cards from 1920 to 1936, and reveals that there were Fitter Families Examinations in Kansas in 1925 and 1927, in Massachusetts in 1925, in Michigan in 1925 and 1928, in Texas in 1925–1927, and at the Kansas Free Fair in 1924. For a particularly telling example of what the examinations entailed and how participants responded, see folder "Margaret Stanton Osborn," 10 Sep. 1920, folder "Individual Analysis Cards," Box #5: Series VI "Fitter Family Studies," ERO Papers.

25. Robert Bogdan, *Freak Show: Presenting Human Oddities for Amusement and Profit* (Chicago: University of Chicago Press, 1988), 66. For his discussion of the role of eugenics in the decline of freak shows, see pages 62–67, 278.

26. In my article, "The Futurama Recontextualized: Norman Bel Geddes's

Eugenic 'World of Tomorrow,'" *American Quarterly* 52, 2 (June 2000): 209–12, I further discuss a display of dwarves envisioned by Geddes for the New York World's Fair. Despite the fact that two promotional reviews of the Midget Colony at the Chicago World's Fair characterized the dwarfs as "modern," "superior," "able, clear-thinking and accomplished people," "not as freaks or oddities, but as real human beings," these positive characterizations countered scientific opinion and a general popular consensus. On Davenport's work with the children at Letchworth Village, see folders "Letchworth Village," CBD Papers. For the complimentary reviews of the dwarfs, see Benjamin Klein, "Modern Lilliputia," 1933, folder "Notes, 1934," Box #1: Series XII "Midget Schedules," ERO Papers; "Midget Village Graduates into Midget City," *Progress* 4,10 (a semi-monthly publication of the Exposition), folder "Clippings, 1933–34, 1938, n.d.," Box #1: Series XII "Midget Schedules," ERO Papers.

27. Martin Pernick, *The Black Stork: Eugenics and the Death of "Defective" Babies in American Medicine Since 1915* (New York: Oxford University Press, 1996), 144, 165 and throughout; Stefan Kuhl, *The Nazi Connection: Eugenics, American Racism, and German National Socialism* (Oxford: Oxford University Press, 1994), 59. The New Jersey Sterilization League and the Pioneer Fund assisted with the translations and distribution.

28. For coverage of eugenics on radio broadcasting, see untitled newspaper article about C. F. Dight's series on "Eugenics and Race Betterment" on WRHM, *St. Paul (Minnesota) Pioneer Press*, 26 Feb. 1928, Leon Whitney Scrapbook, AES Papers; on Science Service's coverage of the Third International Congress of Eugenics, see letter from Watson Davis to Charles Davenport, 8 June 1932, folder "Watson Davis," CBD Papers; for broadcasts of eugenics speeches on WRNY, see "Minutes, 17 May 1930," folder "AES: Minutes, 1925–35, #3," AES Papers; Charles Davenport, "Heredity and Disease," a lecture broadcast over Columbia Broadcasting System (CBS), 27 Nov. 1931, folder "Heredity Lectures," Charles B. Davenport file, CBD Papers.

29. Frederick Osborn, "Adventures in Science" (through Science Service over CBS, 14 Nov. 1940), folder "Frederick Osborn, Papers I, #11," AES Papers.

30. Letters from Mary Watts to Charles Davenport, 13 March 1925 and 24 April 1925, folder "Mary T. Watts #2 (1924–25)," CBD-CSH Series.

31. "Woman Urges Eugenics as Panacea for Nation," n.c., Sioux City, Iowa, newspaper, 6 Oct. 1927, Leon Whitney Scrapbook, AES Papers. The address the article discusses was delivered to the Minnesota Federation of Women's Clubs at Crookston, Minnesota.

32. Letters from Winifred Willson, editor of the *Independent Woman*, to Herbert Spencer Jennings, 9 Feb. 1934 and 21 Feb. 1934, folder "*Independent Woman*," HSJ Papers. Jennings was responsive but ultimately failed to follow through with certain revisions to his article, which remained unpublished. See also "Art in Advertising is Topic of Advertising Women," *New York Advertising Club News*, 20 May 1929, Leon Whitney Scrapbook, AES Papers. The Club met to have a "Dialogue on the Eugenics of Baby's Pictures."

33. "Edith Johnson's Column: Eugenics and the Trim Girl," *Oklahoma City Oklahoman*, 24 Oct. 1927; "Eugenics Subject for Rotary Talks: Club to Hear Mr. Gosney and Mr. Popenoe," *Pasadena (California) Star*, 6 Dec. 1927; "Leader in Eugenics Movement to Speak; Dr. M. S. Taylor, Pres. of the National Eugenics Associ-

ation, Will Speak at the Optimist Club," *Akron (Ohio) Beacon Journal*, 19 June 1928; "Suggests New Law to Halt Marriage of Feeble Minded: Authority on Eugenics Opens Campaign at Meeting of Men's Liberal Club," *Lancaster (Pennsylvania) Intelligence-Journal*, 10 April 1930; all in Leon Whitney Scrapbook, AES Papers.

34. Letter about the Lotos Club from Albert E. Wiggam to Charles Davenport, 2 Jan. 1922, folder "A. E. Wiggam, #2," CBD-CSH Series; on the Town Hall Club, see "Minutes, 26 Nov. 1929," folder "AES: Minutes, 1925–35, #2," AES Papers.

35. All these lectures were given in 1939. See folder "Paul Popenoe #4 (1931–40)," CBD Papers.

36. "Marriage Seen as End to Evils: Preacher Says Too Many Matches Made by Impulsiveness," *Birmingham (Alabama) Age Herald*, 17 April 1928; "Physical Directors Meet at College; State YMCA Society Hears Address by Group of Authorities," *Springfield (Massachusetts) Union*, 18 Nov. 1927; "YWCA Group in Lawrence: Kansas City Women Confer with University of Kansas Students," *Kansas City (Missouri) Star*, 29 Oct. 1927; "Child League Meets," *Gloversville (New York) Leader Republican*, 24 Sept. 1929; all in Leon Whitney Scrapbook, AES Papers.

37. Photo 84, AES Photo Album, AES Papers. The photo most likely was taken in the mid- to late-1920s.

38. C. Ward Crampton, M.D., "The Health Program of the Boy Scouts of America" (speech given at the Hotel Delmonico in New York, 22 Jan. 1937), folder "Conferences—Recreation and the Use of Leisure Time," AES Papers. On the connections of the Boy Scout movement with eugenics, see Marouf Hasian, *The Rhetoric of Eugenics in Anglo-American Thought* (Athens: University of Georgia Press, 1996), 38–42.

39. Letter from Milton Fairchild, president of the Character Education Institution of the U.S.A., to Charles Davenport, 14 Dec. 1928, folder "Milton Fairchild," CBD Papers; also, letter from Mrs. Nelson Goodyear to Davenport, 18 Aug. 1933, folder "Mrs. Nelson Goodyear," CBD Papers.

40. On the involvement of teachers and Parent Teacher Associations (PTA) in eugenics, see papers on the California PTA, folder "AES: Southern California Branch, Records #2," AES Papers. See also various articles in Leon Whitney Scrapbook, AES Papers, including "Lecturer to Address Carlisle School PTA," *Chieftain*, Pueblo, Colo. 22 Jan. 1928; "Banquet Opens Meeting of Parents, Teachers," *Pittsburgh Press*, Oct. 1927; "Wiggam Advocates Cousin Mating to Produce Genius," *Indianapolis Star*, 30 Aug. 1930; "Eugenics Seeks to Help Race, Teachers Told: Head of Society Explains Purposes to Association Section," *Minneapolis Star*, 9 Nov. 1928; "The Betterment of the Human Race by Eugenic Measures," *Minneapolis Evening Tribune*, 26 Dec. 1927. Kuhl, *The Nazi Connection*, 46, writes that racial degeneracy was the focus of the annual meeting of the New York State Association of Elementary School Principals in 1934; the meeting called for "increased sterilization of criminals and low mentality cases."

41. Ernest Steel and Ella White, *Hygiene of Community, School and Home* (New York: Harper and Brothers, 1932), 78, 60, 54.

42. Maude Lee Etheredge, *Health Facts for College Students: A Text-book of Individual and Community Health* (Philadelphia: W.B. Saunders, 1934), 143, 146.

43. Charles Wilson, John Bracken, and John Almack, *Life and Health* (Indianapolis: Bobbs-Merrill, 1945).

44. Steven Selden, *Inheriting Shame: The Story of Eugenics and Racism in America* (New York: Teachers College Press, 1999), 64.

45. On the involvement of educators with eugenics, see memo from Charles Davenport to Harry Laughlin regarding a Waco, Texas, high school teacher's request for information, 29 March 1930, folder "Harry H. Laughlin, 1920, #1," CBD-CSH Series; letter from a Coloma, Wisconsin, History teacher, Merlin Douglass, to Davenport, 14 March 1935, folder "Publications, Requests for," CBD Papers; letter from Lloyd A. Rider, Chairman of the Field Committee of New York Biology Teachers Association, to Davenport, 21 Sept. 1935, folder "Lloyd A. Rider," CBD Papers; letter from Paul Jones and Stanley O'Neill, Biology teachers at Fordson High School in Dearborn, Michigan, to Davenport, 8 June 1932, folder "Paul H. Jones and Stanley P. O'Neill," CBD Papers; "Report of Staff Meeting, 3 May 1937," folder "Carnegie Institute of Washington—Department of Genetics," CBD Papers; correspondence between Ralph Benedict, of Brooklyn College, and Davenport throughout the 1920s and 1930s, folder "Ralph Benedict," CBD Papers.

46. "Report of the Committee on Formal Education, 1928–1," folder "AES: Printing Orders, 1926–42, #4," AES Papers; also, Daniel Kevles, *In the Name of Eugenics: Genetics and the Uses of Human Heredity* (Cambridge, Mass.: Harvard University Press, 1995, 1985), 89.

47. "Course in Eugenics Urged—Columbia papers Declares it Vital to Education," *New York Herald Tribune*, 19 Jan. 1928, Leon Whitney Scrapbook, AES Papers.

48. File "Sweet Briar College," folder "Eugenics Instruction Questionnaire," Box #1: Series X of Harry H. Laughlin Files, ERO Papers. A similar course on "Evolution and Genetics" was taught at Lawrence College of Appleton, Wisconsin, that included topics on the eugenics movement, including mental evolution, social evolution, heredity, inbreeding and crossbreeding, differences among men, inheritance of mental capacities, Mendelism in man, origin and growth of the eugenics movement, crime and delinquency, the desirability of restrictive eugenics, methods of restriction, the dysgenic classes, the color line, positive eugenics, race betterment through heredity, immigration, war, the possibilities and limitations of the eugenics movement. See file "Lawrence College," folder "Eugenics Instruction Questionnaire," Box #1: Series X of Harry H. Laughlin Files, ERO Papers.

49. Only two schools responded to the questionnaire with hostility: the University of Detroit and St. Vincent College in Beatty, Pennsylvania. See file by each school's name, folder "Eugenics Instruction Questionnaire," Box #1: Series X of Harry H. Laughlin files, ERO Papers. A course in "Health and Hygiene" that incorporated eugenics was taught to students at the College of Industrial Arts in Denton, Texas.

50. Letter from Charles Davenport to Lybrand P. Smith, 12 April 1928, folder "Lybrand P. Smith," CBD Papers.

51. "Girard College," folder "Eugenics Instruction Questionnaire," Box #1: Series X of Harry H. Laughlin Files, ERO Papers. The form did not specify what types of records they examined or what they were looking for, but they included

this information on a questionnaire asking about their implementation of eugenics and genetics.

52. On debates over eugenics in the African American community, see Daylanne English, *Unnatural Selection: Eugenics in American Modernism and the Harlem Renaissance* (Chapel Hill: University of North Carolina Press, 2004), and also her article "W. E. B. DuBois's Family *Crisis*," *American Literature* 72, 2 (June 2000): 291–319.

53. On Vassar, see an article that cited Dr. Annie MacLeod, Director of Eugenics at Vassar, "College Girls Trained for Realities of Life, Says Coast Educator," *Scranton (Pennsylvania) Times*, 3 July 1928, Leon Whitney Scrapbook, AES Papers. On Howard University and Yale University, see files by their name in folder "Eugenics Instruction Questionnaire," Box #1: Series X of Harry H. Laughlin files, ERO Papers; also, letter from Dean Martha Tracy to Charles Davenport, 11 Jan. 1940, folder "Woman's Medical College of Pennsylvania," CBD Papers.

54. Because other historians have focused on the history of eugenics with regards to social and political policies and scientific research, I have limited my discussion to popular culture. For more information on these other areas, see Kevles, *In the Name of Eugenics*; Kenneth Ludmerer, *Genetics and American Society: A Historical Appraisal* (Baltimore: Johns Hopkins University Press, 1972); Martin Pernick, *The Black Stork*; Wendy Kline, *Building a Better Race: Gender, Sexuality, and Eugenics from the Turn of the Century to the Baby Boom* (Berkeley: University of California Press, 2001); Stefan Kuhl, *The Nazi Connection*; Edwin Black, *War Against the Weak: Eugenics and America's Campaign to Create a Master Race* (New York: Four Walls Eight Windows, 2003); Phillip Reilly, *The Surgical Solution: A History of Involuntary Sterilization in the United States* (Baltimore: Johns Hopkins University Press, 1991); and Diane Paul, "Eugenics and the Left," *Journal of the History of Ideas* 45 (1984): 567–90.

55. Mark H. Haller, *Eugenics: Hereditarian Attitudes in American Thought* (New Brunswick, N.J.: Rutgers University Press, 1963), 134–41. His discussion of sterilization laws reveals that the definition of "imbeciles" was variously interpreted to include the feebleminded, insane, criminal, epileptic, poor, welfare recipients, rapists, perverts, drunkards, drug addicts, syphilitics, prostitutes, highway robbers, chicken stealers, murderers, and automobile thieves. See also Martin Pernick's discussion of sterilization and other related surgical procedures in *The Black Stork*, 83–84, as well as Reilly's *The Surgical Solution*, throughout.

56. For example, one bulletin board from a eugenics exhibit at the Kansas State Fair read: "The Rising Tide of the Unfit. . . . When Shall This Tide be Stemmed?" It gave statistics of the State Penitentiary, Industrial Reformatory, Industrial Farm for Women, Boys Industrial School and Girls Industrial School in Kansas, showing the rise in inmate population from 1920 to 1928. It emphasized that "The COST to the taxpayers of Kansas for the one year of 1928 was $2,154,468.63." Information from a photo of the exhibit in the AES Photo Album, AES Papers. In his address in 1941 to the AES, Frederick Osborn declared, "A majority of their defects have a constitutional, that is, a hereditary basis. The cost of their care alone is probably a billion dollars a year. They handicap our national life and handicap our preparations for defense." See folder "15th Annual Meeting, American Eugenics

Society, Savoy Plaza Hotel, 31 March 1941," AES Papers. See also Osborn's talk in the same folder, "Human Ability—Democracy's Basic Defense."

57. Sheldon and Eleanor Glueck, *Five Hundred Delinquent Women* (New York: Knopf, 1934), 310.

58. Kevles, *In the Name of Eugenics*, 115–116. See also the pamphlet, "Practical Eugenics," 14, printed and distributed by the AES, 1938, folder, "Printing Orders, 1926–42, #9," AES Papers.

59. Kuhl, *The Nazi Connection*, 44.

60. Ibid., 114.

61. Four articles are listed here as examples, and all are taken from the Leon Whitney Scrapbook, AES Papers: Untitled editorial supporting sterilization, *Springfield (Massachusetts) Union*, 1 May 1930; "Wiggam Advocates Cousin Mating to Produce Genius," *Indianapolis Star*, 30 Aug. 1930; "Modern Women Criticized; Tuberculosis Among Them Is Laid to Their Dress and Habits—Sterilization of Morons Urged," *New York Times*, 25 Jan. 1928; "Women Studying Eugenic Birth Ban," n.c. New Jersey newspaper, 13 April 1930.

62. Kline, *Building a Better Race*, 95–123.

63. "Iowa Eugenics Law Discussed: Board of Control Holds Quarterly Meeting," *Des Moines (Iowa) Register*, 11 Sept. 1929, Leon Whitney Scrapbook, AES papers.

64. Dr. Abraham Myerson, "Sterilization and the Attitude of the Neurologist and Psychiatrist to the Whole Eugenic Approach," 21 April 1937, folder "Conference on Medicine and Eugenics, 1937," AES Papers. As discussed in the last chapter of this book, recent apologies by state governors in Virginia, Oregon, and California in the last two years have acknowledged that, in fact, their state's laws enforced compulsory sterilization.

65. Letter to editor from M. Ogilvie, "People's Forum," *Los Angeles Express*, 6 Sept. 1929, Leon Whitney Scrapbook, AES Papers.

66. Editorial, "Urges Humane Treatment of Defectives," *Minneapolis Star*, 4 Sept. 1929, Leon Whitney Scrapbook, AES Papers.

67. "Sermon 52," folder "H. H. Hester," AES Papers. Hester was pastor of the Kirwin Congregational Church in Kirwin, Kansas.

68. Keith Barrons, "Streamlined Plants: Professional Plant Breeding . . . Benefits the Farmer, the Housewife, Many Others . . . Finer Fruits, More Beautiful Flowers, Tastier Vegetables," *Scientific American* 158 (March 1938): 133–36, here 136, italics added. "Plastic" here seems to be a direct reference to plastic streamlined products, since he refers to molds and is using streamlining as his guiding metaphor.

69. The "mountains and valleys" metaphor is not from Barrons's article, but is a metaphor that Egmont Arens used when referring to the streamlining of language in a letter he wrote to Dr. Janet Aiken, 10 Nov. 1934, folder, "Language, Speed In, 1934–50," Box 58, Egmont Arens Papers. This is further discussed in Chapter 4.

70. Folke Kihlstedt, "Utopia Realized: The World's Fairs of the 1930s," in *Imagining Tomorrow: History, Technology and the American Future*, ed. Joseph Corn (Cambridge, Mass.: MIT Press, 1986), 112, and Bush, *The Streamlined Decade*, 167–68.

71. Lewis Mumford, "The Sky Line in Flushing—Genuine Bootleg," *New*

Yorker (19 July 1939), in File 381, NBG Papers. The Perisphere was designed by architects Wallace Harrison and J. André Fouilhoux, with the interior exhibit by Henry Dreyfuss.

72. The sketch is on a microfilm roll that has been misplaced at the Cooper-Hewitt. I therefore could not get a good reprint of it for publication.

73. All unfootnoted quotations in this section are taken from Geddes's descriptions of the Futurama in his proposal and scripts, File 381, NBG Papers. Jeffrey Meikle, in "Forms, Functions and Mixed Motives: A Natural History of Streamlining," a talk given at the conference on "The Art Deco World," Victoria and Albert Museum, London, 26 April, 2003, 15, mentions that Eero Saarinen, working for Geddes, was chiefly responsible for the design of the "sweeping streamline facade" and the four facades at the center of the mock-up intersection at the middle of the building.

74. For descriptions of the Futurama utilizing the phrases quoted throughout this paragraph, see respectively George Herrick for *Automotive Industries* (25 April 1939): 4; Kenyon Finney, "How to See the World's Fair," *Cue* (6 May 1939): 56; Laura Lee, "What You'll See at the Fair: Roads Without Traffic Cops and Cities Without Slums in World of Tomorrow," *Philadelphia Bulletin*, 6 June 1939; Grace Lane, "Dear Family: Letters of a Toledo Girl in New York," *Toledo Times*, 30 July 1939; and Finney, "How to See the World's Fair," 56 (Finney referred to the similarity of Geddes's chairs to the loveseats on Pullman railcars).

75. Kihlstedt, "Utopia Realized," 108; also cited in Roland Marchand, "The Designers Go to the Fair II: Norman Geddes, The General Motors 'Futurama,' and the Visit to the Factory Transformed," *Design Issues* 8 (Spring 1992): 34.

76. Stuart Chase, "Patterns for a Brave New World," *Cosmopolitan* (Jan. 1940): 83–84; Aldous Huxley, *Brave New World* (New York: Harper and Row, 1932), first two chapters. Though Huxley's text reads as satire and is often interpreted as such by many critics since, he personally accepted eugenics and at certain times in his life promoted social stratification based upon individual difference. See his introduction to the 1946 reprint of *Brave New World*, xvi, xvii. Many thanks to Joel Dinerstein for directing me to these chapters. Also, the Futurama was not the only exhibit at the fair by Geddes to promote a passive female sexuality actualized by a masculine conceptual force. His nude "girlie-show," the Crystal Lassies, contained a similar theme; see Cogdell, "The Futurama Recontextualized," 214–25.

77. Letter from Norman Bel Geddes to Frances Resor Waite, 16 Jan. 1938, in folder "Correspondence, 1938–39," Box 96B, PF 960, NBG Papers.

78. Chase, "Patterns for a Brave New World," 83–84.

79. Letter from Homer N. Calver, Secretary of the Committee on American Museum of Hygiene, to Bruno Gebhard, 14 Sept. 1937, folder 54, "American Public Health Association," BG Papers; this folder also includes a copy of the "Minutes of a Meeting of the Committee on the Hall of Man of the Advisory Committee on Medicine and Public Health," 16 Nov. 1937, at which Gebhard was present. The letter doesn't state the date which Gebhard arrived, only that Calver would meet him and his wife when they did.

80. H. E. Kleinschmidt, M.D., "New Germany Teaches Her People: An Ac-

count of the Health Exposition in Berlin," *American Journal of Public Health* 25, 10 (October 1935): 1108, in folder II-43, Box 3, BG Papers.

81. The seventy-five displays were on view at the New York Museum of Science and Industry in Rockefeller Center during 1937. On Gebhard's proposal, see folder 54, "American Public Health Association," BG Papers, which includes a copy of the "Minutes of a Meeting of the Committee on the Hall of Man of the Advisory Committee on Medicine and Public Health," 16 Nov. 1937.

82. "Minutes: Board of Directors Meeting," 23 Sept. 1937, and "Minutes," 8 Sept. 1937, both in folder "American Eugenics Society: Minutes, 1936–37, #4," AES Papers; also, "Minutes," 9 March 1938 and 5 May 1938, folder "AES: Minutes, 1938–56, #1," AES Papers.

83. "Report of the Activities of the AES for the year April 1, 1939—March 31, 1940," folder "AES: Printing Orders, 1926–42, #12," AES Papers. On the relation between health, child development, maternity and eugenics in the 1930s, see Kline, *Building a Better Race*, 95–123.

84. Frederick Osborn, "Dedicatory Exercises of the American Museum of Health, Held in the Hall of Man at the New York World's Fair," 17 June 1939, folder "Frederick Osborn, Papers I, #10," AES Papers. Osborn began: "Mr. Chairman, Mayor La Guardia, Mr. Whalen, and Friends."

85. Rydell, *World of Fairs*, 56–58. The Johns Manville Company produced asbestos shingle siding for homes. Henry Ford was a longtime eugenics supporter.

86. A "General Motors Press Release," 15–16 April 1939, File 381, NBG Papers, mentioned that Geddes considered the conveyor to be "essential" to the exhibit.

87. Chase's analysis was the only review that Geddes wholeheartedly affirmed as correctly interpreting the exhibit, for reasons that Geddes did not clarify. Geddes wrote: "The most intelligent translation of the Futurama I have seen is your article in the current *Cosmopolitan*. Thank you so much." Letter from Geddes to Chase on 5 Dec. 1939, File 381.43, 19d, NBG Papers. Marchand, "The Designers Go to the Fair, II," 37, also cites Geddes's lamenting the fact that "'the emphasis on speed threw somewhat out of focus the main theme of the great undertaking' and that 'the pace of the flow through the exhibit had been too rapid really to satisfy the serious visitor interests.'"

88. Marchand, "Designers Go to the Fair, II," 30, and File 381.70, Dec. 1939, NBG Papers.

89. Bruno Lessing, Review, *New York Journal-American*, 13 June 1939. Arthur Caylor, in "Behind the News," *San Francisco News*, 1 Nov. 1939, echoed Lessing's sentiment, stating that the Futurama was so popular that some people stood in line "as long as six hours to get in and see the preview of a day when the human race may have progressed to the point where it will be too smart to stand in line for six hours to see anything."

90. A few historians have suggested that the public might have connected the two because of the shared vision they promoted. Rydell quotes historian Bonnie Yochelson on the message communicated by planners of the New York fair, especially in relation to the "Typical American Families" contest. "Just as a seamless, streamlined form masked the complexities of a machine's inner workings, so the ideal of the 'typical American' masked the complexities of American society. De-

spite its constant refrain of tolerance and freedom, the Fair proposed a future society that was homogeneous, exclusive, and harmonious by virtue of its shared heritage," and that excluded those who were "poor, urban, non-white, or foreign born." See Rydell, *World of Fairs*, 58.

91. Walter Dorwin Teague, *Design This Day: The Technique of Order in the Machine Age* (New York: Harcourt, Brace, 1940), 38, 121.

92. Teague, notes for a presentation to Du Pont, Nov. 1936, on Microfilm Roll 16.21, WDT Papers.

93. Article by "DG" of Walter Dorwin Teague Associates, "The Respectability of High Spirits," 30 April 1952 (also published in *Better Design Magazine*, 5 May 1952), on Microfilm Roll 16.31, WDT Papers.

94. Ralph Gulley, "Point of Sale in Merchandising," 22 Jan. 1947, folder "Donald Deskey Associates: Proposals, Speeches," Donald Deskey Papers.

Chapter 4. "Flow Is the Word": Biological Efficiency and Streamline Design

Epigraph from caption titled "Early Transportation," Box 57 "Writings/Lecture Notes/Slide Captions," Egmont Arens Papers.

1. Petrolagar advertisement, 1937, repr. in Ellen Lupton and J. Abbott Miller, *The Bathroom, the Kitchen, and the Aesthetics of Waste: A Process of Elimination*, Ex. Cat. (Cambridge, Mass: MIT List Visual Arts Center, 1992), 69. Lupton and Miller offer a psychological interpretation of the fecal metaphor of the streamline style.

2. John Harvey Kellogg, *Itinerary of a Breakfast* (New York: Funk and Wagnalls, 1926), 3.

3. Henry Fairfield Osborn, "Birth Selection vs. Birth Control," *Forum* (Aug. 1932): 79, also quoted in a letter from Charles Davenport to Frederick Osborn dated 29 July 1932, folder "Henry Fairfield Osborn," CBD Papers. Davenport himself referred to "defectives" as those who put the "brake on social progress"; see letter dated 13 Aug. 1934 from Davenport to Chloe Owings in folder "Chloe Owings," CBD Papers. On the cost of care of defectives, one pastor in a sermon contest sponsored by the American Eugenics Society clarified, "conscious evolution is much less expensive than natural evolution. . . . In order to bring a more abundant life to the people, we must begin at the sources which are pouring poisons into the blood of the race." See "Sermon 27," folder "Sermon Contest, 1926, #3," AES Papers.

4. Kellogg, *Itinerary of a Breakfast*, 96.

5. A useful and accessible collection of laxative advertisements can be found in "Medicine and Madison Avenue," an online collection from Duke University's Rare Book, Manuscript, and Special Collections, at scriptorium.lib.duke.edu/mma.

6. On ptomaine poisoning, see James Whorton, *Crusaders for Fitness: The History of American Health Reformers* (Princeton, N.J.: Princeton University Press, 1982), 216; the other descriptions are from Kellogg, *Itinerary of a Breakfast*, 32, 74. See also Whorton's *Inner Hygiene: Constipation and the Pursuit of Health in Modern Society* (Oxford: Oxford University Press, 2000).

7. Kellogg, *Itinerary of a Breakfast*, 32, 145–46, and Whorton, *Crusaders for Fitness*, 221.

8. Whorton, *Crusaders for Fitness*, 189, and Kellogg, *Itinerary of a Breakfast*, 36, 147.

9. Whorton, *Crusaders for Fitness*, 223.

10. "Sermon 16," delivered at Jethro Memorial Presbyterian Church, Atlantic City, N.J., 1926, folder "William E. Griffin, Sermon 16," and "Sermon 15," delivered at the First Methodist Episcopal Church, Ishpeming, Mich., 1926, folder "Lewis Kent, Sermon 15," both in the AES Papers.

11. Ettie A. Hornibrook, *Restoration Exercises for Women* (London: Heinemann, 1932), ix, 11–13, 15–28, 54–55.

12. "Sermon 15," folder "Lewis Kent, Sermon 15," AES Papers.

13. Kellogg, *Itinerary of a Breakfast*, 71, 107.

14. Ibid., 45–50. On the training of officials at U.S. consulates abroad in immigrant screening techniques, see folder "Harry H. Laughlin, 1923, #2," CBD Papers.

15. Ellsworth Huntington, *Tomorrow's Children: The Goal of Eugenics* (New York: J. Wiley and Sons, 1935), 45; Nancy Tomes, *The Gospel of Germs: Men, Women, and the Microbe in American Life* (Cambridge, Mass.: Harvard University Press, 1998), 32–60, 127; Kellogg, *Itinerary of a Breakfast*, 63; Whorton, *Crusaders for Fitness*, 168–200.

16. Kellogg, *Itinerary of a Breakfast*, 106–8; on surgery, see Whorton, *Crusaders for Fitness*, 218.

17. Lupton and Miller, *The Bathroom, the Kitchen, and the Aesthetics of Waste*, 65, 67.

18. Kellogg, *Itinerary of a Breakfast*, 3.

19. Walter Alvarez et al., *Help Your Doctor to Help You When You Have Constipation* (New York: Harper and Brothers, 1942), 13, 14, 36–37.

20. Ibid.

21. Kellogg, *Itinerary of a Breakfast*, 108–12. By "older civilizations," it seems Kellogg meant civilizations whom he considered to be more evolved, i.e., more technologically developed, not necessarily those that possessed a longer history.

22. Ibid., 33, 110–11, 82–83, 93.

23. Ibid., 73–76.

24. On the benefits of speedy digestion and circulation, see Kellogg, *Itinerary of a Breakfast*, 224, and Whorton, *Crusaders for Fitness*, 243.

25. See brochure "Harper Books for Business Men, Spring 1932," in Box 46 "Publicity/Programs," Egmont Arens Papers. Charles Davenport in his lecture "The Control of Behavior," given in Pittsburgh in Jan. 1925, mentioned that good social temperaments are usually found in people in "good physical health, free from diseases whose poisons irritate the brain." See lecture folder "The Control of Behavior," File "C. B. Davenport," CBD Papers.

26. Taken from the advertisement for *How to Live: The Nation's Foremost Health Book*, found on the back page of Kellogg, *Itinerary of a Breakfast*, 1926 edition.

27. *Official Guidebook, New York World's Fair, 1939* (New York: Exposition Publications, 1939), 151–52. The entry describing the exhibit opens: "That proper

elimination of body waste is essential to our general well-being is a universally accepted fact, but less known, probably, is the belief of many authorities that the correct method for the promotion of intestinal health is one that employs bulk and motility."

28. On streamlining and planned obsolescence as an economic lubricant, see Jeffrey Meikle, *Twentieth-Century Limited: Industrial Design in America* (Philadelphia: Temple University Press, 1979), 70–73, 80–82, 96–99; see also Lupton and Miller, *The Bathroom, the Kitchen, and the Aesthetics of Waste*, 5–8, who refer not to streamlining per se but to the role advertising and planned obsolescence played in the cycle of production and consumption.

29. Charles Davenport, like many men of his social standing and eugenic inclination, attended Battle Creek Sanitarium for "special treatments, . . . the cleaning out of the intestines and improved nutritional conditions," and thanked E. L. Eggleston at the Sanitarium for "the intelligent and attentive consideration you gave to my case." See letter from Davenport to Eggleston, 9 Sept. 1930, folder "E. L. Eggleston," CBD Papers.

30. On Teague, see "Walter Dorwin Teague: Dean of Design, A Portrait," *Printer's Ink* (30 Jan. 1959), WDT Papers; on Loewy, see John Kobler, "The Great Packager," *Life* (2 May 1949): 110–22, located in the Raymond Loewy Papers, Cooper-Hewitt National Design Museum; and "Modern Living," from the Business and Finance section of *Time* (31 Oct. 1949), folder "Product Design and Development Division, Speeches and Writings by Staff, 1953–1957," Container 171, Raymond Loewy Papers, Library of Congress.

31. Letter from Mary Deskey to Donald's mother, folder "Letters: 1922–26," Donald Deskey Papers.

32. See the highly detailed and informative folder "Medical Records, Misc., 1933–1960," Box 65, Egmont Arens Papers, containing various diagnoses, including "Egmont Arens—Intestinal History" from 24 Jan. 1956, and a letter from Arens to Dr. John Tilden Howard of Baltimore's Johns Hopkins Hospital, 18 May 1948.

33. Folder "Anecdotes, I. D. Book," 31 Aug. 1953, file "Publications: Designing for People (Correspondence, Memos, etc)," Box 1, Henry Dreyfuss Papers; also, "Machine Age Artist," *Forbes* (1 May 1951) and "Management: Art for Profit's Sake," *Investor's Reader* (3 Nov. 1952), both on Microfiche #13 "Articles About Dreyfuss, Pre-1950," Henry Dreyfuss Papers. See also Henry Dreyfuss, *Designing for People* (New York: Paragraphic Books, 1955), 41.

34. Labels on original models of the Criterion toilet and matching sink, purchased by the author, stress the "high class" qualities of the "twice-fired vitreous china" from which they are made. See photos of "Criterion Closet," 1936, 1944, 1953, and the "Neovogue Closet," 1940, folder "Industrial Design: Cities Service Petroleum Inc.—Crane, Co.," Box 2; Microfilm Roll #26 "Drawings and Photographs, Crane Co."; Microfilm Roll "Crane—1935"; clipping from *House and Garden*, Building Series (Aug. 1950), on Microfiche #13 "Articles About Dreyfuss, Pre-1950"; memo from Henry Dreyfuss to M. Weinstock, 24 Dec. 1953, folder "Publications: Designing for People (Correspondence, Memos, etc.)," Box 1; correspondence with Crane Co. in Box "Client Solicitation, Budd Co.—Time, Inc.," all in Henry Dreyfuss Papers; see also "Modern Living," from the Business and Finance

section of *Time* (31 Oct. 1949), folder "Product Design and Development Division, Speeches and Writings by Staff, 1953–1957," Container 171, Raymond Loewy Papers, Library of Congress. Microfilm Roll 35–11, WDT Papers, contains images of two sloping toilets from 1954 made by Standard Sanitary Corp. Henry Dreyfuss, in a lecture titled, "Industrial Design: Profile of an Organization," to the Harvard Graduate School of Business Administration, 9 Nov. 1965, stated on page 7, "We may . . . confer with a medical doctor to determine the height and slope of a toilet seat"; see Microfiche #9 "Lectures and Articles by Dreyfuss, 1956–1960," Henry Dreyfuss Papers.

35. Egmont Arens, "House, Incorporated, New York," 28 Dec. 1934, folder "Housing—Pre-fab, Sketches, Notes, Correspondence, Clippings," Box 19, Egmont Arens Papers.

36. "Design for Laving: Postwar Bathroom," *House Furnishing Review* (Dec. 1944), folder "Clippings About Egmont Arens," Box 46, Egmont Arens Papers. The shower was convertible for a steam bath and sprayed from three sides, giving the added benefits of deep skin cleansing and stomach and back massage.

37. Egmont Arens, "The Road-way Housing Plan," folder "Roadway Housing Plan Presentation, 1935," Box 27, Egmont Arens Papers.

38. Letter from Henry Dreyfuss to Henry Luce, 15 July 1938, folder "Time Inc. Client Solicitation," Box "Client Solicitation, Budd Co.—Time, Inc.," Henry Dreyfuss Papers. On Kiesler, see Beatriz Colomina, "The Psyche of Building: Frederick Kiesler's 'Space House,'" *Archis* 11 (Nov. 1996): 70–80.

39. Caption for image "Early Transportation," folder "Writings/Lecture Notes/Slide Captions," Box 57, Egmont Arens Papers. Geddes, in *Horizons*, 25–26, also mentions Malcolm Campbell and notes that his speed of 245 mph was "twice as fast as the time required for man to coordinate brain and hand," predicting that there is a limit to human speed based on this, around 300 mph.

40. Ellsworth Huntington, "The Future of Eugenics," folder "Annual Meeting 1937," AES Papers.

41. Huntington, *Tomorrow's Children*, 27–29.

42. Egmont Arens, "Creative Evolution of the Printed Word, or Tempo in Typography" (address to the Eastern Arts Association, 28 April 1933), folder "Writings," Box 51, Egmont Arens Papers.

43. Ibid.

44. Paul Hugon, "What Makes a Language Easy?" Box 58, Egmont Arens Papers.

45. Egmont Arens, "Creative Evolution of the Printed Word."

46. Editorial, "Is It True What They Say About You?" *Scholastic: The American High School Weekly* 29, 4 (1936), folder "Clippings About Egmont Arens," Box 46 "Publicity/Programs," Egmont Arens Papers.

47. Mike Mills, "Herbert Bayer's Universal Type in its Historical Context," in *The ABC's of [triangle, square, circle]: the Bauhaus and Design Theory*, ed. Ellen Lupton and J. Abbott Miller (New York: Herb Lubalin Study Center of Design and Typography, the Cooper Union for the Advancement of Science and Art, 1991), 38–49; brochure for the "House of Tomorrow" in Donald Deskey Papers.

48. Letter from Egmont Arens to Dr. Janet Aiken, 10 Nov. 1934, folder, "Lan-

guage, Speed In, 1934–50," Box 58, and also her letter to him, 14 Nov. 1934, Box 51, Egmont Arens Papers.

49. In his caption for a slide of a "Scribe," Arens wrote, "This man rode on an ox if he ever rode at all. He spent a lifetime writing out a manuscript and illuminating it. A book which would probably be read by ten or twelve men in the course of 200 years. No need for any streamlining in that day and age." See "Scribe," Box 56 "Images and Captions for Lecture Illustrations," Egmont Arens Papers.

50. Huntington, *Tomorrow's Children*, 68.

51. Letter from Charles Davenport to Frederick Osborn, 10 Feb. 1930, folder "Frederick Osborn," AES Papers. Similarly, a post-1914 "Lecture Announcement" of the Eugenics Record Office quoted Francis Galton from his essay "Inquiries into Human Faculty" (1883). Galton stated that one goal of the "science of improving stock" was "to give to the more suitable races or strains of blood a better chance of prevailing speedily over the less suitable than they otherwise would have had." See folder "Eugenics Record Office—Eugenics Lectures," CBD-CSH Series. Quote about Morgan taken from a clipping from the *Knoxville (Tennessee) Sentinel*, 25 Sept. 1927, Leon Whitney Scrapbook, AES Papers.

52. Caption titled "Early Transportation," Box 57 "Writings/Lecture Notes/Slide Captions," Egmont Arens Papers.

53. Bruno Lessing, in a review in the *New York Journal-American*, 13 June 1939, a copy of which is in the NBG Papers.

54. Egmont Arens, "Creative Evolution of the Printed Word."

55. Folder "Fashion in Typography," Box 51, Egmont Arens Papers; also, Walter Dorwin Teague, "The Growth and Scope of Industrial Design in the U.S.," *Journal of the Royal Society of Arts* 57 (July 1959): 640–51, folder "Writings," Box 79, WDT Papers. Teague offered this assessment: "Thus the tempo of our movement is vastly accelerated, our resources accumulate with awesome speed, our perceptions grow keener and our command of our destiny more complete than men have been used to exercising in the past." I have to think that an unstated reason for "all the speed" is profit; the first to create a new product, and the first to knock-off someone else's, are the ones who make the most money.

56. John Chamberlain, "Books of the Times," *New York Times*, 21 June 1935, folder "Streamlining 1933–36," Box 59, Egmont Arens Papers. The author of *Fishes and Their Ways of Life* was Louis Roule.

57. Slide caption for "Champion Greyhound," Box 57 "Writings/Lecture Notes/Slide Captions," and H. Ledyard Towle, "Projecting Your Automobile Into the Future," *Automotive Engineering Journal* 29, 1 (1931), folder "Streamlining," Box 59, both in Egmont Arens Papers. Arens noted in another caption for a slide of an Irish setter, "A visit to the dog show or the horse show is an education to the designer."

58. One pastor told his congregation, "The modern race-horse has attained a speed undreamed of fifty years ago. He is the product of a biological code rigidly applied through successive generations"; see "Sermon 35," folder "Sermon Contest, 1926, #3," AES Papers. See also "End of the Year Report," section "Genetics of the Thoroughbred Horse," folder "H. H. Laughlin, 1929, #22," CBD-CSH Series; "The

Value of Certain Measurements in Metabolism in Connection with Researches on the Genetics of the Thoroughbred Horse," folder "H. H. Laughlin, 1930," CBD-CSH Series; and "Science Yields to Luck on Turf: Research Can Produce Faster Horses, but Fails to Explain Why Rank Outsiders Win," *New York World*, 30 May 1930, Leon Whitney Scrapbook, AES Papers. The article was written as part of the *New York World's* coverage of the exhibits at the twenty-fifth anniversary of Cold Spring Harbor. See also the exhibits list at the back of *A Decade of Progress in Eugenics: Scientific Papers of the Third International Congress of Eugenics, held at American Museum of Natural History, New York, August 21–23, 1932* (Baltimore: Williams and Wilkins, 1934), and "Genetics," *Time* (10 June 1929), Leon Whitney Scrapbook, AES Papers.

59. Charles Davenport, "Lecture: Aims, Work, Results of the Eugenics Record Office," n.d. (but late 1920s to early 1930s), in folder of same title, File "C. B. Davenport," CBD Papers; letter from Laughlin to Albert Blakeslee, 19 Oct. 1936, folder "H. H. Laughlin, 1936," CBD-CSH Series. See also folder "Kenneth C. MacArthur, Sermon 32, 1926," AES Papers.

60. Note the parallel of these "parasitic muscles" to the "autointoxication" of the constipated modern body; see James Whorton, "'Athlete's Heart': The Medical Debate over Athleticism, 1870–1920," in *Sport and Exercise Science: Essays in the History of Sports Medicine*, ed. Jack Berryman and Roberta Park (Urbana: University of Illinois Press, 1992), 114. Parenthetical comment original. Also, Adolf Loos believed that civilized societies were speedier than less developed ones, and had produced correspondingly a more slender foot; see Adolf Loos, "Footwear (1898)," in Loos, *Ornament and Crime: Selected Essays* (Riverside, Calif.: Ariadne Press, 1998), 95, 96.

61. The corollary between the success of a machine and the evolutionary level of its creator (per the discussion of style as a reflection of racial advance in the Introduction) still held. One "racial" trait typically ascribed to Americans was technological inventiveness.

62. For example, an American Douglas transport plane had won the "longest air race ever held . . . from London to Melbourne," proving that U.S. aviation capabilities were on par with or superior to the European in "performance and efficiency." In November of that year, the M-10,001 Union Pacific train also "Shattered!" the previous transcontinental record; shortly thereafter, Malcolm Campbell made his first attempt of 1935 in the streamlined Bluebird to set the ground-speed record, "whizzing over the sands . . . at 233 miles an hour." These records were for fastest transcontinental flight by racing craft and by commercial planes, for amount of weight carried, and for poshness in interiors. See "Notable Advances in 1934 in Airplane, Automobile and Railroad Development," *New York Times*, 31 Dec. 1934, folder "Streamlining—Airplanes"; "Few Weeks Set New Air, Land and Sea Records," *Chicago Daily News*, 16 Nov. 1934, folder "Streamlining, 1933–36"; "All Records Shattered!" *Aluminum Newsletter* (Nov. 1934), folder "Streamlining, 1933–36," all in Box 59, Egmont Arens Papers. In same box is clipping of Malcolm Campbell's record attempt.

63. "King of the Plain, The Winner of the Title Every Time it Has Been Shown," folder "Streamlining, 1933–36," Box 59, Egmont Arens Papers. Walter Dor-

win Teague also clipped photos of prize-winning dogs and horses, such as one from the *New York Herald Tribune,* 9 Oct. 1927, folder "Source Material: Animals, Dogs, Cats, Wild Birds," Box 3, WDT Papers.

64. On the "well-bred" women of *Vogue,* see folder "Condé Nast, Promotional Materials, Miscellaneous, 1921–22," Box 80, Egmont Arens Papers.

65. For example, see Edward McCartan's sculpture *Diana,* bronze, 1922, from *American Masters: Sculpture from Brookgreen Gardens,* Ex. Cat. (Austin, Tex.: Blanton Museum of Art, 1998), 45, and the photo of the sculptural centerpiece in the Grand Salon of the ship *L'Atlantique,* from "Abord de *l'Atlantique,*" *Arts and Industry* (Nov. 1931): 17, folder "Steamships," Box 17, WDT Papers.

66. On Katherine Lane Weems, see *American Masters: Sculpture from Brookgreen Gardens,* 57.

67. Walter Dorwin Teague, Radiator Ornament for the Lincoln Zephyr Continental and Custom, on Microfilm Roll 35–36, WDT Papers.

68. General Motors brochures "Aerodynamics and Streamlining," Box 49, and Charles Kettering, "Research—An Eye to the Future," folder "Streamlining: Airplanes, 1932, 1935, n.d.," Box 59, Egmont Arens Papers; H. Ledyard Towle, 1931, folder "Streamlining," Box 59, Egmont Arens Papers. On Loewy, see "Modern Living" in Business and Finance section of *Time* (31 Oct. 1949), Container 171, "Product Design and Development Division, Speeches and Writings by Staff, 1953–57," Raymond Loewy Papers, Library of Congress.

69. The slogan "Greyhound through the Fair" was coined by Teague and painted on the buses at the Fair; see Microfilm Roll 16–30, WDT Papers. The photo of the float of America as a greyhound was developed by Charles Dreyer and is found in Box 68, Egmont Arens Papers. The fingers at the top left of the photo are included in the original print. Because of the framing of the photo, the full caption on the side of the float is unclear. My interpretation may therefore be misdirected.

70. The 1933 Nazi compulsory sterilization law was based partly upon California's statute and partly on a "model" sterilization law published in 1929 by Harry Laughlin. Prior to Germany's implementation of eugenic policies, the U.S. had been considered the leader in actualizing eugenic legislation. See Stefan Kuhl, *The Nazi Connection: Eugenics, American Racism, and German National Socialism* (Oxford: Oxford University Press, 1994), 39.

71. On Sanger's slogan, see Diane Paul, "Eugenics and the Left," *Journal of the History of Ideas* 45 (1984): 569, n. 5; letter from W. E. D. Stokes to Anson Phelps Stokes, Jr., 7 Feb. 1921, and letter from Stokes to Charles Davenport, 19 Feb. 1921, folder "W. E. D. Stokes, 1920," CBD-CSH Series.

72. Folders "Frederick Adams" and "A. Wakefield Slaten, Sermon 25," AES Papers.

73. Walter Dorwin Teague, "Rightness Sells," repr. from *Advertising Arts,* n.c., and Teague, "Industrial Design and Its Effects on Sales" (talk to the Advertising Club of Los Angeles, n.d.), both in folder "Writings," Box 79, WDT Papers.

74. To a certain extent in all three, blocked flow hindered fertility as well. In national efficiency, the high birthrate of the "unfit" overshadowed that of the "fit." In bodily efficiency, constipation was thought to lessen sexual desire. In product efficiency, without that phallic, forward-thrusting or breast-like curve, the stream-

line style might have lost some of its sex appeal. See Meikle, *Twentieth-Century Limited*, 184–85.

75. This brings to mind the current use of the word "streamline," which means to pare away waste. On a slightly different note, a trim waist and reformed "tail end" put smooth, streamlined curves onto a body, as women's magazines frequently pointed out with their suggested exercises and advertisements for women's underwear. Copies of these are in the folders on "Streamlining," Egmont Arens Papers.

Chapter 5. Race Hygiene, Product Hygiene: Curing Disease Through Sterilization

1. Folders titled "Eugenics Instruction Questionnaire," Box #1: Series X "Harry H. Laughlin Files," ERO Papers.

2. Ellen Lupton and J. Abbott Miller, *The Bathroom, the Kitchen, and the Aesthetics of Waste: A Process of Elimination* (Cambridge, Mass.: MIT Press, 1992), 20. On the various types of hygiene, see numerous texts on the subject, including Arthur Davis and Warren Southworth, *Meredith's Hygiene: A Textbook for College Students on Physical, Mental, and Social Health from Personal and Public Aspects* (New York: Blakiston, 1954, 1926); Maude Etheredge, *Health Facts for College Students: A Textbook of Individual and Community Health* (Philadelphia: W.B. Saunders, 1934); and Jesse Williams, *Personal Hygiene Applied* (Philadelphia: W.B. Saunders, 1946, 1922).

3. Martin Pernick, in *The Black Stork: Eugenics and the Death of "Defective" Babies in American Medicine Since 1915* (New York: Oxford University Press, 1996), 52, explains some of the shared meanings of "germ" and "germ plasm." He writes, "Broad linguistic and cultural associations shared by scientists and non-scientists alike also linked heredity and contagion. Infection was caused by 'germs'; inheritance was governed by 'germ plasm.' In both cases, a 'germ' meant a microscopic seed. Such seeds enabled both infectious and hereditary diseases to propagate, spreading lethal contamination from guilty to innocent bodies. And the transmission of each kind of 'germ' could be halted by 'sterilization.'"

4. "Sermon 35," folder "Sermon Contest, 1926, #3"; folder "Dr. A. F. Cunningham, Sermon 13, 1926"; "Sermon 2" and "Sermon 7," folder "Sermon Contest 1926, #2," all in AES Papers; and, folder "Henry S. Huntington, Sermon 8," AES Papers. Someone at Lincoln University, an African American college in Chester County, Pennsylvania, responded to Laughlin's questionnaire, "Training in a clean wholesome life is our only contribution in this line"; see "Lincoln University," folder "Eugenics Instruction Questionnaire," Box #1: Series X "Harry H. Laughlin Files," ERO Papers. In "Bathing Beauty: An American Institution," *Vogue* (1 Feb. 1939): 95, the writer described Americans as being "born and bred in the tradition of cleanliness."

5. Sheila Weiss, *Race Hygiene and National Efficiency: The Eugenics of Wilhelm Schallmayer* (Berkeley: University of California Press, 1987), 105. Both Alfred Ploetz

and Wilhelm Schallmayer are considered founders of the German race hygiene movement.

6. Ellsworth Huntington, *Tomorrow's Children: The Goal of Eugenics* (New York: J. Wiley and Sons, 1935), 45.

7. Huntington, *Tomorrow's Children*, 108, 112–13, and Ellsworth Huntington, "The Ultimate Goal of Birth Control," *Birth Control Review* 2, 7 (April 1935), folder "Papers I, #4," Frederick Osborn Papers. A similar comparison of germs and human beings is found in Nancy Tomes, *The Gospel of Germs: Men, Women, and the Microbe in American Life* (Cambridge, Mass.: Harvard University Press, 1998), 124, where she mentions that in the 1920s one writer compared the war on tuberculosis to the Christian crusade against the infidels, stating, "'The germs are the Turks.'" Daniel Kevles, *In the Name of Eugenics: Genetics and the Uses of Human Heredity* (New York: Knopf, 1985), 68, also discusses the parallel between disease and eugenics.

8. This term is found throughout eugenic literature both in the U.S. and abroad; see Weiss, *Race Hygiene and National Efficiency*, 26. Viruses were confirmed in the late 1930s with the invention of the electron microscope. Although smaller than bacteria, they were "just as deadly in the struggle for survival of the fittest," a characterization that was still strong in the late 1930s; see Tomes, *The Gospel of Germs*, 245. Tomes, 45, quotes a writer from 1885: "Man is no more made to become their [microbes'] prey than that of the wild beasts among whom he had to fight his way in the infancy of the race and whom he has conquered or destroyed by his industry, intelligence and work." Tomes, 32, 43, also describes how disease was viewed as a survival of the fittest. Lupton and Miller, *The Bathroom, the Kitchen, and the Aesthetics of Waste*, 19, cite an article in *Collier's* from 1916 in which the writer described the "war of the body against invading germs" as "a great battle that one is called upon to fight"; see William J. Cromie, "Dodging Germs," *Collier's* (23 Sept. 1916): 33.

9. Kevles, *In the Name of Eugenics*, 114. The "final solution" of the Nazis went even farther, utilizing not only sterilization but "euthanasia" and outright murder. The rhetoric of hygiene (the "elimination of parasites") was used to mask the function of the gas chambers, which were filled with a gas that in small doses served as a disinfectant. In the film *Amen* (2002), Director Costa-Gavras elaborates upon this hygienic analogy.

10. Frank Dikötter, "Race Culture: Recent Perspectives on the History of Eugenics," *American Historical Review* 103, 2 (April 1998): 473–74, writes that the ongoing influence of neo-Lamarckianism within eugenics circles needs further examination, as the shift to Mendelism was not always as clear-cut as it has been made out to be.

11. Tomes, *The Gospel of Germs*, 6; also, in 26–34, Tomes discusses earlier theories of disease, the role of sanitation science, and the changes brought by the germ theory of disease.

12. Lupton and Miller, *The Bathroom, the Kitchen, and the Aesthetics of Waste*, 17, cite an article in *House and Garden* 30, 2 (Feb. 1917): 90, on "Bathroom and Civilization" that made this connection. "The bathroom is an index to civilization. Time was when it sufficed for a man to be civilized in his mind," it stated, showing

the connection to evolutionary theory. "We now require a civilization of the body. And in no line of house building has there been so great progress in recent years as in bathroom civilization."

13. Tomes, *Gospel of Germs*, 182, and James Whorton, *Crusaders for Fitness: The History of American Health Reformers* (Princeton, N.J.: Princeton University Press, 1982), 163.

14. Tomes, *Gospel of Germs*, 62, cites an etiquette manual from 1878: "Cleanliness is the outward sign of inward purity."

15. Tomes, *Gospel of Germs*, 161.

16. Ibid., 258, 266–67.

17. Folder "Lecture #29a: Inheritance of Acquired Characteristics," 1924, HSJ Papers.

18. Letter from Charles Davenport to John Harvey Kellogg, 8 Oct. 1923, folder "J. H. Kellogg, #4"; letter from Wilhelmine Key to Davenport, 11 March 1924, folder "Wilhelmine Key, #3, 1920–1932," both in CBD Papers. Davenport replied to her, 19 March 1924 (letter in the same folder), that he thought Kammerer was unreliable because "After making the statement that certain experiments on inheritance of acquired characters had been repeated and his conclusions confirmed it appeared on close questioning that only the preliminary experiments had been made, and no later generations had been reported on." On Kammerer's work, see Reinhard Mocek, "The Program of Proletarian Rassenhygiene," *Science in Context* 11, 3–4 (1998): 609–17.

19. Letter from Charles Davenport to Alfred Lane, 2 March 1931, and letter from Lane to Davenport, 21 July 1930, folder "Prof. Alfred Lane," CBD Papers.

20. In France, eugenics was promoted through the concept of "puericulture," which promoted improving the health of the present generation in order to improve the health of future generations. In both France and Brazil, neo-Lamarckian thought ran strong through the 1930s, as it did in Russia under Lysenkoism. See various chapters in Mark Adams, ed., *The Wellborn Science: Eugenics in Germany, France, Brazil, and Russia* (Oxford: Oxford University Press, 1990).

21. Whorton, *Crusaders for Fitness*, 156–57, citing Charles Rosenburg, "The Bitter Fruit: Heredity, Disease and Social Thought in Nineteenth-Century America," *Perspectives on American History* 8 (1974): 189–225.

22. "University of Colorado—Boulder," folder "Eugenics Instruction Questionnaire," Box #1: Series X "Harry H. Laughlin Files," ERO Papers.

23. "Sermon 37," folder "Sermon Contest, 1926, #4," AES Papers.

24. Folder "H. Arndt, Sermon 46," AES Papers.

25. "Spankings Aid to Britain's 3 'R's," *Houston (Texas) Press*, 1 March 1928, Leon Whitney Scrapbook, AES Papers. Robert Rydell, *World of Fairs: The Century-of-Progress Expositions* (Chicago: University of Chicago Press, 1993), 45, 47, discusses Leonard Darwin.

26. Le Corbusier, *The Decorative Art of Today* (London: Architectural Press, 1987, 1925), 188, 192.

27. Ibid.

28. George Stocking, Jr., *Race, Culture, and Evolution: Essays in the History of Anthropology* (Chicago: University of Chicago Press, 1982), 240, quoting Herbert

Spencer, *Principles of Psychology*, 2nd ed., 2 vols. (New York: D. Appleton, 1872), 1: 422 and Herbert Spencer, *Principles of Sociology*, 3rd ed., 3 vols. (New York: D. Appleton, 1896), 1: 92–93; italics added.

29. Adolf Loos, "Plumbers: Baths and Kitchen Ranges at the Jubilee Exhibition (1898)," in Loos, *Ornament and Crime: Selected Essays* (Riverside, Calif.: Ariadne Press, 1998), 82–85.

30. Ibid., 82, 85–88. He is using the term Germanic linguistically—England and Austria are related as residents in both speak Germanic languages, and he sees England as a more advanced culture. He is contrasting Germanic with French, which as a Romance language is less closely related.

31. Loos, "Footwear (1898)," in Loos, *Ornament and Crime*, 95–96.

32. Tomes, *The Gospel of Germs*, 58.

33. Walter Dorwin Teague, "The Growth and Scope of Industrial Design in the U.S.," *Journal of the Royal Society of Arts* 57 (July 1959): 640–51, folder "Writings," Box 79, WDT Papers. The late date of this comment clearly implies a cultural interpretation, but an evolutionary one is also feasible given Teague's background and evolutionary beliefs.

34. Henry Dreyfuss, *Designing for People* (New York: Paragraphic Books, 1955), 202–3.

35. Tomes, *The Gospel of Germs*, 6–9.

36. Ibid., 140.

37. John Harvey Kellogg, *The Itinerary of a Breakfast* (New York: Funk and Wagnalls, 1926), 41.

38. Tomes, *Gospel of Germs*, 184, 131, and George Sanchez, "'Go After the Women': Americanization and the Mexican Immigrant Woman, 1915–1929," 287, in *Unequal Sisters: A Multicultural Reader on U.S. Women's History*, ed. Vicki Ruiz and Ellen DuBois, 2nd ed. (New York: Routledge, 1994), 284–97. Sanchez is quoting Kenneth Roberts, "The Docile Mexican," *Saturday Evening Post* (10 March 1928): 43. During the 1920s, scientists were working on genetically breeding blight out of various plant strains. Tomes, 11, states that in the early 1900s many middle-class Americans associated disease germs with "poor, immigrant, and non-white citizens," an association which "only deepened their feelings of class prejudice, nativism, and racism."

39. Suellen Hoy, *Chasing Dirt: The American Pursuit of Cleanliness* (New York: Oxford University Press, 1995), 99.

40. On the unteachability of immigrants, see Tomes, *Gospel of Germs*, 132. On psychological tests proving the inferior intelligence of immigrants, see Stephen J. Gould, *The Mismeasure of Man* (New York: W.W. Norton, 1996), 195–98. Kenneth Ludmerer, *Genetics and American Society: A Historical Appraisal* (Baltimore: Johns Hopkins University Press, 1972), 101, writes that "To eugenicists, the high incidence of disease, illiteracy, poverty, and crime in immigrant neighborhoods constituted sufficient testimony to the newcomers' innate inferiority."

41. Hoy, *Chasing Dirt*, 70. In an advertising campaign in the late 1920s, Kleenex capitalized on the common association of the "uncivilized" with the "unsanitary"; they attributed both qualities to the cloth handkerchief and more than

doubled the sales of their product the following year; see Tomes, *Gospel of Germs*, 252.

42. Tomes, *Gospel of Germs*, 161, 252, and Hoy, *Chasing Dirt*, 145.

43. Hoy, *Chasing Dirt*, 137.

44. Ibid., 120, 129, 144, 87, 114, and Tomes, *Gospel of Germs*, 192.

45. Carl Jung, "Your Negroid and Indian Behavior," *Forum* 83, 4 (April 1930): 193–99, in folder "Book Ideas—Misc. Clippings, Correspondence, 1929–1964, n.d.," Box 13, Egmont Arens Papers.

46. Whorton, *Crusaders for Fitness*, 142–43, discusses Ellen Swallow Richards's beliefs about euthenics and her influence on the rise of the home economics movement.

47. Tomes, *Gospel of Germs*, 97, 105, 159, 167, 60, 62, and Hoy, *Chasing Dirt*, 114–15.

48. Tomes, *Gospel of Germs*, 85.

49. Ibid., 189.

50. Hoy, *Chasing Dirt*, 86.

51. Ibid., 114–15, and Tomes, *Gospel of Germs*, 189. Also, see specifically Tomes, 162 and Hoy, 125, although the topic of hygiene and Americanization is discussed throughout both books.

52. Hoy, *Chasing Dirt*, 105.

53. Huntington, *Tomorrow's Children*, 58. See also Haven Emerson, "The Houses We Live In," *Scientific American* 152 (March 1935): 140–41, who connects the evolutionary advance of civilization with homes designed to protect public health. Also, the exhibition "Eugenics in New Germany," curated by Bruno Gebhard and discussed in Chapter 3, was on display at the National Public Housing Show in Portland, Oregon, for nine days in May or June 1935, a fact that reveals some people were making the connection between race hygiene and housing. See letter from Fred Messing to Dr. Carl E. Cummings, Director of the Buffalo Museum of Science, 22 June 1935, Box 042 (3), Folder 3, Buffalo Museum of Science Archives.

54. "Sermon 2," folder "Sermon Contest, 1926, #2," AES Papers, as well as letter from Charles Davenport to David Starr Jordan, 5 Oct. 1921, folder "David Starr Jordan, #3, 1913–1926," CBD Papers.

55. Charles Davenport, "Relation of Lay Organizations to Public Health Work," 1917, File "C. B. Davenport," CBD Papers.

56. Hoy, *Chasing Dirt*, 168, 152.

57. Tomes, *Gospel of Germs*, 111.

58. Raymond Loewy, "How I Would Rebuild New York City," *Esquire* (July 1960): 58–62.

59. Raymond Loewy Associates, "Associated Merchandising Corporation: Implementing Tomorrow," 1944, 167–70, Container 141 "Market Planning Research Division," Raymond Loewy Papers, Library of Congress.

60. Egmont Arens, folder "Roadway Housing Plan Presentation, 1935," Box 27, Egmont Arens Papers. The folder includes newspaper clippings showing that his idea was broadcast in November 1930 by the Chairman of the Democratic National Committee, John J. Raskob.

61. Egmont Arens, "Three-Thirds of a Nation—The Problem of Distribu-

tion," folder "World's Fair," Box 36 "New York World's Fair, 1939," Egmont Arens Papers.

62. Roland Marchand, *Advertising the American Dream* (Berkeley: University of California Press, 1985), 64, 85. As Marchand points out, in the mid-1920s some advertisers strategically had begun to characterize the "masses" (a group generally considered by advertisers to comprise more than half of the American population) as the "salt of the earth" as a way to win the loyalty of this otherwise stigmatized consumer group and therefore maintain their pre-eminent position as educators and elevators of public taste without being condescending.

63. Ibid., 67. This view of the masses had formed the general rule for advertisers during the 1920s, Marchand explains, based upon the influential findings of intelligence tests given in 1919 to all U.S. Army recruits that were publicized early in the decade. These tests, administered by eugenics supporter Robert Yerkes, a Harvard professor of psychology, found that 47 percent of Caucasian and 89 percent of African American draftees were feebleminded, with the average white recruit possessing the mental intelligence of a thirteen-year-old, a fact popularized by Carl Brigham's *A Study of American Intelligence* released by Princeton University Press in 1923. Advertisers targeting a "mass" audience therefore had adjusted their copy to the mental level of a young teenager, whereas "class" publications had purposely distanced themselves from this standard, in one case blatantly refusing to dumb-down content to the level of "Mr. and Mrs. Moron and the Little Morons." See Ludmerer, *Genetics and American Society*, 78, and Kevles, *In the Name of Eugenics*, 81–82, 129. The latter source cites Walter Lippmann's and others' criticism in the early 1920s of Brigham's study and the test results as absurd.

64. On fabric as dust-catching, see Dreyfuss, *Designing for People*, 102; on finishes and materials, see Egmont Arens, "Streamline as You Rebuild," Box 48, and "Show Room Maintenance Important," folder "Publicity, Client Captions, 1935–46," Box 46, both in Egmont Arens Papers, as well as Dreyfuss's description of a cabin on the Lloyd Sabando Transatlantic ship in a personal report from 14 March 1930, "Miscellaneous, Gersten, Al to National Bisc.," on Microfilm Roll #4, Henry Dreyfuss Papers. Lupton and Miller, throughout *The Bathroom, the Kitchen, and the Aesthetics of Waste*, discuss hygienic approaches to design.

65. "Dreyfuss Says Americans Gain 1,000 Hours of Leisure Yearly," *New York Herald Tribune*, 25 Oct. 1953, on Microfiche #6, "Lectures/Articles by Dreyfuss, 1933–49," Henry Dreyfuss Papers.

66. Walter Dorwin Teague, "Prophetic Design: How the Element of Chance Can Be Eliminated," *Automobile Topics* (6 Jan. 1934), folder "Writings—Articles," Box 79, WDT Papers; Teague, *The Designer's Story: The Marmon Sixteen* (Indianapolis: Marmon Motor Co., 1946), a copy of which is in the library of the Cooper-Hewitt National Design Museum; Arens, "Streamline as You Rebuild."

67. Henry Dreyfuss, *A Record of Industrial Designs* (New York: H. Dreyfuss, 1946), 14.

68. Dreyfuss's "Dream House" contained a kitchen with walls, ceilings, and floors made out of "seamless, molded, reinforced plastic. They flow softly into one another, eliminating dirt-catching crevices." See Dreyfuss, "Welcome to my Dream

House" (speech given at the McCall's Congress on Better Living, Washington, D.C., 7 Oct. 1958), Box "Speeches," Henry Dreyfuss Papers.

69. G. R. Schaeffer, the Advertising Director for Marshall Field and Company, "Streamlined Packaging," *Vision* (March 1935), folder "Streamlining, 1933–1936, Various Clippings," Box 59, Egmont Arens Papers.

70. Tomes, *Gospel of Germs*, 144.

71. D. K. Colvin, "The Hoover in the Home," folder "Housing—Pre-fab, Sketches, Notes, Correspondence, Clippings," Box 19, Egmont Arens Papers.

72. Westinghouse news release from 1943, folder "News Releases 1939–54," Box 46 "Publicity/Programs," Egmont Arens Papers.

73. Dreyfuss, "Drawings and Photographs, Crane Co.," on Microfilm Roll #26, and photos of Crane toilets from the box of photographs, both in the Henry Dreyfuss Papers.

74. Betty Frank, "Egmont Arens" (speech given Dec. 1943), Box 61, Egmont Arens Papers.

75. Dreyfuss, "Welcome to My Dream House."

76. Raymond Loewy Associates, untitled document from the early to mid-1940s, Container 171 "Product Design and Development Division, Speeches and Writings by Staff, 1953–57," Raymond Loewy Papers, Library of Congress.

77. The phrase "hermetically sealed" was also used to refer to Geddes's design for the stage area in the Crystal Lassies exhibit at the New York World's Fair.

78. Norman Bel Geddes, *Horizons* (Boston: Little, Brown, 1932), 128–39.

79. Brochures for the streamliner "City of Los Angeles" (which advertised having nurse-stewardesses) and for the Pennsylvania Railroad, both in folder "Railroad—#1," Box 16 "Source Material," WDT Papers.

80. Tomes, *Gospel of Germs*, 175–76, citing Joseph Husband's publication *The Story of the Pullman Car* (1917).

81. " 'Last Word' in Streamlined Engines built by Pennsylvania Railroad," *Evening Post*, 2 March 1936, folder "Streamlining 1933–36, 46," Box 59, Egmont Arens Papers; also, "The Train of Tomorrow," a brochure for Henry Dreyfuss's Mercury for the New York Central System Railroad, folder "Railroads," Box 16 "Source Material," WDT Papers.

82. Promotional booklet for TWA's Lindbergh Line, Box 4 "Source Material," WDT Papers, and a clipping of an advertisement for American Airlines, folder "Streamlining—Airplanes," Box 59, Egmont Arens Papers.

83. Brochure "Announcing The New Streamlined 20th-Century Limited," 1938, Box 16, WDT Papers.

84. Tomes, *Gospel of Germs*, 175–76.

85. Marchand, *Advertising the American Dream*, 77–79.

86. These statistics are taken from Lupton and Miller, *The Bathroom, the Kitchen, and the Aesthetics of Waste*, 23, who offer a chronology of urban plumbing and electricity. They cite Christine Hardyment, *From Mangle to Microwave: The Mechanization of Household Work* (Cambridge: Polity Press, 1988), 28 and Ruth Cowan, "The 'Industrial Revolution' in the Home: Household Technology and Social Change in the Twentieth Century," *Technology and Culture* 17, 1 (January 1976):

159, that in 1925, 53.2 percent of U.S. homes had electricity whereas in 1948, 78 percent did. They also cite Carolyn Shaw, *Consumer Choice in the American Economy* (New York: Random House, 1967), 32–33, that in 1940, "In homes wired for electricity, 64% have mechanical refrigerators, 63% have washing machines, and 52% have vacuum cleaners." Marchand, in *Advertising the American Dream*, 64, n.35, 65, 89, 378–79, notes that to qualify for "consumer citizenship" of either the "class" or "mass" variety, according to national advertisers during this period, one generally had to have a higher than average income, speak fluent English (a skill many recent immigrants did not possess), live in an urban environment, and not be African American. To qualify for "class" status, one generally had to be in the top 5 or 6 percent of the national income and employ at least one servant (and yet, even in 1931, only 57.2 percent of this group owned an electric refrigerator). Radios, too, were targeted for a very elite audience at first but then later became available to the less affluent. The "exclusion of blacks" is apparent from the virtual lack of national advertising in newspapers that targeted this population, such as the *Chicago Defender* and *Pittsburgh Courier*. During 1926 and 1927, in fact, fewer than a dozen national advertisers purchased *any* ads in the former publication, he notes, and of the ones that did, only Colgate Dental Cream "prepared special 'race copy.'" Except for ads for hair products and facial powder, the few ads that did appear featured images of whites.

87. Tomes, *Gospel of Germs*, 86, 199. She notes, 203, that dirt and dust removal were particularly daunting tasks for rural housewives. On Chicago schools, see Tomes, 126; she mentions that schools in the rural South were even worse. Cynthia Henthorn, in *Commercial Fallout: Advertising Narratives of Progress and the Invention of Postwar Social Evolution, 1939–1945* (Athens: Ohio State University Press, 2005), Chapter 3 of the manuscript, describes how designers and manufacturers intended postwar products to finally be within reach of the large numbers of people they had envisioned in the 1930s, owing to the fact the full employment during the war had greatly enlarged the American middle class.

88. Ibid., 11.

89. Ibid., 185,

90. Hoy, *Chasing Dirt*, 173.

91. Tomes, *Gospel of Germs*, 11, 161.

92. Marchand, *Advertising the American Dream*, 194–95; italics added. That eugenicists used similarly exclusive standards for what counted as normality can be seen from a question that was included on the Army Intelligence tests of 1919 intended to determine "native intelligence." Yerkes asked army recruits, "The Knight engine is used in the: Packard/Stearns/Lozier/Pierce Arrow?" See Kevles, *In the Name of Eugenics*, 81.

93. Marchand, *Advertising the American Dream*, 197, citing a Camel advertisement that appeared in *True Story Magazine*, Jan. 1930, fourth cover.

94. Marchand, *Advertising the American Dream*, 272, citing an advertisement that appeared in the *Saturday Evening Post* (23 March 1935): 92; italics added.

95. Walter Dorwin Teague, "Art of the Machine Age" (address to the Art Week Luncheon held by the Boston Chamber of Commerce and Boston Advertising Club at the Hotel Statler, 10 April 1934); Teague, "What Industrial Designers Can

Do: A Leading American Designer Writes Frankly about Functions and Limitations," *Barron's, The National Financial Weekly* (31 March 1941); both in Box 79, WDT Papers.

96. D. K. Colvin, "The Hoover in the Home," folder "Housing—Prefab," Box 19, Egmont Arens Papers. Ads such as this followed in the tradition of exhibits at world's expositions that expounded the cleanliness of high "civilization," from the "sanitary wonders" of the White City of 1893 to the "orderly, healthy, and contented" vision of a streamlined U.S. presented at the New York World's Fair in 1939. On the 1893 exposition, see Hoy, *Chasing Dirt*, 78; on the New York World's Fair, see Donna Braden, "Selling the Dream," in *Streamlining America,* ed. Fannia Weingartner, Ex. Cat. (Dearborn, Mich.: Henry Ford Museum, Sept. 1986–Dec. 1987), 37–54.

97. Marchand, *Advertising the American Dream,* 196, 198, citing Frank Wayne Fox, "Advertisements as Documents in Social and Cultural History" (M.A. Thesis, University of Utah, June 1929), 56. This citation may be a mistake, however, for in 1975 Frank Wayne Fox was an Assistant Professor at Brigham Young University, and published *Madison Avenue Goes to War: The Strange Military Career of American Advertising, 1941–1945* (Provo, Utah: Brigham Young University Press, 1975).

98. Marchand, *Advertising the American Dream,* 199.

99. Ibid., 67, 83, 87. The editor-in-chief was Arthur Brisbane.

100. Teague, "The Growth and Scope of Industrial Design in the U.S.," folder "Writings," Box 79, WDT Papers.

101. Marchand, *Advertising the American Dream,* 223–27, discusses this triumph over nature as the trope of Civilization Redeemed; Meikle follows this theme as well throughout *American Plastic: A Cultural History* (New Brunswick, N.J.: Rutgers University Press, 1995), and suggests it also in *Twentieth-Century Limited.*

102. Hoy, *Chasing Dirt,* 90–91.

103. Clarence Cook Little, "Opportunities for Research in Mammalian Genetics," *Scientific Monthly* (June 1928), Box #1: Series I "A:0-A:01#6, A:0#9," ERO Papers.

104. Albert E. Wiggam, text for *Next Age of Man,* 168, folder "A. E. Wiggam, #3," CBD-CSH Series; italics added.

105. The belief that bodily constitution was partially responsible for illness was not new; it was prominent in Germany in the 1890s; see Weiss, *Race Hygiene and National Efficiency,* 25, and Weiss, "The Race Hygiene Movement in Germany," 12–13. On heredity and its relation to disease in the U.S., see folder "National Research Council: Committee on Heredity in Relation to Disease," 1924, CBD Papers; on the exhibit on the "inheritance of diseases and weaknesses" at Booth 9 at the Third International Congress of Eugenics, 1934, see *A Decade of Progress in Eugenics: Scientific Papers of the Third International Congress of Eugenics, held at American Museum of Natural History, New York, August 21–23, 1932* (Baltimore: Williams and Wilkins, 1934), 502; letter from George Gray to Charles Davenport, 4 Dec. 1939, folder "Miscellaneous Questions, 1939–44," CBD Papers, regarding an article for *Harper's* magazine on "Hereditary Factors in Disease."

106. Tomes, *Gospel of Germs,* 35–42, 127, and the text of Alfred E. Wiggam's *Next Age of Man* (1927), 159, folder "AE Wiggam, #3," CBD-CSH Series. Martin

Holbrook, a New York health reformer in the 1870s, stressed that "infection was no simple act of contamination, but a dynamic process involving microbe and host. For disease to result, the latter had to provide a suitable culture medium, had to be susceptible. . . . When there is no preparation of the soil by hereditary predisposition or lowered health standard, the individual is amply guarded against attack." Health enthusiast Bernarr Macfadden, in his book *Vitality Supreme* (New York: Physical Culture Publishing, 1923), promoted a system called "phycultopathy" that had the goal of securing "'absolute purity' of the blood, a condition that would make disease 'virtually impossible.' 'Even the dread germs of the bacteriologist' were impotent in healthy blood, MacFadden believed." See Whorton, *Crusaders for Fitness*, 144, 297. In a CBS radio broadcast in 1931 on "Heredity and Disease," Davenport used tuberculosis as his example. If you inoculate certain healthy strains with the bacillus, he explained, those individuals will not get the disease. Only the susceptible, those "belonging to hereditarily non-resistant strains," will catch it. Lecture folder "Heredity and Disease" (delivered on the radio, 27 Nov. 1931), File "C. B. Davenport," CBD Papers. Davenport continued to equate the "constitutional, hereditary, genetical factor" in importance with the presence of the bacillus in the environment, and proclaimed there must be a balance between the two. Yet his overall approach, and life's work, even, clearly considered the genetic side as dominant.

107. Norman Bel Geddes, *Miracle in the Evening, an Autobiography* (Garden City, N.Y.: Doubleday, 1960), 93.

108. He used a very similar approach in his design for a postwar prefabricated "house of tomorrow" in 1941, a design that is discussed in the last chapter of this book.

109. Norman Bel Geddes, *Horizons* (Boston: Little, Brown, 1932), 249–58, and Meikle, *Twentieth-Century Limited*, 101–2.

110. Geddes, *Horizons*, 205–21, and Geoffrey T. Hellman, "Profiles: Design for a Living—I," *New Yorker* (8 Feb. 1941): 24.

111. Meikle, *Twentieth-Century Limited*, 93.

112. Russell Flinchum, *Henry Dreyfuss, Industrial Designer: The Man in the Brown Suit* (New York: Rizzoli, 1997), 97–105.

113. Teague also faltered at least once when, in his design for the Wiz receipt register, he created only a casing that was so out of touch with the inner mechanisms that it forced Wiz to consult with engineers in order to redesign it to fit the casing. See Meikle, *Twentieth-Century Limited*, 93. Meikle, 103, also discusses the redesign of the General Electric monitor-top refrigerator as one that replaced a highly functionalist design with a less functionalist, streamlined aesthetic.

114. Donald Deskey, "The New Role of the Industrial Designer in the Planning and Development of New Products," likely from the 1940s or early 1950s, folder "Writings/Philosophy," Donald Deskey Papers. William F. H. Purcell, "The Industrial Designer: Practical Idealist" (talk to the Faculty Club, University of Southern California), on Microfiche #6 "Lectures/Articles by Dreyfuss, 1933–49," Henry Dreyfuss Papers. See also Teague, "Industrial Design and the World of Machinery," Box 79, WDT Papers, and Henry Dreyfuss, "Reveal the Subject and Conceal the Art," on Microfiche #9, Henry Dreyfuss Papers.

115. Teague, "What Industrial Designers Can Do: A Leading American Designer Writes Frankly About Functions and Limitations," *Barron's, The National Financial Weekly* (31 March 1941); Teague, "Industrial Design and the World of Machinery," reprint from *Western Machinery and Steel World* (March 1946), folder "Writings—Articles"; Teague, "Art of the Machine Age"; Teague, "Why Disguise Your Product?" *Electrical Manufacturing* (Oct. 1938): 3, folder "Writings—Articles"; Teague, "Industrial Art and Its Future" (address to the Annual Reception of the School of Architecture and Allied Arts at New York University, 18 November 1936), folder "Writings—Articles"; all in Box 79, WDT Papers.

116. Advertisement for Camp Supports, *Vogue* (15 Jan. 1939): 9.

117. Henry Dreyfuss, "Subway Riders May Dream," *New York Times Magazine,* 5 Nov. 1950, on Microfiche #6 "Lectures/Articles by Dreyfuss, 1933–49," Henry Dreyfuss Papers; italics added.

118. Dr. Abraham Myerson, "Sterilization and the Attitude of the Neurologist and Psychiatrist to the Whole Eugenic Approach" (speech at the Conference on Medicine and Eugenics, New York Academy of Medicine, 21 April 1937), folder "Conference on Medicine and Eugenics," AES Papers. He determined, "We must come to learn that the germ plasm and the environment are not opposing but complementary forces, neither of which can be defined without taking the other into account."

119. Weiss, *Race Hygiene and National Efficiency,* 121–23. On genotype and phenotypes, see Ludmerer, *Genetics and American Society,* 76.

120. Whorton, *Crusaders for Fitness,* 196, citing Irving Fisher, "Impending Problems of Eugenics," *Science Monthly* 13 (1921): 13, 214–31.

121. Charles Davenport, folder "Battle Creek Lectures," 1925, File "C. B. Davenport," CBD Papers.

122. Diane Paul, "Eugenics and the Left," *Journal of the History of Ideas* 45 (1984): 587.

123. Davenport, folder "Battle Creek Lectures," 1925, File "C. B. Davenport," CBD Papers. The same can be said about the biological determinist beliefs regarding disease being promoted by some supporters today of human genetic engineering. Even the language of "predisposition" is the same. This is discussed in the last chapter of this book.

124. Pernick, *The Black Stork,* 74, describes Dr. Haiselden's eugenic goal to be the making of the "United States a nation of physically perfect human beings."

Chapter 6. Future Perfect? The Elusive "Ideal Type"

1. Notes from the Board of Directors meeting of the American Eugenics Society (AES), 23 Sept. 1937," folder "AES: Minutes 1936–37, #4," and Frederick Osborn, "Dedicatory Exercises of the American Museum of Health, Held in the Hall of Man at the New York World's Fair," 27 June 1939, folder "Frederick Osborn, Papers I, #10," both in AES Papers. The seventy-five displays purchased from the Deutsche Hygiene Museum by the Oberlaender Trust in 1937, displayed in the Hall

of Man at the New York World's Fair, were supposed to become the permanent collection for what was intended to be the nation's first health museum—the American Museum of Health, to open in New York City after the closing of the fair. For various reasons, the museum never opened. See folder II-36, "American Museum of Health," BG Papers. This is discussed in more detail in Chapter 3.

2. This number is approximate based upon two sources claiming that over 25,000 operations had been performed by 1937, and almost 36,000 by 1941. See Daniel J. Kevles, *In the Name of Eugenics: Genetics and the Uses of Human Heredity* (New York: Knopf, 1985), 115–16, and the AES pamphlet, "Practical Eugenics," 1938, 14, folder "Printing Orders, 1926–42, #9," AES Papers. Alexander Cockburn, in "Social Cleansing: Eugenics in the United States," *New Statesman and Society* 7,314 (5 Aug. 1994): 16, cites Phillip Reilly's statistic in *The Surgical Solution: A History of Involuntary Sterilization in the United States* (Baltimore: Johns Hopkins University Press, 1991), 94, that between 1907 and 1960, over 60,000 people were sterilized, with sterilizations continuing in Virginia and North Carolina into the 1970s, and Oregon into the 1980s.

3. Correspondence between E. H. Taylor and Charles Davenport, 12 and 17 Dec. 1935, folder "Miscellaneous Questions, 1935," CBD Papers.

4. On Galton and the founding of statistics and biometrics, see Stephen J. Gould, *The Mismeasure of Man* (New York: W.W. Norton., 1996), 107–9, and George Stocking, Jr., *Race, Culture and Evolution* (Chicago: University of Chicago Press, 1982), 167.

5. Letter from John Harvey Kellogg to Charles Davenport, 27 March 1924, folder "J. H. Kellogg, #4," CBD Papers. This approach closely resembles approaches taken in the Human Genome Project and the Human Genome Diversity Project, which will be further discussed in Chapter 7.

6. Kenneth Ludmerer, *Genetics and American Society: A Historical Appraisal* (Baltimore: Johns Hopkins University Press, 1972), 78–79.

7. Correspondence between C. E. Boyer and Charles Davenport, 19 Sept. 1932, folder "C. E. Boyer," CBD Papers. Carl Brigham, a popularizer of the test results, did note the contradiction that these *averages* were "below" the "norms" set by Lewis Terman in his scale; see Gould, *The Mismeasure of Man*, 252–54.

8. "Average American No Adonis to Science: Plaster Composite of 100,000 Males Is of Slight Build, Except Abdominally," *New York Times*, 27 Aug. 1932, 19 and Edward Alden Jewell, "The Masterpiece and the Modeled Chart," *New York Times*, 18 Sept. 1932, xx9. On this topic, see also the work in progress of Mary Coffey (Program in Museum Studies, New York University), "The American Adonis: A Natural History of the American Man."

9. Correspondence between Boyer and Davenport, 19 Sept. 1932, folder "C. E. Boyer," CBD Papers. On exhibits at the American Museum of Natural History during the Second International Congress of Eugenics, see "Eugenics Exhibition," folder "Harry H. Laughlin, 1922, #2," CBD-CSH Series.

10. On the origin of the Jamaican study, see the correspondence between Col. Wickliff Preston Draper of Boston, who funded the study, and Charles Davenport between 1925 and 1926, folder "Col. Wickliff Preston Draper"; also, letter from Davenport to Alfred Kidder, 21 May 1929, folder "A. V. Kidder," both in CBD

Papers, and Daniel Kevles, *In the Name of Eugenics*, 75. A related study was con-
ducted in 1929 and 1930 by Harry Laughlin through the sponsorship of the Eugenics
Record Office and the U.S. House Committee on Immigration and Naturalization.
Laughlin traveled to the Southwest border to study Mexican immigration, which
was then at "high tide." For one month, he investigated "the more immediate and
the possible long-time effect of the present Mexican immigration on the racial
make-up and hereditary quality of the population of those regions of American
states which are now receiving Mexican immigrants." See letter from Harry Laug-
hlin to Charles Davenport, 22 Aug. 1929, folder "Harry H. Laughlin, 1929," CBD-
CSH Series. Some interpretations of the degeneracy of *The Average Man* may have
stemmed from the fact that he was a composite of multiple white ethnicities: his
pure Nordic stock was being polluted through intermixture with immigrant popu-
lations.

 11. Mark B. Adams, "Toward a Comparative History of Eugenics," in *The
Wellborn Science: Eugenics in Germany, France, Brazil, and Russia*, ed. Mark Adams
(Oxford: Oxford University Press, 1990), 220–21. In 1924, a study by the Rockefeller
Foundation aimed to determine the current evolutionary state of Australian aborig-
ines, their mentality, and capacity for "civilization." It concluded that "hardly a
single child, no matter what age, reached a 12-year test" when given the Binet psy-
chological examination. Using this data as proof for the aborigines' status as
"human anachronisms [who] belong by right to a prehistoric age" and who pos-
sessed no capability of "forethought," the study also concluded that "The only
children to reach a moderate level of success were those of mixed blood." See letter
from Edwin Embree, Secretary of the Rockefeller Foundation, to Charles Daven-
port, 3 March 1924, folder "Edwin Embree," CBD Papers. In other words, those of
mixed blood apparently possessed enough whiteness to raise their level of intelli-
gence (a process known in many countries as "whitening"). In comparison with
the "race crossing" study in Jamaica, it is clear that these types of studies needed
not only increased methodological sophistication but also the benefit of neutral
interpretation.

 12. *A Decade of Progress in Eugenics: Scientific Papers of the Third International
Congress of Eugenics, held at American Museum of Natural History, New York, August
21–23, 1932* (Baltimore: Williams and Wilkins, 1934), 489. This shows the sculpture
was made by Mrs. R. G. Harris, which is Davenport's daughter's married name. In
the aforementioned correspondence between Davenport and C. E. Boyer, Daven-
port claims that his daughter in the early 1920s made the sculpture on display in
1932. Jewell, "The Masterpiece and the Modeled Chart," confirms this as well.

 13. Malvina Hoffman, *Heads and Tales* (New York: Bonanza Books, 1936),
3–17; also, Marianne Kinkel, "Circulating Race: Malvina Hoffman and the Field
Museum's Races of Mankind Sculpture" (Ph.D. Dissertation, University of Texas at
Austin, 2001).

 14. Letter from Morris Steggerda to Albert Blakeslee, 4 Aug. 1938, folder
"Morris Steggerda, 1938," CBD-CSH Series.

 15. Examples of both male and female German Nordics are included in the
catalogue for the "Wonder of Life" exhibition in Berlin, 1935, which contained the

photo of the Transparent Man's features that also appeared on the cover of *Hobbies* (Figure 3.2).

16. On Dickinson, see Bruno Gebhard, "Robert Latou Dickinson: A Nonconformist Looks at Marriage and Sex," *Bulletin of the Cleveland Medical Library* 8, 4 (October 1961), citing a reprint of a Dickinson speech in the *American Journal of Obstetrics and Gynecology* 1 (1920): 2–10; see also Warren Lapp, M.D., "Robert Latou Dickinson, 1861–1950, A Biography," written after 1960; both in folder IV-44, BG Papers. Among many other things, Dickinson was president of the American Gynecological Society, a longtime member of the New York Academy of Medicine, founder of the National Committee on Maternal Health, chairman of the Medical and Scientific Committee of Birthright, Inc., Sterilization for Human Betterment, one of the founding members of Planned Parenthood Association, and a contributor to E. S. Gosney's and Paul Popenoe's book *Sterilization for Human Betterment* (New York: MacMillan, 1929).

17. Harry Shapiro, "Americans: Yesterday, Today, Tomorrow," *American Museum of Natural History*, Science Guide 126 (New York: American Museum of Natural History, June 1945), reprinted from *Natural History* magazine, folder IV-44, BG Papers. See also Robert Latou Dickinson, Notes for "Outline of an Address," compiled for the Annual Meeting of the Cleveland Health Museum, 26 Nov. 1946, in folder IV-44, #3 "Correspondence," BG Papers.

18. Shapiro, "Americans: Yesterday, Today, Tomorrow," unpaginated. Shapiro was an astute critic, for apparently Dickinson himself was never able to distinguish "clearly between the 'normal'" or "the average (e.g., Norma)" and "the attainable perfect," according to his daughter. See letter from Dorothy Barbour to Bruno Gebhard, 21 March 1961, folder IV-44, #3, BG Papers.

19. Excerpt from Helen Cody Baker and Mary Swain Routzahn, *How to Interpret Social Welfare: A Study Course in Public Relations* (New York: Russell Sage Foundation, 1947), 146. Also, "Norma, July 6, Front Page Today," notes by Bruno Gebhard in 1945, listing the headlines run by the newspaper, folder IV-44, #2, BG Papers. At the Cleveland Health Museum, Gebhard displayed eighteen-year-old *Norma* and her twenty-year-old "boy friend" *Normman* along with the "Birth Series" models as a tool for "family life education." Bruno Gebhard, "The R. L. Dickinson Models at the Cleveland Health Museum," written after 1945, folder IV-44, BG Papers. See also Bruno Gebhard, "The Birth Models: R. L. Dickinson's Monument," reprint from the *Journal of Social Hygiene* (April 1951), in same folder. Photos in the archives of the Cleveland Health Museum may include one of a contestant for a contest held as late as 1953.

20. Stocking, *Race, Culture, and Evolution*, 163–65.

21. H. Gordon Garbedian, "Science Pictures a Superman of Tomorrow," *New York Times*, 8 Dec. 1929, folder "Oscar Riddle, 1929," CBD-CSH Series.

22. Advertisement for Camp Supports, *Vogue* (15 Jan. 1939): 9.

23. Arthur A. Stuart, "Someday We'll Look Like This," *Popular Science Monthly* (July 1929): 47, folder "Art Education," Box 58, Egmont Arens Papers.

24. Studies that Dreyfuss used in forming Joe and Josephine were Ernest Irving Freese, "The Geometry of the Human Figure," *American Architect* (July 1934); "Report on Anthropometric Measurements," Project 9, Armed Force Medical Re-

search Lab, Fort Knox, Kentucky, 1 Feb. 1943 (in which 3,000 men were measured by the Air Corps and Harvard Medical School), as well as army medical reports from 1954; and, Ernest A. Hooton, "A Survey in Seating," Department of Anthropology Statistical Lab, Harvard University, 1945. See also Russell Flinchum, "Dreyfuss, Design, and Human Factors," *Ergonomics in Design* 8,1 (Winter 2000): 18–24.

25. On Joe as G. I. Joe, see Dreyfuss, *Designing for People* (New York: Paragraphic Books, 1955), 28.

26. Ibid., 26, 34, 40.

27. Ibid., 33.

28. Garbedian, "Science Pictures a Superman of Tomorrow"; italics added.

29. For one democratic utopian vision, see "What Will the Children Be?" *San Francisco Call*, 5 Nov. 1928, Leon Whitney Scrapbook, AES Papers.

30. "Sermon #3," folder "Sermon Contest, 1926, #2," AES Papers.

31. "Clarence G. Campbell: Memorandum," c. June 1928, folder "Eugenics Research Association—Committee on Policy and Research, 1928–29, #1," CBD-CSH Series; Stuart, "Someday We'll Look Like This." Euthanasia supporter Foster Kennedy in 1942 considered the "higher grades" of the feebleminded to be of particular use to society as they could perform "the simpler forms of work"; see Martin Pernick, *The Black Stork: Eugenics and the Death of "Defective" Babies in American Medicine Since 1915* (New York: Oxford University Press, 1996), 165. Charles Davenport also supported a stratified society. See two of his lectures, "Some Social Aspects of Eugenics" and "Aims, Work, Results of the Eugenics Record Office," in lecture folders by those names, File "C. B. Davenport," CBD Papers.

32. "Race of Eugenic Brain Giants Due Soon, Says Mayo," *The Newark (New Jersey) Ledger*, 11 Oct. 1928, Leon Whitney Scrapbook, AES Papers; Stuart, "Someday We'll Look Like This"; Ellsworth Huntington, *Tomorrow's Children: The Goal of Eugenics* (New York: J. Wiley and Sons, 1935), 13; Waldemar Kaempffert, "The Superman: Eugenics Sifted," *New York Times Magazine*, 27 May 1928, Box #1: Series I "A:o #9, Clippings 1920–34," ERO Papers.

33. "Sermon 41," folder "Sidney E. Harris," AES Papers; Harris was pastor of the Bethany Presbyterian Church of Des Moines, Iowa. Stuart, "Someday We'll Look Like This"; "Sermon 17," folder "Henry S. Huntington, 1928," AES Papers; Ludmerer, *Genetics and American Society*, 18. See also Allene Talmey, "A World We'll Never See," *Vogue* (1 Feb. 1939): 164.

34. Charles Davenport, lecture folder "Heredity and Eugenics," File "C. B. Davenport," CBD Papers; Kevles, *In the Name of Eugenics*, 61, citing a 1926 AES publication titled *A Eugenics Catechism*; sermon in folder "Frederick F. Adams," 1926, AES Papers; "Sermon 37," folder "Sermon Contest, 1926, #4," AES Papers; "Sermon 11," folder "Rev. Ruth K. Hill," 1926, AES Papers; Charles Reed, M.D., "Eugenic Ideal Needed for Perfect Marriage," *The New Britain (Connecticut) Record*, 8 June 1928, Leon Whitney Scrapbook, AES Papers.

35. Stuart, "Someday We'll Look Like This."

36. Sermon in folder "Frederick Adams," 1926, AES Papers; Ludmerer, *Genetics and American Society*, 54; letter from C. M. Goethe to the editor of the *Dunedin (New Zealand) Evening Star*, 1 March 1924, folder "C. M. Goethe," CBD Papers.

37. Kevles, *In the Name of Eugenics*, 185–86, 189–91, summarizing and citing J. B. S. Haldane, *Daedelus* (Oxford: Oxford University Press, 1924), 53–58, 63–64.

38. Garbedian, "Science Pictures a Superman of Tomorrow," folder "Oscar Riddle, 1929," CBD-CSH Series.

39. Kaempffert, "The Superman: Eugenics Sifted." For another report that tempered the possibilities of the realization of the "ideal type," see "Super Race Distant Hope: Dr. A. W. Bellamy, University Biologist, Declares Social Instinct Must Be Developed Before Eugenics Will Be Put into Practice," *Los Angeles Times*, 18 Nov. 1927, Leon Whitney Scrapbook, AES Papers.

40. Sermon in folder "Frederick Adams," 1926, AES Papers.

41. Paper from 9 Nov. 1967, folder "Speeches and Writings," Container 2 "Executive Papers," Raymond Loewy Papers, Library of Congress.

42. Donald Deskey, "Radically New Dress System for Future Women Prophesies Donald Deskey," *Vogue* (1 Feb. 1939): 137, and David A. Hanks and Jennifer Toher, eds., *Donald Deskey: Decorative Designs and Interiors* (New York: E. P. Dutton, 1987), 74; Walter Dorwin Teague, "Nearly Nude Evening Dress Designed by Walter Dorwin Teague," *Vogue* (1 Feb. 1939): 143; George Sakier, "No Mechanistic Clothes for Future Women Predicts George Sakier," *Vogue* (1 Feb. 1939): 144; Raymond Loewy, "Raymond Loewy, Designer of Locomotives and Lipsticks, Creates a Future Travel Dress," *Vogue* (1 Feb. 1939): 141; "Preliminary Suggestions for the Graphic Dramatization of the Theme Exhibit for the Communications Building, New York World's Fair, Submitted by Donald Deskey, Industrial Designer, October 29, 1937," folder "Speeches and Writings," Donald Deskey Papers.

43. Walter Dorwin Teague, *Design This Day: The Technique of Order in the Machine Age* (New York: Harcourt, Brace, 1940), 233–34.

44. Sterling North, review of Walter Dorwin Teague, *Land of Plenty: A Summary of Possibilities*, *Philadelphia Bulletin*, folder "Writings," Box 79, WDT Papers.

45. Egmont Arens, "For Release after 8:00 p.m. Saturday, October 21" (from Princeton, N.J., an uncited press release summarizing a talk he gave that day to the Society of Industrial Designers), folder "News Releases, 1939–1954," Box 46, "Publicity/Programs," Egmont Arens Papers. See also Richard J. Harper of Walter Dorwin Teague Associates, "Static and Dynamic Concepts, Fine Printing—Time to Create," 18 Feb. 1949, 6, on Microfilm Roll 16.31, WDT Papers.

46. L. G. Peed, "Streamlining—The Auto Industry's Answer to Public Demand," 16 Jan. 1934, folder "Streamlining," Box 59, Egmont Arens Papers.

47. Teague, "The Basic Principles of Body Design," folder "Miscellaneous," Box 58, WDT Papers.

48. Jeffrey Meikle, *Twentieth-Century Limited: Industrial Design in America, 1925–1939* (Philadelphia: Temple University Press, 1979), 53; Norman Bel Geddes, *Horizons* (Boston: Little, Brown, 1932), 54; Egmont Arens, slide caption for "Transportation—Marine," folder "Writings/Lecture Notes/ Slide Captions," Box 57, Egmont Arens Papers. See also "Packages on Parade," *Television Age* (Aug. 1953): 47, in folder "Clippings About Egmont Arens," Box 46 "Publicity/Programs," Egmont Arens Papers.

49. Meikle, *Twentieth-Century Limited*, 104.

50. Ibid., 93–95.

51. Walter Dorwin Teague, "Industrial Art and its Future" (address to the annual reception of the School of Architecture and Applied Arts, New York University, 18 Nov. 1936), Box 79, WDT Papers. Le Corbusier, *The Decorative Art of Today*, trans. James Dunnett (London: Architectural Press, 1987, 1925), 112.

52. Meikle, *Twentieth-Century Limited*, 46, 187, 131–32, and title to his sixth chapter.

53. "Furniture for Modern Schemes," n.c., n.d., folder "Industrial Design Projects," and folder "Reference: Biographical Files and Reference Files," Donald Deskey Papers.

54. Dreyfuss, *Designing for People*, 96; see also Russell Flinchum, *Henry Dreyfuss, Industrial Designer: The Man in the Brown Suit* (New York: Rizzoli, 1997), 102, 108, n. 40, citing an inter-office memo.

55. Egmont Arens, "Slide #113: Zeppelin," folder "Transportation—Aerial," Box 57, Egmont Arens Papers.

56. Egmont Arens, "Transportation—Marine," folder "Writing/Lecture Notes/ Slide Captions," Box 57, Egmont Arens Papers; Ray Holland, Jr., "Streamlining in Nature," *Scientific American* (May 1935): 247–49, folder "Streamlining 1935–36," Box 59, Egmont Arens Papers; italics added. See also Teague, "The Basic Principles of Body Design," folder "Miscellaneous," Box 58, WDT Papers.

57. Teague, "Art of the Machine Age" (address to the Art Week Luncheon in Boston, 10 April 1934), folder "Writings—Articles," Box 79, WDT Papers.

58. "The Respectability of High Spirits," written by "DG" of Walter Dorwin Teague Associates, 30 April 1952 (also published in *Better Design Magazine*, May 1952), on Microfilm Roll 16.31, WDT Papers.

59. Arens, "Creative Evolution of the Printed Word" (address to the Eastern Arts Association, 28 April 1933), Box 51 "Writings," Egmont Arens Papers.

60. Ellsworth Huntington, "The Future of Eugenics" (presidential address to the Annual Meeting of the AES at the Delmonico Hotel, New York, 14 May 1937), folder "Annual Meeting 1937," AES Papers.

61. "Sermon 11," folder "Rev. Ruth K. Hill," 1926, AES Papers.

62. Geddes's motto was drawn from his Christian Science beliefs and was repeated various times, both in his notes for his Design Course and in his advice to his wife Frances while she was trying to recover from tuberculosis, that "if you conquer the problem psychologically and mentally, you will conquer it physically"; see letter dated 16 Jan. 1939, File 960, NBG Papers. See also Jeffrey Meikle, "Technological Visions of American Industrial Designers, 1925–1939," 4 vols. (Ph.D. Dissertation, University of Texas at Austin, 1976), 2: 238.

63. Letter from Charles Davenport to Frederick Osborn, 20 Feb. 1929, folder "Frederick Osborn," CBD Papers; also, "Report on Standardization Committee, 1 July 1936," folder "International Federation of Eugenics Organizations," CBD Papers.

64. Ray Holland, Jr., "Streamlining in Nature," in folder "Streamlining 1935–36," Box 59, Egmont Arens Papers.

65. "Sermon 3," folder "Sermon Contest, 1926, #2," AES Papers; italics added.

Chapter 7. Conclusion: Pseudoscience? Pseudostyle?

1. Brian Alexander, "Don't Die, Stay Pretty. Introducing the Ultrahuman Makeover," *Wired* 8 (January 2000): 185–87.

2. Ibid., 185.

3. Margaret Talbot, "A Desire to Duplicate," *New York Times Magazine,* 4 Feb. 2001, 42, and Gretchen Vogel, "Human Cloning Plans Spark Talk of U.S. Ban," *Science* 292 (6 April 2001): 31. On defects in clones owing to problems with the process, see Rudolf Jaenisch and Ian Wilmut, "Don't Clone Humans," *Science* 291 (30 March 2001): 2552. On the Raëlians, see also "Clone Cult Believes in Free Love, Aliens," *Sunday Times* (London), 29 Dec. 2002, archived at www.religionnewsblog .com/archives/00001694/html.

4. Talbot, "A Desire to Duplicate," 42. Most statistical summaries regarding the success of animal cloning state, as Talbot does (40), that "Only two or three out of every hundred attempts to clone an animal typically result in a live offspring," and even if the latter is born alive, there are frequently gross deformities in size and other abnormalities resulting in faulty bodily functioning.

5. This information is taken off of Clonaid's website, 16 Nov. 2003, at www .clonaid.com/news.php. The website also has a link to www.humanclonerights.org, which is a website being created by the organization of the same name formed by the parents of the cloned children.

6. Gregory Stock, *Redesigning Humans: Our Inevitable Genetic Future* (Boston: Houghton Mifflin, 2002), 2, 62, and William Gardner, "Can Human Genetic Enhancement Be Prohibited?" *Journal of Medicine and Philosophy* 20 (1995): 69.

7. Two recent publications on the relationship of technology to the body in the early twentieth century are Carolyn Thomas de la Peña, *The Body Electric: How Strange Machines Built the Modern American* (New York: New York University Press, 2003), and Joel Dinerstein, *Swinging the Machine: Modernity, Technology, and African American Culture Between the World Wars* (Amherst: University of Massachusetts Press, 2003). The former addresses the ways that machines were used to theoretically restore energy to bodies in the decades around the turn of the twentieth century, while the latter examines how machines inspired the look and sound of big band and swing music and dance in African American culture during the interwar period.

8. Correspondence between Charles Davenport and Samuel J. Holmes, Jan. 1929, folder "Samuel J. Holmes," CBD Papers.

9. Albert E. Wiggam, "Paper Read by Albert Wiggam" (22 Dec. 1937), folder "American Eugenics Society (AES): Conference on Publicists, 1937," and folder "AES: Conference on Education and Eugenics, 1937," AES Papers.

10. Stock, *Redesigning Humans,* 58, 156, n. 224, n. 237, citing Darryl Macer et al., "International Perceptions and Approval of Gene Therapy," *Human Gene Therapy* 6 (1995): 791–803. Stock, 58, summarizes the results of the poll targeting eight different countries: 22 percent in Israel would support the use of germline engineering, 43 percent in the U.S., 63 percent in India, and 83 percent in Thailand, specifically in response to physical enhancement. He states the numbers were similar for

intelligence, and higher if genetic engineering could prevent inheritance of a serious diseases. Another survey conducted between 1994 and 1996 by Dorothy Wertz, who works in the division of Social Science, Ethics and Law at the Shiver Center in Waltham, Massachusetts, confirms the ongoing interest in eugenics among genetics professionals. "'Eugenic thought,' if interpreted as eugenic outcome based upon individual decisions, underlies genetic practice in much of the world today," particularly in developing nations, she states (507). The survey was sent to "all geneticists in the 36 nations with 10 or more practicing genetics professionals," a total of 4,607 individuals, 2,901 (63 percent) of whom responded to the survey. In the U.S., a separate but similar study was sent to "a random sample of 852 primary care physicians" not certified in genetics but in the masterfile of the American Medical Association, 499 (59 percent) of whom responded. The sample survey of 710 first-time visitors to genetics clinics was responded to by 476 (69 percent) individuals, most of whom were white middle-class women with a median of 13 years of education (495). In general, genetics professionals in English-speaking nations scored lowest in offering directive counseling after prenatal diagnosis aimed at pregnancy termination, yet, in the separate but related survey targeting U.S. primary care physicians and first-time visitors to genetics clinics, many agreed that "it is socially irresponsible knowingly to bring an infant with a serious genetic disorder into the world in an era of prenatal diagnosis" and over one-fifth of patients felt the government should impose mandatory sterilization on a single mother on public welfare with a 50 percent chance of having a blind child (501, 503). Regarding social irresponsibility, the numbers of those who agreed in the U.S. were 26 percent of geneticists, 55 percent of primary care physicians, and 44 percent of patients; 21 percent of patients supported sterilization, but few geneticists and primary physicians agreed. See Dorothy Wertz, "Eugenics Is Alive and Well: A Survey of Genetic Professionals around the World," *Science in Context* 11, 3–4 (1998): 493–510.

 11. John Perreault, *Streamline Design: How the Future Was*, Ex. Cat. (New York: Queens Museum, 28 Jan.–6 May 1984), 2. Perreault is referring to critics at the Museum of Modern Art, who shunned the style. See also John McAndrew, "'Modernistic' and 'Streamlined,'" *Museum of Modern Art Bulletin* 5,6 (Dec. 1938); James Allen, *The Romance of Commerce and Culture: Capitalism, Modernism, and the Chicago-Aspen Crusade for Cultural Reform* (Chicago: University of Chicago Press, 1983), 71, citing a letter from 29 June 1945, Walter Paul Paepcke Archives, Chicago, Illinois; Donna Braden, "Selling the Dream," in *Streamlining America*, ed. Fannia Weingartner, Ex. Cat. (Dearborn, Mich.: Henry Ford Museum, Sept. 1986–Dec. 1987, 1986), 57, citing Teague; Richard F. Bach, Director of Industrial Relations at the Metropolitan Museum of Art in New York City, "The Designer and the Machine Today," *Gift and Art Buyer* (April 1937): 56, Box 49 "Articles/Writings," Egmont Arens Papers; Donald Deskey, "Best Design of the Month," 1936, 42, folder "Donald Deskey Associates," Donald Deskey Papers; Henry Dreyfuss, text of speech delivered to the monthly luncheon meeting of Fashion Group, Inc., 1 May 1934, on Microfiche #6 "Lectures/Articles by Dreyfuss, 1933–49," Henry Dreyfuss Papers; Henry Dreyfuss, *Designing for People* (New York: Paragraphic Press, 1955), 74–75.

 12. Jeffrey Meikle makes this point in "Forms, Functions and Mixed Motives:

A Natural History of Streamlining," talk given at the conference on "The Art Deco World," Victoria and Albert Museum, London (26 April 2003), 10.

13. François Burkhardt, "Form Made for Speed, or Progress as Propaganda: Incentives for Styling," in *Raymond Loewy: Pioneer of American Industrial Design*, ed. Angela Schönberger (Berlin: International Design Center, 1990), 221.

14. Jeffrey Meikle notes that the key metaphor of streamlining—eliminating resistance and friction—implied "smoothing away, through social engineering, all potential disturbances, whether of action or expression." He posits that the decline in streamlining resulted from general recognition of the similarity of its ideals to the "destructive concept of a thousand-year *Reich* in Germany." In his Marxist analysis, William Pretzer describes the style as an anti-democratic, corporate "fiat" that "did not allow for regional, ethnic, popular or class variations," one that "emanated from a panic that sought refuge in the planned, orderly, and ultimately, the authoritarian." See Jeffrey Meikle, *Twentieth-Century Limited: Industrial Design in America, 1925–1939* (Philadelphia: Temple University Press, 1979), 186, 187, 210, and William Pretzer, "The Ambiguities of Streamlining: Symbolism, Ideology, and Cultural Mediator," in *Streamlining America*, ed. Fannia Weingartner, Ex. Cat. (Dearborn, Mich.: Henry Ford Museum, Sept. 1986–Dec. 1987, 1986), 88, 91, citing Ernest Elmo Calkins from *Printers' Ink* (23 Sept. 1930).

15. Meikle, "Forms, Functions and Mixed Motives," 12–17. All the examples in this paragraph are ones he used in his talk, and the critic from 1957 was Deborah Allen.

16. Cynthia Henthorn, *Commercial Fallout: Advertising Narratives of Progress and the Invention of Postwar Social Evolution, 1939–1945* (Athens: Ohio State University Press, 2005). See particularly the section, "Rhetorical Formulas for Derailing the New Deal: The National Association of Manufacturers" in her second chapter. All page numbers cited from this source are from her manuscript, not the final publication.

17. Ibid., 29, and Figure 3-6.

18. Cynthia Henthorn, "The Emblematic Kitchen: Labor-Saving Technology as National Propaganda, The United States, 1939–1959," *Journal of Knowledge and Society* 12 (2000): 153–55, and throughout. Nixon stated, "Would it not be better to compete in the relative merits of washing machines than in the strength of rockets?" (153). See also George Marcus, *Design in the Fifties: When Everyone Went Modern* (Munich: Prestel, 1998), 55–56.

19. Henthorn, *Commercial Fallout*, Chapter 3, 4, 9, 34–35.

20. In discussing the relation of eugenics to streamline design, Henthorn is building upon previous work that I have published as well as upon the work of Mary Donahue, "Design and the Industrial Arts in America, 1894–1940: An Inquiry into Fashion Design and Art and Industry" (Ph.D. Dissertation, City University of New York, 2001).

21. Henthorn, *Commercial Fallout*, Chapter 3, 48, 51–54, 59–62. Many of the points in this paragraph are ones Henthorn makes throughout her chapter in her analysis of many different advertisements for homes of tomorrow. The advertisement featuring Norman Bel Geddes is her Figure 3-25, and was published in *Time* (15 Sept. 1941): 31. In *Design in the Fifties*, 39–40, Marcus states that "veterans of

color . . . were not allowed to buy in these new [postwar suburban] developments," implying the reality matched that portrayed in the advertisements.

22. Henthorn, *Commercial Fallout*, Chapter 3, 55, citing "Old Newspapers to New Houses," *Architectural Forum* (Dec. 1940): 531.

23. Henthorn, *Commercial Fallout*, Chapter 3, 64, and also Henthorn, "The Emblematic Kitchen," 184.

24. Henthorn, "The Emblematic Kitchen," 157.

25. Henthorn, *Commercial Fallout*, Chapter 3, 64.

26. Daniel Kevles, *In the Name of Eugenics: Genetics and the Uses of Human Heredity* (Cambridge, Mass.: Harvard University Press, 1995, 1985), 164, citing H. J. Muller from 1935; Kenneth Ludmerer, *Genetics and American Society: A Historical Appraisal* (Baltimore: Johns Hopkins University Press, 1972), 82; Diane Paul, "Eugenics and the Left," *Journal of the History of Ideas* 45 (1984): 572; Stefan Kuhl, *The Nazi Connection: Eugenics, American Racism, and German National Socialism* (Oxford: Oxford University Press, 1994), 66–67; Martin Pernick, *The Black Stork: Eugenics and the Death of "Defective" Babies in American Medicine and Motion Pictures Since 1915* (New York: Oxford University Press, 1996), 244, n. 22. On the crossover between eugenics and genetics at academic conferences, see letters from Harry Laughlin to Albert Blakeslee, 9 Nov. 1935 and 11 Nov. 1935, folder "Harry H. Laughlin, 1935," CBD-CSH Series.

27. Kevles, *In the Name of Eugenics*, 263, quoting from Francis Crick's essay "Eugenics and Genetics: Discussion," in *Man and His Future*, ed. Gordon Wolstenholme (A CIBA Foundation volume: Little, Brown, 1963), 274–75.

28. Carl Zimmer, "Unnatural Selection," *Discover* (Sept. 2003): 77, quoting Watson from a comment he makes in the British documentary *DNA* (2003).

29. Kevles uses the term "reform eugenicists" in *In the Name of Eugenics* (1985), but the clearest delineation of these categories is found in Kuhl, *The Nazi Connection*, 72–75. Mark Adams, "Toward a Comparative History of Eugenics," in *The Wellborn Science: Eugenics in Germany, France, Brazil and Russia*, ed. Mark Adams (Oxford: Oxford University Press, 1990), 218–19, also dispels the myth of easy separation between eugenicists and geneticists.

30. On the practice of "overlap racism" among reform eugenicists, see Kuhl, *The Nazi Connection*, 74–75; on Jennings, see Kevles, *In the Name of Eugenics*, 173, citing Jennings. The classist beliefs of reform eugenicists are discussed in Kevles, 174–76, in Ludmerer, *Genetics and American Society*, 133, and in Paul, "Eugenics and the Left," 572.

31. Paul, "Eugenics and the Left," 590.

32. Kuhl, *The Nazi Connection*, 82–84; Paul, "Eugenics and the Left," 572; Kevles, *In the Name of Eugenics*, 169–70, 173–75.

33. Kevles, *In the Name of Eugenics*, 252.

34. Ibid., 253, and Dorothy Wertz, "Eugenics is Alive and Well," throughout. On the total number of sterilizations, see Phillip Reilly, *The Surgical Solution: A History of Involuntary Sterilization in the United States* (Baltimore: Johns Hopkins University Press, 1991), 94, and "Virginia Governor Apologizes for Law that Forced Sterilizations," *Los Angeles Times*, 3 May 2002.

35. Kevles, *In the Name of Eugenics*, 275.

36. Mike Anton, "Forced Sterilization Once Seen as Path to a Better World," *Los Angeles Times*, 16 July 2003, A1, A18; Aaron Zitner, "Davis' Apology Sheds No Light on Sterilizations in California," *Los Angeles Times*, 16 March 2003, A12; "Apology for Oregon Forced Sterilizations," *Los Angeles Times*, 3 Dec. 2002, A18; "Virginia Governor Apologizes for Law that Forced Sterilizations," *Los Angeles Times*, 3 May 2002.

37. Daniel Kevles, in the last few chapters of *In the Name of Eugenics*, offers a detailed history of the new eugenics in relation to scientific developments..

38. Gina Kolata, "Scientists Brace for Changes in Path of Human Evolution," *Los Angeles Times*, 21 March 1998, A12; Gregory Stock and John Campbell, *Engineering the Human Germline: An Exploration of the Science and Ethics of Altering the Genes We Pass to Our Children* (New York: Oxford University Press, 2000), 4.

39. Stock, *Redesigning Humans*, 199. Another similarity between some leaders in the biotech industry and streamline designers is the way they are portrayed as Renaissance men. Adam Bryant, in "The Gold Rush," *Newsweek* (10 April 2000): 67, describes how Craig Venter, president of Celera, has "been compared in the media to Copernicus, Galileo, Newton and Einstein," and William Haseltine, chairman of Human Genome Sciences, "cultivates an image as a Renaissance man, choosing all the art works on the walls of the company's offices. The 1998 annual report is filled with images of 15th- and 16th-century paintings of ambassadors, noblemen, and philosophers, with company officers striking similar poses on facing pages."

40. Very few articles about germline engineering explicitly state the dependence of this technology on the use of IVF, perhaps because this is considered to be obvious, but such omission hides the facts that reproduction becomes a technological problem demanding the services of a professional elite, and that men bear none of the risks of these processes, which in fact do have serious effects upon women, as well as on the child-to-be. To use IVF, women must undergo various painful and potentially damaging preparatory procedures. For example, in order to cause super-ovulation and have their eggs surgically withdrawn from their bodies, women's bodies must be prepared through injections of hormonal cocktails that can also cause chromosomal abnormalities and cancer. Conception then occurs not in the womb, but in "the bright light of the laboratory," where embryonic chromosomes are removed, evaluated, rejected, or "enhanced," and development is monitored for abnormalities. Selected embryos are then inserted into a woman's body that has again been hormonally prepared, often in multiples so as to increase the chance that one is accepted. In the case that multiple embryos begin to grow, should this not be desirable or beneficial for the women's health, some of the embryos are then "reduced" in the first trimester by being injected (through a needle through the women's body) with potassium chloride, a process that sometimes damages the other fetuses as well. Janice Raymond, in *Women as Wombs: Reproductive Technologies and the Battle over Women's Freedom* (San Francisco: HarperSanFrancisco, 1993), 6, 13, 130, critiques the use of IVF as a so-called cure for infertility, not only because it fails to cure infertility (which persists—the process really bypasses infertility) but also because 23–60 percent of women "undergo IVF because of the male partners' infertility." She points out that to cure infertility, money could

be better spent on research examining the causes of male and female infertility and working to cure those causes, rather than creating a technology that places such a burden on women, often for a problem that is not even their own. See also Kass, "Preventing a Brave New World: Why We Should Ban Human Cloning Now," *New Republic* (21 May 2001): 35.

41. On human manufacturing, see Kass, "Preventing a Brave New World," 33, 39, and Margaret Talbot, "A Desire to Duplicate," 42. Raymond, in *Women as Wombs*, also gives examples of this concept through her book.

42. Diane Paul, "Genetic Services, Economics, and Eugenics," *Science in Context* 11,3–4 (1998): 483, citing Abby Lippman, "Mother Matters: A Fresh Look at Prenatal Genetic Testing," *Issues in Reproductive and Genetic Engineering* 5 (1992): 144.

43. Kass, "Preventing a Brave New World," 34.

44. Stock, *Redesigning Humans*, 69, 75–76, 122. He uses the analogy that a father wouldn't want to pass on his own genetically engineered genes any more than he would "try to give his Internet-savvy college-bound daughter that state-of-the-art typewriter he used for his term papers." Stock also uses HTML as a model for genetic engineering processes, whereby added genes could be marked on each end by enzymes that would be used as the controls designating the gene to be turned "on" or "off."

45. Alexander, "Don't Die, Stay Pretty," 184, 187.

46. Sharon Begley, "Decoding the Human Body," *Newsweek* (10 April 2000): 55, charts pages 54–57.

47. Stock, *Redesigning Humans*, 62, and Janice Raymond, *Women as Wombs*, 79.

48. Talbot, "A Desire to Duplicate," 42.

49. Raymond, *Women as Wombs*, 31, 49. For other examples of technocratic language equating people with products, later in the book, she discusses other ways that children are treated as products, giving the example of the exportation of children from Guatemala for adoption. Mario Taracena, a Congressman and president of the Commission to Protect Children, described children as Guatemala's "'primary nontraditional product.'" She also discusses the sale of deformed children for an illicit trade in organs, 154–71, and characterizations of aborted fetuses not used for research as "waste," 183.

50. Diane Paul, "Genetic Services, Economics, and Eugenics," 486, citing Ronald Conley and Aubrey Milunsky, "The Economics of Prenatal Diagnosis," in *Aneuploidy: Etiology and Mechanisms*, ed. Vicki L. Dellarco, Peter E. Voytele, and Alexander Hollaender (New York: Plenum, 1985), 442. She also quotes Ruth Hubbard and Eljah Wald, 485, stating that "'Genetic researchers often justify requests for funding by stressing the economic costs of caring for disabled babies. Such eugenic concerns frequently hover in the background of statements scientists, physicians, and genetic counselors make, even when they claim only to be interested in the individuals who manifest a genetic condition or who believe their offspring to be at risk for one.'" Economics is also used as a reason to promote germline engineering over somatic cell gene therapy, whereby medicines with vectors carrying the proper gene are injected into the area needing fixing with hopes that the new

gene will be adopted. This process is somewhat like chemotherapy, whereas scientists argue that germline engineering would fix the problem at its root and avoid costly medical procedures for present and future generations.

51. On insurance companies and employers, see Begley, "Decoding the Human Body," 57; Daniel Wikler, "Eugenic Values," *Science in Context* 11,3–4 (1998): 462; and Todd Woody, "DNA Detectives," *Industry Standard* (29 May 2000): 184.

52. Some proposed bills would have offered financial incentives for women to choose Norplant, whereas others intended to force women to choose Norplant if they wished to continue receiving financial benefits from the state. See "Norplant: A New Contraceptive with the Potential for Abuse," 31 Jan. 1994, a description published on the website of the American Civil Liberties Union, at www.aclu.org/ReproductiveRights. On how these bills would discriminate against minority women, in particular African American women, see Joan Callahan, "Contraception or Incarceration: What's Wrong with This Picture?" *Stanford Law and Policy Review* 67 (Winter 1995–96), and Darci Elaine Burrell, "The Norplant Solution: Norplant and the Control of African-American Motherhood," *UCLA Law Journal* 401 (Spring 1995). Raymond, in *Women as Wombs,* 15–19, describes how Norplant was tested on Third World women, many of whom were persuaded to try it because it was presented to them as a sound product. Many women have serious complications from Norplant, and feminist organizations in various countries have passed resolutions against its distribution and use.

53. William Gardner, "Can Human Genetic Enhancement Be Prohibited?" 65.

54. Ibid., 76–77.

55. Ibid., 76, and Stock, *Redesigning Humans,* 11, 33.

56. Egmont Arens, Caption titled "Early Transportation," Box 57 "Writings/Lecture Notes/Slide Captions," Egmont Arens Papers.

57. If a human being is defined as an organism possessing human DNA, the violation of bodily integrity caused through reproductive sterilization could arguably be extended to the violation of genetic integrity that will occur with germline engineering. The issue of bodily integrity has been debated some in recent articles about genetic engineering, but in the U.S. a large part of the problem depends upon how a human being is defined in relation to debates over abortion. Radical feminists such as Raymond are both pro-choice, as well as opposed to genetic engineering for its effects upon women as well as on the embryo, which could possibly be described as human though not yet a person.

58. Steve Olson, "The Genetic Archaeology of Race," *Atlantic Monthly* (April 2001): 79, on the process of analysis, and also Norman Daniels, "Negative and Positive Genetic Interventions: Is There a Moral Boundary?" *Science in Context* 11, 3–4 (1998). Sharon Begley, in "Decoding the Human Body," 50, falsely states that the Human Genome Project had, as its goal, "determining the exact chemical sequence that constitutes the DNA in every cell of every human body," which is a falsification and oversimplification of the truth; later in the same article, she mentions contrary information, stating that "Humans have perhaps 80,000 genes, and we are 99.9 percent identical," 53.

59. Sharon Begley, "Decoding the Human Body," 53–54. Microsatellite DNA may have a role to play in causing human disease; see E. Richard Moxon and Christopher Wills, "DNA Microsatellites: Agents of Evolution?" *Scientific American* (Jan. 1999): 94–99. According to Robert Sapolsky, "It's Not All in the Genes," *Newsweek* (10 April 2000): 68, "genes don't independently determine when proteins are synthesized. They follow instructions that originate somewhere else." The variations are referred to as single nucleotide polymorphisms, or SNPs.

60. Todd Woody, "DNA Detectives," 170. Pharmaceutical companies are partnering with companies offering genetic sequencing based upon this idea; see Woody, 182. See also Eliot Marshall, "Company Plans to Bank Human DNA Profiles," *Science* 291 (26 Jan. 2001): 575; and Begley, "Decoding the Human Body," 54–57, "The Human Parts List."

61. Larissa Temple, Robin McLeod, Steven Gallinger, and James Wright, "Defining Disease in the Genomics Era," *Science* 293 (3 Aug. 2001): 807. They also note that "distinguishing between normal variations (polymorphisms) and alterations that are detrimental (mutations) remains extremely difficult." On cystic fibrosis and malaria, see Allen Wilcox, "Quest for the Perfect Human Has Severe Flaws," *Los Angeles Times,* 31 Dec. 2001, M5.

62. For example, one study showed that approximately 50 percent of Ashkenazi women "with mutations in the breast cancer susceptibility genes BRCA1 and BRCA2" actually developed breast cancer, whereas "among non-Ashkenazi women who develop breast cancer" only 5 percent have this mutation. "Thus, a genetic mutation is not an absolute prerequisite for a disease and cannot be used as the sole defining feature of that disease." See Temple, McLeod, Gallinger, and Wright, "Defining Disease in the Genomics Era," 808, and Sapolsky, "It's Not All in the Genes," 68.

63. The equation of "defectives" with "disease," as discussed at the beginning of Chapter 5, is telling. See Ellsworth Huntington, *Tomorrow's Children: The Goal of Eugenics* (New York: J. Wiley and Sons, 1935), 45.

64. Anita Silvers, "A Fatal Attraction to Normalizing: Treating Disabilities as Deviations from 'Species-Typical' Functioning," in *Enhancing Human Traits,* ed. Erik Parens (Washington, D.C.: Georgetown University Press, 1998), 105, quoting Phillip Davis and John Bradley, "The Meaning of Normal," *Perspectives in Biology and Medicine* 40,1 (Autumn 1996): 69–70.

65. Stock, *Redesigning Humans,* 105, 44, 101, 104.

66. Ibid., 118, 109.

67. Ibid., 123.

68. Ibid., 118. On 90, in reference to three websites promoting anti-aging drugs, Stock states, "These sites are not the cause but the response to our yearnings."

69. Ibid., 97, 117, 214. On wealth of parents using germline enhancement, see 94. On race, 115, he states, "If you wanted to build a superior human, you would probably choose black skin, at least if the person was going to spend much time in the sun. . . . But don't hold your breath waiting for such engineering. A genetic module for black skin is unlikely to be in big demand anytime soon. Blacks certainly don't need it, and few nonblacks will want it. Race and parentage carry so much

cultural baggage that *few parents would use their children as political billboards when sunscreens . . . and lotions that stimulate melanin production . . . can protect their skin.*" In other words, these parents are white, and wouldn't want to have a dark-skinned child who would stand out as a "political billboard" when they could just apply a temporary product to the child's skin to protect him or her from the sun. Gardner, in "Can Human Genetic Enhancement Be Prohibited?" 66, also writes that genetic screening and germline engineering would be "part of the standard repertoire of reproductive services available to parents with access to advanced medical care." Alexander, in "Don't Die, Stay Pretty," 184, states "the wealthiest of you will live to 150," implying that only the wealthy will be able to purchase the genetic services to halt aging.

70. Alexander, "Don't Die, Stay Pretty," 182, 184.

71. Stock, *Redesigning Humans*, 40, and Stock and Campbell, *Engineering the Human Germline*, 6.

72. Nelson Wivel and LeRoy Walters, "Germ-Line Gene Modification and Disease Prevention: Some Medical and Ethical Perspectives," *Science* 262 (22 Oct. 1993): 535. With regards to cloning, which depends upon very similar processes to those used for germline engineering, Jaenisch and Wilmut, in "Don't Clone Humans," 2552, state, "We believe attempts to clone human beings at a time when the scientific issues of nuclear cloning have not been clarified are dangerous and irresponsible."

73. Kolata, "Scientists Brace for Changes in Path of Human Evolution," A12.

74. The lure of huge profits attained by controlling and "improving" DNA—for biotechnology and for human medical genetics—exerts a strong pull toward controlled, eugenic design. Convincing marketing schemes that depict new services and products as unquestionably beneficial, and media coverage that acts as if these genetic technologies are inevitable, will likely serve to increase support for the new eugenics. Similarly, by putting forward a brash self-confidence, which is necessary to win public confidence, boost the value of biotech stocks, and keep money flowing for research, biotech executives are playing a public-relations game. On current marketing strategies and goals, see Adam Bryant, "The Gold Rush," 65, 67. Similarly, with profit rather than human costs on his mind, Stock, *Redesigning Humans*, 58–59, envisions that, "With a little marketing by IVF clinics, traditional reproduction may begin to seem antiquated, if not downright irresponsible." Stock, 47, also mentions the "fortunes to be made" through germline engineering. On the inevitability of human genetic engineering, see Kolata, "Scientists Brace for Changes in Path of Human Evolution," title on A1; Gregory Stock and John Campbell title the first section of their book "The Realities of Human Germline Engineering," in *Engineering the Human Germline*, and see also their statement on page 5; Margaret Talbot, "A Desire to Duplicate," 40, also quotes Stock on the inevitability of human cloning.

75. Scientists promoting these technologies downplay the possibility that something could go wrong, or, in the case where it does, they assert that they will be able to fix it through new and improved technologies. For example, the genetic variant that scientists associate with sickle-cell anemia is also thought to offer resistance to malaria. Yet, Stock asserts that reducing that variant would not cause a

malaria problem because "Germinal choice can take place only in a high-technology world, and long before the sickle cell allelle has disappeared through genetic selection or engineering, we would almost certainly have buttressed our medical and public health defenses against malaria." Should this not be the case, he suggests that scientists could just add the variant back in (to the next generation of genetically engineered children, that is), as if the lack of the gene in those living when the malaria problem occurs and the ever-growing dependence upon what may be faulty technologies were not problematic. Similarly, as if forgetting these are human subjects, he presumes that "Future genetic engineers may find that predicting the outcomes of new gene groups is difficult, but most combinations probably will not lead to serious dysfunctions." See Stock, *Redesigning Humans*, 143–44, 77.

76. Silvers, "A Fatal Attraction to Normalizing," 108.

77. Victor Margolin, *The Politics of the Artificial* (Chicago: University of Chicago Press, 2002), 82, 84.

Selected Bibliography

Architecture and Design Archives

Egmont Arens Papers, Special Collections Research Center, Syracuse University Library, Syracuse, New York.

Claude Bragdon Archives, Rush Rhees Library, University of Rochester, Rochester, New York.

Donald Deskey Papers, Cooper-Hewitt National Design Museum, Smithsonian Institution, New York.

Henry Dreyfuss Papers, Cooper-Hewitt National Design Museum, Smithsonian Institution, New York.

Norman Bel Geddes Collection, Harry Ransom Humanities Research Center, University of Texas at Austin (NBG Papers).

Raymond Loewy Papers, Cooper-Hewitt National Design Museum, Smithsonian Institution, New York.

Raymond Loewy Papers, Library of Congress, Washington, D. C.

Louis Sullivan Papers, Ryerson Library, Art Institute of Chicago.

Walter Dorwin Teague Papers, Special Collections Research Center, Syracuse University Library, Syracuse, New York (WDT Papers).

Eugenics Archives

Bruno Gebhard Papers, Dittrick Medical History Center, Case Western Reserve University (BG Papers).

Henry Fairfield Osborn Papers, American Museum of Natural History, New York.

All other eugenics related archives listed below are located at the American Philosophical Society, Philadelphia, Pennsylvania.

American Eugenics Society Papers (AES Papers).

American Eugenics Society Papers II—The Mehler Guide.

Charles B. Davenport Papers (CBD Papers).

Charles B. Davenport Papers—Cold Spring Harbor Series (CBD-CSH Series).

Eugenics Record Office Papers (ERO Papers).

Herbert Spencer Jennings Papers (HSJ Papers).

Frederick Osborn Papers.

Architecture and Design Related Secondary Sources

American Masters: Sculpture from Brookgreen Gardens. Ex. Cat. Austin, Tex.: Blanton Museum of Art, 12 June–16 Aug. 1998.

Andrew, David S. *Louis Sullivan and the Polemics of Modern Architecture: The Present Against the Past.* Urbana: University of Illinois Press, 1985.

Berney, Adrienne. "Streamlining Breasts." *Journal of Design History* 14, 4 (2001): 327–42.

Braden, Donna. "Selling the Dream." In *Streamlining America*, ed. Fannia Weingartner, 37–54. Ex. Cat. Dearborn, Michigan: Henry Ford Museum, Sept. 1986–Dec. 1987.

Burkhardt, François. "Form Made for Speed, or Progress as Propaganda: Incentives for Styling." In *Raymond Loewy: Pioneer of American Industrial Design*, ed. Angela Schönberger, 220–229. Berlin: International Design Center, 1990.

Bush, Donald. *The Streamlined Decade.* New York: George Braziller, 1975.

Cole, David. "The Rhetoric of Degeneracy and Evolutionism in the American Critical Response to Modern Art, 1908–1921." Ph.D. Dissertation, University of Texas at Austin, 1996.

Colomina, Beatriz. "The Psyche of Building: Frederick Kiesler's 'Space House.'" *Archis* 11 (Nov. 1996): 70–80.

Davies, Karen. *At Home in Manhattan: Modern Decorative Arts, 1925 to the Depression.* Ex. Cat. New Haven, Conn.: Yale University Art Gallery, 10 Nov. 1983–5 Feb. 1984.

De la Peña, Carolyn Thomas. *The Body Electric: How Strange Machines Built the Modern American.* New York: New York University Press, 2003.

Dinerstein, Joel. *Swinging the Machine: Modernity, Technology, and African American Culture Between the World Wars.* Amherst: University of Massachusetts Press, 2003.

Duncan, Alastair. *Art Deco.* London: Thames and Hudson, 1988.

Flinchum, Russell. *Henry Dreyfuss, Industrial Designer: The Man in the Brown Suit.* New York: Rizzoli, 1997.

Friedel, Robert. *Zipper: An Exploration in Novelty.* New York: Norton, 1996.

Ginzburg, Carlo. "Style as Inclusion, Style as Exclusion." In *Picturing Science, Producing Art*, ed. Peter Galison and Caroline Jones. New York: Routledge, 1998.

Hanks, David A., and Jennifer Toher. *Donald Deskey: Decorative Designs and Interiors.* New York: E. P. Dutton, 1987.

Henderson, Linda. *Duchamp in Context: Science and Technology in the Large Glass and Related Works.* Princeton, N.J.: Princeton University Press, 1998.

———. *The Fourth Dimension and Non-Euclidean Geometry in Modern Art.* Princeton, N.J.: Princeton University Press, 1983.

Henthorn, Cynthia. *Commercial Fallout: Advertising Narratives of Progress and the Invention of Postwar Social Evolution, 1939–1945.* Athens: Ohio State University Press, 2005.

———. "The Emblematic Kitchen: Labor-Saving Technology as National Propaganda, The United States, 1939–1959." *Journal of Knowledge and Society* 12 (Fall 2000): 153–87.

Johnson, J. Stewart. *American Modern, 1925–1940: Design for a New Age.* New York: Harry Abrams, in association with the American Federation of Arts, 2000.

Jordy, William. "Functionalism as Fact and Symbol: Louis Sullivan's Commercial Buildings, Tombs, and Banks." In *American Buildings and Their Architects,* vol. 3, 83–179. Garden City, N.Y.: Doubleday, 1972.

Kihlstedt, Folke. "Utopia Realized: The World's Fairs of the 1930s." In *Imagining Tomorrow: History, Technology and the American Future,* ed. Joseph Corn, 97–118. Cambridge, Mass.: MIT Press, 1986.

Kinkel, Marianne. "Circulating Race: Malvina Hoffman and the Field Museum's Races of Mankind Sculptures." Ph.D. Dissertation, University of Texas at Austin, 2001.

Leach, William. *Land of Desire: Merchants, Power and the Rise of a New American Culture.* New York: Pantheon, 1993.

Lichtenstein, Claude, and Franz Engler, eds. *Streamlined: A Metaphor for Progress.* Princeton, N.J.: Princeton University Press, 1995.

Lupton, Ellen, and J. Abbott Miller. *The Bathroom, the Kitchen, and the Aesthetics of Waste.* Cambridge, Mass.: MIT Press, 1992.

Marchand, Roland. *Advertising the American Dream.* Berkeley: University of California Press, 1985.

———. "The Designers Go to the Fair II: Norman Bel Geddes, the General Motors 'Futurama,' and the Visit to the Factory Transformed." *Design Issues* 8 (Spring 1992): 23–40.

Marcus, George. *Design in the Fifties: When Everyone Went Modern.* Munich: Prestel, 1998.

Margolin, Victor. *The Politics of the Artificial.* Chicago: University of Chicago Press, 2002.

Massey, Jonathan. "Architecture and Involution: Claude Bragdon's Projective Ornament." Ph.D. Dissertation, Princeton University, 2001.

McLeod, Mary. "Le Corbusier and Algiers." In *Oppositions Reader,* ed. K. Michael Hays, 487–519. New York: Princeton Architectural Press, 1998.

Meikle, Jeffrey. *American Plastic: A Cultural History.* New Brunswick, N.J.: Rutgers University Press, 1995.

———. "Domesticating Modernity: Ambivalence and Appropriation, 1920–1940." In *Designing Modernity: The Arts of Reform and Persuasion, 1885–1945,* ed. Wendy Kaplan, 142–67. London: Thames and Hudson, 1995.

———. "Donald Deskey Associates: The Evolution of an Industrial Design Firm." In *Donald Deskey: Decorative Designs and Interiors,* ed. David Hanks and Jennifer Toher, 121–156. New York: E.P. Dutton, 1987.

———. "Forms, Functions and Mixed Motives: A Natural History of Streamlining." Talk at conference on "The Art Deco World," Victoria and Albert Museum, London, 26 April 2003.

———. "From Celebrity to Anonymity: The Professionalization of American Industrial Design." In *Raymond Loewy: Pioneer of American Industrial Design,* ed. Angela Schönberger, 51–61. Berlin: International Design Center, 1990.

———. "Technological Visions of American Industrial Designers, 1925–1939." 4 vols. Ph.D. Dissertation, University of Texas at Austin, 1976.

————. *Twentieth-Century Limited: Industrial Design in America, 1925–1939.* Philadelphia: Temple University Press, 1979.

Michl, Jan. "Form Follows WHAT? The Modernist Notion of Function as a Carte Blanche." *Magazine of the Faculty of Architecture & Town Planning* 10 (Winter 1995): 31–20 [sic]. Published on Michl's website at geocities.com/athens/2360/jm-eng.fff-hai.html.

Mills, Mike. "Herbert Bayer's Universal Type in Its Historical Context." In *The ABC's of [triangle, square, circle]: The Bauhaus and Design Theory*, ed. Ellen Lupton and J. Abbott Miller, 38–49. New York: Herb Lubalin Study Center of Design and Typography, Cooper Union for the Advancement of Science and Art, 1991.

Perreault, John, ed. *Streamline Design: How the Future Was.* Ex. Cat. New York: Queens Museum, 28 Jan.–6 May, 1984.

Pisano, Dominick. "The Airplane as a Cultural and Aesthetic Symbol, 1909–1940." Unpublished essay in Pisano's possession at the Department of Aeronautics, National Air and Space Museum, Smithsonian Institution.

Pretzer, William. "The Ambiguities of Streamlining: Symbolism, Ideology, and Cultural Mediator." In *Streamlining America*, ed. Fannia Weingartner. Ex. Cat. Dearborn, Mich.: Henry Ford Museum, 9 Sept. 1986–23 Dec. 1987.

Pyne, Kathleen. *Art and the Higher Life: Painting and Evolutionary Thought in Late Nineteenth-Century America.* Austin: University of Texas Press, 1996.

————. "Resisting Modernism: American Painting in the Culture of Crisis." In *American Icons: Relations Between European and American Art during the Eighteenth and Nineteenth Centuries*, ed. Thomas Gaeghtens and Heinz Ickstadt, 289–317. Los Angeles: Getty Center, 1992.

Rydell, Robert W. *All the World's a Fair: Visions of Empire at American International Expositions, 1876–1916.* Chicago: University of Chicago Press, 1984.

————. *World of Fairs: The Century-of-Progress Expositions.* Chicago: University of Chicago Press, 1993.

Scherrer, Hans. "À propos de la biotechnique dans le IIIième Reich: Gestaltung im Dritten Reich." *Form* 69 (1975): 21–28.

————. "À propos de la biotechnique dans le IIIième Reich: Gestaltung im Dritten Reich." *Form* 70 (1975): 27–34.

————. "À propos de la biotechnique dans le IIIième Reich: Gestaltung im Dritten Reich." *Form* 71 (1975): 25–32.

Wilson, Richard Guy, Dianne Pilgrim, and Dickran Tashjian. *The Machine Age in America, 1918–1941.* New York: Harry Abrams, in association with the Brooklyn Museum, 1986.

Wright, John L. "The Beginning of the Streamlined Dream, 1919–1934." In *Streamlining America*, ed. by Fannia Weingartner. Ex. Cat. Dearborn, Mich.: Henry Ford Museum, 9 Sept. 1986—23 Dec. 1987.

Evolution and Eugenics Related Secondary Sources

Adams, Mark. "Toward a Comparative History of Eugenics." In *The Wellborn Science: Eugenics in Germany, France, Brazil and Russia*, ed. Mark Adams, 217–26. Oxford: Oxford University Press, 1990.

Allen, Garland E. "The Eugenics Record Office at Cold Spring Harbor, 1910–1940: An Essay in Institutional History." *Osiris* 2 (1986): 225–64.

Berg, Scott. *Lindbergh*. New York: Berkley Books, 1998.

Black, Edwin. *War Against the Weak: Eugenics and America's Campaign to Create a Master Race*. New York: Four Walls Eight Windows, 2003.

Bogdan, Robert. *Freak Show: Presenting Human Oddities for Amusement and Profit*. Chicago: University of Chicago Press, 1988.

Carlson, Elof Axel. *The Unfit: A History of a Bad Idea*. Cold Spring Harbor, N.Y.: Cold Spring Harbor Laboratory, 2001.

Cleverly, John, and D. C. Phillips. *Visions of Childhood: Influential Models from Locke to Spock*. New York: Teachers College Press, 1986.

Cogdell, Christina. "Products or Bodies? Streamline Design and Eugenics as Applied Biology." *Design Issues* 19,1 (Winter 2003): 36–53.

———. "Reconsidering the Streamline Style: Evolution, Eugenics, and U.S. Industrial Design, 1925–1940." Ph.D. Dissertation, University of Texas at Austin, 2001.

———. "The Futurama Recontextualized: Norman Bel Geddes's Eugenic 'World of Tomorrow.'" *American Quarterly* 52, 2 (June 2000): 193–246.

Currell, Sue. "*Life Begins at Forty*: Self-Improvement and Eugenics During the Great Depression." Talk given at the annual conference of the American Studies Association, Houston, Texas, November 2002.

Daniels, Norman. "Negative and Positive Genetic Interventions: Is There a Moral Boundary?" *Science in Context* 11, 3–4 (Autumn–Winter 1998): 439–53.

Davis, Lennard. *Enforcing Normalcy: Disability, Deafness, and the Body*. London: Verso, 1995.

Degler, Carl. *In Search of Human Nature: The Decline and Revival of Darwinism in American Social Thought*. New York: Oxford University Press, 1991.

De la Peña, Carolyn Thomas. "Powering the Modern Body: Theories of Energy Transfer in American Science, Medicine and Technology, 1875–1945." Ph.D. Dissertation, University of Texas at Austin, 2001.

Dikötter, Frank. "Race Culture: Recent Perspectives on the History of Eugenics." *American Historical Review* 103, 2 (April 1998): 467–78.

English, Daylanne. *Unnatural Selection: Eugenics in American Modernism and the Harlem Renaissance*. Chapel Hill: University of North Carolina Press, 2004.

———. "W. E. B. DuBois's Family *Crisis*." *American Literature* 72, 2 (June 2000): 291–319.

Falk, Raphael. "Zionism and the Biology of the Jews." *Science in Context* 11, 3–4 (1998): 587–607.

Falk, Raphael, Diane Paul, and Garland Allen. "Forward." *Science in Context* 11, 3–4 (1998), 329.

Fitzpatrick, Ellen. *Endless Crusade: Women Social Scientists and Progressive Reform*. New York: Oxford University Press, 1990.

Gardner, William. "Can Human Genetic Enhancement Be Prohibited?" *Journal of Medicine and Philosophy* 20 (1995): 65–84.

Gordon, Linda. *Woman's Body, Woman's Right: A Social History of Birth Control in America*. New York: Grossman, 1976.

Gould, Stephen J. *The Mismeasure of Man*. New York: W.W. Norton, 1996.
———. *Ontogeny and Phylogeny*. Cambridge, Mass.: Belknap Press of Harvard University Press, 1977.
Haller, Mark H. *Eugenics: Hereditarian Attitudes in American Thought*. New Brunswick, N.J.: Rutgers University Press, 1963.
Hasian, Marouf. *The Rhetoric of Eugenics in Anglo-American Thought*. Athens: University of Georgia Press, 1996.
Higham, John. *Strangers in the Land: Patterns of American Nativism, 1860–1926*. New Brunswick, N.J.: Rutgers University Press, 1955.
Hofstadter, Richard. *The Progressive Movement, 1900–1915*. Englewood Cliffs, N.J.: Prentice-Hall, 1963.
———. *Social Darwinism in American Thought*. Boston: Beacon Press, 1944, 1992.
Hoy, Suellen. *Chasing Dirt: The American Pursuit of Cleanliness*. New York: Oxford University Press, 1995.
Jensen, Katherine. "Teachers and Progressives: The Navaho Day School Experiment, 1935–1945." *Arizona and the West* 25,1 (1983): 49–62.
Jordan, Winthrop D. *White over Black: Historical Origins of Racism in the United States*. New York: Oxford University Press, 1974. This book is largely derived from *White over Black: American Attitudes Toward the Negro, 1550–1812*. Chapel Hill: University of North Carolina Press, 1968.
Kamrat-Lang, Debora. "Healing Society: Medical Language in American Eugenics." *Science in Context* 8,1 (1995): 175–96.
Kass, Leon. "Preventing a Brave New World: Why We Should Ban Human Cloning Now." *New Republic* (21 May 2001): 30–39.
Kay, Lily. *The Molecular Vision of Life: Caltech, The Rockefeller Foundation, and the Rise of the New Biology*. New York: Oxford University Press, 1993.
Kevles, Daniel. *In the Name of Eugenics: Genetics and the Uses of Human Heredity*. New York: Knopf, 1985.
Kline, Wendy. *Building a Better Race: Gender, Sexuality, and Eugenics from the Turn of the Century to the Baby Boom*. Berkeley: University of California Press, 2001.
Kuhl, Stefan. *The Nazi Connection: Eugenics, American Racism, and German National Socialism*. Oxford: Oxford University Press, 1994.
Lee, Rachel. "Journalistic Representations of Asian Americans and Literary Responses, 1910–1920." In *An Interethnic Companion to Asian American Literature*, ed. King-kok Cheung, 249–73. Cambridge: Cambridge University Press, 1997.
Lepp, Nicola, Martin Roth, and Klaus Vogel, eds. *Der Neue Mensch: Obsessionen des 20. Jahrhunderts*. Ex. Cat. Dresden: German Hygiene Museum, 22 Apr.–8 Aug. 1999.
Ludmerer, Kenneth. *Genetics and American Society: A Historical Appraisal*. Baltimore: Johns Hopkins University Press, 1972.
Mocek, Reinhard. "The Program of Proletarian Rassenhgyiene." *Science in Context* 11, 3–4 (1998): 609–17.
Moore, James R. *The Post-Darwinian Controversies: A Study of the Protestant Struggle to Come to Terms with Darwin in Great Britain and America, 1870–1900*. Cambridge: Cambridge University Press, 1979.

Nies, Betsy. *Eugenic Fantasies: Racial Ideology in the Literature and Popular Culture of the 1920's.* New York: Routledge, 2002.

Paul, Diane. *Controlling Human Heredity: 1865 to the Present.* Atlantic Highlands, N.J.: Humanities Press, 1995.

——. "Eugenics and the Left." *Journal of the History of Ideas* 45 (1984): 567–90.

——. "Genetic Services, Economics, and Eugenics. " *Science in Context* 11, 3–4 (1998): 481–91.

——. *The Politics of Heredity: Essays on Eugenics, Biomedicine, and the Nature-Nurture Debate.* Albany: State University of New York Press, 1998.

Peel, J. D. Y. *Herbert Spencer: The Evolution of a Sociologist.* New York: Basic Books, 1971.

Pernick, Martin. *The Black Stork: Eugenics and the Death of "Defective" Babies in American Medicine and Motion Pictures Since 1915.* New York: Oxford University Press, 1996.

Pickens, Donald K. *Eugenics and the Progressives.* Nashville, Tenn.: Vanderbilt University Press, 1968.

Pyne, Kathleen. *Art and the Higher Life: Painting and Evolutionary Thought in Late Nineteenth-Century America.* Austin: University of Texas Press, 1996.

Raymond, Janice. *Women as Wombs: Reproductive Technologies and the Battle over Women's Freedom.* San Francisco: HarperSanFrancisco, 1993.

Reilly, Phillip. *The Surgical Solution: A History of Involuntary Sterilization in the United States.* Baltimore: Johns Hopkins University Press, 1991.

Ridgeway, James. *Blood in the Face: The Ku Klux Klan, Aryan Nations, Nazi Skinheads, and the Rise of a New White Culture.* New York: Thunder's Mouth Press, 1990.

Russett, Cynthia. *Sexual Science: The Victorian Construction of Womanhood.* Cambridge, Mass.: Harvard University Press, 1989.

Rydell, Robert. *World of Fairs: The Century-of-Progress Exposition.* Chicago: University of Chicago Press, 1993.

Sanchez, George. " 'Go After the Women': Americanization and the Mexican Immigrant Woman, 1915–1929." In *Unequal Sisters: A Multicultural Reader on U.S. Women's History,* 2nd ed., ed. Vicki Ruiz and Ellen DuBois, 284–97. New York: Routledge, 1994.

Schneider, William H. "The Eugenics Movement in France, 1890–1940." In *The Wellborn Science: Eugenics in Germany, France, Brazil and Russia,* ed. Mark Adams, 69–109. Oxford: Oxford University Press, 1990.

Schwarz, Richard. *John Harvey Kellogg, M.D.* Nashville, Tenn.: Southern Publishing Association, 1970.

Selden, Steven. "Eugenics and the Social Construction of Merit, Race, and Disability." *Journal of Curriculum Studies* 32, 2 (Mar.–Apr. 2000): 235–52.

——. *Inheriting Shame: The Story of Eugenics and Racism in America.* New York: Teachers College Press, 1999.

Silvers, Anita. "A Fatal Attraction to Normalizing: Treating Disabilities as Deviations from 'Species-Typical' Functioning." In *Enhancing Human Traits,* ed. Erik Parens, 95–123. Washington, D.C.: Georgetown University Press, 1998.

Smith, Shawn Michelle. " 'Baby's Picture Is Always Treasured': Eugenics and the

Reproduction of Whiteness in the Family Photograph Album." *Yale Journal of Criticism* 2, 1 (1998): 197–220.

Squiers, Carol. *Perfecting Mankind: Eugenics and Photography.* Ex. Cat. New York: International Center of Photography, 11 Jan.–18 Mar. 2001.

Stanton, William. *The Leopard's Spots: Scientific Attitudes Toward Race in America, 1815–59.* Chicago: University of Chicago Press, 1960.

Stepan, Nancy Leys. "Eugenics in Brazil, 1917–1940." In *The Wellborn Science: Eugenics in Germany, France, Brazil and Russia,* ed. Mark Adams, 119–22. Oxford: Oxford University Press, 1990.

Stocking, George, Jr. *Race, Culture and Evolution: Essays in the History of Anthropology.* Chicago: University of Chicago Press, 1982.

The Holocaust: A Historical Summary. Washington, D.C.: U.S. Holocaust Memorial Museum, 1999.

Thomson, Rosemarie. *Extraordinary Bodies: Figuring Physical Disability in American Culture and Literature.* New York: Columbia University Press, 1997.

Tomes, Nancy. *The Gospel of Germs: Men, Women, and the Microbe in American Life.* Cambridge, Mass.: Harvard University Press, 1998.

Trombley, Stephen. *The Right to Reproduce: A History of Coercive Sterilization.* London: Weidenfeld and Nicholson, 1988.

Turner, James. *Without God, Without Creed: The Origins of Unbelief in America.* Baltimore: Johns Hopkins University Press, 1985.

Weiss, Sheila. *Race Hygiene and National Efficiency: The Eugenics of Wilhelm Schallmayer.* Berkeley: University of California Press, 1987.

———. "The Race Hygiene Movement in Germany, 1904–1945." In *The Wellborn Science: Eugenics in Germany, France, Brazil and Russia,* ed. Mark Adams, 8–68. Oxford: Oxford University Press, 1990.

Wertz, Dorothy. "Eugenics is Alive and Well: A Survey of Genetic Professionals around the World." *Science in Context* 11, 3–4 (1998): 493–510.

Whorton, James. "'Athlete's Heart': The Medical Debate over Athleticism, 1870–1920." In *Sport and Exercise Science: Essays in the History of Sports Medicine,* ed. Jack Berryman and Roberta Park, 109–35. Urbana: University of Illinois Press, 1992.

———. *Crusaders for Fitness: The History of American Health Reformers.* Princeton, N.J.: Princeton University Press, 1982.

———. *Inner Hygiene: Constipation and the Pursuit of Health in Modern Society.* Oxford: Oxford University Press, 2000.

Wikler, Daniel. "Eugenic Values." *Science in Context* 11, 3–4 (1998): 455–70.

Zenderland, Leila. "Biblical Biology: American Protestant Social Reformers and the Early Eugenics Movement." *Science in Context* 11, 3–4 (1998): 511–25.

———. *Measuring Minds: Henry Herbert Goddard and the Origins of American Intelligence Testing.* Cambridge: Cambridge University Press, 1998.

Zimmer, Carl. "Unnatural Selection." *Discover* (Sept. 2003): 77–78.

Zohar, Noam. "From Lineage to Sexual Mores: Examining 'Jewish Eugenics.'" *Science in Context* 11, 3–4 (1998): 575–85.

Index